藝術行路
黃才郎 的繪畫探索

策展人：李欽賢　Curator: Lee Chin-Hsien

A Journey of Art Exploration:
Huang Tsai-Lang's Paintings and Drawings

指導單位 Supervisor

文化部
MINISTRY OF CULTURE

主辦單位 Organizer

國立台灣美術館
National Taiwan Museum of Fine Arts

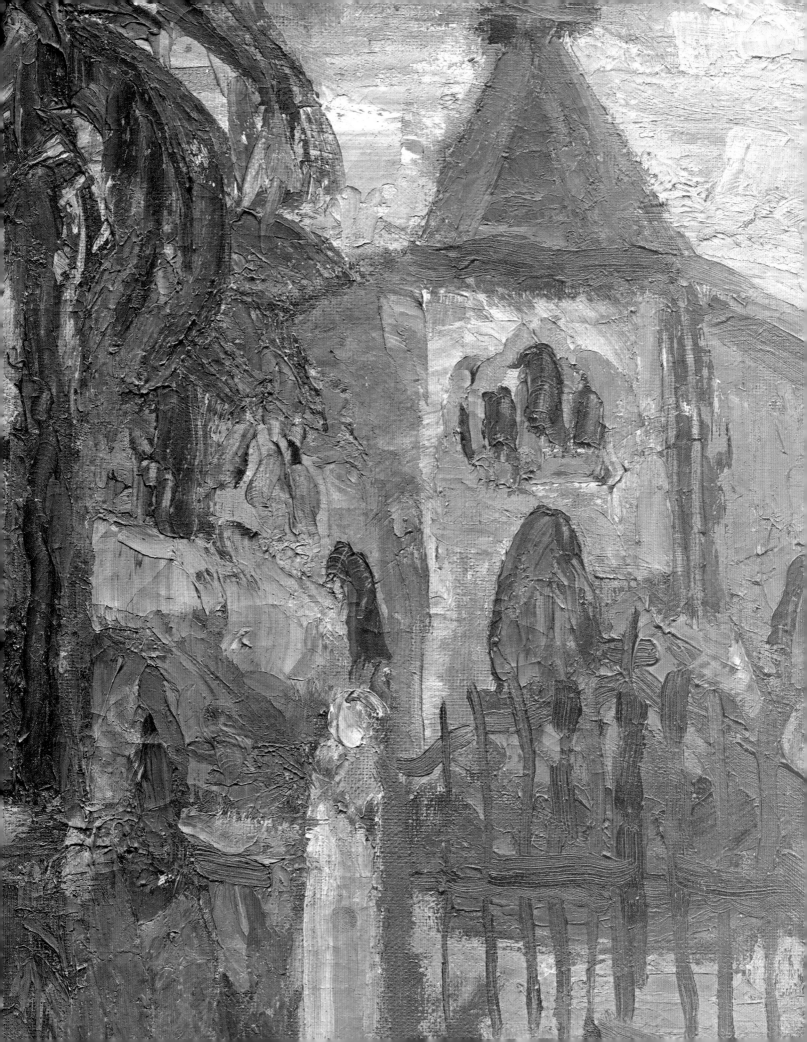

目次　Contents

館長序

2015 年臺灣藝術界盛大歡送國立臺灣美術館館長黃才郎榮退的記憶仍歷歷在目，經過 8 年潛心蟄伏的創作，這位歷任四所美術館館長的藝術行政巨人，以藝術家的身分重新回到國立臺灣美術館舉辦個展「藝術行路－黃才郎的繪畫探索」，向世人揭露他過去深藏不露的創作實力以及持續不滅的創作熱情。

黃才郎早年先進入郭柏川畫室習畫，後考進中國文化大學美術系接受廖繼春、李梅樹、楊三郎、林克恭等名師指導。畢業後，他首先從事美術教育與編輯等工作，而 1981 年應申學庸邀請，進入當時甫成立之行政院文建會任職，成為他人生的轉捩點，開啓了他公部門的藝術行政生涯。在體制內三十餘年，黃才郎主導「年代美展」、「臺灣地區美術發展回顧展」、「中華民國國際版畫雙年展」等重要展覽、推動公共藝術政策立法、陸續接任高雄市立美術館、臺北市立美術館及國立臺灣美術館等公立美術館館長，不遺餘力地擔任藝術與社會體制間的溝通橋樑，用心締造臺灣藝術文化的美好環境，並發揮關鍵性的影響力。

公務繁重之餘，黃才郎也從未放下畫筆，利用手邊畫具留下一系列速寫之作。自畫像、風景、裸女等簡潔蒼勁的線條，顯現出畫家未曾荒廢的筆力。他的作品取材自日常生活中隨處可見的平凡事物，如桌上鮮花供果、路旁隨風搖擺的蘆葦叢、童年記憶中甜美的甘蔗田，透過他的慧眼關照，揮動畫筆塗抹出《橘子》系列的沉靜禪意。而一筆筆細密勾勒的〈甘蔗〉，顯現出翻飛葉叢的活潑生命力。回顧黃才郎長期發展的不同創作系列，從早年對鄉土和表現主義的關懷、反映社會需求的理想，到嘗試金箔等新材料的運用，顯現其長年的藝術行政眼界和敏銳觸覺，促使他不斷追尋如何再創新局，與時俱進。

國立臺灣美術館長期關注臺灣本土藝術家的創作，每年持續策畫資深藝術家及臺灣藝術史主題展，展現臺灣藝術家多元的創作面貌，鼓勵不同的研究觀點。本次展覽接力國父紀念館舉辦的「纏綿－黃才郎作品展」，邀請美術史學者李欽賢策劃，擴大展出 181 件精選作品，以九大子題總結黃才郎綿延至今的創作歷程，從學生時期第一幅油畫作品〈佳里教堂〉開始，展示以裸女、花果靜物、風景為主題的精彩畫作，以及〈紅甘蔗園〉等近年的大型力作。期待觀眾能透過本展體會黃才郎的藝術成就，不僅是身為行政巨人為臺灣藝術環境開拓出一條康莊大道，也是身為畫家的不忘初衷、懇切踏實的藝術探索之旅。

國立臺灣美術館館長

Director's Foreword

With memories still vivid from when the arts community in Taiwan honored Mr. Huang Tsai-Lang in 2015 when he retired from his directorship at the National Taiwan Museum of Fine Arts (NTMoFA), eight years have since passed, which this influential figure who served as director of four art museums in Taiwan has devoted to making art. He now returns to the NTMoFA as an artist, presenting the solo exhibition, *A Journey of Art Exploration: Huang Tsai-Lang's Paintings and Drawings*, where he will be revealing what he has largely kept private in the past - his creative capabilities and unwavering passion for making art.

Huang was trained at the painting studio of Kuo Po-Chuan in his early years and was later admitted to the Department of Fine Arts at the Chinese Culture University, where he was mentored by Liao Chi-Chun, Li Mei-Shu, Yang San-Lang, Lin Ko-Kung, and other preeminent teachers. After he graduated, he began his career working as an art educator and editor. In 1981, he was recommended by Shen Hsueh-Yung to work at the then-newly-founded Council for Cultural Affairs under the Executive Yuan. This turning point in Huang's life opened up his ensuing art administration career in the public sector, where he then worked for over 30 years. Huang was the driving force behind many major exhibitions, including the *Era Art Exhibition*; *Art Development in Taiwan - A Retrospective Exhibition in Four Parts*; and *International Biennial Print Exhibit, R.O.C.,* and also pushed for the enactment of the public art policy bill. Throughout the years, he was appointed Director of the Kaohsiung Museum of Fine Arts, Taipei Fine Arts Museum, and National Taiwan Museum of Fine Arts, where he worked diligently at these public museums serving as a bridge between art and public institutions. He was devoted to building a positive environment for art and culture in Taiwan and was critically influential.

Outside of his busy work schedule, Huang continued to make art and used the tools he had at hand to create sketches. The succinct and dynamic lines on his self-portraits, landscapes, female nudes, and other subject matters demonstrate his vigorous artistic skills which he continues to hone. He often depicts common everyday things, such as flowers and fruits, reeds he saw swaying by the road, and the sweet sugar cane field from his childhood memory. With his keen, observant eye, he depicted a series of tangerines that exudes a calm, serene sense of Zen. The sugarcanes that he illustrates with intricate strokes show vibrant energy with vivacious and dynamic vegetation. In revisiting the different art series which Huang has spent many years developing, his earlier works conveyed his concerns and thoughts on nativism and expressionism and ideals that reflected social needs. He then began to experiment with new materials, including gold foil. This shows the wide horizons and sensitive perceptions he has acquired from working extensively in the field of art administration, which continues to propel him to innovate and advance with the times

The National Taiwan Museum of Fine Arts pays long-term focus on artworks by Taiwanese artists, with exhibitions curated each year featuring veteran artists and focusing on the art history of Taiwan. The exhibitions present a diverse range of creative works by Taiwanese artists and encourage different research perspectives. This exhibition follows the exhibition, *Lingering – Huang Tsai-Lang Solo Exhibition*, which was presented at the National Dr. Sun Yat-Sen Memorial Hall. Curated by art historian, Lee Chin-Hsien, this exhibition includes a prolific oeuvre of Huang, with 181 artworks presented. Divided into nine categories, a comprehensive review is proposed on Huang's extensive and ongoing creative journey, departing from his first oil painting, *The Jiali Church*, created when he was a student to other exciting pieces of female nudes, still lifes with flowers and fruits, and landscapes. Also on view is his recent large-scale work, *Red Sugar Cane Farm*. We hope our audience can gain insights into Mr. Huang Tsai-Lang's art achievements through this exhibition. In addition to being a tremendous art administration figure who has paved the way for art in Taiwan, he is also an artist who has kept his original intentions at heart, as he continues on a journey to diligently and steadfastly explore art.

Director, National Taiwan Museum of Fine Arts

創作自述

黃才郎

打從兒時拿到畫具開始接近美術一直到今日，生活中綿長的享受與習慣還是離不開繪畫。

此次展出作品包括我生平第一張油畫〈佳里教堂〉，另分別有風景、人物、靜物與素描、水彩等一百八十餘件作品。

展出意象直接得自生活週遭的橘子、黃金葛、公共事務、水仙、蘆葦，百合花、人體、自畫像與甘蔗園等，意在追求傳統美學與黑白之美，及青綠山水中墨筆沈著剛勁的魅力，在攢三聚五的聚合中追尋群化、纏綿重疊的感覺。

系列取材自便捷易得的小物件。橘子是吉祥供果，水仙亦是應節花卉，可予玩賞清供。其中，橘子的朱色系應用在黑白間，作品宛如水墨畫中的鈐印，相互輝映，進而構成各類佈置，把玩其聚合構成之美。

橘子

橘子平頭聳肩的身影，凸顯飽和的中廣身材，下移的重心，顯現出寬廣的平面，橘子不再只是橘子，而是一團渾厚穩定的立體。明顯拱出的飽滿輪廓，濃郁的皮層圍繞著立體，成排成列時，體積明顯的個體東倒西歪、各具表情。百看不厭的橘子，就是最佳的題材。

水仙

年節清供應節亮麗青翠，隔幾天就謝了，畫下水仙重組而成的景緻，加以經營結構，上、下留白，可得恢宏氣概，賞心悅目。貼金布箔，幻化黑白畫中常有的靜觀自得、勾連倚偎之景緻。

黃金葛

以黃金葛粗賤遍地竄生的特質，採取其葉片草莖滋生攀長垂掛伸展的姿態，變化多元。片片綠葉成叢集聚，葉片方向性的豐富變化，宛如人生實境，黑白映照，組織成一幅意境奧妙的剎那之美。縱觀扦搭交錯盤踞，風情萬種，猶如人生的情感，纏繞糾結出豐美的一生，不輟的生命力。

公共事務

進入出版社，主編《西洋美術辭典》；踏入美術行政公共事務，尤以「公共藝術」立法影響最大最深遠。公共藝術「1% for art」通過立法院審議那一天，特別將 1986 年完成的一件關心戶外雕塑議題的作品加筆畫了一片綠地，象徵公共藝術發展的未來遠景，並更名為〈心想事成－公共藝術構想〉，作為此重要事件的誌記與紀念。高雄市立美術館開館後，畫了一幅〈彩虹－雨後高美館〉，紀念碑式的顯現出高美館的壯麗。當年接任行政院文化建設委員會美術科長後，有感而發畫了一幅〈公文〉，表達願為藝術行政與公部門之間的橋樑作紀念以聊表心聲。

人物

人物系列包括素描、速寫、家人、人體與原民系列。人物入畫講究形、神、量體及線條在空間的位置，量體表現則靠線條與肌肉轉折交接所顯現，量體感出自線條的交待，整體密合無間，愛嬌的官能樣態才會出現。

此次展出作品，從第一幅〈佳里教堂〉到近作一百八十餘件，其中黑白佔九十餘幅。我喜歡黑色表現的魅力，以黑計白，以白當黑，墨分五彩，本身就美不勝收；黑白之美有其獨特美感，也是我所鍾愛的畫面氛圍。

一路走來莫忘初衷，自小學把玩 24 色粉蠟筆，加上金銀兩色更為興奮起，至高中在長榮校內古蹟建物寫生、北門高中陳基隆老師闢設美術教室自習、郭柏川教授畫室課外習畫，及考上文化大學美術系所畫出的作品－〈佳里教堂〉是揣摩康丁斯基抽象繪畫進入野獸派，表現主義的開始。

大學美術系的學習與好奇讓我走入美術的大世界，同時在系主任施翠峰教授推薦下，進入當時由英文中國郵報創辦的《美術雜誌》擔任美術編輯顧問。服役期間，留營守崗，準備陸光美展參賽，時常到靶場作畫，渡過八個禁足時光，畫下靶場紀實。

退伍後從事美術教育工作，進入雜誌社擔任編輯顧問，主編《西洋美術辭典》。任教延平中學時，在校舍頂樓搭工作室指導考美術系學生及課外活動團隊素描水彩。隨後接受申學庸教授邀請，進入新成立的行政院文化建設委員會，擔任第三處（藝術處分為兩科：音樂美術科及表演藝術科）美術科科長；踏入公部門，作為擔任美術與公部門的橋樑，讓政府強大的資源能夠通達藝術界所期待的願景中，同時也讓藝文界的期待能讓政府了解，兌現成為文化政策的實現。

文建會創辦之初，在首任主委陳奇祿先生支持下，推出「明清時代臺灣書畫展」、顏真卿逝世一千二百年紀念之「中國書法國際學術研討會」、「年代美展」、「臺灣地區美術發展回顧展」及開辦「中華民國國際版畫雙年展」等大型重要展覽，為美術理想一展抱負。

後來進入高美館、北美館、國美館，誠如民間所說「人在公門好修行」。任內鼓勵館內同仁研究館藏：高美館策劃「時代的形象」、北美館作臺灣美術史五個斷代的研究展、國美館「國美無雙」、「刺客列傳」等整理臺灣美術發展史，皆鼓勵館員策展。

2015 年屆齡自國立臺灣美術館館長退休，可利用於創作的時間更多，專程出外寫生於甘蔗園中，兒時記憶「火車交甘蔗」行車叮噹響不絕於耳。此生至今不忘初衷，彙整手邊作品舉辦展覽，在對美術的喜好與纏綿不斷之愛上再造新程。

Artist's Statement

Huang Tsai-Lang

Since I first got my hands on something to draw with as a child and started to grow closer to art, I still to this day deeply enjoy drawing, and it has become something that I can't live without.

Included in this exhibition is my first oil painting, *The Jiali Church*, and also over 180 other artworks, including landscapes, portraits, still-life paintings, drawings, and watercolor paintings.

You will see images depicting events and things from my everyday life, such as tangerines, devil's ivy, narcissuses, reeds, lilies, people, self-portraits, sugarcane groves, and also the jobs I had in the public sector, and many other things. My intention is to achieve traditional aestheticism and a sense of beauty created using the colors of black and white, as well as creating blue-green shanshui (mountains and waters, or landscapes) with calm yet dynamic ink strokes, seeking to capture feelings of coming together, lingering, and overlapping through assemblages and convergences that are multifold.

Common everyday objects have inspired my art series, including tangerines which are regarded as a symbol of good fortune and are used as ritual offerings, and also the seasonal flower of narcissuses which are enjoyed for their beauty, and they also make an elegant floral offering. By juxtaposing the warm hues of tangerines against a black-and-white backdrop, the artworks created appear like the seal inscription in a traditional ink painting. They complement each other and further develop into various arrangements, resulting in a playful beauty derived from the coming together of different elements.

Tangerines

A tangerine looks like it has a flat top, shrugged shoulders, and a plump body that's wide and bottom-heavy. More than just a tangerine, it is also a substantial and stable three-dimensional form. With a distinctive rounded contour that is wrapped in a layer of rich and dense skin, when tangerines are lined up next to each other, the weightier ones tend to topple and roll over, and each fruit has its own distinctive features. I'll never get bored of looking at tangerines, and they make a great painting subject.

Narcissuses

Delightful narcissuses make an elegant offering during spring festivities. I've painted them after they'd withered a few days after being offered, capturing them after the metamorphosis, with structural enhancement incorporated and negative spaces purposely kept at the top and bottom to result in a splendid and aesthetically-pleasing sight to behold. Gilded with gold foil, the scene created projects a tranquil effortlessness and a lingering connectedness that's often found in black-and-white paintings.

Devil's ivy

The devil's ivy is an evergreen plant that is found sprawling in many places, and I've captured the plant's climbing, stretching, and hanging leaves and stalks, depicting a medley of their shifting gestures. Their clustering leaves show the blades pointing in different directions and feel like a metaphor for life, and set against a reflective black-and-white contrast, the resulting paintings suggest life's profound ephemeral beauty.

Public Affairs

When I worked in publishing, I was editor-in-chief of a *Dictionary of Western Arts* (西洋美術辭典) in traditional Chinese, and after I transitioned into the field of art administrative public affairs, my involvement in setting the laws and regulations on the installation of public art was considered the most influential part of the work I did. When the public art "1% for Art" bill was passed by the Legislative Yuan, I added a green area to an artwork I had made in 1986 due to my concerns about issues related to outdoor sculptures, and the added gesture symbolized a future prospect for public art development. I also renamed the artwork, *A Wish Comes True – An Idea of Public Art*, to commemorate this significant event. When the Kaohsiung Museum of Fine Arts opened, I painted, *Rainbow – KMFA After the Rain*, which employed a monumental style to showcase the museum's magnificent stature. When I was appointed to serve as Section Chief of the Arts at the Council for Cultural Affairs under the Executive Yuan, I created a piece titled *Official Document* to express my determination to serve as a bridge to connect art administration with the public sector.

People

The series on people includes drawings, sketches, members of my family, human figures, and also a series on indigenous peoples. When portraying people, attention to form, essence, volume, and the position of the lines are important, and volume is expressed by the crossing and connecting of lines and muscles. The quality of the volume comes from how the lines are expressed, and only when everything is intricately connected, the features can then be delicately portrayed.

The exhibition opens with *The Jiali Church* and extends to show over 180 artworks, and over 90 artworks from the lot are in black and white. I am particularly fond of the color black, and when black and white are interchangeably applied and the five grades of ink show through, the result is spectacularly gorgeous. I adore paintings that show unique black-and-white aesthetics.

I've kept my original intentions in mind throughout my journey, which started with 24 crayons in grade school, and I was over the moon when silver and gold were later added. In high school, I painted the historical heritage buildings on the campus of Chang Jung Senior High School and trained in an art class run by Chen Kee-Lung from Beimen Senior High School. I was also under the tutelage of Kuo Po-Chuan at his painting studio and was later admitted to the Department of Fine Arts at the Chinese Culture University, where I painted *The Jiali Church*, which was an interpretation of Kandinsky's abstract art that was marked by Fauvist style, which launched the beginning of Expressionism.

My university art training further piqued my curiosity and guided me into the vast world of art. Referred by then Head of the Department, Prof. Shih Tsui-Feng, I started to work as an art editing consultant for *Meishu zazhi* (美術雜誌, Fine Arts Magazine) under *The China Post*. While serving my military duties, I often stayed in the military camp to guard the post and to also prepare for the *Army Brilliance Art Exhibition*. I often painted the firing range and spent much of my time there when I was confined to the military camp.

After I was discharged from the military, I started to work in the field of art education and then served as an editing consultant at a magazine, where I was in charge of publishing the *Dictionary of Western Arts*. I also taught at Yanping High School, where I mentored art students in a makeshift rooftop studio and also organized extracurricular activities that involved drawing and watercolor painting. Subsequently, I was invited by Prof. Shen Hsueh-Yung and started to work at the then-newly inaugurated Council for Cultural Affairs under the Executive Yuan, as Section Chief of the Arts in the 3rd Department (The Arts Division was divided into two sections, the Music Art Section and the Performing Art Section). I served as a bridge that connected the arts communities and the public sector, in order for the resources available from the government to be distributed to the arts communities and to help fulfill their visions. At the same time, the arts communities' expectations were communicated to and understood by the government, in order for them to be translated into practical cultural policies.

When the Council for Cultural Affairs was founded, with support from its inaugural minister, Chen Chi-Lu, many major large-scale exhibitions and events were organized, including *Taiwanese Calligraphy and Ink Painting from Ming and Qing Dynasties*; *International Seminar on Chinese Calligraphy in Memory of Yen Chen-Ching's 1200th Posthumous Anniversary*; *Era Art Exhibition*; *Art Development in Taiwan - A Retrospective Exhibition in Four Parts*; and *International Biennial Print Exhibit, R.O.C.*, which led to the realization of many artistic visions and ideals.

I then served at the Kaohsiung Museum of Fine Arts (KMFA), Taipei Fine Arts Museum (TFAM), and National Taiwan Museum of Fine Arts (NTMoFA), where I experienced the inimitable fulfillment of serving the public. During my services at the museums, I encouraged the staff to study the collections of the museums and to curate exhibitions, which led to the organization of several exhibitions that concentrated on the development of Taiwanese art history, including the *Retrospective Exhibition of Painting Development in Taiwan* at KMFA; a research-driven exhibition at TFAM that focused on five distinct eras in the art history of Taiwan; and *Unique Vision: Highlights from the National Taiwan Museum of Fine Arts Collection* and *"The Pioneers" of Taiwanese Artists* at NTMoFA.

After serving my directorship at the National Taiwan Museum of Fine Arts, I retired in 2015 and now have more time to create art. I would go out to paint outdoors in a sugarcane grove, which would bring back childhood memories of the bells on trains that were loaded with sugarcanes. I shall always keep my original intentions in mind, and as I sort through my artworks to prepare for this exhibition, I look forward to embarking on a new journey driven by my affection and lingering love for art.

專文
Essays

搭起美術與社會的橋樑－黃才郎的繪畫探索

李欽賢
| 策展人

極少有機會看到黃才郎館長的作品，有聞黃館長要開畫展，真的沒料到，但終於有機會看到了原作。印象中這位曾經主持過四個重要美術館的行政人才，竟能在繁重的公務夾縫中，沒有停止繪畫，其數量之龐大，技法之純熟，風格之多元，令人不得不讚嘆。

黃才郎館長是推動臺灣美術與社會接軌的旗手，儘管他策劃過無計其數的畫展，唯獨其個人創作卻深藏不露，如今終於從美術行政跑道轉換到畫家的舞臺，宛若繪畫圈獨走的一匹「郎」。

一、最早的油畫「佳里教堂」

黃才郎（以下敬稱略）1950年生於臺南佳里，年幼失怙，由祖父母扶養長大。1957年就讀臺南縣佳里國民學校，直至1963年畢業。

佳里古名蕭壠，原是平埔族社名，荷蘭佔領臺灣之後，應運漢人入墾引進牛隻。日本時代佳里庄升格為佳里街，可見佳里已是人口聚集的城鎮，市街頗為繁榮，也是鄰近村落前來採買的市場集散地。

關於兒時記憶，印象較深的是小學生時擁有一盒廿四色粉蠟筆，內附金、銀兩色，令他十分興奮，開始作畫自娛。還有每當親戚朋友來市場採買，經過自家門時總會招手問候，人情味十足。鎮上也有戲院，快散場時戲院會打開大門，開放給民眾「看戲尾」，黃才郎也會跟玩伴們來過過戲癮。

佳里也有古廟，金唐殿位於市區中心，還有離市區一公里外的佳里興震興宮，有葉王製作的交趾陶。黃才郎就讀大學時，震興宮交趾陶已被注目，老師曾交代他返鄉幫忙拍攝交趾陶的照片。可是不久震興宮發生被竊事件，所以後來震興宮壁堵的交趾陶都加一層透明防護罩。

成長於佳里的少年黃才郎，有過民間藝術洗禮之體驗，成為後來靜物畫的色彩元素，和造形之民藝象徵。

那個年代尚未實施九年國教，所以必須參加考試才能升學，進取心極強的黃才郎，在家人的支持下，1963年考上臺南市立初級中學，這是臺南第一所初中，即今大成國中。

彼時臺南是最典型的古都，隨處都是古蹟，初夏滿開的鳳凰樹，和古意盎然的建築物，令他大開眼界，浸淫古都，展開求學、習畫、寫生的青少年歲月，臺南可以說是黃才郎藝術的原點。

高中一年級，黃才郎進入臺南市私立長老教會長榮中學，紅磚教室是歷經半世紀的古樓，古蹟建築寫生其實是入學初衷。不過，升上高二則轉學至離家較近的北門高中，因為北門高中有美術準備室，更可以讓他專心練習石膏像素描。

高中時期比較好玩，有一陣子迷上撞球，家族中有位關心他的長輩，知道他喜愛畫圖，就力勸他應該要到臺南市郭柏川畫室習畫，接受老師的指導必能更有精進。當年郭柏川已是「南美會」的首席人物，在南臺灣畫壇地位崇高，是數一數二的名師。1968年黃才郎經長輩提點，進入郭柏川畫室習畫。郭老師說他只收愛畫的學生，而非面授考前衝刺。從此投考大學美術系，是青年黃才郎最大的嚮往。

郭柏川畫室其實是成功大學教授宿舍，也是老師的居處。那是一幢木造日式平房，進門有個小庭院，它原是日本時代臺灣軍第二聯隊的將校官舍，宿舍進門玄關右方房間就是郭柏川入室弟子習畫的地方。那時候董日福當助教，董氏長期在師門薰陶，亦習得老師精簡、速筆之線

條和鮮麗的彩瓷設色之真功夫。年少的黃才郎看在眼裡，心中暗暗惕勵自己好好下功夫，期盼能向師兄看齊。

翌年（1969 年），經過一番屬兵秣馬，積極準備之後，一心嚮往走上美術之路的青年黃才郎，終於如願以償考取中國文化學院（今文化大學）美術系，開始接受美術的科班教育，除素描和水彩之外，首次接觸油畫材料。

1971 年放假返鄉寫生的油畫〈佳里教堂〉，為了補足古意，賦予蒼茫的紫紅色，凸顯古屋斑駁之美。長老教會在佳里設教已久，戰前移建今址的教堂曾遭空襲炸毀，戰後的 1952 年重建時，採磚造建體敷上水泥，所以佳里的教堂並非紅磚屋，僅圍牆保留初砌的紅磚。

黃才郎的古蹟意識覺醒得甚早，許是受到臺南古都所啓發的，師事郭柏川也感受到老師拿手的「紅朱膏」色澤（民間製作「紅龜粿」的食用紅色素），但是黃才郎〈佳里教堂〉一作中的色彩比較含蓄，沒那麼艷麗。更重要的是他不忽略代表南國風情的二株椰子樹，直衝畫布頂端，並求得構圖平衡。

同年（1971 年）又另畫一幅大膽奔放的〈佳里教堂〉，除了術科學習繪畫技巧之外，他也多方研讀各種美術知識，文化美術系學科之薰陶，知道康汀斯基（Wassily Kandinsky, 1866-1944）是西洋現代美術抽象畫的開山大師，他應用物象解構再構成的立體派理念，究其本意就是「破」。黃才郎嘗試打破既有物象手法，特別打散前景樹叢和空中雲層，將之佈局到畫面上就形成半抽象了！

二、美術大學生的雙刀流

「雙刀流」是指既能繪畫又能寫作的兩方力道，美術系學生黃才郎確已具備兩刀才華。

1970 年教育部同意施翠峰（1925-2018）從國立藝專（今國立臺灣藝術大學）美工科主任，借調至文化學院主持美術系，這時黃才郎才升上二年級，導師是施翠峰摯友楊乾鐘（1925-1999），專責素描教學。油畫課老師是李梅樹（1902-1983），助教為黃朝謨（1939-）。

1971 年油畫課師生同往三峽寫生，黃才郎創作油畫〈三峽〉，紅綠對比的趣味性，本來也是郭柏川「油畫東方化」的實驗色彩，本作得到傳承。黃才郎的古蹟意識也畫〈臺南孔廟大成殿〉與〈臺南天后宮小巷夜景〉二件水彩。〈臺南孔廟大成殿〉構圖四平八穩，天際之紫色和廟殿的橙紅，皆屬明暗面處理，少線條，去人影，氣氛更顯靜謐，極富「全臺首學」之廟堂莊嚴。〈臺南天后宮小巷夜景〉亦屬明暗對比手法，受光面由色塊創出各種造形，即使是具象的廟宇側影，卻營造出抽象效果。

同年（1972 年）的〈畫室〉一圖，色彩轉為鮮艷，紅色巨幅的「畫中畫」溢出畫布外緣，凝視中的畫家足下有光線照進來，尤其是〈畫室〉一作明與暗對比分外強烈。創作此畫時，黃才郎尚在文化美術系就學中，表現十分傑出，不僅是美術系學會會長，還創辦美術系刊，觸鬚還延伸到校外的「英文中國郵報（The China Post）」發行之《美術雜誌》，參與編務，儘管身負多重任務，仍然勉力投入創下〈畫室〉之百號大作。由英文「中國郵報」出資出版的輕薄型《美術雜誌》，是文化美術系主任施翠峰推薦黃才郎擔綱文字編輯，報導臺灣畫家，以及開闢西洋美術史專欄。由於施翠峰早就發現黃才郎能寫能畫，是可造之材，雙刀流角色扮演得甚為出色。

1972 年洪瑞麟（1912-1996）甫從瑞芳懷山煤礦退休，幾位畫友想相約去蘭嶼寫生，主要是洪瑞麟離開長年在地底坑洞暗黑的環境後，極思追尋廣闊光明的世界，看海、

追陽光，更想體驗蘭嶼的離島風情，可是當時蘭嶼尚未開放觀光。黃才郎是英文中國郵報《美術雜誌》編輯，身具記者身分，於是畫友們請黃才郎出面申請，提出當代知名畫家欲組團前往蘭嶼寫生之計畫，而獲得核准。一行人包括洪瑞麟、陳景容、周月坡、張萬傳、汪壽寧、黃昌惠以及黃才郎共七人同行，搭乘小飛機飛往蘭嶼。上飛機之後，際因洪瑞麟最胖，駕駛員基於飛行平衡考量，給大家調整座位，第一次搭飛機的黃才郎在搖搖晃晃飛行途中，自是驚嚇到搭機還有失衡的危險性。

抵達蘭嶼後立刻展開寫生活動，白天各自取景作畫，晚上相互觀摩當天的畫作。本來照原定計畫行程結束，就要離開蘭嶼，卻遇上颱風警報，不飛了！這下可苦了洪瑞麟與張萬傳這一對多年酒友，因為備酒已喝光，張萬傳四處尋酒，終於找到一家雜貨店，看見供桌上有一瓶祭拜的酒，百般懇求老闆賣給他，老闆拗不過酒仙，只好讓他帶回去過酒癮。

黃才郎是畫友中最年輕的小老弟，大學都還沒畢業，卻是最稱職的領隊，幫大家張羅大大小小的事，能力出色令團員佩服。他也細心觀察前輩們的作畫方式，他看洪瑞麟沾墨速寫，張萬傳快筆揮灑等等，自己則帶去粉彩顏料，畫下島上漁民的拼板舟，和原住民居住的茅草屋，並盡情捕捉海天陰晴變化的自然。畫友們速寫概以留白居多，而黃才郎以粉彩塗抹，極似素描般的賦色，營造出大氣流動的感覺。

回程因颱風過境後飛機停飛，臨時被安排搭乘軍用船返回本島，結束了這趟飛行加航海的蘭嶼寫生之旅。不久，黃才郎主編的《美術雜誌》刊出同行畫家的蘭嶼寫生作品，每一幅都是有名氣的當代畫家力作，自認後生晚輩的黃才郎十分謙虛，並沒有刊登自己的畫作，不敢掠前輩之美。

文化美術系學生時期的素描習作，最可圈可點的是人物畫的心理探討，如 1971 年的〈星期五下午〉，描寫職業婦女的小周末心情，1973 年將這樣的心理描寫製作成銅版畫，送往「臺北國際婦女會」參加作品評比入圍，發表入圍後再擇日赴現場實際操作製版技法，終於獲得版畫大專組第一名。

那個年代「臺北國際婦女會」主辦的獎項極有份量，獎狀上簽名的評審大師也有外國人，得獎系具有國際評價的榮譽。這一年（1973 年）黃才郎自文化學院美術系畢業。

三、教與編交替間的夾縫作畫

教是教學，編是編書，黃才郎兩頭忙亦未停下畫筆。

1973 年文化美術系畢業，緊接著的是服預備軍官役。大學生需要先赴臺中成功嶺受訓，即使是緊湊的軍旅生活，黃才郎也常把握瞬間，抽空畫了一幅〈成功嶺靶場〉。照理說，靶場景觀甚單調，他卻找到了平行、斜坡和直線，構成各地原始民族常見的幾何形圖像。

服役期間會常搭火車移防或回家，他順手畫下一般畫家忽略的車廂角落，〈火車上的茶杯〉，是一張複合構圖，上面畫窗邊有臺鐵專用的玻璃蓋杯，和可上下提拉的老式車窗窗檔；下圖是杯架與手指的特寫。彼時的列車可以開窗，車上又有服務生會提著滾燙的大水壺為旅客沖茶，水壺外面裹著一層帆布，避免乘客燙到，這款風景今已不再。

還有另一幅鉛筆素描的〈火車上〉一作，畫夜快車沙發座椅兩名女子並坐，一人倚窗，另一人拉下帽沿，睡姿各異，亮點是圖中女生穿著當時最流行的喇叭褲，創作年代是 1974 年。

此外，有同時期精密描繪的〈夜宿宮廟前庭〉，廟門前庭的龍柱旁，緊裹著被單只露出頭部的人，是部隊演習至田中附近，在旨臨宮夜宿的駕駛兵，一旁還擺放著軍鞋，當時他們二人是一組的。另有兩幅他筆下的〈貓〉，是很少描繪的題材，筆觸圓柔輕緩，應是興來之作。

退伍後一度在臺北市私立延平中學任教，也在雄獅圖書公司附設的「雄獅兒童畫班」授課。此期間黃才郎與美術同好王蕙芳女士共組家庭，夫婦合辦「一代兒童美術教室」，致力兒童美術教育之推廣。

小孩子的畫總是天真爛漫，色彩繽紛，可是黃才郎當時的畫作，卻反而是襌風進入簡素的單色素描，如〈延平中學校園老樹〉和〈延平中學校園〉，有如參襌的水墨意境。

黃才郎認為人物畫講究形、神、量體及線條在空間的位置；量體表現則靠線條與肌肉轉折交接所顯現，量體感出自線條的交代，整體密合無間，愛嬌的官能樣態才會出現。

結婚之後生下女兒黃之千和長男黃茂嘉，這其間也都有描繪襁褓中的兒女。1979 年的小品速寫〈小千畫像〉和〈茂嘉畫像〉，亦充分顯露稚子愛嬌神態。兩作都有署款題字，俾作永久紀念，為子女作畫的時間都在深夜，可見黃才郎無時無刻不在畫畫，連凌晨時刻亦不放過。

大學時代黃才郎已有不少裸女習作，速寫的線條和姿態已練到爐火純青之地步。大學畢業後也持續畫模特兒，一直到 1980 年累積不少裸女題材的油畫和素描。從 1973 年畫浴室內〈裸女〉，到 1976 年的〈黑衣少女〉，進而 1979 年的油畫〈裸女〉，有一個值得提出來討論的觀點，就是黃才郎的裸女畫完全基於「忠實本土女性身材」的出發點，簡單地說即是忠於真實的身材，沒有特意修飾。

明治時代日本青年畫家留學歐洲，盡是學到標準八頭身的歐洲模特兒，一旦回到日本可就難有同樣身材的女性模特兒了！像黑田清輝（1866-1924）就把日本女子變造成他能夠接受的修長身段。最先打破這道瓶頸的畫家是萬鐵五郎（1885-1927），1913 年萬鐵五郎創作〈日傘之裸婦〉即其一例。2000 年臺北市立美術館舉辦「東亞油畫的誕生與開展」之會場上，〈日傘之裸女〉譯為〈撐傘的裸婦〉參與展出。萬鐵五郎是日本野獸派先驅者，受到歐洲野獸派狂放風格之影響，敢於挑戰日本裸女的五短身材，強調頭大身短的畸形美。從畸形轉化成日本女子造形之美的，是留法的梅原龍三郎（1888-1986），梅原也是傾向野獸派的畫家，所以作風比較大膽。

1980 年黃才郎進入《雄獅美術》叢書部，主持《西洋美術辭典》編輯之艱巨任務，這是臺灣美術出版品的創舉，也是第一本中文美術辭典。基於美術知識紮根之需，以及為往後研究打下基礎，最早是由黃才郎率先提議，然後協同《雄獅美術》編輯部同仁，以及專業領域的教授，費時兩年才完成，臺灣首度發行美術辭典，竟是僅卅歲出頭的青年黃才郎獨具之遠見。

四、提升臺灣美術能見度第一人

1981 年行政院首創文化建設委員會（簡稱「文建會」，今升格為文化部），起用陳奇祿（1923-2014）擔任主委，隸屬文建會第三處處長申學庸聘請黃才郎出任美術科長。有史以來中央政府初設專責美術行政的國家級公部門，美術科長黃才郎順勢展開臺灣美術能見度的行動力。「美術」一詞是日本時代才有的新造漢字日文，戰前的「臺灣美術展覽會」（簡稱「臺展」）已出現「美術」之字眼；戰後各級學校雖有美術課，但社會上對美術內

涵之認知相當有限，黃才郎在科長崗位上，最知道美術進入社會的重要性，更急切的是提升「臺灣的美術」，讓社會看得見。1983 年文建會主辦「明清時代臺灣書畫展」，於國泰美術館正式展出。

歷經三百多年歲月星霜的臺灣古書畫，怎麼尋訪？這全都是黃才郎親自找各界關係，戮力奔走，艱辛達陣的。臺南古都，古城竹塹（新竹）是擁有臺灣古書畫最多的地區，臺南由熟知古書畫藏家的潘元石（1936-2022）嚮導，新竹有議員蕭再火領軍，同行採訪的伙伴尚有黃華源和蕭宗煌。潘元石為了取信於藏家，力促出借珍貴書畫，甚至拿自己的房契作抵押，始能順利借成。果然本展中有很多今人才初識的古代書畫家如林覺、林朝英、呂世宜等人，以及他們從來不曾面世的古書畫，都得以公諸於世。

國泰美術館座落於臺北市襄陽路，二二八公園對面的國泰集團大樓一樓，是當年最具規模，最有水準的美術展覽場地。黃才郎策劃的「明清時代臺灣書畫展」打響「臺灣美術」的名號之後，又籌劃「國際版畫展」，迎接海外美術走進臺灣。此兩展的新聞性，立即引起社會廣大迴響，尤其是「明清臺灣書畫展」，更是臺灣文化界美術尋根之始。

科長任內又進一步策劃「臺灣地區美術發展回顧展」，將臺灣美術從古代到現在的重要代表作，以薪火相傳的接力方式，分成四大單元從 1895 年 2 月至 3 月底，展出四檔期，地點也在國泰美術館。但是同年發生國泰旗下的「十信金融弊案」，國泰美術館亦被迫封館。

1980 年代公立美術館才剛誕生，典藏方針尚在摸索階段，「臺灣地區美術發展回顧展」在黃才郎的規劃下盛大登場，有歷史脈絡，有學術觀點，有斷代風格。唯有黃才郎具備臺灣美術史知識，在陳奇祿主委的肯定與支持下，「臺灣的美術」終於出土，並獲致重新評價。

美術科長任期七年間，還有不少企劃案持續進行。黃才郎為了取得正式公職資格，又要準備拚高考，通過高考後仍留在文建會推動業務，可是他儘管再忙也不忘繪畫。1980 年代獨創「纏綿系列」的黃金葛寫生，黃金葛是一種生長力旺盛的爬藤植物，綠葉與藤蔓糾結交錯，盤踞之姿強勁有力，有夠纏綿又富生命力。本系列創作採複合媒材，襯托植物本來的強韌，其實是黃才郎嘗試新時代、新藝術的探索，同年代的〈籠中鳥〉，也是從單純物象中的再變造，是黃才郎欲跳脫寫生，追求新藝術的嶄新創作。不過，反過來看 1983 年寫生的〈橘子系列〉，雖然是寫生，但背景全放空，達到求得全畫空靈之境，連簽名亦有禪意。

1988 年應學者訪問計劃獎助，赴美研究文化行政為期十個月，把握異國寫生的黃才郎有備而來，他帶來單色炭精筆和紙，隨時找時間作畫。一天從賣場購物回住處途中，經過公園看到一只空的購物袋被風捲起飄飛，黃才郎將之撿回畫了一張〈購物袋〉。美國人的購物袋大多數是土黃色牛皮紙，畫幅中紙袋佈滿摺痕的明暗面，配以背景的公園意象，造型格外豐富。

以〈購物袋〉為背景的樹枝意象，又畫了另一張特寫的〈七里香樹籬〉，也是訪美期間新創的樹幹與樹枝之佈局，很接近新藝術的探索。同年在華盛頓現場寫生的〈華盛頓特區〉，系古建築素描，主題鮮明，美國情調十足。另外有一幅〈華盛頓喬治城〉，是街頭寫生繪下的某個角度。對黃才郎來說，旅美面對異域風光的衝擊，尤其是單身羈旅中，單色畫更能反映出孤寂的心情，反而因為獨處而昇華為單純，甚至連人影也都不見了！

五、藝術扎根‧南臺灣發聲

〈心想事成－公共藝術構想〉是一幅黑白基調爲主的大件作品，創作於 1990 年前後，小部分塗綠，此構想代表都會公共藝術的存在，綠意是城市連結自然的象徵。本來的願景早就出現於 1986 年 11 月的《雄獅美術》月刊，刊物中登載公共藝術座談會之紀錄，文建會美術科長黃才郎是與談人之一。《雄獅美術》率先提出公共藝術新名詞，但當時大家共同理解的，僅限於街頭雕像或公園雕塑，所以座談會的發言，大都是針對臺北市公共藝術的空間規劃，以及如何選擇高品質的藝術作品。唯有黃才郎提到「用行政命令，從公有建築做起」，這句話正是後來公共藝術法案的基礎。

1990 年黃才郎辭去文建會之職，應邀擔任立法委員陳癸淼的文化立法助理，主要任務系爲公共藝術法案能提出立法院審查。翌年（1991 年）立法院三讀通過「文化藝術發展條例」，其中的公共藝術法案，規定公有建築物需提撥總工程費 1% 比例，作爲公共藝術設置基金。今天我們最容易撞見的臺北市公共藝術，就是捷運車站裝置的藝術作品，有在月臺上的，有由天花板垂吊而下的，或雕、繪在牆壁上的。

1994 年高雄市立美術館落成，黃才郎由去年（1993 年）的籌備處主任正式升任館長，全國第三座美術館開幕當天，堪稱南臺灣藝壇最大盛事。

開館展中極爲轟動的是「雄辯的聲音－布爾代勒雕塑大展」。布爾代勒（Antoine Bourdelle, 1861-1929）是法國現代雕塑巨匠，強壯男子表現力是其作品之特徵，會場中展出的〈大戰士〉巨作，高雄市立美術館有意購藏，卻苦於典藏經費有限，於是找上媒體聯合報和民生報合作，發起「保存布爾代勒－爲臺灣留下大師之美」募款

活動，高雄金融業的三信合作社亦大力響應，同時也接受市民小額捐款，終於買下布爾代勒〈大戰士〉雕像，永久保留在高雄。

高雄市立美術館一連串推出引人注目的大展，使得這座南臺灣美術殿堂的評價節節升高。館長黃才郎於開館第二年（1995 年），畫了一張〈彩虹－雨後高美館〉大作，代表高雄市立美術館起跑出發的紀念碑式形象，黑白爲主，彩色爲輔，荷花池水面貼金箔，運用綜合媒材和超現實藝術的幻境組合，可見黃才郎追逐當代新表現法的企圖心甚強。

1995 年是高美館創立第二年，恰逢臺灣雕刻家黃土水百歲冥誕，館長黃才郎積極策劃「黃土水百年誕辰紀念特展」，親自循線走訪本地收藏家，並赴日本向有關單位洽借黃土水師字輩的高村光雲、北村西望、朝倉文夫等日本大師眞跡，一併展出，俾作臺日雕刻家的比較研究，這方是學術性策展應該做的陳列方針，也是高美館最先做到的。

黃才郎在高雄市立美術館陸續注入世界級的雕塑資源，1997 年策劃法國雕塑界另一位大師「邁約爾展」，又造成轟動。邁約爾（Aristide Maillol，1861-1944）與前述之布爾代勒的風格正好相反的是，邁約爾係以女性題材爲主，調和古典主義的健美求得現代性造形。

首任高美館館長黃才郎，全力規劃館務方向，思考館藏的定位，以及籌辦各項大展之腦力激盪中，黃才郎的繪畫亦力圖激變，他採取「微觀藝術」的新時代藝術、新感覺之新創作來見證。

1992 年〈橘子系列－百吉〉，就無數墨色橘影中，強調出唯一的橙紅，主題「系列」之意，即代表會繼續畫下

去。1995 年的〈野薑花〉是枝葉怒張，竄出玻璃瓶的單色之花，展葉之姿極富現代藝術性。鉛筆畫的蘆葦系列，黃才郎從蘆葦叢裡找出特寫鏡頭，看似隨意其實是獨到之眼。

這種特寫的手法使上色彩，更有黃才郎獨自的藝術性詮釋，就舉〈南瓜〉、〈大頭菜〉及〈纏綿系列－玫瑰〉連作兩幅作例子，花果之藝術性不言可喻，畫中交代的背景亦不失藝術性，上舉之作品採細密描繪的功夫，大處著眼，直逼小處，屬「微觀」的觀察眼，最常見於當代日本膠彩畫家所繪的蔬果花卉，有些甚至極近「俳畫」的簡素意境。

這些作品都是出任高雄市立美術館館長之後的創作新實踐，也是黃才郎藝術創作的再蛻變。

六、館長在傾聽，館長在汲取

2000 年黃才郎接任臺北市立美術館館長，2009 年又出任國立臺灣美術館館長，這中間也有一陣子擔任文化建設委員會的處長和臺北市文化局副局長。此期間主持過多少會議，館長在傾聽；決策過多少藝術展，館長汲取為創作的活水。黃才郎對藝術生態更是了然於心，他最知道社會民眾要什麼。

兩館館長任內最值得大書特書的貢獻，就是將美術擴大為社會性話題，首先在北美館籌劃「臺灣地區美術發展回顧展」，以十年為分目，從 1950 年代至 1990 年代，劃出各年代承先啟後的臺灣現代美術史連線，展出檔期長達二年。

2013 年在國美館推出一系列臺灣藝術「刺客列傳」，以跨世紀 1990 年至 2014 年為斷代，共六個世代年青藝術家的研究型企劃展。

將臺灣美術推廣至社會的功勞之一，還有與郵局合作發行臺灣近代畫家郵票，四套共十二枚。黃才郎在文建會美術科長任內，早已意識到郵票是最容易廣為流傳，讓民眾認識臺灣美術之途徑，也曾經向郵政總局建議，但那個年代朝野印象中，除張大千之外沒有其他畫家而作罷。由於黃才郎執意推動，直到 2002 年臺灣畫家畫作印製成郵票，傳遞至家家戶戶終於實現。

1998 年黃才郎創作〈水仙三聯屏〉，總長近三百公分巨作，全畫為油彩貼金箔，又因為是橫幅形式，令人想起日本江戶時代尾形光琳所畫的〈燕子花圖屏風〉，由於是屏風所以更巨幅，但較之光琳畫燕子花之日本匠人的裝飾性；黃才郎筆下的水仙更富東方文人味。

這一年黃才郎出任北美館館長，百忙之中，他的畫風又陸續轉變，2002 年的兩幅〈橘子系列〉是文人畫風的水彩，但也持續畫油彩〈橘子系列〉的「微觀」創作手法，微觀之作猶有〈聖誕紅〉。

北美館長任期中，黃才郎有大量的人體速寫，尤以 2006 年至 2008 年三年間最為量產，已走出早期練素描的基本姿態，轉進立體雕塑觀照的人體畫，意思是說，人像切入雕塑家所要求的肢體難度，才有新穎的人體素描作品。

黃才郎的人體速寫宛如紙上雕塑，他以「塑」之要求，用筆「雕」出畫像，頗有羅丹作品的架勢，單純人體速寫中，男女模特兒皆有，僅畫線條省略明暗。

另外更富有雕塑性的人體是微胖的女性，非曲線玲瓏的肢體，反而更像雕塑。黃才郎憑雕塑觀點捕捉人體，出現千姿百態，不僅是素描力寶刀猶在，簡筆速寫自有其造形的價值，這好像是一批為塑而繪的前置作業，造形性質獨特很值得雕塑入門者參考。

大量速寫人體的 2006 年至 2008 年之間，黃才郎每遇公差，晚上夜宿旅店也不忘拿起紙筆，對著鏡子畫起自畫像。大學時代他也有自畫像，那一年他嚮導一群知名臺灣畫家旅遊蘭嶼，發揮青年黃才郎的領導力，自畫像也透露著自信的眼神。當上館長之後，顯現的是計劃館務遠景的決心和氣魄，均一一浮現在自畫像中的表情。

速寫手法的自畫像，自己對鏡凝視自己，梵谷也是畫過不少自畫像的畫家，梵谷是油彩所以較多彩色筆觸變化；黃才郎繪自畫像用鉛筆，倒是很有線條變化。筆者看到黃才郎這一組自畫像，特地排比出所有梵谷的自畫像作對照，自我凝視，目光炯炯，招牌短髭下，緊閉唇線，都和梵谷的自畫像一樣地顯現出堅毅與自信。

2001 年巴黎出差中，也畫了簽字筆的即興速寫，筆觸渾厚，線條簡單。2006 年北美館協助東京松濤美術館辦理「陳進百歲紀念展」，赴東京洽公時也在下塌的旅館畫窗外所見。在澀谷的高層大飯店臨窗寫生，也盡是現代高樓大廈，圖畫處理成像積木疊出的造形。反過來看 2008 年的〈Tours 旅店〉，是出差到法國於居所的戶外一景，是一幅精繪的古典建築素描。

黃才郎大半生歷經北中南三大美術館長，外加台北當代美術館之「四館王」，有過通覽海內外今昔藝術的體驗，所以一路走過來，館長都在傾聽，在全方位的見識之後再吸收，黃才郎了解自己的創作不能重覆。

2015 年國美館退休前後，畫有一系列類似花卉標本精描細繪的〈百合〉鉛筆畫，意在檢視繪畫功力，也在探索未來創作怎麼走？這種為創作再出發的自勵心，頗有美國畫家 John James Audubon（1785-1851）從觀鳥開始，終生細密畫鳥的精神。同時期也有著色的油彩〈野薑花〉就是細密描繪之實例，他細心觀察與琢磨就是準備繪畫再出發的企圖。

七、回溯大地生命力

館長退休後創作再出發的〈紅漆盤上的橘子〉，是持續長年來橘子系列之總結。橘子有本地種與日本種色澤不同之變化以外，全畫拼發出臺灣民藝的風味，意思是這幅畫有在地人祭拜供品的調子。

上一節介紹過館長退休之際，一系列鉛筆畫的〈百合〉連作，2021、2023 年再新創油彩的〈香水百合〉、〈百合〉，是最近的作品。同期間的新創作，黃才郎開始勾勒〈甘蔗園〉鉛筆速寫，也將之移到畫布上繪〈甘蔗〉、〈甘蔗田〉、〈甘蔗園〉，其中尤以〈甘蔗園〉的長卷氣勢，代表黃才郎企圖找回大地生命之源。

黃才郎的原鄉佳里有糖廠，也有糖業鐵路通過佳里，佳里近郊遍布的甘蔗園，也是黃才郎的少年記憶。〈紅甘蔗園〉是油畫三聯屏，總寬 216×90 公分之巨作，這一件大手筆的油畫長卷，反映了黃才郎一生未曾中斷過的創作生涯，經過行政業務的各階段高峰，看遍海內外收藏的寶庫，省思自己的創作如何再創新局，目前正在回溯大地生命力。生長在糖鄉的孩子大都有過從糖鐵小火車偷偷拉下甘蔗的頑皮行為，這些香甜的記憶其實也是喚回黃才郎童年生活的原點。

Building the Bridge between Art and Society –
Huang Tsai-Lang's Exploration of Paintings and Drawings

Lee Chin-Hsien

| Curator

It is a rare opportunity to be able to view Huang Tsai-Lang's works. Knowing that he is going to hold a solo exhibition, I unexpectedly but finally have an opportunity to see his authentic works. An administrative talent, Huang was the director of four major art museums in Taiwan. It is truly impressive that, in spite of his heavy public duties, he has been able to continue painting consistently, and has created such an impressive large body of work with mature techniques and diverse style.

Huang was a flagbearer of bridging Taiwanese art and society. Even though he used to plan innumerous art exhibitions, his own works have been seldom shown publicly. Nowadays, his has finally shifted his focus from art administration back to painting. He is indeed "one of a kind" in the painting circle.

1. The Earliest Oil Painting – *The Jiali Church*

Huang was born in Jiali, Tainan in 1950. His parents passed away when he was little, so he was raised by his grandparents. In 1957, he entered the Tainan County Jiali Elementary School, and graduated in 1963.

Jiali is historically known as Siaulang, which is derived from the village name Soulang of the Plain Indigenous People. After the Dutch occupation, cattle were introduced into the region following the cultivation of the Chinese Han people. During the period of Japanese rule, Jiali was upgraded from Jiali Village to Jiali Street, which showed that Jiali had become a town with a growing population and busy commercial activities at that time. Meanwhile, Jiali was also a large market and distribution center that attracted shoppers from nearby villages.

Huang remembered one thing from his childhood vividly: when he was an elementary student, he had a box of oil pastels with twenty-four colors, including gold and silver. It was his prized possession, with which he began drawing as self-entertainment. Another thing is that whenever relatives or family friends came to the market for grocery shopping and passed by their home, they would always wave and greet his family – a fond memory brimming with hospitality. In the town, there was also a theater.

When the show was about to end, the theater doors would be open so that the public could gather to "watch the ending." Huang and his playmates would also join the crowd.

Historical temples can be found in Jiali as well. The Jintang Temple (金唐殿) is located at the town center, and the Jiali Zhengxing Temple (佳里興震興宮) is one kilometer away from downtown Jiali. The latter is especially famous for the Koji pottery works made by Ye Wang. When Huang was a college student, the Koji pottery works of the Zhengxing Temple had already captured much attention. His teacher had asked him to help take pictures of the Koji pottery works when he returned to Jiali. However, after a while, a theft targeting the Koji pottery works took place at the temple. Since then, the Koji pottery works that decorated the temple walls have been protected by transparent covers.

Huang's experience of growing up in Jiali was enriched by folk art, which later became an integral part of Huang's still life palette and the folk symbolism in his expression of form.

Back then, the nine-year compulsory education was not yet implemented. So, students had to take an entrance exam to study in junior high schools. Being highly driven and motivated, in 1963, Huang was accepted into Tainan Municipal Junior High School with the support of his family, which was the first junior high school in Tainan and later renamed Dacheng Junior High School.

Back in those days, Tainan was the most typical historical city – historical sites were found at nearly every corner. In early summer, the fully blooming poinciana and all the ancient buildings opened Huang's eyes, as he immersed himself in the historical city, where he would receive education, study art, and paint from life in his teenage years. Tainan is indeed the starting point of Huang's art.

Afterwards, Huang became a freshman at private Tainan Presbyterian Senior High School (now Chang Jung Senior High School), of which the classrooms are half-century-old redbrick

buildings. Huang's intention of studying there was to draw the historical architecture. However, in his sophomore year, he transferred to the Beimen Senior High School, which was closer to his home and had an art preparation room that allowed him to concentrate on practicing sketch drawing with plaster statues.

In high school, Huang loved seeking fun outside school, and for a while, was captivated by playing pool. A caring family elder who knew he loved drawing suggested him to study art at the Kuo Po-Chuan Art Studio in Tainan City, where his skills could definitely improve under the guidance of the artist. At that time, Kuo was already a leading figure in the Tainan Fine Arts Association (臺灣南美會), and was a renowned teacher highly esteemed in the art scene of southern Taiwan. In 1968, Huang followed the suggestion of the family elder, and started studying painting at the Kuo Po-Chuan Art Studio. Kuo told him that he only accepted and mentored students who genuinely loved painting rather than doing tutelage for college exams. Since then, Huang's biggest dream had been to study fine arts in college.

The Kuo Po-Chuan Art Studio was National Cheng Kung University's faculty dormitory as well as Kuo's residence. A Japanese-style one-story wooden house, it had a small yard right behind the entrance. Previously, it was part of the residences of generals and officers in the Second General Army under the Taiwan Army of Japan. The first room on the right-hand side next to the landing was where Kuo's pupils studied painting with him. Back then, Tung Jih-Fu (1955-2016) was Kuo's teaching assistant. Having been mentored by Kuo, Tung had acquired the teacher's authentic skills in terms of his succinct lines created with fast brushstrokes and the colorful, ceramic-like palette. Still a youth at the time and having observed Tung's artistry, Huang was secretly determined to work on his craft and emulate his senior fellow pupil.

One year later (1969), and after much hard work and preparation, having long set his mind to studying art, Huang's wish was finally granted, as he was accepted into the Department of Fine Arts, Chinese Culture College (now Chinese Culture University), where he began receiving formal art education. In addition to sketch drawing and watercolor painting, he also learned to paint oil for the first time.

In 1971, Huang returned to his hometown to paint from life, and created the oil painting – *The Jiali Church*. To make up for the lack of quaintness, he added a red-purple color suggestive of antiquity to highlight the time-worn beauty of the old building. The Presbyterian Church set up the church in Jiali a long time ago. Before the war, the church was moved to its current location and was unfortunately bombed in an air raid. In its reconstruction after the war in 1952, the brick building was covered with a concrete exterior. So, the Jiali Church today does not have a redbrick appearance, and only the original redbrick fences are kept the same.

Huang became aware of historical sites at an early age. Perhaps he was inspired by the historical city of Tainan. Mentored by Kuo Po-Chuan, he also perceived Kuo's signature use of vermillion (the edible red food dye used to make "turtle-shaped red rice cake"). Yet, the color palette of *The Jiali Church* is comparatively reserved and less glaring. More importantly, he has not forgotten about the two coconut trees – a symbol of the southland – which he has extended to the top of the canvas to achieve a compositional balance.

Also in 1971, Huang painted another *The Jiali Church* in a bold, unfettered style. Meanwhile, apart from improving his painting techniques and skills, he also spent much time studying different art genres and absorbing his academic learning from the Department of Fine Arts at Chinese Culture College. He knew that Wassily Kandinsky (1866-1944) was deemed the founding artist of Western modern abstract painting, whose Cubist concept formulated by deconstructing and reconstructing object images was intended for "creative disruption." Consequently, in this painting, Huang attempted to break with traditional depiction of object images, and specifically spread out the trees in the foreground and the clouds in the distant sky, creating a semi-abstract arrangement in the image.

2. The Two Swords of the College Art Student

The "two swords" refer to the abilities to paint and to write – two distinctive talents embodied by Huang, who was still college art student at the time.

In 1970, the Ministry of Education approved the temporary transfer of Shih Tsui-Feng (1925-2018), who was the director of the Fine Arts Division of the National Taiwan Academy of Arts (now National Taiwan University of Arts), to serve as the director of the Department of Fine Arts, Chinese Culture College. Huang had just entered his sophomore that year, and Shih was his college advisor. Shih's good friend Yang Chien-Chung (1925-1999) was responsible for teaching sketch drawing in the department. Li Mei-Shu (1902-1983) was Huang's oil painting teacher, and the teaching assistant of the class was Hwang Chao-Mo (1939-).

In 1971, the teachers and students of the oil painting class conducted a painting trip to Sanxia. Huang created *Sanxia* (三峽), an oil painting with an intriguing color contrast of red and green, which continued Kuo's experimental colors for the "orientalization of oil painting." Huang's attention to historical sites also led him to create two watercolors: *Ta-Cheng Hall of Tainan Confucius Temple* (臺南孔廟大成殿) and *An Alleyway at Night near Tainan Tianhou Temple* (臺南天后宮小巷夜景). The composition of the former is steady and balanced. The purple of the distant sky and the orange-red of the temple hall display Huang's handling of light and shade. Reducing the use of lines and removing figures, the atmosphere exuding from the painting is rather serene, fully accentuating the solemnity and majesty of the "first institute of learning in Taiwan." The latter is also characterized by a vivid contrast of light and shade. The side facing the light is composed of various forms of color blocks. Although the painting depicts the profile of the temple in a concrete way, Huang is able to create an abstract effect in the image.

Art Studio painted in the same year (1972) revealed a more vibrant palette. The large-scale red "painting within the painting" exceeds the canvas; the light from the outside lights up the feet of the painter, who is gazing at his own work; and the contrast of light and shade is particularly intense. At the time of making this work, Huang was still an art student in college, but a remarkable one indeed – he was not only the president of the Fine Arts Student Association, but also the founder of the departmental magazine. He even extended his work to outside the school: he partook in the editorial affairs of *Fine Arts Magazine* published by the English newspaper, *The China Post*. In spite of the heavy multitasking, he still painstakingly created *Art Studio*, a size 100 painting. Huang became an editor of *Fine Arts Magazine*, the small magazine funded and published by *The China Post*, under the recommendation of Shih Tsui-Feng, who was the director of the Department of Fine Arts, Chinese Culture College. Huang's job was to write about Taiwanese painters, and pen a column of Western art history. Before his recommendation, Shih had already discovered that Huang could paint and write, and considered him a promising talent. Indeed, Huang played both roles splendidly.

In 1972, Hung Jui-Lin (1912-1996) had just retired from Huaishan Coal Mine in Ruifang, and wanted to go on a painting trip to Lanyu with other painters. After leaving the dark, underground environment, in which Hung had worked for years, he longed for the expansive, bright world, and wanted to see the ocean, bathe in sunlight, and experience the island scenery of Lanyu. However, there was one problem: Lanyu was not open for tourism at the time. Since Huang was an editor at *Fine Arts Magazine* of *The China Post*, and was considered a working reporter, the group of painters therefore asked Huang to help them. Huang submitted the application and a proposal, explaining that a group of renowned painters would like to conduct a painting trip to Lanyu; and the plan was eventually approved. This group of painters comprised seven people, namely, Hung Jui-Lin, Chen Ching-Jung, Chou Yueh-Po, Chang Wan-Chuan, Wang Shou-Ling, Huang Chang-Hui, and Huang Tsai-Lang, who then flew to Lanyu

on a small plane. On the plane, seeing that Hung was the chubbiest, the pilot had to rearrange the seats of the group due to the balance of the flight. As it was the first time that Huang traveled airborne, the wobbly, bumpy flight was a scary experience for the young artist, who had just realized that a plane also faced the risk of losing its balance.

The painters started painting immediately after they landed. During the day, they each looked for sceneries to paint; and at night, they gathered together to view each other's works created that day. Originally, they would have left Lanyu after finishing their trip, but the flight was canceled due to a typhoon warning. This was a terrible news to Hung Jui-Lin and Chang Wan-Chuan because the two bibulous friends had run out of liquor that they had prepared. After searching through the island, Chang found a grocery store that had a bottle of wine on the altar, which was prepared for religious offering. The owner was unable to refuse the plead of the persistent artist, and had no choice but selling him the wine so that the artists could satisfy their thirst.

Although Huang was the youngest in the bunch and still a college student, he was an admirable guide, who assisted everyone in taking care of different matters big and small. The rest of the group was all very impressed with his capability. He was also observant as to how the older painters worked – Hung had the habit of dipping his brush in ink to sketch; and Chang was fast in brushwork when he painted. Huang himself brought pastel paint, and depicted the tatala boats (traditional fishing boats of the Tao people) and straw houses of indigenous islanders, and freely captured the constant natural changes of the sea and sky. Whereas other painters from the group mostly did sketches with much blankness, Huang filled the blank space of his drawings with pastel, coloring his works in the fashion of sketching and creating a feeling of atmospheric flow.

As for their return, because all the flights were canceled due to the typhoon, the painters were arranged to take a naval ship back to mainland Taiwan, eventually completing the painting trip to Lanyu with first a flight and a sea voyage in the end. After a while, an issue of *Fine Arts Magazine* edited by Huang published the Lanyu-themed paintings by this group of artists. Every work was a brilliant piece by a famed painter. Considered himself a junior, Huang humbly excused his own works from the issue, daring not to steal the march from the established artists.

The most praiseworthy thing about Huang's sketch exercises from his time at Chinese Cultural College's Department of Fine Arts is his psychological exploration in his figure drawings. For instance, *Friday Afternoon* of 1971 portrays the mood of working women waiting for the upcoming weekend. In 1973, he turned this piece of psychological delineation into a copper engraving, and entered it into a competition by the Taipei International Women's Club (TIWC). After the work was selected into the second stage, he was asked to demonstrate the making of the print on another date, and was finally awarded the first prize of the collegiate group in printmaking.

In that era, awards organized by the TIWC were considered prestigious. Among the judges that signed the award certificate were foreigners as well, meaning the award was an honor of international value. In the same year (1973), Huang became a college graduate.

3. Painting in Spare Time Apart from Teaching and Editing

In spite of his demanding works of teaching and editing books, Huang has never stopped painting.

Huang graduated from college in 1973, and did his reserved officer service right afterwards. College graduates needed to first receive military training at Chenggong Ridge in Taichung. Despite the busy military life, Huang utilized his free time and painted *Shooting Range at Chenggong Hill*. The view of shooting ranges is normally tedious. However, Huang was

able to find parallel, oblique and straight lines in the view to construct geometric images often found in different indigenous cultures.

When serving in the army, Huang often had to take the train for deployment or returning home. He would spontaneously draw some random corners in train cars that might be overlooked by other painters. *Tea Glass on the Train* is a composite composition: the top of the image is a lidded tea glass used in the train cars of Taiwan Railways Administration and a window grip on an old-fashioned push-pull train window. At the bottom of the image are a glass holder and a close-up drawing of fingers. Back in those days, train windows could be opened, and servers on the train would bring a large teapot with hot water to make tea for passengers. The exterior of the teapot would usually be covered with a layer of canvas to protect passengers from being burned. Such a sight no longer exist today.

Another pencil sketch drawing, *On the Train*, depicts two women sitting next to each other on a nighttime express. In the image, one woman is leaning against the window, and the other has the trim of her hat pulled down; both were sleeping but in a different manner. The highlights of the image are the women's bell-bottom pants, which are the fashion of the time. The year of the painting is 1974.

Also from the same period is *Stay the Night at the Front Yard of a Temple*, which is a minutely delineated painting: next to the dragon column of the temple's front courtyard are two people wrapped in sheets, and the only visible part of their bodies is the head. They were drivers staying the night at the front yard of Zhilin Temple (旨 臨 宮) during an army drill in Tianzhong. Next to them were their military boots. At that time, two drivers were paired as a group. There are two other works, both titled *Cat*, which is a rare subject in Huang's work. Judging from the soft and light brushwork, they are probably created at a strike of inspiration.

After finishing military service, Huang first taught at private Yanping High School in Taipei, and also at Hsiung Shih Children's Art Class annexed to Hsiung Shih Art Books Co., Ltd. During this period, Huang married his fellow art lover, Wang Hui-Fang. The couple founded the One Generation Children's Art Class (一代兒童美術教室) that is dedicated to the promotion of children's art education.

Children's drawings were always innocent and colorful, but Huang's paintings from this period contrarily entered an unadorned and monochromatic stage of Zen-style sketch drawing, for instance, *Old Tree on the Campus of Yanping High School* and *Campus of Yanping High School* both reveal the artistic conception of Zen-style ink painting.

Huang believes that the essence of figure painting lies in form, expression, volume and the spatial placement of lines. The expression of volume is created through the twisting and interjoining contours and muscles, whereas the sense of volume is produced by lines. The combination of these factors creates an integral whole, which is the only way to portray the endearing, tender looks and postures.

After Huang got married, the couple gave birth to their daughter, Huang Chih-Chien, and their son, Huang Mao-Chia. Huang also painted their infant children during this period. The sketch works, *Portrait of Xiao-Chien* (Xiao-Chien is an endearing nickname of his daughter) and *Portrait of Mao-Chia*, also fully demonstrate the adorable looks of the children. Both works are signed with inscriptions and are intended for permanent commemoration. The works were painted deep in the night, showing that Huang was painting all the time, even when it was way past midnight.

Huang had created quite a few sketch exercises of female nude when he was in college, and could be said to have already mastered delineating contours and postures. After graduation, he continued painting models, and had accumulated many oils and sketch drawings featuring female nude until 1980. From *Female Nude* of 1973 that depicts a bathroom scene, *The Young Girl in Black* of 1976, to *Female Nude* of 1979,

one can detect a discussion-worthy point: Huang's female nude is entirely based on "being authentic to the body of local women." Simply put, he has truthfully depicted women's bodies without deliberately refining them.

In the Meiji era, young Japanese painters who had studied in Europe only learned to paint well-proportioned European models that were eight heads tall. After they returned to Japan, it was difficult to find female models with a similar figure. For instance, Kuroda Seiki (1866-1924) is known to lengthen the figure of Japanese women to make them look slenderer in his works. The first painter to overcome this gridlock was Yorozu Tetsugoro (1885-1927), and his *Nude Woman with a Parasol* of 1913 is one of the examples. In 2000, the Taipei Fine Arts Museum (TFAM) presented *Oil Painting in the East Asia: Its Awakening and Development*, and this painting of Yorozu's was exhibited under the title, *Nude Woman with an Umbrella*. A Fauvist pioneer in Japan, Yorozu was deeply influenced by the European Fauvist style, and bravely took on the challenge of portraying the stubby figure of Japanese women, placing an emphasis on disproportionate beauty with larger heads and shorter bodies. Umehara Ryuzaburo (1888-1986), who had studied art in France, was the one who transformed such disproportion beauty into the formal beauty of Japanese women. Stylistically speaking, Umehara also leaned towards Fauvism, and was bolder in his approach to art.

In 1980, Huang started working at the book series department of *Hsiung Shih Art Monthly*, where he was entrusted with the mission of editing *Dictionary of Western Arts* – a groundbreaking art publication in Taiwan as well as the very first art dictionary in Mandarin. The idea of the dictionary came from Huang, who deemed such a publication necessary for deepening the root of art knowledge and building a solid foundation for future art research. He thereby collaborated with his colleagues at the editorial department of *Hsiung Shih Art Monthly* and professors from respective fields to complete the dictionary in two years of time. Who would have known that the very first dictionary of arts in Taiwan originated from the

distinctive vision of a young man, who was only in his thirties at the time.

4. A Trailblazer Who Increased the Visibility of Taiwanese Art

In 1981, the Executive Yuan established the Council for Cultural Affairs (CCA, and now Ministry of Culture), and appointed Chen Chi-Lu (1923-2014) the chairman of the CCA. Shen Hsueh-Yung, who was the director of the Third Department of the CCA, invited Huang to be the chief of the Fine Arts Section. The CCA was the first public agency founded by the central government to be in charge of arts administration. As chief of the Fine Arts Section, Huang then took the advantage to create the visibility of Taiwanese art with concrete actions. The term "bijutsu" (meaning art or fine arts) was a newly coined term in Japanese Kanji during the Japanese rule. Before the war, the term could already be found in the Taiwan Fine Arts Exhibition (Taiten). After the war, although schools of different levels had art classes, the society in general had a pretty limited understanding of art. As the section chief, Huang knew best the importance of introducing art to the society, and more importantly, the urgency of increasing the visibility of "the art of Taiwan" so that the society could truly see Taiwanese art. In 1983, the CCA presented *Taiwanese Calligraphy and Ink Painting from Ming and Qing Dynasties* at the Cathay Art Museum.

How should one find all those ancient calligraphies and ink paintings in Taiwan from more than three centuries ago? Huang utilized his relations and networks, and personally visited collectors to achieve the goal. It goes without saying that the task was not an easy one. The historical cities of Tainan and Hsinchu were two regions where most ancient calligraphies and ink paintings were found in Taiwan. In Tainan, Huang's guide was Pan Yuan-Shih (1936-2022), who was familiar with collectors of ancient calligraphies and ink paintings, and in Hsinchu, Hsiao Tsai-Huo, who was a councilman at the time. Huang's companions also included Huang Hua-Yuan

and Hsiao Tsung-Huang. In order to build a trust with one of the collectors to loan the precious collection, Pan even used his own house deed as a collateral so that the artworks could successfully be exhibited. It was no surprise that the exhibition featured many ancient calligraphers and painters that modern audience had just begun learning about, for example, Lin Jue, Lin Chao-Ying, Lu Shih-Yi, and many more. Finally, their calligraphies and ink paintings that the world did not know of were now displayed in front of the world.

Located on Xiangyang Road in Taipei City, the Cathay Art Museum was on the first floor of the Cathay Holdings building, which was right across the 228 Peace Memorial Park. It was the largest and most up-to-standard art exhibition venue of the time. After Huang successfully generated the publicity of "Taiwanese art" with *Taiwanese Calligraphy and Ink Painting from Ming and Qing Dynasties*, he subsequently planned *International Print Exhibition*, introducing foreign art to Taiwanese audience. Because of their news value, the two exhibitions soon received much feedback from the public, particularly the former, which became the origin of finding the root of Taiwanese art for the cultural sector in Taiwan.

During his term as the section chief, Huang further planned *Art Development in Taiwan – A Retrospective Exhibition in Four Parts*, which showcased iconic works of Taiwanese art from the ancient times to the present day. Exhibited successively, the exhibition was divided into four topics and presented from February to the end of March 1985. The exhibitions were held at the Cathay Art Museum as well. However, the financial scandal involving the 10th Credit Cooperative affiliated to the Cathay Holdings in the same year caused the Cathay Art Museum to be shut down.

In the 1980s, public art museums were just established, and the guidelines for museum collections were not yet very clear. Under Huang's planning, *Art Development in Taiwan – A Retrospective Exhibition in Four Parts* was open to the public, and showed historical context and academic viewpoints

in historical periods. With Huang's knowledge of Taiwanese art and the recognition and support of the CCA chairman Chen Chi-Lu, "the art of Taiwan" was finally unearthed and could be re-evaluated.

Having served at his post for seven years, Huang still had many ongoing plans and projects. In order to become officially qualified for civil service, Huang also prepared for the senior civil servant examination. After he passed, he stayed at the CCA to continue his work. However, he never forgot to paint regardless how busy he was. In 1980s, he created *Lingering Series*, which featured devil's ivy, a perennial vine that has a vibrant, lush vitality. The entangling green leaves and curling vines manifest a strong presence, indicating a lingering, ample force of life. The series was created with mixed media to set off the tenacity of the plant. Meanwhile, the use of mixed media was a new attempt to explore the new era and new art. *Birds in a Cage* created in the same period also features the conversion of simple object image, which is an innovative work that marks Huang's desire to step away from painting from life to pursue a new form of art. On the other hand, although *Tangerine Series* (1983) is a painting from life, the entirely blank background achieves an overall effect of etherealness; and even the artist's signature exudes a feeling of Zen.

In 1988, Huang was offered a fellowship by the visiting scholar program, and conducted a ten-month visit to the U.S., where he researched on cultural administration. He was well-prepared for the trip, and planned to take the opportunity to paint from life in the foreign country. With charcoal pencils and paper, he sketched whenever he had time. One day, as he returned from grocery shopping, and was on his way back to his residence, he saw an empty shopping back blown midair and flew across the sky. He picked up the object, and drew *Shopping Bag* after he got home. In the U.S., most shopping bags are brown paper bags. In the drawing, the paper bag with fold marks expressed by contrasting bright and dark sides is paired with the imagery of a park as a backdrop, displaying a rather rich form.

Subsequently, with the imagery of tree branches in the background of *Shopping Bag*, Huang created another work depicting a close-up image, titled *Fences of Common Jasmine Orange*, which also features an arrangement of tree trunks and branches newly invented during the visit, and is close to the exploration of Art Nouveau. In the same year, Huang created *Washington, D.C.* when he visited the city. The work is a sketch of historical architecture, which has a clear theme and shows a vivid American charm. Another work, *Georgetown, Washington, D.C.*, is a sketch work depicting the street from a certain angle. To the artist, when dealing with the shock of the foreign and exotic landscape – especially the fact that he was traveling alone in the U.S. – monochromatic drawings seemed to best express his lonely mood. He was even able to sublimate his solitude and simplify his works by completely removing all figures.

5. Deepening Roots of Art · Speaking Up for Southern Taiwan

A Wish Comes Ture – An Idea of Public Art is a large-scale work created around 1990, and is mainly in black and white, with only a small portion of green. The work represents the existence of public art in an urban area, and the patch of greenery symbolizes the connection between a city and nature. Such a vision first appeared in the November issue of *Hsiung Shih Art Monthly* in 1986. The issue included the record of a public art forum, in which one of the discussants was Huang, who was the chief of the Fine Arts Section at the CCA. At that time, *Hsiung Shih Art Monthly* was the first to use the new term "public art," which was still commonly understood as sculptures and statues found on the streets or parks. So, discourses in the forum mostly focused on the spatial planning of public art in Taipei City, and how to select high-quality artworks. Huang was the only one to state that "public buildings should take the lead through executive orders" – this statement was the foundation of later laws concerning public art.

Huang resigned his post at the CCA in 1990, and was invited to be legislator Chen Kuei-Miao's assistant for cultural legislation. His main task was to facilitate the bill of public art for the review at the Legislative Yuan. The next year (1991), the Legislative Yuan passed the "Culture and the Arts Reward and Promotion Act," which stipulated that the construction of a public building should allocate one percent of the total cost of the construction project as the funds for installing public art. Today, we could easily find works of public art in Taipei metro stations in Taipei City – some are on the platforms; some are hanging from the ceiling; and some are sculptures or murals on the walls.

In 1994, the Kaohsiung Museum of Fine Arts (KMFA) was inaugurated, and Huang was promoted from the KMFA Preparation Office director to be the director of the KMFA. The opening of the third largest art museum in the country was considered the grandest event in the art scene of southern Taiwan back then.

One of the highly well-received inaugural exhibitions was *The Eloquent Voice – Antoine Bourdelle Sculpture Exhibition*. Antoine Bourdelle (1861-1929) was a master of French modern sculpture, and an iconic attribute of his works is the expressiveness of masculine, strong men. The KMFA intended to acquire Bourdelle's *Great Warrior (without legs)*, a masterpiece showcased in the exhibition. However, the museum was short of funding for the acquisition, and consequently contacted *The Union Daily* (聯合報) and *Min Sheng Bao* (民生報) to co-launch a fundraising event, named "Keeping Bourdelle's Masterpiece in Taiwan," which was responded by the Kaohsiung Third Credit Co-operative with great support and received small donations from citizens. In the end, the museum was able to permanently keep Bourdelle's *Great Warrior (without legs)* in Kaohsiung.

Subsequently, the KMFA presented a series of eye-catching exhibitions, increasingly building a good reputation of this major art institution in southern Taiwan. In the second year

of the museum (1995), Huang painted *Rainbow – KMFA After the Rain* – a memorial image of the newborn KMFA is depicted mainly in black and white, and is embellished with a touch of color. The water surface of the lotus pond is pasted with gold leaves. The fantastic combination of mixed media and surrealist expression demonstrates Huang's ambitious pursuit of fresh and contemporary expression in art.

The second year of the KMFA (1995) also coincided with the posthumous centenary birthday of Taiwanese sculptor Huang Tu-Shui, and Huang, as the director of the museum, actively planned the special exhibition – *The Centenary of Huang Tu-Shui.* He personally followed available clues to visit local collectors, and traveled to Japan to meet with different institutions for loaning authentic works of Japanese masters from the generation of Huang Tu-Shui's teachers, such as Takamura Koun (1852-1934), Kitamura Seibo (1884-1987), Asakura Fumio (1883-1964), etc. to be showcased in the exhibition and form a researched comparison between Taiwanese and Japanese sculptors. Such direction of display artworks is now considered a prerequisite to academic curating, and the KMFA was the first to have achieved this goal.

Subsequently, Huang brought world-class resource of sculpture into the KMFA: in 1997, he planned the homonymous exhibition of another renowned French sculptor, *Aristide Maillol*, which caused quite a stir again. Stylistically contrasting to Bourdelle, Aristide Maillol (1861-1944) is known for his works of feminine topics, which are harmonized with the classicist portrayal of robust physique to create a modern form.

As the inaugural director of the KMFA, Huang was devoted to planning the administrative affairs, contemplating on the position of the museum's collection, and organizing various major exhibitions. As a painter, he has also striven for innovation, which is validated by his shift to "microcosmic art" – an art form of the new era and the new creation informed by a new sensibility.

Tangerine Series – A Hundred Auspiciousness (1992) emphasizes on the only colored tangerine in the midst of numerous ink-colored tangerines. The use of the word "series" in the thematic title indicates the artist's intention to continue on with the series. *Ginger Lilies* (1995) features the flowers with leaves and stems prominently shooting vigorously out of a glass vase. The depiction of the spreading leaves is highly contemporary. The pencil drawing series of reeds features close-up images of thickets of reeds, which might appear to be random but shows Huang's unique eye.

Such combination of close-up images and coloring is Huang's distinctive artistic interpretation. Examples include *Pumpkin*, *Kohlrabis*, and two paintings that are created consecutively and both titled *Lingering Series – Roses*. The artistry in his depiction of flowers and vegetable is obvious, and the background of these paintings also displays artistic qualities. These are created with the solid technique of minute delineation: the artist begins macrocosmically and narrows down microcosmically, displaying an observant eye of "microcosm." This approach is most commonly found in the portrayals of vegetable, fruit and flowers by contemporary Japanese gouache painters. Some even exude a sense of simple elegance close to that of "haikai painting."

The abovementioned works were new creations in a fresh style created after Huang became the director of the KMFA, and collectively embodied Huang's creative transformation in art making.

6. The Director Listened, the Director Absorbed

In 2000, Huang was appointed the director of the Taipei Fine Arts Museum (TFAM); and in 2009, he was appointed the director of the National Taiwan Museum of Fine Arts (NTMoFA). During this period, he also served as the departmental director of the CCA and the deputy director of the Department of Cultural Affairs, Taipei City Government.

He had chaired innumerous meetings, in which he carefully listened. He had made countless decisions regarding art exhibitions, which he absorbed for his artistic creation. Furthermore, Huang had a very clear understanding of the art ecology, and knew what society and the public needed.

In his directorship of the TFAM and the NTMoFA, his greatest contribution was his endeavor in making art a social topic. First of all, the TFAM organized *Art Development in Taiwan – A Retrospective Exhibition in Four Parts*, which was divided by decades starting from the 1950s and continuing to the 1990s. The exhibition mapped out the developmental trajectories of Taiwanese modern art of every era, and was on view for an impressive length of two years.

In 2013, the NTMoFA launched an exhibition series of Taiwanese art – *"The Pioneers" of Taiwanese Artists*, which was a researched-based exhibition project divided into six generations of artists from 1990 to 2014.

Another praiseworthy achievement of promoting Taiwanese art in society was the collaboration with Chunghwa Post to issue four sets and a total of twelve stamps featuring artworks of early modern Taiwanese painters. When Huang was the chief of the CCA Fine Arts Section, he was already aware that stamp was the most easily circulated form to acquaint the public with Taiwanese art, and had made the suggestion to the Directorate General of Posts (now Chunghwa Post Co., Ltd.). However, at that time, both the government and the general public only knew famous art masters like Chang Ta-Chien. So the plan was shelved. It was only due to Huang's persistence that the paintings of Taiwanese artists were finally printed on stamps in 2002, and delivered to countless households.

In 1998, Huang painted *Narcissuses*, a massive piece that is nearly three meters long. The horizontal triptych is an oil painting pasted with gold leaves, and consequently reminds people of *Irises*, a screen painted by Japanese painter Ogata Korin (1658-1716) of the Rinpa school during the Edo period. In the form of a screen, this work of Huang's seems even more massive. Comparing to Ogata's delineation of irises, which demonstrates the decorativeness of Japanese craft, Huang's daffodils are informed by an Eastern literati style.

The year of 2000 was when Huang assumed the position as the TFAM director. Despite his busy schedule, his painting style changed continually. In 2002, he painted two watercolors from *Tangerine Series*, which also showed a literati style, but he also continued *Tangerine Series* in oil, for which he adopted the "microcosmic" approach. Another work created through this approach is *Poinsettia*.

During his directorship at the TFAM, Huang produced a considerable number of human body sketch drawings, in particular, the three years between 2006 to 2008. Judging from this body of work, Huang already moved away from delineating basic postures in early sketch training, and moved onto the human body drawings comparable to three-dimensional sculptures – that is, the figures depicted are in difficult postures usually demanded by sculptors, which injects a sense of freshness into this batch of human body sketches.

Huang's human body sketches give the impression of sculptures on paper. Based on the objective of "carving," he used pencils to "sculpt" the figures, evoking the style of Rodin's works. His pure human body sketches feature both male and female models, and are only expressed through lines without adding light and shade.

Additionally, he also drew chubby female figures, which were more sculptural forms, instead of slender, curvy bodies, making his sketch drawings even more like sculptures. Portraying the forms of human body from a sculptor's point of view, Huang's sketch drawings reveal a wide range of postures and forms. Not only does he prove his solid skills of sketching, but his use of simple lines and quick sketching also show the value of plastic form. In a way, these sketch drawings are like preliminary exercises for sculptures, and their unique formal qualities are especially valuable for those who have just started making sculptures.

During the period from 2006 to 2008, when Huang was drawing human body sketches extensively, whenever he was on a business trip and stayed at a hotel, he would pick up his pencil and paper at night to draw self-portraits by looking at himself in the mirror. Huang drew self-portraits in college as well. One year, he served as a guide to a group of renowned Taiwanese painters to Lanyu. As a young college student, his leadership impressed the group of established painters, and his self-portraits revealed such confidence in his eyes. After he was appointed the director of various museums, Huang showed obvious resolution and vigor in his vision of planning museum affairs, which could also be observed in the facial expressions of his self-portraits.

The quickly sketched self-portraits required Huang to gaze at himself in the mirror. Vincent van Gogh (1853-1890) also painted quite a few self-portraits, but most are in oil color with visible changes of colorful brushstrokes. Huang's self-portraits are drawn with pencils, and display vivid variations of lines. After seeing this group of self-portraits by Huang, I have specially lined them up and compared them to van Gogh's self-portraits. The self-gaze, bright eyes, signature mustache, and tightly pressed lips all covey a sense of resoluteness and confidence similar to van Gogh's self-portraits.

In a business trip to Paris in 2001, Huang also improvised a quick sketch drawing using a sharpie, which is characterized by thick brushstrokes and simple lines. In 2006, the TFAM assisted the Shoto Museum of Art in Tokyo in organizing the exhibition, *Centennial Celebration of Chen Chin*. During his trip to Tokyo, Huang also drew the view outside his hotel window: drawing from life by the window of a high-floor hotel in Shibuya, Huang depicted the surrounding modern high-rises, which were portrayed as stacked building blocks. Contrarily, *Hotel in Tours* created in 2008 features an outdoor scene from his temporary residence in France when he was on a business trip. The drawing is simply a sketch drawing of finely delineated classical architecture.

Throughout a large portion of his life, Huang served as the director to three major art museums respectively in northern, central, and southern Taiwan. Furthermore, he was also the director of the Museum of Contemporary Art, Taipei. This earned him the nickname of "king of four museums." At the same time, his job gave him the experiences of viewing art of the past and the present from both Taiwan and abroad. Therefore, Huang has carefully listened throughout his career, gaining comprehensive knowledge before he absorbed it all because he has always known that he should not repeat himself in artistic creation.

Around his retirement from the NTMoFA in 2015, Huang drew a series of pencil drawings, titled *Lilies*, which comprises minute depictions of flowers similar to floral specimen illustrations. His intention of creating the series was to examine his drawing skills, while exploring the direction of his artistic creation in the days to come. Such motivated self-preparation for a restart in artistic creation is similar to the spirit of the American painter, John James Audubon (1785-1851), who began from bird watching and spent his entire life creating meticulous drawings and paintings of birds. During this period, Huang also painted *Ginger Lilies*, which is considered a fine example of his dedication to minute delineation. The fact that Huang has extensively observed and carefully depicted his subject matter indicates his ambition in picking up his paint brush again.

7. Retracing the Life Force of the Earth

Tangerines on a Red Lacquer Tray was painted after Huang retired, which concludes the *Tangerine Series* created over the years. In addition to the different colors of native and Japanese tangerine species, the overall painting exudes the mood of Taiwanese folk art, which means that this painting carries the feel of traditional offerings made by Taiwanese people in religious rituals.

In the previous section, I have mentioned a series of pencil

drawings featuring lily, which Huang created around his retirement. In 2021 and 2023, he painted new oils, titled *Oriental Lilies* and *Lilies*, which was completed recently. During this period, Huang has started various new works: he has begun the pencil sketch for *Sugar Cane Farm*, and has transferred the pencil drawing onto the canvas to create *Sugar Cane, Sugar Cane Field*, and *Sugar Cane Farm*. Among these newly painted works, the long horizontal oil, *Sugar Cane Farm*, indicates Huang's intent to rediscover the source of earth's life.

In Huang's hometown Jiali, there used to be a sugar refinery, and the sugar railways also ran through the town. Sugar cane farms could be found all over the outskirt of Jiali as well. These scenes constitute Huang's memory of Jiali in his youthhood. *Red Sugar Cane Farm* is an oil triptych. Measured at 216 centimeters by 90 centimeters, the piece is a massive horizontal oil painting. At the same time, the work also shows a very important fact: Huang has never stopped making art throughout his life. Having gone through different culminations in administrative affairs as a civil servant, and having viewed artistic treasures in Taiwan and abroad, Huang has consistently contemplated on how to achieve artistic innovation in his artistic career, and is now retracing the life force of the earth. Children grew up in the hub of sugar industry had the mischievous experience of stealthily pulling sugar canes from the train cars of the sugar railways. Such sweetness of life is indeed what evokes Huang's memory of childhood.

自然美與金箔妝－讀黃才郎笑心之作

陳長華
| 作家

前言

2023 年 2 月下旬，黃才郎生平首次個展在臺北市國父紀念館舉行。開幕之日，包括他的師長輩、擔任公職時的主管與同事、親戚朋友、學生和一般觀眾擠滿了會場。當開幕儀式告一段落，近年受疾病困擾的他，環繞展場親身導覽之後，在貴賓室稍作片刻休息，略顯倦態的臉上仍難掩興奮之情。

「你在致詞時提起李梅樹老師講的是『揪心之作』還是『笑心之作』？」

「是笑心之作喔！」他用臺語回答。

資深畫家李梅樹 1964 年受聘擔任陽明山華岡文化大學美術系教授。黃才郎於 1971 年入學後，成為他賞愛的優秀學生。除了課堂學習，並有機會進入梅樹先生畫室觀摩。恩師之教，透過傳藝和言行，讓他受惠至今。

「笑心之作」，是李梅樹面對自己畫作的美言。作為一位創作者，與傾力完成、無愧於心的作品相望時，從口中迸出了出自內心的滿足與愉悅。自由舒展的畫筆既是出自含笑的心，那麼畫面所表現的，自然也是無愧於信仰藝術的初衷。

青春畫刀

1969 年，黃才郎考入文化大學美術系。童年沉迷於用粉蠟筆塗鴉的記憶猶在，少年時代到資深畫家郭柏川畫室習畫的感受也未消退；如今步入人生嶄新的學習階段，內心升起對藝術更大的憧憬，「終於能夠買畫刀和顏料作畫了。」1971 年，他完成有生以來第一幅油畫作品〈佳里教堂〉。取材自臺南佳里的畫作，有熟悉的故鄉天候溫度和草木形影，在色彩和形狀上，試著揣摩當時所崇拜的俄羅斯畫家康丁斯基之野獸派表現主義手法。

同一年的〈三峽〉，是李梅樹油畫課的寫生習作。位於臺北盆地西南方的三峽，為李梅樹的出生地。當年師生前往寫生，同行尚有時任助教的畫家黃朝謨等人。

婦人溪邊浣衣，是梅樹先生經典的寫生景致；他的學生面對的主景則是臨溪的街屋，建物相依，高低錯置，各朝方向，彷如不規則的五彩積木，饒富趣味。

油畫〈迪化街老牆〉和水彩作品〈臺南天后宮小巷夜景〉皆是 1972 年左右完成。〈迪化街老牆〉呈現大稻埕歷史街道除舊一面，正值青春年少的畫者，用抒情的色彩與明暗對比，留下對歲月無情的感嘆。〈臺南天后宮小巷夜景〉可能是黃才郎研習水彩之後首幅重色的水彩畫，此作以夜景為主題；鬱黑之夜，青色路燈在幽靜小巷鋪陳上明下暗兩層氛圍。在有限的照明下，老舊房舍的部分結構經由凸顯，顯得篤定而自在。

黃才郎在文化大學美術系的學習，接續先前在郭柏川畫室的基礎素描訓練，培養了爾後的創造力和鑑賞銳眼。1972 年，因為在《英文中國郵報》旗下的《美術雜誌》擔任美編顧問關係，有一次難得的蘭嶼寫生機會，同團幾乎都是師輩畫家，包括洪瑞麟、張萬傳、陳景容、周月坡、汪壽寧、黃昌惠等，他完成了〈蘭嶼海灘〉、〈蘭嶼黃昏的軍艦島〉、〈蘭嶼風光〉等多幅粉彩。〈蘭嶼海灘〉以獨木舟之靜置，對照白浪之翻滾動盪；〈蘭嶼黃昏的軍艦島〉刻劃沐浴於晚霞暮色的軍艦島，背光的島體孤立於海中心，映現著大地寂寥的一景。〈蘭嶼風光〉事後在林克恭老師鼓勵下，擴充格局，並以油彩表現。以居高遠眺之婦人作為近景，下方搭襯青綠的海水與獨木舟，足見他欲讓畫面飽滿的企圖心。

青年黃才郎在拘謹沉靜之外，另有叛逆不羈一面，1972年的幾幅自畫像隱約帶出這些面向。1973年的〈成功嶺靶場〉，看似繽紛色彩與類幾何形狀構成的寫景，實則另有故事；原來他在成功嶺服役時，因抽菸遭罰到靶場割草，他帶著畫箱前往，面對著跟前一片紅土，心生感動，因而創作這一幅作品。

灰黑白的迷戀

黃才郎早期作品大半圍繞在寫生，來自鄉村的拙樸個性本質也表現在筆觸上，畫面顯出早熟的沉實，有些還流露出淺約的「少年維特」煩惱情懷。像1972年的作品〈畫室〉，主述畢業展收件前夕的焦慮自我；他在久坐苦思之後，借助紅色主題，致用課堂所學的印象派概念，完成了的畫室寫景，帶著散文式的興味。

隨著畢業展〈畫室〉的現身，流瀉著晦暗情緒的灰黑白逐漸上畫。反射內心的畫語，可能先是來自初入社會的微慌不安吧，然後是受逐漸迎來的生活變遷與職場壓力影響，到了1980年代，屬於他的美術書寫就更流動著鬱結的感性。1980年的〈秋日落葉〉，以大樹枯枝駕凌飄零落葉，註解對季節的感懷，調入暗色的枝幹預言了凜冽多日。1980年以炭精筆和蠟筆完成的〈籠中鳥〉，進一步呈現主觀的觀察視角，也對灰黑白與創作對象物的緊密扣合效果產生信心。

往後到1988年，他更加堅實地掌握灰黑白。此時的他，已是傑出的公部門文化行政專才，職場的歷練與經常接觸名作佳構，視野得以無邊擴展，在觀摩心得與自我既有畫藝修持交會之下，創作越發精進。這一年，他獲得美國「傅爾布萊計畫 Fulbright Program」獎助，前往華盛頓特區研究文化行政。在返回客居公寓途中的公園，看到一只在寒風中飄揚的購物袋，驅動了靈感，當晚畫成〈購物袋〉，炭筆構成背景漸層效果，加添於上的是重疊細黑線條描繪的七里香，然後推進了主視覺的紙袋，借物寫情，寓意著異鄉人之孤單。

〈華盛頓特區〉與〈購物袋〉屬於同時期作品。旅途中最為簡便的炭筆和畫紙，驅使了一個來自他鄉畫者的創作慾，透過灰黑白，揮就古老建築與天空瞬息變化，取代了彩色繽紛格局，反而更能達到預想的陳年走痕。1986年他參與完成公共藝術立法，以炭筆為基調、輔以綠色油彩完成〈心想事成－公共藝術構想〉。2000的〈蘆葦〉雖在表現外在事物，然而風中之葦草似觸發他的心念在前，炭筆的線條層層推加，留白則給予自由滋長植物喘氣和嘆息的空間，是結合了視像與冥想之作。

玫瑰。橘子。黃金葛

有「花之女王」美譽的玫瑰是繪畫常見的靜物題材。大半畫家執著演練玫瑰於瓶中展姿；黃才郎的畫中玫瑰則投射了個人的視覺體驗，並藉由創作過程，享受與畫布對唱的樂趣，其中以1998年的油畫〈纏綿系列－玫瑰〉最具代表性。偌大的畫面僅以七朵豔紅花朵領銜，並強調中央佇立的一朵枝葉完整。油彩所勾勒的紅花綠葉，顯現真實存在的榮景，其餘用鉛筆素描的花與葉隱退於繁華之後，油彩與鉛筆兩種材質相互烘托，虛實承載營造了空間距離，賦予玫瑰角色空前的擔當，這是走出「瓶中花」窠臼且讓黃才郎產生會心之笑的作品。

黃才郎類似以油彩和鉛筆或炭筆，穿透畫面空間距離的形式表現，也用在〈橘子系列〉，像1992年的〈橘子系列－百吉〉，居中的橘子得天獨厚，也唯一上彩；它周圍的同伴僅是炭精筆成型，而素面的眾多果實中，有的也僅具模糊輪廓，甚至只出現簡易圓圈。若不是創作者獨有的美感領會和勇於嘗試，充其量也不過是平淡的

靜物寫生，再完美的橘子描繪也只是靜止個件，連同少了想像空間與美境延伸，想必這就是黃才郎自我鑽研所想攀登的畫之境界。

與〈橘子系列－百吉〉同年完成的〈祖母畫像〉，似乎也在表現同樣的境界趣味。他以祖母為主題，背景擁簇著由近拉遠的玫瑰花海，意味了無止境的慈愛與懷念。相較於一般肖像畫作，此畫結構明顯強厚，透過背景花卉的襯托，畫面產生難見的活潑愉悅光彩，畫中人好似生前在人間赴宴那般康健貴氣。

黃才郎以素描和油彩對比、營造視覺驚艷的空間處理手法，一直施作到 1991 年以後的〈姬百合〉、〈香水百合〉等。他善用有限的紅色在畫面作點睛之效，有效的制約並提撥有限的紅，在黑色筆觸當中跳躍，也像指揮棒之於樂團，帶動美與詩情的旋律於作品當中，〈姬百合〉與〈香水百合〉皆有如此情調，而更早之 2004 年水彩〈水仙〉，紅色雖僅現於單薄的束帶，但亦足夠點醒畫面神采。

黃才郎在作品上施以金箔已成為特色風格，緣起於一次參加國際研討會，聽一位學者指出東西方使用金箔產生之相異效果，西方表現出金碧輝煌，東方則予人神秘印象。之後，他開始在作品加入真金的金箔裝飾，從商家買回金箔後自行敷貼，金箔得一再重疊，直到產生預期的空間變化效果方休。包括 1995 年〈彩虹－雨後高美館〉、1996 年〈大頭榮〉、1996 和 2002 年的〈橘子系列〉等都有金箔上畫。在金箔相襯之下，由炭精筆、油彩所築構的空間獲得擴大，作品也增添了雍容魅力。

以黃金葛為繪畫對象的作品，是黃才郎〈纏綿系列〉其中一項重要主題。〈纏綿系列－黃金葛〉起始於 1980 年前後，這種居家種植植物不時展現自由隨興之姿，枝莖盤纏之間，也出現若有若無的距離感。到了 1988、1989 年，他筆下的黃金葛由直白敘述轉入隱喻抒情，以炭精筆將之入畫，或用油彩表現綠色葉面的生機，再輔以炭精筆，描繪灰黑漸層的鄰葉旁枝。1989 年的〈纏綿系列－黃金葛四〉畫中隱約出現了男女背影，讓閑散的自然綠栽銜接到紅塵之情，對「纏綿」圖像作了浪漫的釋解。

人物畫像的真與美

人物系列在黃才郎作品當中佔有相當比例，當中又以人體、自畫像居多。最早的一幅裸女是 1972 年大學四年級所作，1973 年的一幅坐姿裸女，入選「臺灣全省美術展覽會」，另一幅參加「臺陽美展」獲得「葛達利獎」。從接受科班教育至今，超過半世紀以來未曾間斷人體創作，人體的線條走痕、神情狀態、量體表現等構成要件，持續成為他鑽研畫藝的課題之一。

黃才郎筆下的裸女幾乎都五官平凡，也少見像法國印象派巨匠雷諾爾所繪之豐腴、充滿官能美的形象。他藉著人體畫，表現對「美」的觀看要點：「美」即是真實，凡血肉之軀都可以入畫。「美」的魅力有賴等待發現，在肢體靜處時刻，因為微小呼吸所牽動的肌肉輕忽變化，也不無可能帶來想像，並觸動了觀者對「美」的感受。完成於 1976 年的〈黑衣少女〉便是驗證其中一個想法。身著黑色內衫的年輕女孩，靦腆地用雙手輕握裙擺，雙腿的立姿也顯生澀；但這非刻意擺現的體態，透過精細畫筆處理少女的骨肉與神情，反而產生一種征服視覺的力量。

1981 年畫於租屋的〈裸女〉，讓模特兒坐在樓梯扶欄，有力而堅定的線條帶出熟女軀體，肌肉與骨幹的轉折承合，俱在畫者的考量並致力實現。黃才郎歷年累積數量

可觀的鉛筆人體素描，都出自面對模特兒作畫，這一部分最能呈現他早年所受的嚴格基礎訓練，並從長年的自我鍛鍊中獲致當中神髓。他沉穩堅牢的素描能力用在諸多系列作品上，提升了畫面的細膩感和深度，鉛筆和炭筆之描繪或渲染，與油彩互補交融，也形成個人獨有的創作語彙。

自古以來，透過畫家自畫像，是探知對方生命經歷與當刻情緒的途徑之一。黃才郎最早的一幅鉛筆自畫像於1972年出品，彼時還是大學生。畫中的他，視線微低，雙脣緊抿，形色露出一抹不妥協。1981年他出任公職，直到2015年退休，三十多年當中，利用公餘之暇作畫，許多鉛筆自畫像完成於出差的旅店。他白日洽公或參訪，入夜時刻結束當日行程，準備隔日資料後，面對鏡子速寫自己，因而出現了穿背心內衣或運動衫的畫面。有些自畫像神情愉悅，也有的疲憊上臉，當日工作的順利與否一覽無遺。自畫像的髮量也記錄了他從少年到花甲的歲月；老去的是人之容顏，不變的是畫筆的眞！

紅甘蔗的滋味

黃才郎熱中草木、花卉和果實題材，從躍躍滋長、茂盛飽滿到殘敗枯萎，每一個階段都讓他萌生提筆動力。他畫青綠的橘子，也畫熟透多汁的黃金橘。2002年的〈橘子系列〉風華迎面，2009年〈綠色的橘子〉挾帶著果林的氣息。他畫野薑花，從花束入門插瓶時開始下筆，隔週再畫一回時，花之風姿綽約已不復存在了，他還是樂此不疲，隔周再畫，畫到花葉都凋零了才止住。一系列水仙作品也是出自同樣情緒，畫中水仙有的亭亭玉立，花開正好；有的不堪時間逼迫，出現無力倦態，黃才郎總是沉迷這種與果實花卉一起度日、榮枯與共的感情表現。

在數十年從自然擷取題材的過程當中，黃才郎在從容寫實的同時，也加入感性的寫意，企圖跳脫了制式的彩筆繪形。也許是看遍世界各大美術館的收藏，加上長年在文化行政機構和美術館工作關係，深厚的閱歷助長他的創作，也無形中帶來挑戰，尤其在退休之後，得以專心從事夢寐以求的畫業，但在欣慰之餘總是不忘逐新，並厚實作品的能量和高度。

「甘蔗園系列」是他最新的創作題材。2022年之後，他一如往年，繼續畫玫瑰、畫百合、畫萬年青……但在鄉野與甘蔗園相遇之後，紅甘蔗走入他的題材行列。不同於玫瑰、水仙或野薑花，黃才郎的甘蔗直接來自泥土，他無畏風雨日曬前往蔗園寫生，這個系列明顯出現黃綠色調，用來表現茁壯中的莖稈外葉朝氣。有些畫中的甘蔗已長成，紫紅的細長蔗身平臥於婆娑莖葉下，依稀可以感受到微風在園中的聲息。豐富多彩的構圖足見他感受的不單是甘蔗本身，而是由此喚醒的農家子弟戀鄉情懷。甘蔗園如浪襲來的視覺衝擊，引領他重新審視生活之美和創作泉源所在，藉此迎向更漫長與康莊的藝術之路，產生更多的「笑心之作」是必然的，自然也受到眾人的關注和期待！

Natural Beauty and Ornamental Gilding – Reading Huang Tsai-Lang's Works of Heart's Delight

Chen Chang-Hwa
| Writer

Introduction

In the second half of February 2023, Huang Tsai-Lang held his first-ever solo exhibition at Dr. Sun Yat-sen Memorial Hall in Taipei. On the opening day, guests from his teachers' generation, his former supervisors and colleagues from his days as a civil servant, his relatives and friends, as well as his students and the general audience filled the entire venue. After the opening ceremony finished, the artist who has been discomforted due to illness in recent years personally gave a guided tour through the whole exhibition. When he finally had a chance to take a break in the VIP lounge afterwards, his slightly tired-looking face still brimmed with a sense of excitement.

"In your toast, you mentioned something that Li Mei-Shu once said. Was it 'a work of painstaking effort' or 'a work of heart's delight'?"

"It was indeed 'a work of heart's delight," said the artist in Taiwanese.

In 1964, established painter Li Mei-Shu was offered and accepted a professorship at the Department of Fine Arts, Chinese Culture College (now Chinese Culture University) located on Yangmingshan. After Huang was accepted into the college in 1971, he became one of Li's favorite outstanding students. In addition to learning from the art master in class, he was given the opportunity to observe in Li's studio as well. The art master taught by imparting painting skills as well as speech and action, which Huang has always found beneficial even until this day.

"A work of heart's delight" is how the art master described his own painting: as an artist, when Li looked at the works that he gave all he could to complete with a clear conscience, the sense of satisfaction and joy felt in his mind was conveyed through these words. When the unfettered brush is inspired and driven by a delighted heart, the painted image naturally expresses one's original and unadulterated belief in art without remorse.

The Youthful Palette Knife

In 1969, Huang passed the entrance exam and was accepted into the Department of Fine Arts, Chinese Culture University. At this time, he could still vividly remember the childhood fun of losing himself in doodling with oil pastels, as well as the thrill of studying painting at established painter Kuo Po-Chuan's studio as a youth. As he entered a new stage of learning in life, an even bigger longing towards art began to emerge in his mind – "finally, I could buy palette knives and paint to start painting." In 1971, he finished his first oil – *The Jiali Church*. Inspired by his hometown Jiali in Tainan, the painting depicts the familiar weather and plants in Jiali, with the palette and shapes which Huang created by emulating the techniques of Fauvist expressionism used by Russian painter Wassily Kandinsky (1866-1944) – an artist that Huang greatly admired at the time.

Sanxia created in the same year (1971) was an exercise painted from life in Li Mei-Shu's oil painting class. Situated in the southwest of the Taipei Basin, Sanxia was Li's birthplace. Back then, this teacher-student painting trip was also joined by painter Hwang Chao-Mo (1939-), who was the teaching assistant in the class. Li painted the scene of women doing laundry by a river – a classic theme of painting from life. The students, on the other hand, dealt with the main scene comprising townhouses built along the river. The attached buildings in various heights and facing different directions were like irregular, colorful building blocks, producing a richly interesting sight.

The oil painting *A Time-honored Wall on Dihua Street* and the watercolor *An Alleyway at Night near Tainan Tianhou Temple* were both created around 1972. The former depicts the dilapidated historical streets in Dadaocheng. The young painter employed lyrical colors and a vivid contrast to record a sentimental view created by relentless time. The latter might possibly be Huang's first heavy-colored watercolor painting after he began studying watercolor. The theme of the painting is nightscape: in a gloomy, dark night, blue-green streetlights from

a small alleyway produce two different types of atmosphere, with the upper part of the image looking brighter than the lower part. With limited lighting, parts of random run-down houses are highlighted, conveying a placid, carefree feeling.

Huang's art learning in the university continued the basic sketch training that he had received at Kuo Po-Chuan's studio, and contributed to the development of his subsequent creative power and a keen eye for appreciation. In 1972, because of his work as an art editing consultant at *Fine Arts Magazine* affiliated with *The China Post*, Huang had a rare opportunity to go on a painting trip to Lanyu. Joining this group were established painters from the generation of Huang's teachers, including Hung Jui-Lin, Chang Wan-Chuan, Chen Ching-Jung, Chou Yueh-Po, Wang Shou-Ling, and Huang Chang-Hui. In this trip, Huang painted several pastels, including *Beach in Lanyu, Warship Rock in Lanyu at Sunset,* and *Lanyu Scenery. Beach in Lanyu* depicts a tatala boat lain quietly on the beach, forming a contrast to the rolling white waves. *Warship Rock in Lanyu at Sunset* portrays Warship Rock against the hazy twilight. The backlit rock standing alone in the sea constitutes a lonely landscape. *Lanyu Scenery* was later expanded per the suggestion of artist Lin Ko-Kung, and was re-done in oil. With the foreground of a woman gazing into the distance from a vantage point, which is matched with the teal seawater and a tatala boat in the lower part of the painting, the painting fully shows the painter's ambition to fill up the entire image.

As a young artist, Huang also had a rebellious, freewheeling side to his character, apart from being circumspective and calm. Several of his self-portraits of 1972 implicitly show this side of him. *Shooting Range at Chenggong Hill* (1973) appears to be a colorful delineation of a scene with semi-geometric shapes and forms, but in fact, there is another story to this work: when Huang received military training at Chenggong Hill, he was caught smoking and punished to cut grass at the shooting range. He brought his painting kit along with him, and was touched by the lot of red soil, which led to the creation of this work.

Fascination with Gray, Black, and White

Huang's early works mostly revolve around painting from life, and his uncomplicated nature as a young man growing up in the countryside is expressed through his brushstroke. The precocious steadiness visualized by his images sometimes reveals a slight sentimentality of the "young Werther." An example of this is *Art Studio* (1972), which expresses his angst before turning in the piece for the graduation exhibition. After a long pensive period in front of the easel, he eventually used a red theme combined with the impressionist expression he had learned in class to complete this depiction of a scene in the art studio. Overall, the work is characterized by a prosaic charm.

As *Art Studio* was showcased in the graduation exhibition, a palette of gray, black and white that exuded gloomy emotions ensued in his following works. Such painting language that reflected the inner world perhaps originated from his anxiety and unease about entering the workforce, and was influenced by his increasingly changing life and the pressure building up at work. Until the 1980s, his artistic creation overflowed with a stronger sensibility informed by melancholic feelings. *Fallen Leaves in Autumn* (1980) features leafless tree branches with fallen leaves, articulating a sentimental comment on the season. The tree branches depicted in dark tones hint at the advent of a chilling winter. In 1980, he drew *Birds in a Cage* with charcoal pencil and crayon, which further foregrounds a subjective perspective of observation. This work also gave him a sense of confidence in relation to the rapport of portraying his subject in gray, black, and white.

As time progressed, he had developed a more solid grasp on utilizing such a monochromatic palette in 1988. At this time, he was already a civil servant specializing in cultural administration in the public sector. His experience in the work field gave him opportunities to view famous and superb works of art, and his artistic horizon was constantly expanded. Benefiting from viewing great art at work and his steadfast practice of painting skills, his creative work became

increasingly better. In this year, he was also awarded the grant of the Fulbright Program to research about cultural administration in Washington, D.C. During his stay in the US, he once saw a shopping bag blown into the air by the biting wind in a park as he was on his way back to his rental apartment. The inspiring sight drove him to create *Shopping Bag* that very night: upon a gradient background drawn with charcoal, the image of common jasmine orange depicted with layered thin, black lines is then added to the background as a foil to the main subject of the work – the paper bag, with which the artist expressed his feelings, using the object as a metaphor for the solitude of an outlander.

Washington, D.C. was created in the same period as *Shopping Bag*. In travel, charcoal and paper were the most convenient drawing instruments, which kindled the creative urge of this out-of-town artist. Using gray, black, and white, Huang portrayed the time-honored architecture and the sky with transient changes. Removing vibrant colors from his composition, the artist could even better visualize the age-old traces that he aimed to portray. In 1986, Huang participated in making the laws and regulations related to public art, and created *A Wish Comes True – An Idea of Public Art*, a charcoal drawing with a touch of green in oil. As for *Reeds* (2000), the painting might appear to delineate the external world; however, it is the swinging reeds in the wind that might have first triggered the artist's thinking. Huang layered the charcoal strokes, and created the blankness as a space of breathing and lamenting for the freely growing plant, making the work a combination of visual image and meditation.

Rose · Tangerine · Devil's Ivy

Reputed as "the queen of flowers," rose is a common subject of still life. However, while most painters are captivated by depicting roses in vases, Huang's portrayals of roses are often mixed with the projection of personal visual experience. Through the creative process, he has enjoyed the fun of duetting with his canvas, and the oil, titled *Lingering Series – Roses* (1998), is the most representative in this case: in the entire image, only seven vibrantly red flowers are delineated carefully, and the one at the center is accentuated with the full stem and leaves. Whereas the coloring in oil paint foreground the authentic, thriving existence of the red flowers and green leaves, the rest of the flowers and leaves are sketched with pencil and seem to retrieve into the background. The oil and pencil complement each other, whilst the virtual and the substantial produce a sense of depth in the image, making the colored roses extremely prominent. This work not only steps out of the old rut of "flowers in a vase," but is also a work of heart's delight to the artist.

This use of oil color combined with pencil or charcoal drawing – an approach that creates the effect of spatial distance in the image – can also be found in his *Tangerine Series*. For example, the one-and-only tangerine at the center of *Tangerine Series – A Hundred Auspiciousness* is the only colored one, whereas the rest is drawn with charcoal pencils. Among these tangerines, some have blurry outlines, and some are even constructed only with simple circles. Were it not for the artist's unique aesthetic understanding and courage in experimentation, the work would have been a simple, plain still life drawing; and no matter how perfectly the tangerines are depicted, they are merely still objects without the space of imagination and extension of artistic conception. Surely, what the work has achieved is the realm of painting that Huang has striven for in his painstaking self-study.

Portrait of Grandmother, which was created in the same year as *Tangerine Series – A Hundred Auspiciousness*, also seems to portray a similar intriguing realm of painting. Featuring Huang's grandmother, the background of the painting is consisted of a seemingly extending sea of roses, indicating endless care and remembrance. Comparing to common portraits, the composition of the painting is discernibly structured in a strong and stable way. With the floral background as a foil, the image exudes a rare luster of liveliness and pleasantness, and the figure in the painting looks healthy and dignified, just like when she was alive and ready for a party.

Huang's approach of constructing the visually surprising space by contrasting sketch drawing and oil painting has continued in other works, such as *Morning Star Lilies* and *Oriental Lilies*, created after 1991. In these works, he makes a good use of limited red in the image to produce a focal point, effectively containing but highlighting the smidgen of red, which pops out in the midst of black brushstrokes. Like the working of a baton on an orchestra, the red composes a beautiful and poetic melody in the works. Both *Morning Star Lilies* and *Oriental Lilies* exude a similar charm. In his watercolor, *Narcissuses*, created earlier in 2004, the color red is only used in painting the singular, thin band. However, it is more than enough to enliven the expression of the image.

Gilding, or gold leafing, in painting has already become a stylistic characteristic in Huang's work. His use of gold leaf was inspired by a speech in an international conference, where he listened to a scholar talking about the dissimilar effects of gold leafing in the West and the East. Whereas the technique gives a splendid sense of opulence in the West, it somehow creates a mysterious impression in the East. Since then, he started adding real gold leaf to decorate his works. He uses store-bought gold leaves and paves them by himself. The trick to gold leafing is that the gold leaves must be imbricated until one achieves the expected effect of spatial change. His works, such as *Rainbow – KMFA After the Rain* (1995), *Kohlrabis* (1996), and *Tangerine* Series from 1996 and 2002, are all incorporated with gold leaves. Foiled by the gold leaves, the space constructed with charcoal pencil and oil color is visually expanded, adding a luxuriant glamor to the works.

Devil's ivy is one of the major themes in Huang's *Lingering Series*. *Lingering Series – Devil's Ivy* was started around 1980. Huang depicted the indoor plant and its unfettered, spontaneous growth; and the portrayal of the entangling stems also reveals a slight sense of distance. Until 1988 or 1989, his depiction of devil's ivy shifted from a straightforward manner to being metaphorical and lyrical. He drew the subject with charcoal pencil, or used oil color to express the vitality of the green leaves, before adding charcoal pencil drawing to delineate the surrounding leaves and stems in gradient gray and black. In *Lingering Series – Devil's Ivy IV* (1989), the artist also added an indistinct couple viewed from their backs, and thus, linked the idle natural greenery with romantic affections in this mundane world, interpreting the idea of "lingering" embodied by the image in a romantic way.

Authenticity and Beauty of Portrait Paintings

Figure paintings take up quite a considerable proportion in all of Huang's works, among which the largest group comprises human body drawings and self-portraits. The earliest female nude was done in 1972, when Huang was a graduate in college. In 1973, his work depicting a sitting nude was selected into the Taiwan Provincial Fine Art Exhibition (also known as the Provincial Exhibition), and his another work was awarded in the Tai-Yang Art Exhibition. Since he began receiving professional art education until today, for over half a century, Huang has never walked away from the subject of human body, The contour, the expression, and the volume of human body are topics that the artist has continuously explored in painting and drawing.

Almost all of Huang's female nudes depict women with plain features, and rarely show female images of plump contours and sensual beauty favored by French impressionist master Pierre-Auguste Renoir (1841-1919). Huang's figures drawings and paintings visualize the essentials for viewing "beauty": "beauty" comes from authenticity, and all body types can be the subject of painting. The allure of "beauty" is to be discovered – even though the body stays still, all the subtle changes of muscle movements caused by breathing could potentially awaken one's imagination, and trigger the spectator's perception of "beauty." *The Young Girl in Black* completed in 1976 attests to such thoughts: the young girl dressed in a piece of black garment bashfully holds the hem of her skirt with her hands. Her standing posture also shows a sense of shyness. Nevertheless, this is not a posture posed

deliberately. Through the artist's refined and careful delineation of the girl's flesh, bone, and look, the painting somehow exudes a power that is visually persuasive.

Painted in 1981, *Female Nude* depicts a model sitting on the stairs banister. The mature female body is delineated with strong, steady lines. The twists and junctures of muscles and bones are well-considered and elaborately portrayed by the painter. Over the decades, Huang has accumulated an impressive number of human body pencil drawings, which were all created through painting models. This group of drawings best demonstrates the strict basic training that Huang received in the early days, which he has assiduously perfected through years in order to capture the essence of his models. His solid, reliable sketching skills are applied to his various series of works, elevating the minuteness and depth of the image. The drawing or rendering of pencil and charcoal complements the oil coloring, and vice versa, forming an art language characteristic of his own.

From long ago, self-portraits have served as a way to explore the life experiences of the painters and their feelings and emotions at the time when the self-portraits were created. Huang's earliest pencil self-portrait dates back to 1972 when he was a college student. In the drawing, his eyes are lowered, and his lips are pressed tightly together. The look on his face shows a fraction of uncompromising spirit. Over the course of more than thirty years from the time when he became a civil servant in 1981 to his retirement in 2015, Huang would use his spare time from work to draw and paint. Many of his pencil self-portraits were created in his hotel rooms when he was on business trips. During the day, he would make official calls or visit places; and in the evening, after he finished his work that day and was done preparing materials for the next day, he would draw a sketch of himself with a mirror; hence, the images of him in his undershirt or sweatshirt. He looks delighted in some of the self-portraits, and exhausted in some; one can therefore guess at whether his work went well that day based on the expression. As a matter of fact, the amount of his

hair in these self-portraits also suggests the elapsed time from his youth to his mature years. Yet, although his visage might have grown old, his drawing has remained true and honest.

Savoring the Red Sugar Canes

Huang is enthusiastic about the themes of plants, flowers, and fruits. Whether they are vigorously growing, lushly thriving, or practically withering away, each of these stages inspires him to pick up his brush. He has painted green tangerines as well as ripe, juicy ones in orange color. The *Tangerine Series* of 2022 is luscious and inviting, and his *Green Tangerines* of 2009 exudes an air of the orchard. His also paints ginger lilies: he would begin painting the bouquet of flowers when it was put in the vase. Then, he would revisit the ginger lilies one week later. Even though the blossoms already passed their prime and started drooping, he still found painting them enjoyable, and would only stop when the flowers and leaves had all withered and fallen another week later. His series of narcissuses was painted in a similar mood. Some of the works in the series portray the narcissuses standing upright, fully blooming; and some show the life of the flowers draining away under the power of time. It seems that the artist has always been fascinated with such sentiment-filled expression created through long hours of observing fruits and flowers and appreciating the prime and disappearance of their life.

Over the course of decades of finding subjects from nature, Huang has integrated sensibility-informed lyricality with unhurried realistic depiction, which shows his intention to escape from the conventional style of painting. Having viewed the collections of major art museums worldwide and after years of working at cultural administrative institutions and museums, his vast experience have definitely contributed to his artistic creation, but it has also presented an imperceptible challenge, especially now that he is finally able to concentrate on his painting after retirement. While he finds comfort in art making, he has never stopped seeking innovation and increasing the energy and height of his creation.

Sugar Cane Series features Huang's latest creative theme. After 2022, he has consistently painted his usual subjects of rose, lily, and evergreen. However, after he encountered sugar cane farms in the countryside, the red sugar cane has become his subject as well. Unlike the roses, narcissuses, and ginger lilies in his work, the sugar canes depicted by the artist grow directly from the earth. Regardless of the weather, he has painted sugar cane farms from life. The series shows prominent tones of yellow and green, with which Huang expresses the growing stems and vivacious leaves of sugar canes. In some of the paintings, the sugar canes are ripe, and their long, purple-red stems already lie beneath the dancing leaves. Spectators could almost hear the sound of breeze brushing through these leaves in the farm. The rich, colorful compositions evince that he has not merely perceived the sugar canes alone but also the nostalgia awakened in a person that grew up in the countryside. The waves of visual impact made by sugar cane farms have led him to reexamine the beauty of life and revisit this source of artistic inspiration, thus embarking on a longer and more inspiring artistic path. It is only natural that he will create more "works of heart's delight," which surely engage our attention and are highly anticipated.

以「締造良好創作環境」為志：黃才郎藝術行政的踐履行路

蔡昭儀
│ 國立臺灣美術館研究發展組組長

「藝術為我畢生職涯」，是今年 74 歲的黃才郎為自己下的人生註腳。印證於他半世紀以來的工作經歷，他是一位繪畫創作者，擔任過美術雜誌編輯、藝術教師、美術辭典主編、文化事務主管機關高階主管、美術館館長等。他不僅以廣闊的專業歷練打破了一般人對於「藝術」作為一種「職涯」的想像，更值得注意的是，他「藝術職涯」的廣度，可謂與臺灣文化生態的衍異、創作環境的變化、美術館及藝術行政專業的發展並轡前行。

黃才郎半世紀以來的人生，有近 32 年的黃金歲月奉獻於藝術行政的公務職涯，包括：行政院文化建設委員會首位美術科科長 (1982 ～ 1989)、高雄市立美術館首任館長（1994 ～ 1999）、臺北市政府文化局副局長（1999 ～ 2000），臺北市立美術館館長（2000 ～ 2007）、兼任台北當代藝術館館長（2006）、文建會處長（2007 ～ 2009）、國立臺灣美術館館長（2009 ～ 2015）等。他曾是主導文化藝術發展走向的政策制定者，亦是在臺灣 1980 年代以來的「美術館時代」中擔任過四座公立美術類博物館館長（藝術界以「四館王」譽之）的第一人。[1]

黃才郎曾提及，踏入公部門、開始他藝術行政職涯的契機，來自於 1981 年文建會第三處首任處長申學庸的邀請以及一句觸動其使命意識的關鍵話語：「我們來扮演

橋樑的角色！讓政府的力量可以過橋，實現民間藝術界的願景。」[2] 自此以後到 65 歲自國美館退休，原以藝術創作為人生志業的黃才郎，展開了他以美術行政為顯、繪畫創作為隱的雙向藝術行路。1991 年，黃才郎曾以〈為締造良好創作環境而努力〉一文自抒職涯發展理念，強調「誠意」是從事文化藝術工作者最重要的態度，而所謂的「誠意」，寄寓在「作好一個專業工作者、追求品質，讓具體的表現來驗證；懷抱熱誠，講究專業知識良心，全力以赴」的自我要求上，而當時已屆四十不惑之年的黃才郎更自我砥礪：「我願：作一個誠懇的藝術工作者，隨時不忘充實自己，期望在推動社會文化發展環境中，盡自己的本份。」[3]

在近五十年來臺灣美術文化環境劇烈遞變的過程中，黃才郎親自見證，並深度參與。客觀而言，他是文化潮騷中的重要人物之一，但並非扮演其中衝鋒陷陣的造浪者，而更趨近於是一位促進改變的推手、使美術環境實質動變發展的中流砥柱。本文將專注於黃才郎藝術行政的踐履行路，探討他在三十餘年來的公務職涯如何以「締造良好創作環境」為志，經由諸多具體落實的政策、制度與實際推動案例，踐履他作為「誠懇的藝術工作者」的專業職志。

1 臺灣的「美術館時代」發軔於 1980 年代：1983 年臺灣第一座公立美術館臺北市立美術館成立，1988 年位於臺中的臺灣省立美術館開館（1999 年改制為國立臺灣美術館），1994 年座落南臺灣的高雄美術館成立；在北中南三大公立美術館之外，2001 年台北當代藝術館也正式開館。黃才郎為目前為止，為唯一曾擔任過此四座公立美術館館長者。
2 林姿君，〈國美館館長黃才郎榮退　美術界盛大歡送〉，《典藏》，網址：＜ https://artouch.com/art-news/content-3045.html ＞（2023.3.1 瀏覽）。
3 黃才郎，〈為締造良好創作環境而努力〉，《文訊》，71 期／革新號第 32 期（1991.9），頁 7-9。

踏實踐履的藝術行路

國內美術的發展，就像質地堅美的一塊璞玉，而來
自美術工作者、美術相關事業及藝術行政的用心與
努力，在在都將是琢磨的力量。

黃才郎，1986

黃才郎擔任文建會美術科長期間，在 1986 年創作的一
幅名爲〈公文〉的素描上註記了上述這段話語。彼時他
顯然胸懷抱負與信心，對臺灣美術的整體發展投以無限
期待，他的視野之思並非僅著眼在官方的政策立場，在
直指藝術相關專業朝向分流發展的態勢之時，更亟思促
成政府機構、民間事業單位、美術工作者的協調運作，
使多方力量在面對文藝環境劇變的挑戰之際，能夠匯流
成「琢磨璞玉的力量」。他 1981 年以「成爲藝術界與
公部門間的橋樑」之使命感踏入公部門，三十餘年的公
職生職，不管身在何種職位上，讓政府資源通達到藝術
界所期待的願景中，始終是其核心目標。藝術界常以「美
術館時代的專業館長」稱譽黃才郎，究其實質，他的影
響與貢獻不僅在其 20 年公立美術館首長的傲人資歷，
更在於他美術館營運上的視野與觀點、行政規劃處理的
策略與組織、以及實務推動上的實踐力與執行力。從其
職涯發展層面來觀察，黃才郎進入美術館體系前對文化
藝術事務的廣泛涉獵及觀念建構，是他成爲「專業館長」
的重要基礎與底氣。

黃才郎的藝術行政經驗，最早可回推至 1971 年，還在就
讀中國文化大學美術系三年級就經由當時的系主任施翠
峰推薦，爲英文中國郵報的《美術雜誌》擔任美術文稿
策劃、編輯，並主筆「西洋美術專欄」，前後共撰寫了
22 期的世界名作介紹（自 1971 年 10 月至 1973 年 7 月）。
大學畢業後，他以「彌補國內對西洋美術認識的片斷與
零散」爲理念進行《西洋美術辭典》的編譯，先是在《美
術雜誌》專任編輯期間（1973-74）草成 A、B 兩大字母
段落，並於 1980 年入職雄獅美術叢書部主編後，再歷時
兩年多主編《西洋美術辭典》。[4] 此書內容包括美術用語、
西洋美術發展史、藝術流派、藝術家傳略、技法、畫材
用語及主題等，是國內第一部權威性的西洋美術學習與
學術研究的基礎工具書，並於 1982 年榮獲金鼎獎。此部
辭典的出版，蘊生於黃才郎對西洋美術發展的求知堅持，
同時寄托著他對提升國內藝文知識環境、普及美術教育
的用心。

黃才郎曾言，他入職文建會期間（1981 ～ 1989）所懷
抱的理想，在「釐清似是而非的美術行政觀念，發揮
自己在專業知識上的體認，使政府的財力、組織與政策
能在國家發展上發揮最貼切的力量，作成最有效益的應
用。」[5] 他的理念以及起而行的諸多作爲，可從此一期
間文建會的美術類出版品及傳媒報導中尋得例證。而
黃才郎對文化藝術事務的觀點與識見，則從其 1988 ～
1989 年發表在《聯合報》、《中央日報》、《中國時報》
等報端的專欄或專稿文字中有更清晰的顯影。

4 詳黃才郎〈爲締造良好創作環境而努力〉及本書〈黃才郎年表〉。
5 黃才郎，〈爲締造良好創作環境而努力〉，頁 9。

1988 年 1 月他應傅爾布萊特學者訪問計畫邀請，赴美國進行為期 7 個多月（1988/1/15 至 8 月底）的藝術行政專題研究，除了藉此難得的國外研習機會積極拓展視野，並從他山之石的經驗與案例中，重新檢驗與再建構個人對藝術行政專業的觀念與體認。他勤以筆耕方式來整理、介紹、評述及反芻所思所見，從赴美開始到返國後半年多的時間裏，在報端發表了近三十則的手札與文稿。除了藝術鑑賞類型的文字外，相關內容可大分為以下幾個面向：

1. 他關注國家力量如何妥適的施行在文化藝術的推展上同時兼及藝術自由發展的空間、文化政策如何對應變化的潮流與思想、政府如何將藝文環境的建構融入法定政治體系政策面使文化設施及文化事業共榮發展，並對美國的相關作法、各國政府最高文化藝術專責機構的組織性格及運作重點等多有分析與評介。

2. 分析藝術創意對建構國家文化形象、突出文化特色的辨識度的重要性，主張「文化工業」是提振經濟不可或缺的公共事務，並以日本、韓國、法國、美國為例，介紹各國的施政應對及發展目標設定。

3. 從國際案例思考文化遺址的保存與活化如何突破「形式化」的窠臼走向一種「活的存在」，並對國外民俗藝術傳承的理念及推動計畫、民俗技藝的傳承及保存多有介紹。

4. 觀察與評析「公眾藝術」對城市景觀塑造、激發市民共同情感的重要性，並介紹美國地方政府相關的推動案例。

5. 對美國的藝術行政研修方式有多則介紹，並指出在國內文化事務的推動上，藝術行政的觀念、技術、人才是未來發展的關鍵，而專業藝術行政人員缺乏是必須急起直追去解決的問題。

6. 介紹美國政府對基礎藝術教育的目標、企圖與主張，以及將美術館、博物館、劇場、藝術中心、藝術季、公視節目、民間非營利文教機構等納為藝術體驗及倡導資源的作法。

7. 多則文稿涉及美術館營運的觀察與評述，內容包括：藝術品捐贈的文化公益性、參加開幕預展酒會的效益、美術館展覽建構情境引導的方式、美術館設置市民畫廊對地方藝術發展的鼓舞、不同的展覽策劃觀點與組織結構對異文化雙向交流的有效性與說服力等。

8. 闡述地方公辦美展對提倡創作風氣的效益及影響力，期許以新的運作形態來反映社會形勢及畫壇結構的遞變。

這些文稿匯集了黃才郎多年來專業知識的積累、工作實務經驗的精珀、公務考察的他國案例借鑑、以及在美專題研究的心得。他後來辭卸文建會職務短暫離開公務機關期間（1990-1991），曾擔任立法委員陳癸淼的文化立法助理，當時是協助起草「文化藝術獎助條例」中「1% for art」（公共建設以百分之一經費設置藝術品）的關鍵人物，即築基在他對國外公共藝術政策及施行方法的深入研究，以及亟思以文化政策協助藝術創作者獲得更多發表及工作機會的初心。[6] 而黃才郎對文化發展議題的廣泛關切、對

6　陳碧琳、周雅菁，〈探索藝術品之外的臺灣公共藝術政策〉，2021，網址：＜ http://news.deoa.org.tw/index/contentpage?id=249 ＞（2023.6.10 瀏覽）。

藝術生態環境或巨視或微觀的關懷視野，則在他進入「美術館館長」生涯後，踐履在美術館營運的理念與實務上。

美術館營運的視野與觀點、策略與組織

黃才郎在 1992 年 1 月 30 日就任高雄市立美術館籌備處主任之後，歷任臺灣南、北、中三大公立美術館館長至 2015 自國美館年退休；他的美術館館長生涯，歷經臺灣藝術創作走向多元且蓬勃發展、藝文生態環境崢嶸多變以及直面全球化挑戰的 90 年代及千禧時代。他對美術館營運的視野與觀點、藝術行政的策略與組織，在其擔任首任高美館館長期間的多項創建規劃中即可見梗概，並且在其高美館、北美館、國美館時期，依三館的發展屬性有不同的偏重與開拓。

高美館是臺灣第三座公立美術館，1994 年開館之時，即便北美館、省美館已營運多年，黃才郎仍然是當時宣示建構「美術史美術館」主張的首位美術館館長。李俊賢曾言黃才郎時代的高美館風格是表現在經常性的展覽上，他以「美術史」做爲觀照考量，[7] 儘管這些展覽間並未具足美術史觀、史識上的關連性，但臺灣美術的各類展覽都以具美術史內涵的角度來取捨，國際展也盡皆爲具西方藝術史定位的國際大師，他任內的多項展覽，如「時代的形象－臺灣地區繪畫發展回顧」（1994）呈現臺灣美術發展概況、「國之重寶－國立故宮博物院文物珍藏特展」（1994）爲故宮文物首次南下展出、「黃金印象－奧塞美術館名作特展」（1997）展出法國奧塞

美術館典藏之 60 幅印象派名作，皆爲帶動南臺灣藝術展參觀熱潮之大展。平實而論，黃才郎對「美術史美術館」理想的信守與堅持踐履在他 18 年的館長生涯中，他持續以展覽進行臺灣美術史的建構（相關內容將在下一單元討論），並且始終主張典藏品常設展出的重要性：

> 美術館以典藏品顯現一館風格，……時代的改變，影響典藏觀念從「存藏」到「展示」，又從「研究」到「教育」，典藏品也有了不同的身份與價值。……館員應在行政理念與專業價值判斷上歸零，還給典藏品自身的意義。因此，將典藏品無性格、無價值判斷的常設展示，可提供民眾與學者專家欣賞研究更寬廣的空間。
>
> 黃才郎 [8]

黃才郎在高美館時期設置了書法、雕塑的專題長期陳列室，北美館時期則每年推出展期近一年的典藏精選展或主題展，國美館時期則主導策辦眞正具常設性格的「國美無雙－館藏精品常設展」（2011～2017）及「國美無雙 II－館藏精品常設展」（2012～2017）。這些展覽的共通特質，除了在展陳三館各自的典藏特色、與全民分享國家與社會珍貴的文化資產，亦具有顯影臺灣美術發展脈絡與創作表現的企圖，並讓每件作品以「無雙」之姿，開放給國內外美術館觀眾及研究者自由鑑賞。黃才郎對美術館藏品的關注，亦體現在典藏相關制度的建構上。他就任北美館館長當年（2000）即大刀闊斧的推動典藏品典檢，針對入藏登錄方式、作品狀態、藏品內容

7　李俊賢，〈後黃才郎時代的高雄美術館－高美館 10 年觀察〉，《典藏今藝術》，132 期（2003.9），頁 142。

8　黃才郎，〈美術館的公部門文化與專業走向〉，《現代美術》93 期（2000），頁 3-4。

等作一全面的檢視與資料補正，後續並對藏品的寄存、庫房及典藏品的管理、藏品及圖檔的提借等行政法規進行新訂或修訂。掌握典藏品的現況與品質、提昇藏品管理效率的相關作為，也延伸到他任職國美館館長期間，其中一項重要工作，即為 2010 年啟動的為期 6 年的「典藏品點檢計畫」。

黃才郎認為美術館教育肩負社會教育的使命，相較於學校教育，美術館教育的特色是重視直接感受與體認的「經驗性」、從視覺經驗中自由聯想的「自主性」與「多樣性」、適用於不同年齡與大眾背景的「終身」教育。他在高美館開館之初即著手規劃全國首創的「資源教室」，旨在營造出民眾能直接參與、觸摸、創作、遊戲於其中的「動態的」學習環境。高美館的「資源教室」在 1997 年 5 月初次開放，配合展覽設計了相關的展示情境與教案，提供學校教師申請帶領學生使用，並在 1998 年 12 月起常態性開放。[9] 北美館的「資源教室」則在他就任後於 2002 年 9 月成立，主要以配合展覽來設計體驗情境，提供國小、國中學校團體及家庭親子觀眾使用。[10] 此外，他亦是國內美術館體系中曾計劃性、組織性的推出教育展的唯一一位館長。2001～2004 年期間，他引進法國龐畢度中心兒童工作室策辦的 4 檔「為兒童而藝術」的展覽：「藏在石頭裡的鳥：關於布

朗庫西作品的遊戲空間」（2001）、「11 張床：一樣／不一樣」（2002）、「城市中的旅行」（2003）、「發現馬諦斯與畢卡索教育展」（2004）。在吸取他山之石的經驗後，於 2005 年由北美館自行策劃並邀請臺灣本地藝術家參展，以「為藝術而教育」（為了藝術的目的去做教育的解析）的理念推出「樂透可見與不可見教育展」，以及「為教育而藝術」（以兒童為使用者的本位來進行展覽規劃思考）推出的「水墨桃花源教育展」。[11] 這兩檔富於教育意義的展覽，營造出生動有趣的「直接學習」與「親身體驗」環境，透過遊藝嬉戲的方式，體驗藝術家的創意，並以此來培養目標觀眾對藝術的感受力。

鼓勵在地創作風氣、扶植年輕藝術家，亦是黃才郎公務職涯中持續努力的目標。他任職文建會時，自 1983 年起即主導推動「地方美展」政策，提供國內藝術家及美術團體更多展覽的機會，並著重在地方上辦理，除了以此來匯集並呈現本土美術的發展成果，亦旨在及時強化逐漸淡薄甚至有湮沒之虞的美術發展軌跡，讓地方藝術家繼起的腳步有更大的自信。[12] 高美館時期，他開辦「創作論壇」與「市民畫廊」系列，前者旨在發掘優秀的藝術創作者並提供實驗創作發表的機會，後者則展出高雄藝術家作品並整理在地創作者的生涯回顧資料；此外，

9 　黃才郎，〈高雄市立美術館資源教室案例探討〉，《藝術家》289 期（1999）：頁 350-351。

10 　黃才郎，〈遊玩藝術的空間－北美館的資源教室〉，《遊於藝：2003 美術館教育國際研討會論文集》，（臺北：臺北市立美術館，2003），頁 83-84。

11 　黃才郎，〈為藝術而教育；為教育而藝術〉，《「跨入藝術：談藝術家與美術館教育者的合作計畫」美術館教育國際研討會論文集 2005》（臺北：臺北市立美術館，2005），頁 32。

12 　黃才郎，〈期待地方美術史的發皇－由重視縣市美展培養文化自信〉，《聯合報》（1988.10.29），第 5 版。

13 　〈歷任館長〉，《高雄市立美術館》，網址：＜ https://www.kmfa.gov.tw/AboutUs/AboutKmfa/planning/history.htm ＞（2023.3.31 瀏覽）。

他將「高市美展」改制爲「高雄獎暨高雄市美術展覽會」，開公辦競賽展風氣之先，於複審打破媒材分類。[13] 就任北美館館長後，於 2001 年把「臺北獎」更名爲「臺北美術獎」，以不分類別、不限制尺寸的方式競比，亦提高首獎獎金，使年輕創作者可憑藉藝術創意獲得獎金並進入美術館展出；此外，並開放年輕藝術家申辦北美館的申請展，亦將這些藝術新秀的優秀展出作品納入典藏。調任文建會第三處處長時，爲協助青年藝術家進入藝術市場以獲得畫廊產業及收藏界的關注，在 2008 年臺北國際藝術博覽會中規劃了「Made In Taiwan—新人推薦特區」。於國美館任內，在 2011 年開辦國美館「數位藝術策展案」及「數位藝術創作案」競爭型徵件機制暨展覽，提供臺灣新媒體藝術優秀創意人才發表的資源及舞台。此外，銜文化部政策，他在 2013 年推動成立了國內第一個「藝術銀行」，藉收購作品來鼓勵創作並支持藝術家的經濟生活，同時以租用展示來提升企業和民間單位對藝術的支持，亦讓觀眾於公共場域有更多親近及鑑賞藝術的機會。

黃才郎在高美館籌備期間，即將「國際本土化、本土國際化」列爲美術館經營中的遠程目標，這個遠程目標縱貫於他三大美術館的館長生涯之中，並以引進國外重要展覽、推介臺灣藝術至國際展出爲落實的方法。[14] 這個理念，其實在他擔任文建會科長期間即有具體推動案例，如 1982 年他發起並主導策辦的「中華民國國際版畫展」交予北美館展出，爲 1983 年甫開館的北美館打開國際能見度及現代美術館形象，也將國際版畫創作的趨勢與訊息帶入國內，此雙年展並在舉辦經年之後，成爲國際版畫界的重要賽事之一；[15] 另，他在 1987 年企劃「中華民國現代十大美術家展」[16] 赴日本木下美術館及東京中央美術館別館展出，呈現創作六十年以上的第一代畫家的繪畫風貌。

觀察黃才郎對美術館總體展覽結構的擘劃觀點，建構臺灣美術史、國際本土化、本土國際化，可謂構成其展覽思維的三向結構。「國際本土化」旨在將世界藝術之多樣面貌、藝術史重要流派之創作思維及美學內涵帶入臺灣，擴大國人的國際視野。他在高美館時期引進查·克羅斯（Chuck Close）、布爾代勒（Emile-Antoine Bourdelle）、卡·阿貝爾（Karel Appel）、培梅克（Constant Permeke）、邁約（Aristide Maillol）、畢費（Bernard Buffet）等知名大師及「比利時表現主義」等國際重要展覽；北美館時期，則在 2001～2006 年期間領導引進國際時尚、設計、建築類等 7 項大展，擴大了北美館現當代藝術的營運類型及視野；國美館時期，則以東尼·克雷格（Tony Cragg）、亞科夫·亞剛（Yaacov Agam）、卡帕（Robert Capa）、「Videonale 當代國際錄像藝術對話」等展覽，呈現國美館推動國際接軌的成果。黃才郎的「本土國際化」，意在整合臺灣美術的發展脈絡，並將創作特色推介至國際場域；這個展覽運作

14 張淑華記錄整理，〈與黃才郎談高雄市立美術館的展望〉，《雄獅美術》277 卷（1994），頁 12-28。

15 本展自第二屆（1985）起改名爲「中華民國國際版畫雙年展」，每兩年辦理一次，以大型展覽促進國際交流，北美館承辦至 2002 年第十屆，第十一屆（2004）起轉由國美館接辦。

16 本展應邀展出的畫家有黃君璧、張大千、李梅樹、顏水龍、沈耀初、林玉山、李澤藩、楊三郎、陳進、劉啓祥。

方向在他高美館、北美館時期各有推動，但以在國美館時期成果最為豐碩，相關展覽推進至中國大陸的中國美術館及廣東美術館、韓國的首爾市立美術館及光州市立美術館、日本的相田美術館、匈牙利的布達佩斯藝術館及路德維格現代美術館、塞爾維亞佛伊弗迪納當代美術館、美國康乃爾大學強生美術館等專業場館展出，並且透過館際間對等合作、共同策展等方式為平台，提高臺灣藝術在主辦國的能見度。此外，特別值得一提的是他整合「國際本土化、本土國際化」概念的策略化操作。黃才郎就任北美館館長後，在「2000 臺北雙年展－無法無天」首先啟用雙策展人制，由臺灣策展人和國外策展人共同策劃合作，同時大幅增加參展國家，期許以本土的養分來充實國際化的過程，以國際的格局來拓展本土的視野。他轉進國美館服務後，則以 2012 年起連續 3 年舉辦的「國際科技藝術展」來建構臺灣與世界的創意激盪及理念交流平台，藉由具前沿性格、與時代趨勢同步脈動的數位科技藝術，讓國內外藝術家同場競技，並進行創作思維的深度對話。

臺灣美術史的建構視野

對臺灣美術史的整理與建構，或可說是黃才郎公務生涯中「一生懸命」的職志。從文建會科長到美術館館長，他一以貫之地將臺灣美術史的整理與耙梳、美術發展成果的條理呈現視為重點工作，並且在不同的職務時期對臺灣美術有不同的結構性思考與呈現。

黃才郎 1981 年入職文建會，彼時臺灣尚未進入「美術館時代」，臺灣美術史的研究與建構亦方興未艾，他在時任文建會主委陳奇祿的支持下，戮力推動辦理多項具研析性格、歷史脈絡、專題觀點的大型公辦美展，開啟公部門主導籌辦具美術史意識的「臺灣美術」展覽的先河。如 1982 年的「年代美展」，可說是當時首次呈現臺灣美術發展軌跡的官辦專題展先例，邀請了 97 位藝術家各提出民國 40 年（1951）以前、民國 41 到 55 年（1952～1966）、民國 56（1967）年以後的三階段創作，以作品作為研析藝術家繪畫歷程的標的，並作為臺灣美術數十年來發展的具體例證。[17]1983 年的「明清時代臺灣書畫展」，則歷時一年九個月進行大規模的訪查，從官方及民間徵借 738 件作品（最後選展其中 214 件），作者包括清光緒五年以前的臺灣本地書畫家、大陸來臺講學及旅行的書畫家等，[18] 呈現臺灣三百多年承續中原文化的傳統書畫藝術發展概貌；本展不僅具有彙整臺灣書畫藝術發展史料的企圖，亦是一項計畫性的在地文化史整理專案。1984 年黃才郎主導辦理更具規模及企圖心的「臺灣地區美術發展回顧展」，以「傳薪續火書畫藝術」（民國前 251 年至民國 60 年，1661-1971）、「新美術運動的發軔」（民國前 16 年至民國 34 年，1896-1945）、「團體畫會的興起」（民國 13 年至 50 年，1924-1961）、「近代美術的發展」（光復後到民國 60 年，1945-1971）四個單元，進行臺灣美術史的建構與探究。

延續其在文建會時期主導辦理「臺灣美術」展覽的經驗

17 陳奇祿，〈序文〉，《年代美展》（臺北：行政院文化建設委員會，1982），頁 6。
18 黃才郎，〈執行報告〉，《明清時代台灣書畫展》（臺北：行政院文化建設委員會，1984），頁 462。

與理念，黃才郎就任高美館館長之後，除了設置「書法之美」、「臺灣近代雕塑發展－館藏雕塑展」兩個長期的專題陳列室，以館藏精品來展陳書法、雕塑的概要歷史脈絡，同時亦陸續推出「時代的形象－臺灣地區繪畫發展回顧」（1994）、「『臺灣－戰後五十年』紀實攝影展」（1995）、「西潮東風－印象派在臺灣」（1997）、「臺灣書法三百年」（1998）等展覽，對臺灣美術的生發與變化進行回顧與耙梳。

在北美館館長任期間，黃才郎對臺灣美術史的建構意志，除了體現在 2001～2007 年間持續每年一檔的「典藏常設展」，用作品的展陳序列或主題取向來呈現臺灣美術發展梗概及創作的多元面向，最重要的成果，則落實在 2003～2004 年間由其主導規劃的系列型「臺灣地區美術發展回顧展」上。此系列展覽定調於戰後臺灣美術發展的整理與研究，並以十年為一單位，陸續推出 1950 年代至 1990 年代的五項研究策展，計有：「長流－五〇年代臺灣美術發展」（2003）、「前衛－六〇年代臺灣美術發展」（2003）、「反思－七〇年代臺灣美術發展」（2004）、「開新－八〇年代臺灣美術發展」（2004）、「立異－九〇年代臺灣美術發展」（2004）。此系列展覽為北美館自立館以來，首次以系統化、計畫性策展來回溯與探討臺灣美術發展的首例，並目標性地依展覽研究成果，入藏了諸多具歷史脈絡意義的美術史重要作品。

在國美館館長任期間，除了推動辦理「畫家風景‧國民風景－百年臺灣行旅」（2011）、「現代潮－五〇、六〇年代臺灣美術」（2011）、「凝望的時代－日治時期寫真館的影像追尋」（2010）、「『看見的時代－影會時期的影像追尋』1940s～1970s」（2014）等主題展，他自到任隔年起（2010），即以計畫主持人的角色，鼓勵館員從不同的創作世代進行策展研究。此展覽計畫案經歷二年半、總計 11 次工作會議的討論、研究與籌備，漸次釐定策展的概念、雛型、薦選藝術家的方向及初稿名單，[19] 最後以 1931（民國 20 年）～1980（民國 69 年）出生的藝術家為對象，用臺灣坊間慣用的每十年為一世代的「年級生」為切分方法，在 2013～2015 推出以「刺客列傳」為名的共五檔藝術家世代的研究展：「臺灣美術家『刺客列傳』1931～1940－二年級生」（2013）、「1941～1950－三年級生」（2013）、「1951～1960－四年級生」（2014）、「1961～1970－五年級生」（2014）、「1971～1980－六年級生」（2014～2015）。「刺客列傳」系列展覽，試圖突破以往的美術史策展模型，在「主流藝術」的架構外，尋介在創作美學上具有差異性格的非典型藝術家。這個策展策略的應用，除了嘗試經由異質的考察脈絡進行藝術家建檔來積累臺灣美術的研究資源，亦期待以他們自成一格、特立獨行的創作實踐理路為「刺點」，反身思考其在臺灣美術中的位置。

黃才郎從一個認知美術史觀、史識重要性的行政官員，

19 本系列展覽在黃才郎的推動與催生下，自 2010.1.25 至 2012.7.30 總計辦理 11 次的策展工作會議，各次會議討論重點，詳蔡昭儀〈差異‧殊相‧時代語脈——「刺客列傳」藝術家薦選視角再思考〉，《台灣美術家刺客列傳藝術論壇論文集》（臺中：國立臺灣美術館，2015），頁 41-68。

到具有美術史建構任務並長任近 20 年的公立美術館館長，他結構臺灣美術史類展覽的視野，或可視爲官方系統書寫美術史方式的一種縮影。其公務職涯所推辦的相關展覽，不乏美術史研究的三個重要軸線：一是以時間爲橫軸所進行的斷代式耙梳；二是以時代主流思潮或創作風格爲界分之架構；三是用形式、媒材爲內容區劃之理型。他關注美術史研究中的世代、分期、個人風格相關議題；在其所主導策辦的大型展覽及系列型展覽中，顯明的「黃才郎風格」，體現於他對展覽體例的建構、組織型態的設定、考察座標的細緻規劃上。這種講究組織邏輯、操作模型的展覽方法學，具體實踐在他北美館時期以十年爲一世代的五檔美術史回顧展、國美館時期的五檔「刺客列傳」系列。相對的，這兩項系列展，也顯影他在美術館館長生涯中，不斷試圖跨越既有的美術史研究範式，以展覽爲方法，從不同的論述場域或觀看視角來尋求更具彈性及靈活度的分期概念或類型學，嘗試對臺灣美術的閱讀與辯證注入新能量的努力。

結語：始終誠懇的藝術工作者

黃才郎三十餘年的藝術行政公務職涯，未曾或忘「作好一個專業工作者」的初心；如果說成爲藝術界與公部門的橋樑是他的起點，締造良好創作環境、促進臺灣美術發展則是他心之所繫的理想。黃才郎將藝術行政當成一種「創作性」的工作，[20] 他在政策、體制中尋求藝術行政的創見，以推陳出新的運作形態來反映當代社會及國內外藝壇結構的遞變，促使相關創建式規劃能完善的施行與運作，完成對藝術環境最有利的貢獻。他期許自己作一個誠懇的藝術工作者，因此始終抱樸守眞、務實篤行，講究專業、追求品質，在全力以赴之後，讓具體的表現來驗證。他在公職生涯中懷抱熱誠、實踐理想，他的執著與成果，早已超越今日我輩對於藝術行政的想像與定義；而他的作爲與成就，也將成爲有志於藝術行政專業的後繼者繼往開來的引領力量與典範。

20 黃才郎，〈美術館的公部門文化與專業走向〉，頁 3。

"Building an Ideal Environment for Artistic Creation" as the Goal: Huang Tsai-Lang's Journey of Art Administration

Tsai Chao-Yi

| Chief Curator of Research and Development Division, National Taiwan Museum of Fine Arts

"**Art is my lifework**" – this is Huang Tsai-Lang's comment on his life this year at the age of seventy-four, a statement truly and completely validated by his work experiences throughout the past half century. Having always been a painter at heart, Huang was an editor at an art magazine, an art educator, the chief editor of an art dictionary, a senior executive at the authority of cultural affairs, and the director of several art museums. With his extensive and professional experiences, he has not just changed people's common perception of making "art" a "career," but has also brought our attention to the "breadth" of his "**career in art**," which has progressed parallelly with Taiwan's evolving cultural ecology, the changes of the creative environment, and the development of art museums and art administration as a profession.

Huang devoted thirty-two years of his life's prime to art administration in the public sector. Over the years, he served at various posts, including the inaugural chief of the Fine Arts Section, Council of Cultural Affairs (CCA), Executive Yuan (1982-1989) ; the inaugural director of the Kaohsiung Museum of Fine Arts (KMFA; 1994-1999); the deputy-director-general of the Department of Cultural Affairs, Taipei City Government (1999-2000); the director of the Taipei Fine Arts Museum (TFAM; 2000-2007), during which he also served as the director of the Museum of contemporary Art (MoCA), Taipei (2006); a departmental director at the CCA (2007-2009); and the director of the National Taiwan Museum of Fine Arts (2009-2015). He was the policy maker who held the power to determine the development and direction of culture and arts, as well as the only person who has ever served as the director of four major public art museums in Taiwan since the advent of "the era of art museums" in the 1980s (an achievement that earns him the nickname – "the king of four museums.")[1]

Huang once mentioned his opportunity of entering the public sector: it was per the invitation of Shen Hsueh-Yung (申學庸) in 1981, who was the director of the Third Department of the CCA, and a key statement made by Shen, which kindled his sense of mission – "**let's play the role of a bridge so that the government's power can pass through us to realize the vision of the art world and the private sector.**"[2] Since then until his retirement from his post at the NTMoFA at the age of sixty-five, having previously determined to make artistic creation a vocation of his life, Huang embarked on a dual journey of art, in which he was an art administrator in the eyes of the public and a painter in his own private time. In 1991, Huang wrote an article titled "Striving for Building an Ideal Environment for Artistic Creation" to express his ideals in career development. In this article, he emphasizes on "**sincerity**" as the most important attitude for a cultural and art worker. This "**sincerity**" depends on asking oneself "**to be a professional in pursuit of the quality of work, which can be verified by one's performance at work, and to always have fervor to do one's best based on professional knowledge and conscience.**" Being over forty years old when he wrote the article, Huang even expressed the following self-expectation: "**I wish to be a sincere art worker, who never forgets to improve oneself and shall do my job in facilitating the development of the socio-cultural environment.**"[3]

1 Taiwan entered "the era of art museums" in the 1980s: in 1983, Taiwan's first public art museum, the Taipei Fine Arts Museum, was inaugurated. In 1988, the Taiwan Provincial Museum of Fine Arts (reformed into the National Taiwan Museum of Fine Arts in 1999) was inaugurated in Taichung. In 1994, the Kaohsiung Museum of Fine Arts was inaugurated in southern Taiwan. Apart from the three major public art museums founded respectively in northern, central and southern Taiwan, the Museum of Contemporary Art (MoCA), Taipei was inaugurated in 2001. So far, Huang is the only person who has served as the director to all four public art museums in Taiwan.

2 Lin, Tzu-Chun. "Director Huang Tsai-Lang of the National Taiwan Museum of Fine Arts Retires, and the Art World Throws Him a Grand Farewell Party." ARTouch. https://artouch.com/art-news/content-3045.html (viewed on 2023.3.1)

3 Huang, Tsai-Lang. "Striving for Building an Ideal Environment for Artistic Creation." *Wenshun*, no. 71; Renovation, no. 32 (1991.9), pp. 7-9.

In the recent fifty years, Taiwan's art and cultural environment has undergone a period of drastic vicissitudes. Huang has personally witnessed these changes, in which he took part as well. Objectively speaking, he is one of the important figures in the cultural tides. However, instead of being one of the trailblazers, he was more like a propeller that fostered changes, a resolute force that brought about actual developments in the art environment. This essay focuses on Huang's steadfast journey of art administration, and discusses how he has set his mind to "building an ideal environment for artistic creation" in more than thirty years of civil career, in which he truthfully realized his professional goal of being **"a sincere art worker"** through fully implemented policies, systems, as well as the projects he facilitated.

An Art Administrarion Journey of Steadfast Practice

The domestic development of art is like a raw yet pristine piece of unrefined jade, and the dedication and efforts of art workers and the sectors of art enterprises and art administration form the polishing force.

Huang Tsai-Lang, 1986

When Huang worked as the chief of the Fine Arts Section at the CCA, he noted the passage stated above on a sketch drawing, titled *Official Document* (1986). At that time, he was clearly ambitious and confident, and had much expectation of the overall development of Taiwanese art. In his visionary thinking, he was not just concerned with the government's policy and its stance, but also pointed to compartmental development of art as a profession and expressed a sense of urgency in facilitating the coordinated operation of governmental agencies, enterprises in the private sector, and art workers so that the multiple forces could converge into **"the force to polish the unrefined jade"** when facing the challenge of a drastically changing environment of arts and culture. Since

he became a civil servant in 1981, his central goal throughout his civil career was always to realize the vision of the art world through the resources of the public sector. In the art world, Huang has been known as "the professional director in the era of art museums." To more closely examine Huang's career, it becomes clear that his influences and contributions have gone beyond his impressive resume as the director of several public art museums for two decades, and have largely stemmed from his vision and viewpoints in terms of the operation of art museums, his strategy and organization in administrative planning and handling, as well as his practical and executive capabilities related to implementation. Observing the developmental trajectory of Huang's career, his extensively engagement in cultural and art affairs and the construction of related ideas had formed a vital foundation of and his confidence in being "a professional museum director."

Huang's earliest experience in art administration could be traced back to 1971. When he was still a junior studying in the Department of Fine Arts at Chinese Culture University, he was referred by the Head of the Department, Prof. Shih Tsui-Feng (施翠峰), to work as an editor for *Meishu zazhi* (Fine Arts Magazine) under *The China Post*, for which he also wrote a column on Western art to introduce famous artworks from around the world. He was the chief editorial writer for twenty-two issues of the magazine (from October 1971 to July 1973). In 1980, he entered Hsiung Shih Art Books. Upholding the ideal of **"making up for the fragmented and scattered understanding of Western art in the nation,"** he worked as the chief editor of *Dictionary of Western Arts*.[4] This dictionary was the first authoritative reference book for beginners in learning Western art and academic research in Taiwan, and was awarded the Golden Tripod Award in 1982. The publication of the dictionary was the result of Huang's persistent study of the development of Western art, and was informed by his endeavor in improving the domestic knowledge environment of art and popularizing art education.

4 See Huang Tsai-Lang's "Striving for Building an Ideal Environment for Artistic Creation, " and "A Chronology of Huang Tsai-Lang" in this publication.

According to Huang, his ideal during his post at the CCA (1981-1989) was **"to clarify ambivalent ideas related to art administration and use one's understanding informed by professional knowledge to most aptly exercise the power of the government's financial resources, organization and policy and put it to use in the most efficient way in terms of national development."**[5] His ideas and various concrete actions could be validated by CCA's art publications and the media reports from the period corresponding to his time at the CCA. Moreover, his viewpoints on and insights into cultural and art affairs could be more clearly seen from his columns or feature articles published on *Union Daily News, Central Daily News*, and *China Times*.

In January 1988, at the invitation of the United States' Fulbright Program, Huang traveled to the U.S. as a visiting scholar to conduct research on art administration for more than seven months (from January 15 to the end of August 1988). In addition to expanding his horizons, he was able to reexamine and reconstruct his own ideas and understanding of art administration as a profession through the experiences and cases of other people. He wrote diligently to sort out and reflect on what he had learned and thought. From traveling to the United States to his return, in more than half a year, he published nearly 30 columns and articles on newspapers. Along with writings about art appreciation, the content of his writings could be divided into the following aspects:

1. Huang paid attention to how the national power looked after both the promotion of art and culture as well as the space for the free development of art, how cultural policy coped with the changing waves and thoughts, how the government incorporated the construction of arts environment into legal policy so as to facilitate co-prosperous development of cultural facilities and cultural enterprises, while recording his analyses and comments on the approaches adopted in the United States as well as the institutional characteristics and operation points of the highest governmental agencies responsible for cultural and art agencies in different countries.

2. He analyzed the importance of artistic creativity in terms of constructing the national cultural image and highlighting the recognizability of cultural features. He asserted that "cultural industry" was the indispensable public affair for boosting the economy, and introduce other countries' corresponding policies and developmental goals, using Japan, Korea, France and the United States as examples.

3. He reflected on the international examples of preserving and revitalizing cultural heritage to break through the old ruts of "formalization" and move towards the "living existence." He also introduced the ideas and plans of other countries in terms of continuing the legacies of folk art and the continuation and preservation of folk craft.

4. He observed and commented on the importance of "public art" in relation to shaping the cityscape and forging citizens' shared sentiments, while introducing relevant cases of promoting public art by the local governments in the United States.

5. He introduced the education of art administration in the United States, and pointed out that the ideas, techniques, and talent of art administration in Taiwan would be the key to the future development of cultural affairs. In this regard, the lack of professional art administrative personnel was an imminent problem that needed to be addressed.

6. He introduced the U.S. Government's goals, attempts, and claims in relation to fundamental art education, and the method of including art museums, museums, theaters, art centers, art festivals, public television programs, non-profit cultural and educational organizations in the private sector as part of artistic experiences and promotional resources.

5 Huang, Tsai-Lang. "Striving for Building an Ideal Environment for Artistic Creation," p. 9

7. Many of his articles were his observations of and comments on the operation of art museums, which included various topics: the public cultural interest of art donation; the effect of attending exhibition previews; the situation-oriented approach to exhibition production at art museums; the encouragement to local art development by establishing galleries for citizens at art museums; and the effectiveness and persuasiveness of different curatorial perspectives and organizational structures on cross-cultural exchange.

8. He elaborated on the benefit and influence of local government-funded art exhibitions in terms of boosting the creative atmosphere, and hoped to reflect the changes of social situations and the structure of the painting circle through new forms of operation

These writings have gathered Huang's professional knowledge accumulated over many years, the essential spirit of his work and practical experience, examples of other countries studied during official visits; and the knowledge gained from his research project in the United States. After Huang resigned from his post at the CCA and briefly digressed from his career as a civil servant (1990-1991), he had worked for Legislator Chen Kuei-Miao (陳癸淼), assisting him in the making of cultural laws. Huang was the key figure in drafting the part of "One Percent for Art" (one percent of the fundings for public construction projects should be used for the installation of public art) in the "Culture and Arts Reward Act" (文化藝術 獎助條例), which was built upon his extensive research into foreign public art policies and implementation methods, as well as his eagerness to help creators gain more opportunities for publishing their works or getting jobs through cultural policy.[6] On the other hand, Huang's broad attention to the issues of cultural development, as well as his macrocosmic and microcosmic care and vision for the art ecology were realized

through his ideas and practice related to the operation of art museums after he started working as an "art museum director."

Vision, Perspective, Strategy and Organization in Relation to the Operation of Art Museums

Huang Tsai-Lang's career as an art museum director spanned from the 1990s to the 2010s, during which Taiwan's art scene ushered in creative diversity and flourishing development, and the art ecology prospered with new talent and unending changes, while having to directly face the challenge of globalization. Huang's vision and perspectives in relation to art museum operation, as well as his strategies and organization of art administration could be observed from his several groundbreaking plans when he served as the inaugural director of the KMFA. Furthermore, during his directorship at the KMFA, the TFAM, and the NTMoFA respectively, the developments and characteristics of the three museums all demonstrated different emphases and achievements.

The KMFA is the third public art museum in Taiwan. When the KMFA was inaugurated in 1994, even though the TFAM and the then Taiwan Provincial Museum of Fine Arts (now NTMoFA) were already open for quite some years, Huang was still the first museum director who advocated the construction of "a museum of art history." Li Jiun-Shian (李俊賢) once commented that the style of the KMFA during Huang's directorship was expressed through regular exhibitions. Huang used "art history" as a point of reference and consideration.[7] Although these exhibitions did not show much connection in terms of art historical perspectives and historical knowledge, these different types of exhibitions themed on Taiwanese art were curated based on perspectives informed by art historical implications. Even the international exhibitions featured internationally celebrated masters that held a certain position in

6 Chen, Pi-Lin, and Chou Ya-Ching. "An Exploration of Taiwan's Public Art Policy Outside the Artworks." 2021. http://news.deoa.org.tw/index/contentpage?id=249 (viewed on 2023.06.10).

7 Li, Jiun-Shian. "The Kaohsiung Museum of Fine Arts after Huang Tsai-Lang's Directorship – A Decade-long Observation of the KMFA." *Artco Monthly*, no. 132 (2003.9), p. 142.

Western art history. The various exhibitions presented during his term as the director had all garnered a large audience in southern Taiwan. These exhibitions included *Retrospective Exhibition of Painting Development in Taiwan 1739~1980* (1994) that demonstrated the general development of Taiwanese art; *Great National Treasures of China: A Special Exhibition on Loan from the National Palace Museum* (1994), which was the first time that exhibits from the National Palace Museum were shown in the south; and *L'Age d'Or de l'Impressionnisme* (1997) that showcased sixty Impressionist masterpieces in the collection of the Musée d'Orsay. In fairness, Huang's belief and persistence in the idea of "the museum of art history" were fully put into practice in his eighteen-year-long career as an art museum director, during which he continued the construction of Taiwanese art history through exhibitions (a point that will be discussed in the next section), and consistently asserted the importance of permanent exhibitions of museum collections as validated by his words below:

The style of an art museum is embodied by its collection.... As time changes, the idea of collection has evolved from "conservation" to "display," and from "research" to "education," whereas the artworks in a collection have also acquired a different identity and value. Museum staff should get rid of their administrative ideas and professional value judgment, allowing artworks to reveal their own meanings. So, the permanent display of artworks in the museum collection without imposing any character and value judgment provides the general public, scholars and experts a more expansive space of appreciation and research.

Huang Tsai-Lang.[8]

At the KMFA, Huang founded the galleries for the long-term display of calligraphies and sculptures. At the TFAM, he planned exhibitions featuring highlights from the museum collections and thematic exhibitions that were on view for nearly one year long. At the NTMoFA, he led and planned the exhibition projects that truly demonstrated the qualities of permanent exhibitions, including *Unique Vision: Highlights from the National Taiwan Museum of Fine Arts Collection* (2011-2017) and *Unique Vision II: Highlights from the National Taiwan Museum of Fine Arts Collection* (2012-2017). These exhibitions all shared certain commonalities: apart from showing the respective features of the three museums and sharing valuable national and social cultural assets with the public, they all demonstrated an intention to present the developmental context and creative expression of Taiwanese art, as well as showcased the artworks as "unique" existence so that audiences and researchers from Taiwan and abroad could freely appreciate them. Huang's attention to artworks in museum collections was also shown in building collection-related systems. When he assumed the post of the TFAM director (2000), he launched a series of bold and decisive actions as regard to the inspection of the museum collection, including acquisition registration, artwork status, artwork content, etc., comprehensively inspecting and mending the information of artworks. Subsequently, he focused on making or revising administrative regulations and rules regarding the storage of artworks, the management of the vault and the collection, the loaning of artworks and artwork images, etc. These endeavors in gaining comprehensive knowledge of the status and quality of the museum collection and enhancing the efficiency of managing artworks were also carried over into his directorship at the NTMoFA, during which one of the vital tasks was the six-year "Collection Inspection Plan" launched in 2010.

To Huang, art museums shoulder the mission of social education. Comparing to school education, art museum education emphasizes on the "experience" of direct perception and realization, the "freedom" and "diversity" of free

8 Huang, Tsai-Liang. "Public Sector Culture and Professional Direction in Art Museums." *Modern Art*, no. 93 (2000), pp. 3-4.

association through visual experience, and the "lifelong" education suitable and available for all ages and people from different background. During his initial period at the KMFA, he planned the "Art Resource Classroom," the first of its kind in the entire nation, which aimed to create a "dynamic" learning environment so that people could directly participate, touch, create, and seek fun in the environment. The KMFA's "Art Resource Classroom" was inaugurated in May 1997, and began opening to the public regularly from the December of 1998 onward.[9] The "Art Resource Classroom" at the TFAM was founded in the September of 2002, after Huang assumed the director, which mainly worked in tandem with the museum exhibitions through the design of experience-based situations to be used by student groups from elementary and junior high schools and parent-child audiences.[10] Furthermore, Huang was also the only director who has ever presented a series of planned and organized education exhibitions in Taiwan's museum system: from 2001 to 2004, he introduced four exhibitions created by the Children's Workshop at the Centre Pompidou in Paris. These exhibitions were *L'oiseau Cache dans la Pierre – Un espace-jeu autour de l'oeuvre de Brancusi* (The Bird Hidden in the Stone – A play space based on the works of Brancusi; 2001), *11 Beds- Alike/Unalike* (2002), *Travel Around a City* (2003), and *Matisse/Picasso Discovery Workshop* (2004). After absorbing the experiences of these examples, in 2005, he invited Taiwanese artists to join the exhibitions, and presented *Lots o'LOTTO: Visible and Invisible* curated based on the idea of "education for art" (educational analysis for artistic purposes), and *Ink Painting*

Dreamland with a curatorial emphasis on the idea of "art for education" (planning the exhibition with children as the user).[11] The two highly educational exhibitions produced a lively and intriguing environment that facilitated "direct learning" and "personal experience," in which audiences could experience the artists' creativity through playing with art – an approach adopted to nurture the target audience's perceptual ability of art.

To encourage local creative atmosphere and nurture young artists was a lasting goal during Huang's career in the public sector. When he was working at the CCA, he led the promotion and implementation of policy regarding "local art exhibitions" since 1983. The policy not only offered Taiwanese artists and art groups more exhibition opportunities, but also emphasized on the locally organized exhibitions, which both produced the effect of gathering local art achievements and timely strengthened the increasingly forgotten, even disappearing, developmental trajectories of art, giving younger local artists a more confident foothold in their subsequent endeavors.[12] When Huang was at the KMFA, he founded the "Forum for Creativity in Art" and "The Gallery for Citizens" series. The former aimed to discover excellent art creators and offered them an opportunity for publishing experimental works. The latter comprised exhibitions of Kaohsiung-based artists and teased out the materials of local artists' careers. Moreover, Huang reformed the Kaohsiung City Art Exhibition into the Kaohsiung Prize and Kaohsiung Fine Arts Exhibition, and pioneered in the scene of government-sponsored, competition-based exhibitions by canceling categories of media in secondary review.[13] After he assumed the post of the TFAM director, Huang renamed the

9 Huang, Tsai-Lang. "A Case Study of the Art Resource Classroom at the Kaohsiung Museum of Fine Arts." *Artist*, no. 289 (1999), pp. 350-51.

10 Huang, Tsai-Lang. "Art Experience Corner at the Taipei Fine Arts Museum." *Play with Art: 2003 International Symposium on Art Museum Education*. Taipei: Taipei Fine Arts Museum, 2003, pp. 83-4.

11 Huang, Tsai-Lang. "Education for Art, and Art for Education." *Stride into Art - the Collaboration Between Artists and Museum Educations: International Symposium on Art Museum Education 2005*. Taipei: Taipei Fine Arts Museum, 2005, p. 32.

12 Huang, Tsai-Lang. "Expecting the Prosperity of Local Art History–Developing Cultural Confidence by Valuing County and City Art Exhibitions." *Union Daily News* (1988.10.29), p. 5.

13 "Former Directors," Kaohsiung Museum of Fine Arts. https://www.kmfa.gov.tw/AboutUs/AboutKmfa/planning/history.htm (viewed on 2023.3.31).

Taipei Award into the Taipei Art Awards in 2002, changing the competition into an uncategorized competition without limiting the dimensions of artworks, while raising the prize money of the first prize so that young artists could win the prize money with their artistic creativity and have a chance to exhibit in the museum. In addition, the TFAM also launched a program of application exhibitions for young artists, and the artworks of emerging artists showcased in the exhibitions would be acquired and included into the museum collection. When Huang was appointed the director of the Third Department of the CCA, he planned the "Made In Taiwan" section in Art Taipei 2008 as a way to enter young artists in the art market so that they could gain the attention of the gallery industry and the circle of collectors. During his term at the NTMoFA, he launched an open call and an exhibition program in 2011: the "Digital Art Curatorial Project" and the "Digital Art Creation Project," both of which were competition-based and aimed to provide outstanding Taiwanese new media artists the resources and a platform for presenting their works. Huang also followed the policy of the Ministry of Culture to promote and establish Taiwan's first "Art Bank" in 2013, which has encouraged artistic creation and supported artists financially through acquiring their works. In turn, these artworks can be rented to private corporations and organizations as a way to foster their support for art. Meanwhile, the approach also offers the audience a bigger chance to approach and appreciate art in public places.

Constructing the Horizons of Taiwanese Art History

The organization and construction of Taiwanese art history was a goal that Huang strove to achieve "with his utmost effort" during his civil career. From working as the chief of the CCA's Fine Arts Section to serving as the director of different art museums, Huang consistently viewed organizing and teasing out Taiwanese art history and presenting the results

of artistic development in a systematic manner as a major task. Additionally, he was able to consider and present Taiwanese art in structural yet dissimilar ways when he worked at different posts in various periods.

Huang started working at the CCA in 1981. Back then, Taiwan had not yet entered "the era of art museums." With the support of Dr. Chen Chi-Lu (陳奇祿), who was the chairman of the CCA at the time, he facilitated and coordinated several government-sponsored art exhibitions, which displayed an analytical and research-based tendency, respective historical context, and thematic perspectives, forming the precedence of the public sector's taking the lead in organizing exhibitions of "Taiwanese art" infused with the consciousness of art history. For instance, *Exhibition of Periodic Works* (1982) was the precedent of a government-sponsored thematic exhibition focusing on the developmental trajectories of Taiwanese art. The exhibition invited ninety-seven artists to respectively propose artworks from three periods, namely, prior to 1951, from 1952 to 1966, and after 1967, to illustrate the decades-long development of Taiwanese art with examples. *Paintings and Calligraphic Works in Taiwan during the Ming-Ch'ing Period* (1983) was based on a large-scale survey that took about one year and nine months. An impressive total of 738 pieces of artworks were loaned from the public and private sectors (among which 214 pieces were on view in the exhibition). Artists of these artworks included local calligraphers and painters from Taiwan before 1879, as well as calligraphers and painters from mainland China, who lectured or traveled in Taiwan.[14] Overall, the exhibition presented a general survey of traditional Chinese calligraphy and painting in Taiwan over the course of more than three centuries. The exhibition not simply displayed an intent to gather and compile the historical materials related to the development of traditional calligraphy and painting in Taiwan, but was also a programmatic project to sort out local cultural history. In 1984,

14 Huang, Tsai-Lang. "Performance Report." *Paintings and Calligraphic Works in Taiwan during the Ming-Ch'ing Period.* (Taipei: Council of Cultural Affairs, Executive Yuan, 1984), p. 462.

Huang led the organization of a more ambitious exhibition project of an even larger scale – *Art Development in Taiwan - A Retrospective Exhibition in Four Parts*. The exhibition conducted the construction and exploration of Taiwanese art history in four sub-themes: "The Continuation of Traditional Calligraphy and Painting" (1661-1971), "The Genesis of the New Art Movement" (1896-1945), "The Emergence of Painting Groups" (1924-1961), and "The Development of Early Modern Art" (1945-1971).

After Huang became the KMFA director, he continued his experiences and ideas of organizing exhibitions themed on "Taiwanese art" at the CCA, and founded two long-term thematic galleries at the museum, namely, "The Beauty of Calligraphy" and "Modern Sculpture Development in Taiwan – Exhibition of Museum Collection," to portray the general historical context of calligraphy and sculpture with highlights from the KMFA collection. At the same time, he also presented various exhibitions successively to review and tease out the beginning of and changes in the development of Taiwanese art, including *Retrospective Exhibition of the Painting Development in Taiwan 1739-1980* (1994*), Taiwan – Fifty Years After World War II, A Fact-recorded Photography Exhibition* (1995*), When East Meets West: Impressionism in Taiwan* (1997), and *Calligraphy in Taiwan (1645-1945)* (1998).

During his directorship at the TFAM, Huang's will to construct Taiwanese art history was embodied by the annual exhibition series – *Highlights from the Permanent Collection* (2001 to 2007), in which the order of the displayed works outlined the general development of Taiwanese art and its creative diversity. The most important achievement was *Art Development in Taiwan - A Retrospective Exhibition in Five Parts* (2003-2004), which was a series of exhibitions planned

by Huang to concentrate on organizing and studying the post-war development of Taiwanese art. With a ten-year interval, the exhibition series successively presented five research-based exhibitions featuring the developments from the 1950s to the 1990s, and comprised the following exhibitions: *From the Ground Up – Art in Taiwan 1950-1959* (2003), *The Experimental Sixties: Avant-Garde Art in Taiwan* (2003), *Reflections of the Seventies: Taiwan Explores Its Own Reality* (2004), *The Transitional Eighties - Taiwan's Art Breaks New Ground* (2004), and *The Multiform Nineties: Taiwan's Art Branches Out* (2004). The exhibition series was the TFAM's first systematic and project-oriented curatorial endeavor since inauguration, which traced and explored the development of Taiwanese art. In addition, based on the research results of these exhibitions, the museum also made targeted acquisitions to include numerous important works informed rich in historical and contextual meanings into the museum's collection.

During his directorship at the NTMoFA, Huang led and organized various thematic exhibitions, such as *Scenery and Vistas of Taiwan through the Eyes of Artists: A Century of Taiwanese Landscape and Scenic Art* (2011), *The Modernist Wave – Taiwan Art in the 1950s and 1960s* (2011), *In Sight: Tracing the Photography Studio Images of the Japanese Period in Taiwan* (2010), and *The Era Seen: The Pursuit of Images During the Days of the Photo Club 1940s-1970s* (2014). The next year after Huang took office (2010), as the head of the exhibition project, he encouraged the museum staff to conduct curatorial research on different generations of artists. The preparation of the exhibition project took two and a half years and eleven work meetings, and underwent an extensive process of discussion, research and preparation to gradually determine the curatorial concept, a rudimentary model, the direction of selecting artists, and the preliminary list of artists.[15] Finally,

15 With Huang's effort and facilitation, eleven curatorial work meetings were convened for the exhibition series from January 25, 2010 to July 30, 2012. For the points of discussion in these meetings, see Tsai Chao-Yi, "Difference, Diversity and Varied Historical Contexts: Reconsidering the Selection Criteria of 'The Pioneers of Taiwanese Artist' Series." *Collected Papers of the Forum on "The Pioneers" of Taiwanese Artists*. (Taichung: National Taiwan Museum of Fine Arts, 2015), pp. 41-68.

artists born between 1931 and 1980 were selected as the subject, and were divided according to "generation" based on a ten-year interval customarily used in Taiwan to present the exhibition series, titled *The Pioneers of Taiwanese Artists* – a five-part, research-based exhibition series featuring various generations of artists. The five exhibitions were *The Pioneers of Taiwanese Artist, 1931-1940* (2013), *The Pioneers of Taiwanese Artist, 1941-1950* (2013), *The Pioneers of Taiwanese Artist, 1951-1960* (2014), *The Pioneers of Taiwanese Artist, 1961-1970* (2014), and *The Pioneers of Taiwanese Artist, 1971-1980* (2014-5). As an exhibition series, *The Pioneers of Taiwanese Artists* broke through past art history-based curatorial models, and sought out atypical artists whose creations and aesthetics unfolded unique differences outside the common framework of "mainstream art."

Huang's vision in structuring the exhibitions of Taiwanese art history could be viewed as an epitome of the art history written by the official system. Reviewing the exhibitions facilitated and organized by him throughout his career as a civil servant, three important threads of art historical research could be detected: 1. Periodic organization based on the chronological timeline; 2. Structuring based on mainstream thinking waves or creative style of specific periods; 3. Genres divided based on form and medium. Huang paid close attention to topics related to generation, periodization, and individual style in the research of art history. In the large-scale projects or exhibition series led and organized by him, the "style of Huang Tsai-Lang" was vividly embodied by his construction of exhibition style, the design of organizational form, and the thorough planning of survey coordinates. Such an exhibition methodology that emphasized on organizational logic and operative models was fully realized in the five retrospectives of art history based on a generation of ten years during his directorship at the TFAM as well as the five-part exhibition series of *The Pioneers of Taiwanese Artist* at the NTMoFA. Correspondingly, these two exhibition series

also manifested his persistent endeavor to surpass existing research paradigms in the field of art history during his office as the director of both museums. Using exhibition as the method, Huang aimed at more flexible and nimble approaches to the concept of periodization or typology, injecting a fresh energy into the reading and dialectics of Taiwanese art.

Conclusion: A Consistently Sincere Art Worker

Throughout his more than thirty years of career as an art administrator in the public sector, Huang never forgot his original intention of "**being a professional worker**." Whereas being the bridge between the art circle and the public sector was his starting point, to build an ideal creative environment and facilitate the development of Taiwanese art was the ideal to which he fully dedicated himself. To Huang, art administration was a "creative" work.[16] He pursued creative insights into art administration in relation to policy and system, utilizing innovative operative models to reflect the vicissitudes of contemporary society as well as the Taiwanese and international art scenes so as to comprehensively implement and operate these innovative plans to achieve the contributions most beneficial to the art environment. He expected himself to be a sincere art worker, and always adhered to his original aspiration and remained earnest in his steadfast practice, while pursuing professionalism and quality of work. After he gave all he could, he then let the concrete results to validate his work. Throughout his career in the public sector, he was driven by his passion to realize his ideals. His persistence and results have far exceeded our imagination and definition of art administration; and his conduct and accomplishments will continue to be a guiding force and exemplar for those who aspire after a career in art administration.

16 Huang, Tsai-Lang. "Public Sector Culture and Professional Direction in Art Museums," p. 3.

卸甲歸田風華顯，光透晶鑽七彩耀：黃才郎的繪畫面向

姚瑞中
| 國立臺灣師範大學美術系兼任教授

某年某月某日赴北美館評審，中午休息時與黃才郎館長閒談，聊及許多館長年少習畫回憶，高二時進入郭柏川畫室學習，考上文化大學美術系後獲陳銀輝、陳景容、周月坡、施翠峰、楊乾鐘、沈以正、莊尚嚴等名家指導，經系主任施翠峰推薦進入英文中國郵報《美術雜誌》，擔任美術文稿編輯與策劃，開始撰寫西洋美術專欄介紹世界名作（自 1971 年 10 月至 1973 年 7 月，共主筆 22 期），為當時封閉的臺灣藝術界打開了一扇通往西方藝術世界的門扉，並受教於廖繼春、李梅樹、楊三郎、林克恭、吳承硯、黃朝謨、郭柏川等老師，對於臺灣近、現代藝術頗有接觸與理解。

退伍後自 1975 年起擔任世界紅卍字會臺灣省分會附設慈幼幼稚園美術教師四年，因緣巧合教到對繪畫非常感興趣的我（當時六歲），在此四年教職生活穩定，遂與王蕙芳女士成婚並孕育千金黃之千，之後與師母共同創辦「一代兒童美術教室」，致力於兒童美術教育推廣，更得貴子黃茂嘉，同時擔任私立延平中學、私立長青幼稚園、雄獅兒童畫班美術教師。黃館長對兒童美術教育頗為重視，認為美感教育重在啟發想像力、創造力並從生活性出發，而非升學主義下的填鴨式齊頭平等教育，藝術教育貴在啟發天賦、開拓想像力與原創性，但當時缺乏全面性引介西方美術的客觀工具書，因深感坊間許多錯誤資訊，遂延續 1974 年與作家劉延湘小姐合譯的《西洋美術辭典》A、B 兩大字母段落，在 1980 年擔任雄獅美術叢書部主編時協同編輯何傳馨、李梅齡、沈德傳、李伊文、王效祖等人費時兩年餘，編纂完成《西洋美術辭典》，統一專有名詞、藝術家、流派、技法……等譯名，成為當時華語地區通用標準，對學術研究、期刊、論文……等文獻資料，翻譯群貢獻厥偉，更榮獲 1982 年新聞局頒給圖書金鼎獎，想當年在下畢業論文也參考過這本影響甚鉅的工具書。

1981 年行政院文化建設委員會初創（2012 年升格為文化部），黃老師應當時第三處（藝術處）處長申學庸之邀擔任美術科首位科長（1982~1989），這個突如其來的人生重大決定遂成為其生涯分水嶺，暫時無暇分身創作，深知臺灣藝文環境須要專業團隊全力灌溉耕耘，在首任陳主委奇祿先生大力支持下，遂積極推動許多前瞻性與影響深遠之政策。1990 年辭卸文建會職務，為推動「文化藝術獎助條例」公共藝術「1% For Art」法案，而進入立法委員陳癸淼辦公室擔任文化立法助理（1990~1991），撰寫法案條例至立法通過，此案影響臺灣公共藝術生態甚為深遠，造福許多藝術家、策展人並促進相關藝文產業蓬勃發展，90 年代起擔任高雄市立美術館首任館長，1999 年臺北市文化局成立，接受邀任文化局副局長一職，2000 年至 2007 年擔任臺北市立美術館（兼代台北當代藝術館）館長、2009 年起擔任國立臺灣美術館館長，成績斐然。2015 年在藝術界依依不捨下，於臺北國際藝術村舉辦屆齡退休歡送會，回顧其藝術行政經歷與成就，既是前無古人、應也後無來者了。

黃館長大半輩子都在耕耘臺灣本土藝文環境並推動臺灣當代藝術的國際能見度，當 2023 年初春收到「纏綿」個展邀請卡之際，很難想像老師在公務如此繁重之下還能默默耕耘畫作。直到前往國父紀念館參觀由曲德義老師擔任召集人、劉永仁策劃的「纏綿」個展，才發現個展規模宏大、結構齊全，從長期發展的不同系列當中，凡對藝術略有認識者皆能感受其深情執著，每件畫作就像一封封情書與手札，訴說內心對家庭、生活乃至土地、自然的各種天真爛漫情懷，雖近期罹患帕金森症之苦仍鍾情繪畫創作，在與疾病共存中甘之如飴，日復一日試圖從生活周遭不甚起眼的平凡事物，表現臺灣豐富人文

風土之美，一筆一劃戰競爬梳、經營畫面誠懇實在，創作態度與風範令後輩難望其項背，仔細觀展後略從七個面相切入賞析：

一、好風光

1971 年十月二十五日根據「2758 號決議」中華民國退出聯合國那年，在黃館長完成生平第一幅〈佳里教堂〉油畫之前，高中於長榮校內古蹟寫生加上赴陳基隆老師闢設的美術教室自習以及郭柏川畫室習畫基礎，因此信手捻來並不生澀，大筆揮灑相當寫意。考上文大時臺灣正好失去國際認同，國民政府維護中華正統核心價值觀開始動搖，大學生紛紛下鄉向陌生鄉土與常民文化學習，許多文人雅士轉向古蹟、廟宇或教堂這類建築景觀進行考察研究，深入民間祭儀、常民生活與原住民部落，導致許多素人創作者陸續被挖掘，臺南南鯤鯓出身乩童的洪通便是代表之一，明亮鮮豔的熱帶島嶼與樸素庶民情懷，給當時被三民主義、反攻大陸、解救同胞政策所洗腦的文青們醍醐灌頂，打開了探索臺灣美學的可能性，打破教條、走出畫室、融入社會底層成為當時覺青的摸索方向，因此深具表現張力的〈佳里教堂〉出現並非偶然。

同時期紅瓦綠屋的〈三峽〉（1971）傳統民厝或是描寫夜晚暗巷的〈臺南天后宮小巷夜景〉、斑剝質感的〈迪化街老牆〉（1972）、用色強烈的〈臺南孔廟大成殿〉（1971），皆可看出受到色彩對比濃烈的「野獸派」與揮灑主觀情緒的「表現主義」影響，畫面構圖採取幾何分割配置，厚重油彩堆疊、色彩豔麗鮮明，大量使用互補色在視網膜產生強烈對比躍動，刮擦厚實油彩質感與觸感別具一格，此類關注鄉土傳統建物的表現性繪畫手法，已與當時學院主流傳統寫實主義分道揚鑣，走向更

具情感性、在地性與樸實性的嘗試。

1980 年國民政府秘密在蘭嶼龍頭岩建立了核廢料處儲存場前，早年蘭嶼六個部落民風純樸，達悟族大船祭或飛魚祭皆保留古法儀式，1972 年七月與洪瑞麟、張萬傳、陳景容、汪壽寧、周月坡、黃昌惠老師前往臺東與蘭嶼進行考察與寫生時，受到原住民文化震撼與感召，以粉彩畫紙完成了〈蘭嶼黃昏的軍艦島〉（1972）、〈蘭嶼寫生〉（1972）等畫作，同時也拍製了 8 釐米電影，從畫面中可以感受到青澀筆觸背後是一雙探索生命力的明眸，寫生也成為日後主要創作方法，不但能體驗陽光、雲朵、溫度、陰影、風速、鹽味⋯⋯等各種環境自然變化，身體毛孔流出的汗水、瞳孔縮放、皮膚灼熱、海風輕拂⋯⋯這些細微巧妙的時刻變異與大自然合一的沈浸式體驗，非蹲在畫室描繪模特兒或靜物所能比擬。

1973 年西畫組畢業後旋即入伍於臺南營區並結識潘元石，放假之餘常借用其版畫工作室創作，服役期間擔任助理情報官兼任美工官，曾因準備陸光美展參賽留營守崗時到靶場作畫，渡過八個禁足時光畫下了〈成功嶺靶場〉（1973）與〈成功嶺〉（1974）。當年政局動盪不安，中華民國退出聯合國後慘遭友邦雪崩式斷交，人心惶惶、政局艱難，對岸仍處十年文化大革命後期，國民黨 1966 年成立中華文化復興運動推行委員會的「新生活運動」政策方興未艾，軍中雖然枕戈待旦、反攻大陸氣氛濃厚，但畫中的成功嶺卻灑滿日光、生氣勃勃，絲毫感受不到二岸軍事角力肅殺氣息。反倒是〈深夜的吳興街巷口〉（1974）似乎隱含著更多不安氣息，畫面中央透視點帶領觀者視野進入幽暗畫面深處，當時吳興街在臺北市算邊陲區域、靠近四獸山腳且多為農田、附近還有兵工廠重兵駐守，入夜頗為蕭瑟，隱約表現出當時社會高壓統治下的低迷氛圍。

1987年七月十五日解嚴前應「美國在臺協會」邀請,前往美國考察訪問美國藝術行政一個月,這趟西方取經之旅反思了臺灣文化政策之不足,隨著政治巨人蔣經國於1988年元月十三日去逝,政治上掀起明爭暗奪的權力鬥爭,副總統李登輝在暗潮洶湧中登上總統寶座,臺灣一躍成為亞洲經濟四小龍。此時應美國傅爾布萊特學者訪問計畫邀請赴美十個月,研究文化行政及公共藝術,出國考察期間深深被國外良好創作環境打動,此行對後來制定影響臺灣藝文環境重大的公共藝術政策提供良善參考模式,參訪之餘也抽空完成一些小品,例如〈華盛頓特區〉(1988),或是擔任高美館館長時完成的〈彩虹—雨後高美館〉(1995),這件畫作以金箔替代水波,黑色荷花池畔嶄新高美館升起七彩彩虹,象徵南臺灣邁入美術館時代新里程碑。

一轉眼二十年過去,2015年自國美館退休後常在自家附近寫生,維持公職期間有空便勤於寫生的習慣,例如〈蘆葦〉(2000)即描繪陽明山上蘆葦因其象徵樸實無華、堅韌不拔與安忍品格,能在乾旱土壤頑強生長,看似隨風搖曳卻又借力使力,不卑不亢,任憑風吹雨打最終仍挺直腰,整片山頭白色芒花盛開如雪片紛飛頗有詩意,也間接隱喻只要能長期堅持下去,在臺灣貧乏藝文環境下仍可遍地開花,出人頭地。

二、靜謐物

靜物畫乃中西藝術史重要題材之一,從古典到當代皆被藝術家視為創作根本基礎,除了鮮嫩果實體現生活感之外,更有許多複雜含義,甚至成為藝術觀念的主要基石,例如法國印象派大師塞尚的靜物畫將水果視為立體幾何結構與多視點啟發了立體派與抽象主義,或是德國觀念藝術大師波伊斯用水果結合燈泡的「現成物」,皆可見

識到水果靜物的深刻影響。黃館長長期以來創作的靜物數量相當多元,僅以靜物畫視之略顯不足,因其色彩大多呈現某種黑白神秘而靜謐的侘寂狀態,故在此稱為「靜謐物」。

臺灣民間習慣將橘、芒、瓜、果奉為供奉神桌之蔬果以表奉齋虔誠,然西方自文藝復興乃至古典主義以來,對靜物畫另有一套觀點,即對上天給予生命養分充滿讚嘆之心。而近代幾波藝術運動,無論是印象派、晚期印象派、立體主義、未來主義、超現實主義……皆從靜物當中延伸出眾多流派,這幾波運動自歐洲帝國主義東傳日本,再輾轉傳入臺灣與南洋,明治維新全盤西化政策透過日治時期教育與競賽制度,對臺灣當時美術界影響甚鉅。1949年國民政府來臺後因大時代環境驟變,西洋畫更名為「西畫」,水墨畫更名為「國畫」,東洋畫也改名為「膠彩畫」,可以嗅出濃厚國族情結。

由於50年代白色恐怖主義盛行,加上60、70年代因政治戒嚴諸多禁忌,藝術家對敏感議題仍有所顧慮,雖然少部分藝術創作者嘗試挑戰傳統與保守勢力,例如黃華成發表於1966年的「大台北畫派宣言」,但保守環境對創新者並不友善,美術系畢業後不是組織畫會互相取暖或開設畫室勉力餬口,便是離鄉背井出國發展,不然就是進入教育體制謀取安定教職,能靠藝術市場維生可謂鳳毛麟角、萬中選一,與現今藝文環境相比不可同日而語。有才華者若無法改變原本體制,有背景、財力者可選擇放棄不知未來在哪裡的臺灣,前往歐美已建構良善的藝文環境發展;若有機會能改變在地藝文體制,那是相當吃苦不討好且辛苦緩慢的文化工程,在黨國保守勢力控制下,不但要懂得官場文化,應對進退更需得宜,如風中小草在惡劣氣候下破土而出,從創辦兒童美術班到進入文建會而放棄專職個人創作,這種悲壯情懷在

1972 年帶有骷顱頭的〈靜物〉似乎已可嗅出端倪，無非就是基於愛鄉愛土的決心吧！

歷經政治解嚴、經濟起飛的 80 年代，90 年代初股市破萬點，臺灣錢淹腳目，大家樂與地下賭盤興盛，社會百花齊放、群魔亂舞，初一、十五商家拜土地公迎財神，民間一片欣欣向榮，廟宇供桌堆滿供品，遂興起將這些所謂好彩頭的「幸運物」入畫的念頭，挑選帶有吉祥表徵的水果作為描繪對象，橘子是民間普遍約定成俗的如意供果，臺灣民間常以臺語「五橘」（有錢）諧音代表財運，在〈橘子系列－百吉〉（1992）中的畫面部署與一般靜物畫不太一樣，中間六顆橘子只有一顆是橘色、其餘五顆為黑白，四周看似花布實乃許多橘子的黑白殘影，產生時間流動性效果頗奈人尋味。而其它許多入畫水果皆具本土特色，例如〈大頭菜〉（1996）往往被視為平安與幸運象徵，金黃色的〈芒果〉（1994）代表感情專一，〈南瓜〉（1995）因其多籽，諧音有多子多福之意，畫面背景有時會以交錯線條構成平面空間景深，有時會用半透明油彩層層疊染產生空氣透視感，端視當時感受與畫面需求而定。

進入 2000 年後繪製的一批水果靜物如〈橘子系列〉（2002），開始以水墨常用的朱標、墨、金箔、畫仙板進行混合技法實驗，至於〈綠色的橘子〉（2009）就跟早期繪製水果不太一樣，已非純粹只是靜物或蔬果而已，在意義與結構上有較多言外之意，例如〈紅漆盤上的橘子〉（2018）看似靜物，實則探討鏡像與疊影的空間錯置關係，宛若攝影的重複曝光效果，背景花布看似圖案，實際上隱喻了時間與空間疊合所產生的重量感，上方往往密集、漸次往下稀疏甚至索性留白，這在一般靜物畫中並不常見，所挑選果菜皆暗藏民間俚語或雙關語含義，在色彩搭配上早期色彩較為鮮明，多有吉祥如

意好彩頭的喜氣，近期畫作偏向黑白與彩色共構畫面，有時數粒果實可能只有少數為彩色且數量不一，畫面下方留白淡出或敷以金箔，這種看似未完成之感並非時間不夠無力繪製，而是畫面有些緊實、有些鬆散、有些瀟灑、有些隱晦，在虛實動靜之間產生了某種不可言說的禪意。

三、花兒香

花卉乃文人雅士寄情寓意之物，黃館長早期有許多在畫室完成的系列畫作，例如〈纏綿系列－黃金葛（四）〉（1989）便是其中佳作，花草輪廓筆觸蒼勁宛若書法，中央三朵葉子以暗綠色敷彩、往四周淡出，綠葉成叢集聚，葉片方向性變化豐富，抒情中帶有微風吹動態勢，試圖描繪野生之物乃最具競爭力與生命力的象徵意義，這種臺灣民間常見的裝飾用植物，因為具備常綠狀態也經常用來作為招財、化煞的風水作用，畫面背景筆觸瀟灑自在，平淡中有著昂然生長氣宇，似乎飄蕩著陣陣撲鼻香氣，無怪乎作為個展主視覺圖像最為纏綿。

「百合花系列」中的〈姬百合〉（1991）原產荷蘭但屬於「亞洲型百合」，花朵數量多、聚集在花莖頂端向四面綻放，以黃、橘色為主，花瓣偶有褐色斑點，表面上有百年好合、美好家庭、偉大愛意、深切祝福之含義，就當時大環境來看，1990 年三月的「野百合學運」剛過不久，臺灣主體意識抬頭，無論是文化界乃至於美術界都開始反省根植於臺灣的精神與價值是什麼？1991 年四月，當時尚未擔任國美館館長的倪再沁，發表於雄獅美術雜誌的一篇「西方美術・臺灣製造－臺灣現、當代美術的批判」掀起驚濤駭浪，一時檢討臺灣藝術界西方化、現代化乃至現代主義的「本土化論戰」開展，野百合遂成為代表本土文化的象徵物。雖然黃館長表示，純

粹只想傳達野百合象徵臺灣寶島之美，這也是當年西班牙船隻經過基隆、在海上看到遍地野百合高喊福爾摩沙的第一印象，但放眼任內積極推動的本土文化政策與法案，自然有其象徵意義，那就是再美麗珍貴的事物若無法從自身土地上開出燦爛花朵，那一切也不過是外來的舶來品或不切實際故國鄉愁罷了。

除了以筆作畫之外，黃館長自 1995 起開始運用金箔入畫，金箔除了用於神聖空間（廟宇、教堂、祭壇……）的裝飾之外，也常被視為富貴華麗之象徵。一般來說，貼金箔前要先用筆繪上一層按金漆，有透明水膠或紅、黃色油膠的區別，等一段時間乾燥後再一張、一張慢慢以手指按到畫面膠膜黏貼，底漆厚薄決定金箔在畫面凹凸肌理與明暗折射效果，而每張金箔接面也故意不似日本「琳派」以大片金箔、大面積、水平垂直的裝飾性按金手法，相反地將金箔當作一種顏料概念使用，特別注重在油畫顏料上按上金箔所留下的「手勢」與「手感」，也就是製造一種金箔筆觸所產生的躍動，這種特別注重「動態」的手法在其他一些作品中也能見到。

〈纏綿系列－玫瑰〉（1998）畫幅下方常留白、四周以極薄油彩層層堆疊，放鬆淡出、中央暗黑如瞳孔般深邃，紅花青葉雖多有賦彩，黑白看似未完成，實則為黃館長特別喜歡黑色雋永魅力，以黑計白、以白當黑，墨分五彩，相當耐看。在象徵愛情的〈玫瑰花園〉（2022）一作中，紅玫瑰源自古希臘神話的美麗女神阿芙羅狄特（Aphrodite 也是羅馬神話裡的維納斯 Venus）為愛人流血的表徵，象徵熱情、永恆、美麗、愛情與渴望，以上所繪植物在臺灣民間都帶著正面幸福意涵，更象徵著好兆頭，逢年喜慶、居家饋贈二相宜，對於開幕式講究風水吉時乃不可或缺之良兆與祝福也。

水仙乃應景花卉，象徵友誼、幸福、吉祥，也是歲朝清供之佳品。此系列代表作〈水仙三聯屏〉（1998）以油彩加炭精筆畫在畫布上，天空貼上金箔，下方根部畫面多有留白，黃館長雖自述「上、下留白，可得恢宏氣概」，與畫面上方精細描寫的花朵對比之下，失根並非貪圖方便，似有更為深刻意涵，對於經歷「中西文化論戰」、「鄉土文學論戰」至「本土化論戰」洗禮，似更趨近「西方藝術、臺灣製造」所影射失去本土養份的藝文環境，間接暗示著唯有接地氣方能成大器，也是作為館長生涯的個人期許，即推動臺灣本土藝術乃當務之急。

雖然自然寫生比室內靜物更為變化難測，但黃館長特別鍾情此道，近期的「蘆葦系列」葉片方向性變化豐富蒼勁，宛如個人人生歷練寫照，黑白筆觸更具表現張力，莖乃中空，除了象徵文人自尊、堅韌不拔精神外也隱喻頑強生命力，在風中搖曳往往予人如夢似幻、隨順蒼涼之美感，扭動彎曲造型呈現某種「流體」韻律感，因此看不見的「風」才是蘆葦系列之創作核心，無論是夏季颱風、春季微風、秋季薰風乃至東北季風，蘆葦不因四季更迭而有所張揚或萎靡，仍平實搖曳、舒展如常，如大地肌膚吞納吐氣、柔軟卻頑強。而作為嘉南平原特產的甘蔗，更是讓黃館長一畫就是四十餘年，「甘蔗園系列」便是其中代表，這類臺灣佳里家鄉的經濟作物在其近期代表作〈甘蔗田〉（2022）中可見到，紅甘蔗乃歸寧吉祥物，不但象徵節節高升，更有甜甜蜜蜜、同甘共苦之意涵，畫中枝幹扭動、草葉亂舞，已將單純植物外型抽象化為宛若書法般蒼勁線條，烈日當空下的草根性是一片黃金土地，花兒香、水果甜，好一幅南國田園豐盛饗宴，充滿了對家鄉與土地的自信與情懷。

四、恨纏綿

就讀文大美術系期間，系上除了描繪石膏像、靜物之外也會安排模特兒練習人體結構，其中最刺激的莫過於直面女性裸體模特兒了，在當時拘謹保守的冷戰時代，美術系裸體寫生課程是令其他科系男同學甚為羨慕與神秘的一堂課，同學們目不轉睛地看著近在咫尺的裸體女模，有的坐著、有些躺著、也有站著的，教室內鴉雀無聲，只聽見沒有停歇的筆刷聲與急促呼吸聲，同學們害羞地看著陌生人的裸體細節，發現東方人比例與西方石膏像的天差地別，甚至開始懷疑老是畫高鼻大眼、肌肉噴張、五官深邃的勞孔或大衛，真的符合在地美學嗎？

在〈裸女〉（1972）畫作中躺臥女姓完全就是東方臉孔與身材，雖然擺設手法難免參考歐洲古典繪畫樣式，但並未刻意套用西方尺度予以美化，紅藍綠搭配用色雖強烈但互相協調，腿部略長似廣角鏡頭效果，以互補色原理在觀者視網膜中混色，陰影處不用黑色而使用環境反射光補色，臀部反光面以紅牆面的補色填以綠色，胸部一抹粉綠反光色讓整幅畫面更是瞬間靈活起來，在高彩度與高明度雙重搭配下，人物顯得更為生氣盎然。而背對著的〈裸女〉（1973）用色較為粉嫩，背景白色磁磚所構成的冷冰矩陣讓肉體顯得圓潤渾厚，牆上鏡面反射的透視線拉深了空間感，搭配紅色地磚，肉體膚色由下方微紅色緩慢上升到腰部以上的淡淡碧綠，雖完全沒有描繪女體正面卻似有言外之意甚為耐人尋味。

退伍後創作的〈裸女〉（1975）與在學時期畫風有明顯轉變，色彩更為亮麗，膚色層次豐富，寫實性多於表現性。〈黑衣少女〉（1976）這幅裸露少女右胸的油畫相對來說色彩較為內斂，背景使用薄塗法，油彩半透明性層層暈染而產生的空氣層次感相當耐看。同時期的〈麗達與天鵝〉（1976）則引用希臘神話故事，斯巴達國王廷達瑞俄斯（Tyndareus）被兄弟驅逐出國，顛沛流離到了希臘中部，埃托利亞國王慧眼識英雄加以收留，並把全希臘最美的女兒麗達（Leda）嫁給他，但眾神之父宙斯卻也愛上麗達，化身天鵝前往引誘並與其交歡，後來產下兩枚雙黃蛋，孵出兩男兩女。根據此神話，黃館長將白色天鵝羽毛觸感與麗達嫩肌翹臀做了構圖上的巧妙結合，裸模背對觀者委婉傳達了該淫亂神話故事所誕生的雙子座傳說以及引發木馬屠城記特洛伊戰爭的海倫。

2006 至 2008 年完成的一批女體速寫雖然距離 1979 年使用碳筆速寫的「裸女」已間隔二十七年，因文官生活忙碌少有閒暇功夫專心創作，但仍可看出黃館長寫實功力深厚，未曾荒廢繪畫基本功夫，筆觸蒼健有力，線條俐落豪不拖泥帶水，裸模姿態與動作更加扭動並帶有動勢，有些甚至採高難度動作，由於保持這種困難姿勢時間有限，必須在短暫時間內快速勾勒、精準下筆，觀察角度也更為刁鑽，與早期恬靜女性優雅之姿截然不同，透過手上炭精筆快速準確在紙上舞動，逝去的青春肉體似乎又在黑白速寫中燃起了往日情懷，年歲漸增雖長智慧，只恨不能日日與青春纏綿矣。

五、覺有情

人為萬物之靈，情為靈魂之根，愛情令人銷魂牽掛，古往今來更為藝術根本核心，裸體與情色往往是一面二刃，端看觀者角度而定，但性癮易尋、真愛難覓，畫皮畫骨難畫心，心有靈犀乃下筆，筆鋒可見真溫情。

70 年代黃館長除了在畫室畫下許多裸體女模之外，其實那趟關鍵的東臺灣之旅鬆動了當時深受復興中華文化的刻板教條，發現被當年政府塑造成負面形象的「山地人」其實相當純樸，這批「原住民系列」雖是比較少見

的入畫題材，但卻透過現場觀察與即興寫生，相當程度進入了保有原始部落人民的日常生活，1972年〈臺東母與女〉這張出現原住民的水彩搭配碳精筆之畫作，肖像色彩低沈且帶著淡淡憂傷，而〈部落老人〉與〈臺東女子〉（1972）以鉛筆速寫準確勾勒神韻，同時期以粉彩繪制的〈蘭嶼老婦〉（1972）則是1973年進行油畫〈蘭嶼風光〉的原始畫作，同樣是一位婦女坐在海邊望向右側，右後方則是紅白線條五艘獨木舟與三位穿丁字褲的達悟族勇士，海平面拉得頗高與婦女眼光等齊，天空雲彩略為陰暗，斜著向右緩緩飄離。一般來說，前往蘭嶼考察大多將目光聚焦在勇猛威武的勇士身上，很少將維持家庭瑣事的婦人置於如此大面積前景地位，這幅畫作似乎透露了為何黃館長八年後毅然決然投入後勤補給的文建會工作，也暗示對持家主婦、尤其是三年後娶得夫人的尊重態度。

而「親人肖像」系列表現了對家族血脈相傳的情感，除了早期的〈侯嘉隆的祖母〉（1975），多數作品皆洋溢著對兒孫柔情之愛，細微筆觸尤可見呵護之心，線條乾淨利落不哆嗦，無論是女兒〈小千畫像〉（1979）還是兒子〈茂嘉畫像〉（1979&1980），筆峰特別柔軟，怕是吵醒熟睡中的孩子。九年後完成的油畫〈小千畫像〉（1988），女兒左手拿著一隻可愛小熊玩具，淡藍背景紫色烘托膚色粉嫩純淨，可感受到父親的驕傲與憐愛之情。佛陀曾說十法界「人身難得！」能投胎成為一家人要嘛來報恩、要不來討債，因緣果報相當奇妙，家家有本難唸的經，俗話「十年修得同船渡，百年修得共枕眠」，四十餘年來夫妻倆鶼鰈情深，師母常伴左右照顧、不離不棄，或冒風寒陪伴戶外寫生，或攙扶老伴現跡各大美展，沐浴在藝術世界中如神仙伴侶，似乎又回到剛相識的那段青澀歲月。

菩提薩埵乃「覺有情」的意思、大乘佛教中「菩薩」的簡稱，解眾生之苦為臺灣儒釋道合一的寺廟精神，人生八大苦：生、老、病、死、愛別離、求不得、怨憎會、五蘊熾盛，上至尊龍嬌鳳、下至販夫走卒，皆求無上離苦得樂解脫之道，這些根本煩惱乃至於大、小隨行煩惱常困擾凡人來世今生，面對無法倒轉的時空與過往記憶，黃館長2022年揮舞畫筆完成〈祖父的畫像〉與〈祖母的畫像〉二幅油畫，面對已逝親人以筆當手輕撫滿是皺褶臉頰，深情款款、一筆一劃仔細端詳記憶中親情滿溢的先祖，往事似乎歷歷在目，夢中也許未曾得見，能在畫中相逢對望可能更為圓滿無礙，血緣維繫的親情無需多言，面對無可避免的生離死別，時間似乎在此停止、愛恨情仇終歸平等。

回頭再看〈敬香〉（2001）這幅畫作，雖未繪製人物，但從畫面上方密集按上金箔往下遞減至一包傳統紅色線香，抽象物質性金箔暗示了對於無上正等正覺、不可知神秘力量藉由冉冉薰香轉化為敬神尊祖的介質。由此推想，黃館長對於傳統宗族乃至於民間信仰雖無皈依或受洗，皆秉持開放心態，接受世間一切善法、願度有緣眾生、慧眼獨具、籌募資源、廣結善緣、勤添舞台，誰說他不是藝術界的活菩薩呢？

六、拭明鏡

藝術永恆命題乃「我是誰？」、「我從何處來？」與「將往何處去？」人生一瞬誰非過客？藝術家窮其一生無非想提煉精華、創作千古不朽鉅作，然作品多如過江之鯽、澔如天上繁星，但能名垂千古者幾希？許多藝術家往往透過自畫像質問「我是誰？」廣為人知者非林布蘭特、梵谷莫屬，從年少輕狂畫到暮年晚鐘，從悲欣交集畫到癡狂自殘，只要從事繪畫創作者一定繞不過這二座山

頭，幾乎每位藝術家或多或少都會面對鏡中自己，留下藝術家孤獨容顏。

黃館長當然也不例外，1972 年完成的〈自畫像〉可見英挺俊俏、意氣風發的青春少年時期，在完成此油畫之後的三十餘年，由於忙於家庭生計與瑣碎公務，抽不出時間仔細端詳鏡中自己。在擔任公職期間來回穿梭國際各大美術館，旅店反倒成了短暫過渡的人生驛站，旅館大廳各色人種來來往往皆為過客，無論在大都會交際應酬洽談國際展覽、參與會議、推廣交流，或在海角天涯轉機，能有歇息獨處時光很是要緊，〈旅店（窗外）〉（2006）或〈Tours 旅店〉（2008）畫作，不難看出以鉛筆描繪自我的「自畫像系列」（2006）多為國外洽公偷閒之作，客房廁浴鏡中人兒到底是誰？是二個孩子的父親？土生土長的臺灣人？還是苦幹實幹的公務人員？往日在繪畫中度過無憂無慮、美好生活的熱血青年如今又在何方？

這些畫面中的人物皆著輕便內衣，線條果斷瀟灑，題有落款或短文，眼光直視鏡中自己不曾閃躲，二鬢鬍鬚已白，眼花花、霧茫茫、髮蒼蒼，跟黃館長西裝筆挺出現在開幕式或會議形象判若二人，卸下外在形象反而更容易關注內心細微變化，對於老去乃至不知何時將至的死亡，眼神流露出某種欣然接受命運的安排與對世間美妙事物之留念，卻也在肉體不斷地消亡與重生中釋懷。「未曾生我誰是我？生我之時我是誰？」也許藝術最大的滿足不是向外尋找一切美麗事物，而是向內心幽微深處、如剝洋蔥般層層剖析，到最後才發覺「美」乃最後歸宿矣。

七、藍曬圖

從以上六個繪畫面向大致能理解總是面帶微笑的黃館長，面對人生採取積極樂觀態度，然而本文所歸納的光透晶鑽七彩耀、也就是第七個沒有畫布的繪畫又是何物呢？

黃館長在大批判的 80 年代身在體制內默默推動改革，用政策、法案、法規、制度……所繪製的「臺灣美術復興藍圖」，包括提出「文化海報」（1981）、主導籌劃辦理「年代美展」與「地方美展」（1982）、籌劃拍攝系列前輩美術家紀錄影片並著手整理臺灣繪畫史蹟資料（1983）、策劃執行鑄銅保存臺北市中山堂黃土水〈水牛群像〉石膏浮雕分贈臺北市立美術館及中南部公立美術館（1983）、籌劃辦理「臺灣地區美術發展回顧展」（1984）、「中華民國國際版畫雙年展」（1985）……等，對於本土藝術史料的整理與建構不遺餘力，為臺灣美術史學者的學術研究提供不少第一手資料，也為鍾愛的版畫藝術開創國際新格局。國際交流就更不在話下，1985 年主導策劃辦理「明清時代臺灣書畫」赴比利時、法國、義大利、德國、菲律賓等地展出。1986 年主導策劃辦理「中華民國傳統版畫特展」赴韓國華克山莊美術館展出，也主導策劃「中華民國工藝展」前往中南美洲八國巡迴展出以及赴日本接洽「臺灣地區美術發展回顧展」事宜，要知此時尚未解嚴，許多黨國禁忌依舊暗藏深宮大內，能在中華道統下推動本土前輩藝術並非易事，更別說支持當時更激進的前衛藝術了。

自 1992 年擔任高雄市立美術館籌備處主任時發起「文化環保」，與林懷民、吳靜吉、許博允、邱坤良、楊英風、楚戈等人主張推動公共建築應設置藝術品美化空間，並於 1994 年擔任首屆館長主導策劃辦理「高雄建築 300 年」特展、「時代的形象－臺灣地區繪畫發展回顧展」以及一系列國際交流展，例如 1995 年主導推動辦理「朱銘：箱根雕塑森林大展」、「臺灣近代雕塑發展」、「黃

土水百年誕辰紀念特展」……等，以及許多國際展覽「比利時表現主義」、「查·克羅斯 (Chuck Close) 版畫特展」、「趙無極回顧展」、「黑色的精靈－巴斯奇亞畫展」……等，為南臺灣打開國際交流視野與高度格局。

2000 年至 2007 年擔任臺北市立美術館館長並於 2006 年兼任臺北當代藝術館館長，期間領導北美館引進時尚、設計、建築類展覽，自 2003 年主導策劃「臺灣地區美術發展回顧展」系列，以十年為一單位，陸續推出 50 至 90 年代臺灣美術史研究展，開創北美館計畫性策展、目標性典藏方略，計有「長流－五〇年代臺灣美術發展」、「前衛－六〇年代臺灣美術發展」、「反思－七〇年代臺灣美術發展」、「開新－八〇年代臺灣美術發展」、「立異－九〇年代臺灣美術發展」，並於 2004 年推動「正言世代：臺灣當代視覺文化」展覽赴美國康乃爾大學強生美術館展出，2006 年首開兩岸美術館互動交流的「臺灣美術發展 1950~2000」於中國美術館展出；「展開的現實主義－1978 年以來中國大陸油畫」則於臺北市立美術館展出。2007 年調回文化建設委員會，陸續擔任第一處與第三處處長，規劃 MIT（Made in Taiwan－新人推薦特區）計畫，自 2008 年開始於臺北國際畫廊博覽會展出至今。

2009 年起擔任國立臺灣美術館館長，積極推動臺灣當代藝術國際能見度，例如「感官拓樸－臺灣當代藝術體感測」、「時空中的一個點－廣東美術館藏當代藝術作品展」、「複語·腹語－臺灣當代藝術展」（韓國光州市立美術館）、「浮世山水－臺灣藝術心貌」（日本相田美術館）、「臺灣響起」（匈牙利布達佩斯藝術館及路德維格現代美術館）、「複感·動觀－2011 海峽兩岸當代藝術展」、「交互視象－2013 海峽兩岸當代藝術展」、「轉動藝臺灣」（韓國首爾市立美術館）、「凝

視自由：臺灣當代藝術展」（塞爾維亞佛伊弗迪納當代美術館）、「界－臺灣當代藝術」（美國康乃爾大學強生美術館）……。自 2012 年起持續推動辦理大型國際科技藝術展，並奉文化部指示研擬籌備藝術銀行，為年輕藝術創作者提供流通管道。2013 年起推出臺灣藝術家「刺客列傳」研究展，以 1931 年至 1980 年出生的藝術家為對象，每十年為一個世代，共五個世代藝術家的研究型策展。

綜觀以上主導推動的國內外展覽策略藍圖，也可以視之為某種文化建設的大型總體「藍曬圖」，其初衷乃秉持天下究竟沒有所謂的完美體制，就算有完善制度也不能掛保證能產出天才藝術家與絕代名作，甚至許多藝術大師往往因為體制保守、思想箝制、孤絕於世導致橫空出世，作為當時文建會官員與各大美術館館長，與其花力氣面對批判甚至踢皮球給其他單位，還不如面對核心問題逐一檢討解決，雖然藝文環境諸多限制，但勤加耕耘咬牙推動許多立意良善的藝文政策，公文上字裡行間的批示乃至於當年閒暇之餘創作的畫作，乍看之下似乎與社會脈動無甚關聯，但通過以上逐一簡要判別，還是有著被大時代巨輪輾壓過仍屹立不搖的痕跡，不禁令人想起 1978～79 年王夢麟的民歌：「大風起，把頭搖一搖，風停了，又挺直腰，大雨來，彎著背讓雨澆，雨停了，抬起頭站直腳。不怕風，不怕雨，立志要長高，小草實在是並不小。」這段時期的黃館長想必也是位熱血青年，心中早已暗自為藝術拋頭顱、灑熱血、畫藍圖了吧！

從以上規劃的藍圖來看大致有幾個原則，即堅持推崇本土前輩大師、確立中青壯輩美術史地位、提攜年輕創作者、鼓勵新媒體藝術探索、強調史料研究的重要性、廣為出版流通相關本土創作者專輯與學術期刊，加上本土化與國際化並行的靈活展覽策略與親民姿態，柔軟又堅

毅地呼應了館長筆下的蘆葦精神，這支只能在公文內看得見的筆，是從藝術家本位出發、服務於藝術家立場、發揚光大藝術家光環，譜寫出另一道看不見的光譜，畫出了無形的臺灣美術藍圖，這不是普通文化技術官僚所能譜寫的，也非動動嘴、撥經費、搞空間就完事了，因此這張無形卻縝密規劃的藍圖絲毫不輸前六項有形繪畫面向，其高度與廣度相信世人日後自有評斷。

當然，若眾人只停留在黃館長歷練豐富的藝術行政職務，而忽略其嚴以律己的藝術家身分，對任何抱持初心踏入藝術世界者來說都是件憾事，成就眾人夢想而將自身才華隱藏五十年已非常人所及，運用瑣碎片刻默然以簡便畫具悠悠塗抹也甚瀟灑，雖因客觀條件限制導致畫幅皆不大，卻也無損其藝術價值，題材雖為日常生活所及平凡之物，就算是怡情養性也非易事，更何況一生提攜同輩乃至後進不遺餘力之無私精神更為難得。要知握有權力者多、知所進退者稀，辭藻華麗者眾而悶頭實幹者少，藝術界不乏八面玲瓏、嘴燦蓮花、趨炎附勢者，然其過往五十年恪守藝術行政本份不踰矩、不外顯、不急功，待退休後回歸少時藝術初衷持續精進，實乃真性情大丈夫也。

Returning to His Original Passion with Contended Charisma, and Creating Masterpieces with Radiance in Profusion: The Mesmerizing Paintings by Huang Tsai-Lang

Yao Jui-Chung

| Department of Fine Arts, National Taiwan Normal University

One day I was on a jury at the Taipei Fine Arts Museum (TFAM). During the lunch break, director Huang Tsai-Lang and I had a cozy chat over his early memories of learning to paint. When Huang was a high school sophomore, he was apprenticed to Kuo Po-Chuan in the latter's atelier. After enrolling in the Department of Fine Arts, Chinese Culture University, Huang sat at the feet of several masters such as Chen Yin-Huei, Chen Ching-Jung, Chou Yueh-Po, Shih Tsui-Feng, Yang Chien-Chung, Shen Yi-Cheng, and Chuang Shang-Yen. Upon the recommendation of department chair Shih Tsui-Feng, *Meishu zazhi (Fine Arts Magazine)* of *The China Post* hired Huang as an art article editor and planner, and he thenceforth wrote columns on great masterpieces of Western art (he served as the chief editorial writer for 22 issues from October 1971 to July 1973), affording the then closed Taiwanese art circle a tantalizing glimpse of the Western art world. Huang was also mentored by Liao Chi-Chun, Li Mei-Shu, Yang San-Lang, Lin Ko-Kung, Wu Cheng-Yen, Hwang Chao-Mo, and Kuo Po-Chuan, hence a profound understanding of modern and contemporary Taiwanese art.

After his discharge from the compulsory military service, Huang had taught art to students in the kindergarten affiliated with the Red Swastika Society, Taiwan Branch for four consecutive years from 1975, during which I (a six-year-old child with a keen interest in painting then) was one of his students in the kindergarten. Having a stable teaching role here, Huang married Wang Hui-Fang and raised their daughter Huang Chih-Chien in this period. Later, Huang and Wang co-founded the "One Generation Children's Art Class" and devoted themselves to the promotion of arts education for children. Then Wang bore Huang a son, Huang Mao-Chia. During that period, Huang Tsai-Lang wore more than one hat as an art teacher at the Yanping High School, the Evergreen Preschool, and the Hsiung Shih Children's Painting Class. He sets great store by children's arts education, arguing that aesthetic education should focus on inspiring imagination and creativity in a down-to-earth fashion rather than on formal equality under credentialism. Arts education is about nurturing talents and fueling imagination and originality. However, an objective, comprehensive reference book on Western art remained wanting at that time. Given that the public had been fed misinformation about Western art, and following the entries beginning with the letters A and B he translated with Liu Yan-Xiang in the *Dictionary of Western Arts* in 1974, Huang, as the editor-in-chief of the book department of Hsiung Shih in 1980, completed the compilation of the *Dictionary of Western Arts* in collaboration with editors Ho Chuan-Hsing, Lee Mei-Ling, Shen Te-Chuan, Lee Yi-Wen, and Wang Hsiao-Tsu. It took them two years to accomplish this monumental task. The lexicon standardized the translated terminology of proper nouns, artists' names, styles, techniques, etc. in the Sinophone world at that time, which not only contributed significantly to the body of literature such as academic studies, journals, and theses, but also won the Golden Tripod Awards in the book category sponsored by the Government Information Office in 1982. This widely influential lexicon was included in the references for my graduation thesis as well.

In 1981, the Executive Yuan established the Council for Cultural Affairs (CCA; upgraded to the Ministry of Culture in 2012). At the invitation of Shen Hsueh-Yung, who was then chief of the CCA's Third Section (Art Section), Huang took the office of the first head of its Fine Arts Division (1982-1989). This striking, crucial decision marked a watershed in Huang's career, which temporarily rendered him too busy to create art. Understanding that the development of Taiwan's artistic and cultural environment entails the endeavor of professional teams, and with the strong support from the first CCA chairperson Chen Chi-Lu, Huang actively promoted many forward-looking and far-reaching policies. In 1990, Huang resigned from the CCA and worked as a cultural legislative assistant (1990-1991) in the office of Legislator Chen Kuei-Miao in order to promote the "1% For Art" bill

for public art under the "Culture and the Arts Reward and Promotion Act." Huang drafted the bill and witnessed its passage. This bill has had a profound, enduring influence on the ecology of public art in Taiwan, benefiting many artists and curators in addition to facilitating the expansion of related industries. In the 1990s, Huang was appointed the first director of the Kaohsiung Museum of Fine Arts (KMFA). In 1999, the Taipei City Government established the Department of Cultural Affairs, and Huang was invited to serve as the department's deputy director-general. From 2000 to 2007, Huang was the director of the TFAM and the acting director of the Museum of Contemporary Art, Taipei (MoCA, Taipei). After 2009, Huang served as the director of the National Taiwan Museum of Fine Arts (NTMoFA) and notched up remarkable success. In 2015, with great reluctance to see his retirement, the Taiwanese art circle threw Huang a farewell party at the Taipei Artist Village. In retrospect, Huang's experience and achievement in arts administration are nothing if not unprecedented in history and probably unrivalled hereafter.

Huang spent most of his life improving Taiwan's artistic and cultural environment as well as the international visibility of contemporary Taiwanese art. When I received the invitation to Huang's solo exhibition "Lingering" in the early spring of 2023, I was truly surprised by Huang's diligence in painting despite his tight schedule as a civil servant. It was not until I visited the National Dr. Sun Yat-sen Memorial Hall for the solo exhibition "Lingering" convened by Prof. Chu Teh-I and curated by Liu Yung-Jen that I was humbled by its epic scale and elaborate structure. Anyone who has superficial acquaintance with art can feel Huang's passionate commitment in these different series developed over time. Each of these paintings resembles a love letter or a handwritten note which confesses his innocent and unaffected feelings towards his family, life, as well as land and nature. He perseveres with painting even though he has been suffering from Parkinson's disease recently. Day after day, he endures the disease gladly, trying to highlight the beauty of humanities, natural conditions, and social customs of Taiwan in the ordinary things around our routine-like quotidian existence. He creates his works with prudent brushstrokes and sincere compositions, making it difficult for the later generations to hold a candle to his creative attitude and demeanor. After attentively viewing this exhibition, I appreciate and analyze it from the following seven aspects.

I. Charming Scenes

No sooner was the United Nations (UN) General Assembly Resolution 2758 passed on 25 October 1971, than the Republic of China (ROC) was expelled from the UN. Before Huang completed his first oil painting *The Jiali Church*, he was a student of the Chang-Jung Senior High School, who sketched from the historic sites in the school, took up individual study in Chen Kee-Lung's atelier, and apprenticed to Kuo Po-Chuan. Therefore, every stroke of Huang's brush bears his signature as untrammeled as freehand in style. Around Huang's enrollment in the Chinese Culture University, the international society denied Taiwan diplomatic recognition, and the Kuomintang (KMT) government wavered in upholding the core values of Chinese orthodoxy. Undergraduates went to the countryside to learn from popular custom and folk culture. Literati and elegant scholars began to survey and study architectural landscapes such as monuments, temples, or churches. They delved deep into folk rituals, ordinary people's life, and aboriginal tribes, where they discovered many amateur artists, among whom Hung Tung was one of the iconic figures. Originally a spirit medium in Nankunshen, Tainan, Hung tended to create works featuring colorful tropical islands and unadorned folk sentiments, which enlightened the patriotic youth who had been brainwashed by the Three Principles of the People and the policy of reclaiming the Mainland. The possibility for exploring the aesthetics of Taiwan was ergo created, and it started a craze among awakened youth for abandoning doctrines, transcending the confines of ateliers, and empathizing with the underclass.

Accordingly, *The Jiali Church*, a powerfully expressive painting, was by no means a product of happenstance.

The influences of Fauvism with stark color contrasts and Expressionism with subjective emotions were at work in the paintings that Huang created in the same period, such as the red and green tiles of the traditional houses in *Sanxia* (1971), the depiction of the dark alley at night in *An Alleyway at Night near Taiwan Tianhou Temple* (1971), the visual texture in *A Time-honored Wall on Dihua Street* (1972), and the vibrant colors in *The Ta-Cheng Hall of the Tainan Confucius Temple* (1971). Their compositions are geometrically divided with thick, layered paint and bright colors. The strong contrasts in the massive complementary colors hit the viewer's retina. The scraped thick paint gives the paintings a sui generis tactile quality. Orientated toward sentimentality, locality, and simplicity, Huang's nativist concern in his expressionist paintings of traditional architecture and the classical realism in the academic mainstream did reach a parting of the ways at that time.

The folkways of the six tribes on Orchid Island were as unsophisticated as guileless before the KMT government completed the Low-Level Radioactive Waste Storage Site in Ji-Pamoyan in 1980. The ancient rituals have been preserved in the Chinurikuran Festival and the Flying Fish Festival of the Tao people. In July 1972, Huang was shocked and inspired by the aboriginal culture when he conducted field surveys and sketching from nature in Taitung and on Orchid Island together with Hung Jui-Lin, Chang Wan-Chuan, Chen Ching-Jung, Wang Shou-Ling, Chou Yueh-Po, and Huang Chang-Huei. He not only created several paintings such as *Warship Rock in Lanyu at Sunset* (1972) and *Lanyu En Plein Air* (1972) with pastel on paper, but also produced an 8mm film. Behind the innocent brushstrokes in the composition lurks a pair of bright eyes that craves vitality. Sketching was thenceforth his primary creative approach. Huang immersed himself in the natural variations (e.g. sunlight, clouds, temperature, shade, wind speed, and the salty smell in sea breeze) along with his glistening sweat, pupil responses, and sunburnt skin. He created his works in perfect harmony with these subtle, delicate natural variations, which was absolutely unobtainable by simply depicting any model or still life in an atelier.

No sooner did Huang graduated from the Western Painting Division of the university in 1973, than he did his compulsory military service in the barracks in Tainan where he got acquainted with Pan Yuan-Shih. Huang often used Pan's printmaking studio to create his works while on leave. Huang doubled as an assistant intelligence officer and an art designing officer during his compulsory military service. He once painted at the firing range when staying behind for the Luguang Art Exhibition. It took him 8 stay-behind shifts to create the works *Shooting Range at Chenggong Hill* (1973) and *Chenggong Hill* (1974). During those years, Taiwan was in the throes of the avalanche of broken diplomatic ties after the ROC withdrew from the UN, and the political turbulence filled Taiwanese people with consternation. On the other side of the strait, the People's Republic of China (PRC) was still in the late stage of the Cultural Revolution. The KMT government established the Chinese Cultural Renaissance Movement Implementation Committee in 1966, and the concomitant "New Life Movement" was flourishing and still in the ascendant. At that time, the atmosphere of reclaiming the Mainland prevailed and the army was fully prepared and biding its time for the battle, but the Chenggong Hill in Huang's painting appears exuberant in the sunlight, not even a sense of serious cross-strait military confrontation. Instead, his painting *Late Night in an Alley on Wuxing Street* (1974) seems to ooze a greater dangerous charm. The vanishing point at the center of its composition leads the viewer's vision deep into the gloom of the alley. In that period, Wuxing Street was in the periphery of Taipei City, near the Four Beast Mountains and surrounded by farmland. There was even a munitions factory in the vicinity with a strong military presence. This painting shows a bleak and desolate streetscape, in which

the then oppressive societal atmosphere under the high-handed rule in Taiwan finds implicit expression.

Before the lifting of martial law in Taiwan (15 July 1987), Huang visited the United States for a one-month on-the-spot study on American arts administration at the invitation of the American Institute in Taiwan. This experience-learning tour to the West prompted him to cogitate on the deficiencies in Taiwan's cultural policy. With the demise of the political giant Chiang Ching-Kuo on 13 January 1988, an internecine political power struggle took place. The then Vice President Lee Teng-Hui took over the presidency of Taiwan in a hall of mirrors, and Taiwan soon became one of the Four Asian Tigers. Around that time, the Fulbright Program invited Huang to conduct a ten-month visit to the United States for observing and studying American cultural administration and public art, where he deeply admired the congenial environment for artistic creation. This visit served as a valuable source of reference for the public art policy-making that significantly impacted the artistic and cultural environment in Taiwan. Huang also created some small-scale works during the visit, such as *Washington, D.C.* (1988). Furthermore, he finished the painting *Rainbow – KMFA After the Rain* (1995) during his incumbency as the museum's director. In this painting, the ripples are represented by gold leaves. A rainbow appears above the inaugurated KMFA beside the dark lotus pool, marking a major milestone that ushered Southern Taiwan in the new era of art museums.

Twenty years elapsed. Huang often sketches near his home after retiring from the NTMoFA in 2015, maintaining his sketching habit whenever he had time during his public service. For example, his painting *Reeds* (2000) portrays the reeds in the Yangmingshan National Park. They are emblematic of unpretentiousness, indomitableness, and calm endurance, capable of thriving on arid land. Seemingly swaying in the wind, they leverage the natural force, neither servile nor overbearing. They still stand upright with invincible spirit despite hardships. The white reed flowers cover the entire mountain top as if fluffy snowflakes fell

from the sky, which is nothing if not poetic. This painting is also an indirect metaphor for the fact that one can still succeed and flourish robustly in the infertile artistic and cultural environment of Taiwan if he/she perseveres with his/her cause.

II. Tranquil Objects

Still lifes have been one of the key subjects in the history of both Chinese and Western art. From classical to contemporary times, artists have regarded still lifes as the basic fundamentals of artistic creation. In addition to conveying the sense of life in the form of fresh, juicy fruits, still lifes carry many complex connotations and even serve as a major cornerstone of artistic concepts. For instance, the profound influence of still lifes manifests itself in the works by French Impressionist Paul Cézanne and German conceptual artist Joseph Beuys. The former's still lifes treat fruits as three-dimensional geometric structures with multiple vanishing points, which inspired Cubism and Abstractionism. The latter's readymade combines a fruit with a light bulb. The still lifes created by Huang over the years have been in a great profusion insofar as to transcend the narrow definition of "still life." Their black-and-white coloring presents a wabi-sabi state as mysterious as tranquil, so I term them "tranquil objects" here.

In Taiwan, it is customary to offer fruits like oranges, mangoes, and melons to the deities as a sign of devotion and fasting from meat. However, since the Renaissance and Classicalism, the West has had a different perspective on still lifes, viz., holding the God-given sustenance for life in awe and admiration. The art movements in modern times, be they Impressionism, Post-Impressionism, Cubism, Futurism, or Surrealism, have all evolved many genres from still lifes. These art movements spread eastward from imperialist Europe to Japan and then to Taiwan and Southeast Asia. Through the education and competition systems under Japanese rule, Taiwan's art scene was also greatly influenced

by the total Westernization policy of the Meiji Restoration. The overall context changed radically after the KMT government retreated to Taiwan in 1949. Western painting, ink-wash painting, and Japanese painting were respectively renamed "western-style painting," "Chinese painting," and "Eastern gouache painting." These terms savored of popular nationalism.

The White Terror repressed Taiwanese civilians under the KMT government in the 1950s, and Taiwanese society was fettered by many political taboos during the martial law period in the 1960s and 1970s, making artists at that time hesitate over whether to address sensitive issues. Although a few artists sought to challenge traditions and conservatism, such as the "Manifesto of the École de Great Taipei" written by Huang Hua-Cheng in 1966, the conservative milieu remained unfriendly to trail-blazers. Arts graduates either founded painting societies to share meager resources, or opened ateliers to scrape a meager living, or left their hometowns to pursue a career abroad, or found a stable teaching position in the education system. Those who were able to make a living in the art market were the cream of the crop and ergo as scarce as hen's teeth. But the shoe is on the other foot now in terms of today's artistic and cultural environment. Previously, if art talents couldn't change the rigid system, those who had powerful patrons or financial resources might choose to leave Taiwan, a place where a question mark hung over its future, for the Occident to build their careers in a well-established artistic and cultural environment. If they had the opportunity to transform the local arts system, it would be a very strenuous, unrewarding, and time-consuming cultural engineering project. Under the control of the conservative party-state, they needed not only to understand the culture of officialdom, but also to conduct themselves properly, as if a blade of grass braved the windy weather. Huang founded a children's art class, and then suspended from artistic creation to take up a position in the CCA. His painting *Still Life* (1972) that features a skull seems

to have yielded subtle clues about such a solemn and stirring frame of mind. He must be acting with no other thought than to love his native land!

After the lifting of martial law in Taiwan, Taiwan's economy began to take off in the 1980s, and the TAIEX skyrocketed over 10,000 points in the early 1990s. The Taiwanese were really rolling in money. The illegal lottery "Da-Jia-Le" and underground casinos became phenomenally popular. Taiwanese society was freely blossoming, and a host of devils danced in riotous revelry. On the first and fifteenth day of each month in the lunar calendar, merchants worshiped the Lord of the Land and greeted the God of Wealth. The folk scene was flourishing, and temple tables piled high with offerings. Huang therefore came up with the idea of incorporating these "lucky charms" that symbolize good fortune into his paintings. He chose fruits with auspicious connotations as his subjects. Oranges constitute a customary offering to the gods. The folk often use the term "five oranges" in Chinese as a homonym of "ū-tsînn" (wealthy) in Taiwanese. The composition layout of his painting *Tangerine Series: A Hundred Auspiciousness* (1992) differs somewhat from those of ordinary still lifes. Five of the six oranges are painted in black and white, with only one in tangerine. These oranges seem to be surrounded by printed fabric, which turns out to be the afterimages of many oranges. The effect of elapsing time it creates is quite thought-provoking. Many of the other fruits and vegetables in his paintings brim with nativist features. For example, *Kohlrabis* (1996) is conventionally considered a symbol of safety and luck. The golden yellow *Mangoes* (1994) represents faithfulness. *Pumpkin* (1995) implies many descendants and good fortune because a pumpkin contains many seeds. Sometimes the backgrounds of these paintings are interlaced with lines to provide the depth of field on a plane, and sometimes they are layered with translucent oil paint to create a sense of perspective, which depends on his feeling and the need of the composition at the time of painting.

The batch of fruit still lifes created by Huang after 2000, like *Tangerine Series* (2002), began to show his technique

hybridization experiments with vermillion paint, ink, gold leaf, and rice paper plate that are frequently used in ink-wash paintings. Appearing different from his early fruit still lifes, *Green Tangerines* (2009) is not so much a fruit still life as a work with undertones in terms of meaning and structure. Seemingly a still life, *Tangerines on a Red Lacquer Plate* (2018) addresses the spatial dislocation between mirror images and ghost images, which resembles the effect of multiple exposure in photography. The printed fabric in the background looks like a pattern, yet it actually conveys a metaphorical sense of weight fostered by the superimposition of time and space. The background comprises the densely painted upper part and the sparsely colored or even simply blank lower part, which is a rarely seen approach to still lifes. The fruits and vegetables he selected as his subjects all imply common slangs or puns. His earlier works are more brightly colored, having cheerful connotations of felicity and good fortune. His recent paintings are characterized by the interplay among black, white, and other colors. Sometimes only a few fruits are colored and their number varies. The lower part of the composition is either left blank or covered with gold leaves. This seemingly unfinished state is by no means the consequence of a relative lack of time. Instead, the composition is somewhat compact, somewhat loose, somewhat unfettered, and somewhat veiled, thus presenting a sublime mystery of Zen amidst the real and the virtual as well as the dynamic and the static.

III. Fragrant Flowers

Literati and elegant scholars tend to draw inner sustenance from flowers. Among the early painting series that Huang completed in his atelier, *Lingering Series: Devil's Ivy IV* (1989) counts as a masterpiece of this genre. The contour lines of the plant are as vigorous and forceful as calligraphic brushstrokes. The three leaves at the center are colored in dark green and fading out in all directions. The closely clustered green leaves are rich in directional changes, as if a gentle breeze ruffled them with a touch of lyricism. Huang attempts to communicate the symbolic

meanings of wild things as the most competitive and vital. Pothos vines are ornamental plants commonly seen in Taiwan. They are evergreen and often used on the grounds of feng shui to increase wealth and eliminate inauspicious influence. The brushstrokes of the background are as free as relaxed with noble, unsullied bearing embedded in contentedness, giving the viewers an impression that the floral fragrance fills the room. It is no wonder that none of his works is more touching and lingering than this painting as the key visual of his exhibition.

Morning star lily originates from the Netherlands but belongs to "Asiatic hybrid lily." In Huang's painting *Morning Star Lilies* (1991), the large number of flowers cluster at the top of the stems and bloom in all directions. They are painted mainly in yellow and tangerine with occasional brown spots on the petals. Lilies carry the meanings of living a long and happy life together, happy family, great love, and heartfelt wishes. It was shortly after the Wild Lily student movement that arose in March 1990, a movement that heightened Taiwan's subjective awareness. Both the cultural and the art circles began to reflect on the spirit and values rooted in Taiwan. In April 1991, Ni Tsai-Chin, who was not yet the NTMoFA's director at that time, published an article titled "Western Art, Made in Taiwan: A Criticism of Modern and Contemporary Taiwanese Art" in *Hsiung Shih Monthly*, which sparked heated discussion and provoked the nativist debate over the Westernization, modernization, and modernism in Taiwan's art scene. Wild lilies ergo became an emblem of Taiwanese culture. Huang said that he simply attempted to convey the beauty of the spellbinding island Taiwan with wild lilies, which was also the first impression of the Spanish sailors passing by Keelung where they saw numerous wild lilies and exclaimed "Formosa" in admiration at sea. Nonetheless, if we look at the nativist cultural policies and bills that Huang had actively promoted during his period in office, we may comprehend their symbolic meaning, that is, if the most beautiful and precious things do not thrive and blossom from their native land, they are nothing but imported goods or unrealistic nostalgia for the motherland.

In addition to brushes, Huang began to apply gold leaves to his paintings after 1995. Gold leaf is not only used for decoration in divine spaces (e.g. temples, churches, and altars), but also regarded as a symbol of wealth and gorgeousness. Generally speaking, a coat of primer should be applied to the work with a brush before putting gold leaves on it. There are transparent water-based primer and red or yellow oil-based primer. After the primer had completely dried, Huang carefully pressed the gold leaves onto the surface of the painting piece by piece with his fingers. The thickness of the primer determines the texture, chiaroscuro, and refraction of the composition. Instead of adopting the technique of the Rinpa school that applies large sheets of gold leaf to large areas as decoration along horizontal and vertical axes, Huang uses gold leaves as a kind of pigment, with a special focus on the "touch of hand" given by pressing gold leaves onto oil paint. These gold-leaf brushstrokes generate a dynamic motion, and such a motion-focused technique is also evident in his other works.

Huang's painting *Lingering Series: Roses* (1998) is surrounded by extremely thin layers of oil paint applied in a relaxed, fading out fashion, whilst the lower part of its composition is left blank. The center part is as dark as the pupil depth. Although the red flowers and green leaves add colors to this work, the black and white render it seemingly unfinished. In fact, Huang has a predilection for the timeless enchantment of black. He makes black and white shine more brilliantly in each other's company, and divides the ink into five shades, which is nothing if not pleasing to the eye. The painting *Rose Garden* (2022) indicates romance. Red roses originate from ancient Greek goddess Aphrodite (also known as Venus in Roman mythology) who bleeds for her lover, symbolizing passion, eternity, beauty, love, and desire. All the plants drawn in the aforementioned paintings carry positive, auspicious connotations of good fortune in Taiwanese society. They are suitable for the Chinese New Year or other festivities both at home and as gifts. These plants are indispensable symbols of

good omens and blessings for the opening ceremony that is particular about feng shui and propitious time.

Narcissuses are flowers for specific occasions. They are not only emblematic of friendship, happiness, and auspiciousness, but also a traditional offering on the New Year's Day. *Narcissuses* (1998) is Huang's tour de force in this series. He drew on the canvas with oil paint and charcoal pencils. The sky is pasted with gold leaves, and the lower part of the composition is left blank. Huang states that "awe-inspiring boldness can be derived from blanks at the top and the bottom." In contrast with the elaborately depicted flowers in the upper part of the composition, the rootless state seems to bear a more profound meaning rather than just for the sake of convenience. Experiencing the baptism of the "East-West Cultural Debate," the "Taiwanese Literature Movement," and "Taiwanization," Taiwan's artistic and cultural environment is suffering from nativist malnutrition. It approximates to that insinuated in the article "Western Art, Made in Taiwan" and indirectly implies that the only way to forge a successful career is to be down-to-earth. This is Huang's personal expectation as well, namely the top priority to promote Taiwanese nativist art.

Although sketching from nature is more protean than indoor still lifes, Huang loves the former dearly. His recent *Reed Series* has a rich and vigorous variation in the direction of the leaves, which provides a vivid portrayal of Huang's personal life experience. The black-and-white brushstrokes are charged with expressive power. The hollow stems of reeds not only symbolize literati's dignity and perseverance, but also imply robust vitality. The swaying reeds in the wind often convey the aesthetic beauty of psychedelia, obedience, and desolation. The twisting and bending shape of the reeds brings a rhythmic sense of "fluidity." Therefore, invisible "wind" is the very kernel of the *Reed Series*. Whether confronting summer typhoon, spring breeze, autumn warm wind, or northeast monsoon, reeds neither flare nor wilt with the seasonal change, but still sway plainly and stretch as usual, just like the breath

of the earth, gentle yet tenacious. Sugarcanes, a specialty of the Chianan Plain, have been a subject of Huang's paintings for more than four decades, which is epitomized by his *Sugar Cane Field Series*. Huang's recent work *Sugar Cane Field* (2022) presents the cash crop in his hometown Jiali, Tainan. Red sugarcanes are deemed an auspicious item for the custom of a married womanvisiting her parents. Red sugarcanes not only symbolize promotion, but also connote happy marriage and sharing joys and sorrows. In this painting, the sugarcanes twist with wildly dancing leaves. The appearance of the plant is transmuted into forceful calligraphic brushstrokes through abstraction. Huang depicts the golden land under the scorching sun as the grassroots incarnate. The flowers are fragrant and the fruits are sweet. What a bucolic scene of the southern countryside, brimful of nativist confidence and affection for his hometown.

IV. Lament for Lost Youth

When Huang was a student in the Department of Fine Arts, Chinese Culture University, the department not only trained the students in plaster bust sketch and still life, but also arranged models for them to learn how to draw human body structure. Of all these practices, facing nude female models was the most exciting. In the conservative Cold War era, the nude sketching course in the Department of Fine Arts was the envy of and a mystery to male students in other departments. The students gazed steadily at the nude female models almost within reach, with some of the models sitting, some reclining, and some standing. A heavy silence lingered in the classroom. No other sound than those of uninterrupted brushstrokes and rapid breathing could be heard. The students shyly observed the details of the nude strangers and discovered the disparate body proportions between the Orientals and Western plaster statues. They even began to wonder if it was really in line with the local aesthetics to keep drawing Laocoön or David who has a high nose, big eyes, well-developed muscles, and pronounced facial features.

In Huang's painting *Female Nude* (1972), the reclining protagonist has a completely oriental face and physique. Although the composition is inevitably based on the style of European classical painting, the Western scale is not deliberately employed for beautification. The red, blue, and green colors are intense but stand in harmony. The legs are relatively longer, producing the effect of a wide shot. The colors are mixed in the viewer's retina by the principle of complementary colors. The shade is not painted in black, but complemented with ambient reflection. The reflective surface of the hip is filled with green as a complementary color to the red wall. A touch of pastel green reflection on the breasts further breathes life into this painting. Saturated chroma and high brightness work in tandem, rendering the protagonist exuberant. His another painting *Female Nude* (1973) with the protagonist's back towards the viewer is more gentle in terms of coloring. The lifeless matrix of white tiles in the background makes the protagonist appear plump and fleshy. The vanishing point in the mirror on the wall intensifies the sense of space. The red floor tiles serve as a foil to the protagonist's skin color which changes from light red of the lower body to light green of the upper part. Without showing the front side of the naked woman, this painting seems to carry a thought-provoking undertone.

Huang's painting *Female Nude* (1975) shows a remarkable turn in style that he took after his discharge from the compulsory military service. It is brighter in color and richer in skin layer, hence more realistic than expressive. In his oil painting *The Young Girl in Black* (1976), the coloring of the girl with her right breast naked is relatively understated. Huang applied the technique of scumbling to the background. The airy layers created by the rendered translucent oil paint are quite pleasing to the eye. His painting *Leda and the Swan* (1976) created in the same period invokes a story from Greek mythology. Tyndareus, the Spartan king, was expelled from his kingdom by his brother and exiled to central Greece. The king of Aetolia

had a good eye for Tyndareus' talent. The king not only offered him shelter, but also married Leda, the most beautiful princess of Greece, to him. However, Zeus, the king of the gods, also fancied Leda. He disguised himself as a swan to seduce Leda and had sex with her. Later, Leda laid two double-yolk eggs that hatched two boys and two girls. According to this story, Huang ingeniously combined the tactile quality of white swan feathers with Leda's tender buttocks in the composition. Having her back towards the viewer, the nude model euphemistically alludes to the legend of Gemini derived from this salacious myth and Helen of Troy who caused the Trojan War in which Troy fell to the ruse of the Trojan Horse.

Huang created a batch of female nudes between 2006 and 2008, a hiatus of 27 years after he drew female nudes with charcoal in 1979. His hectic schedule as a civil servant left him little time for artistic creation. Nevertheless, his paintings have proved that he maintains consummate realistic painting skills and doesn't neglect the fundamentals. His brushstrokes are bold and powerful, and the lines are clear-cut and straightforward. Momentum built up through the curvy posture of the nude models. Some of them even took difficult postures. Since they could maintain these difficult postures only for a short while, Huang must sketch quickly and precisely with more crafty observation. This is far removed from the composed female elegance in his early paintings. He draws quickly and precisely with charcoal pencils on paper, seeming to recapture his lost youth in the black-and-white sketches. He grows older and wiser, only to lament with a nostalgic yearning for the halcyon days.

V. Bodhisattva

Of all creatures, human is the only one endowed with intelligence. Romantic love is the root of our soul. People may feel overwhelming joy or sorrow about love. Romantic love is also the innermost core of the arts since times immemorial. Nude and erotic are two sides of the same coin. It depends on the viewer's interpretation. Sex is easy to have, whilst limerence is hard to seek. Drawing the appearance and structure is one thing, capturing the quintessence another. Huang didn't draw until inspiration struck. His warm and sincere emotions find expression in the strokes of his painting brush.

In addition to the copious female nudes he painted in his atelier during the 1970s, Huang's crucial trip to eastern Taiwan compromised his dogmatic values instilled by the ideal of reviving Chinese culture. He found that the "aborigines" portrayed negatively by the government are actually unsophisticated and guileless. A rare painting subject notwithstanding, Huang's *Indigenous People Series* has mirrored the quotidian existence of tribal people to a great extent through on-site observation and improvised sketches. *Mother and Daughter in Taitung* (1972) is a painting of indigenous people created by Huang with watercolor and charcoal pencil. It wears subdued colors with a subtle touch of melancholy. *A Tribal Elder* (1972) and *A Woman in Taitung* (1972) are pencil sketches that accurately demonstrate the charm and grace of the figures. His pastel drawing *An Elder Woman* (1972) is the predecessor of his oil painting *Lanyu Secnery* (1973). Both works feature a woman sitting at the seaside and looking to her right. Behind her are five chinedkulans interlaced by red and white lines and three Tao warriors in thongs. The sea level is elevated to be on a par with the woman's line of sight. The clouds are slightly gray, drifting slowly away to the right. Those who survey Orchid Island tend to focus on brave, formidable warriors rather than foreground women who handle housekeeping. This painting seems to reveal the reason why Huang decided to join the CCA that played the role of logistical support eight years later. It also implies a respect for housewives, especially the woman he married three years later.

Huang's *Family Portrait Series* exhibits his emotional bond with his family lineage. Except for his early work *Hou Chia-Lung's Grandmother* (1975), most pieces in this series are brimful of his tender love for his children and grandchildren. His pampering is particularly embodied in his delicate, lithe,

and clear-cut brushstrokes. Be it *Portrait of Xiao-Chien* (1979) for his daughter or *Portrait of Mao-Chia* (1979/1980) for his son, Huang's brushstrokes are especially gentle, as if he were afraid to make noise lest he wakes up the sleeping child. In *Portrait of Xiao-Chien* (1988), an oil painting Huang completed nine years later, his daughter holds a cute Teddy bear in her left hand. The purple color in the light blue background serves as a foil for the flawless, glowing skin of the protagonist, which vividly shows forth the father's pride and tender affection for his daughter. In the ten dharma realms, a human incarnation is rare, precious, and difficult to obtain. To be reincarnated into a family implies either to repay the kindness or to demand debt repayment. Predestined affinity and preordained fate are rather fantastic. Every family has a skeleton in the cupboard. A Chinese saying goes: "It takes hundreds of rebirths to bring two persons to ride in the same boat; and it takes a thousand eons to bring two persons to share the same pillow." Over the past four decades, Huang and his wife have been each other's one and only. His wife is always at his side to take care of him. She accompanies him either to sketching in chilly wind, or to major art exhibitions. They bask in the art world as a couple with a happy marriage and a harmonious relationship, seeming to relive the youthful days when they first met.

Bodhisattva means "enlightened sentient beings," an abbreviation for Mahāyāna bodhisattva. In Taiwan, to relieve the sufferings of all sentient beings is the spirit of the temple where Confucianism, Buddhism, and Taoism converge. The eight sufferings of sentient beings are birth, aging, sickness, death, separation from what is dear, encountering what is not dear, not finding what one seeks, and the five aggregates that are objects of clinging. From the upper class to the lower one, all are seeking the path to emancipation and sheer bliss. We, as mortals, are always plagued by these root and secondary afflictions. Facing the irreversible space-time and memories, Huang completed two oil paintings titled *Portrait of Grandfather and Portrait of Grandmother* in 2022. Gently and lovingly, he caressed the wrinkled cheeks of his late

grandparents with the brush as his hand. He carefully recalled his affectionate ancestors in his memories stroke by stroke. The past seems to be vivid in his mind. He may not be able to dream of them, yet to meet them in the paintings may be more consummate and unhindered. Consanguineous family love is self-evident. Confronting the unavoidable separation in life and parting at death, Huang seems to make time stop elapsing here and now, and let all love-hate relationships end.

Let's go back to Huang's painting *Incense Offering* (2001). No human figure appears in this painting. However, gold leaves are densely pressed onto the top of its composition and gradually reduced downward to a packet of traditional red incense. The abstract materiality of gold leaves suggests the transformation of the mystifying power of the unsurpassed, complete, and perfect enlightenment into a medium of reverence for the deities via the burning incense. We can infer that Huang is open-minded about traditional clans and folk beliefs, even though he has no religion. He accepts all the good teachings in the world and is willing to help all sentient beings. With his discerning eye, Huang pools resources, makes good connections through his good deeds, and sets stages for the younger generation. Who says he is not a living bodhisattva in the art world?

VI. Mind as a Mirror Bright

"Who am I?" "Where am I from?" and "Where am I going?" They have been the eternal propositions of the arts. Life is ephemeral, and every person is nothing but a passer-by in this world. Artists devote a lifetime refining themselves with no other thought than to create immortal magnum opuses. Although the number of artworks in this world is as large as a school of silver carps moving down a stream and as the massive stars in the night sky, how many of them will go down in history and earn eternal glory? Many artists tend to ask "who I am" via self-portraits, foremost Rembrandt and Van Gogh who had created paintings from their frivolous youth to twilight years, from mixed feelings of grief and joy to madness and self-mutilation. The two art masters are definitely well-known

to everyone who engages in painting. Almost every artist will more or less look at himself/herself in the mirror, drawing his/her lonely portrait.

Huang is certainly no exception. His *Self-Portrait* (1972) shows a handsome and exuberant youth. During the three decades after the completion of this oil painting, he was occupied with his livelihood and the minutiae of bureaucracy, and barely had time to look carefully at himself in the mirror. He shuttled among major art museums in the world during his public service, turning hotels into the relay stations in his life. People of different races come and go in the hotel lobby, which is illustrated in his paintings *Lodging (Window View)* (2006) and *Hotel in Tours* (2008). For a man who arranges international exhibitions, participates in meetings, engages in publicity and exchange activities in metropolises or waits for the connecting flight at a foreign airport, it is essential to have time to rest and stay alone. It is easy to tell that the pieces in his *Self-portrait Series* (2006) drawn with pencil were mostly created during the breaks in his busy schedule of work overseas. Who is exactly the person in the mirror of the hotel room? Is he a father of two children, a native Taiwanese, or a hard-working civil servant? Where is the passionate young man who used to live a carefree and wonderful life of painting?

All the figures in these paintings are in their underwear. The contour lines are as decisive as untrammeled, accompanied by Huang's signature or short paragraphs. Huang looks straight at his reflection in the mirror, seeing a man with poor eyesight and a graying head and beard, which is diametrically opposite to the man who attends opening ceremonies or meetings in a well-tailored suit. It is much easier for Huang to capture every nuance of his mind after removing his external façade. In the face of ineluctable aging and unpredictable death, his eyes gleam not only with the pleasure of resignation to fate, but also with his fond memories of beautiful things in the world, and, on the other hand, he seeks relief in the constant demise and rebirth of the flesh. "Before birth, who was I? After birth, who am I?" Perhaps the greatest satisfaction for artists is not so much looking

outward for beautiful things as delving into the innermost self like peeling an onion layer by layer, and finally they'll have a personal epiphany that "inner beauty" is the final destination.

VII. Blueprint

The aforementioned six aspects of Huang's paintings gave us a general understanding of his positive philosophy of life behind his smile. Nevertheless, what does it mean by creating masterpieces with radiance in profusion, namely the seventh aspect of his painting without canvas?

In the 1980s, the age of great criticism, Huang silently pushed for reforms in the system with policies, bills, regulations, and institutions. The "Blueprint for Taiwanese Art Renaissance" he drew up includes proposing the "Cultural Posters" (1981), organizing the "Epoch Art Exhibition" and the "Local Art Exhibition" (1982), producing the documentaries of senior artists and collating the material of Taiwanese painting history (1983), preserving Huang Tu-Shui's plaster relief *Taiwan Buffalos* in Taipei Zhongshan Hall with bronze replicas to be sent to the TFAM and public museums in central and southern Taiwan (1983), as well as organizing "Art Development in Taiwan: A Retrospective Exhibition in Four Parts" (1984) and "International Biennial Print Exhibit, R.O.C." (1985). He spared no effort to collate and construct the historical material of Taiwanese art, which has not only offered Taiwanese art historians invaluable primary sources for their research, but also broke the international ground for his beloved prints. His engagement in international exchange was all the more so. In 1985, he supervised the exhibition "Painting and Calligraphy of Taiwan during the Ming and Ching Dynasties" that toured Belgium, France, Italy, Germany, and the Philippines. In 1986, he supervised the "Special Exhibition: Collectors' Show of Traditional Chinese Woodcut Prints" hosted by the Grande Walkerhill Seoul, South Korea and the exhibition "Arts and Crafts from the Republic of China" that toured eight countries in Latin America. He also went to Japan to discuss the preparation for "Art Development in Taiwan: A Retrospective

Exhibition in Four Parts." It's noteworthy that Taiwan was still ruled by martial law and rife with political taboos in that period. Promoting nativist art under the Chinese orthodox was like herding cats, let alone supporting the much more radical avant-garde art then.

Huang initiated the campaign of "cultural environment protection" when he served as the director of the KMFA preparatory office in 1992. Together with Lin Hwai-Min, Wu Jing-Ji, Hsu Po-Yun, Chiu Kun-Liang, Yang Yuyu, and Chu Ko, Huang advocated that public buildings should contain works of art for beautification. After serving as the first director of the KMFA in 1994, Huang supervised the exhibition "The Architectural Beauty of Kaohsiung 1683-2000," "Retrospective Exhibition of the Painting Development in Taiwan 1739-1980," a series of international exchange exhibitions such as "Ju Ming: Sculpture Exhibition at the Hakone Open-Air Museum, Japan," "Modern Sculpture Development in Taiwan: Exhibition of Museum Collection," and "The Centenary of Huang Tu-Shui," as well as many international exhibitions such as "Belgian Expressionism," "Chuck Close Print Exhibition," "A Retrospective of Zao Wou-Ki," and "Jean-Michel Basquiat." It can be said that Huang opened up new horizons for southern Taiwan and raised its international visibility.

Huang was the director of the TFAM from 2000 to 2007 and the acting director of the MoCA, Taipei from 2006. In this period, he introduced exhibitions on fashion, design, and architecture into the TFAM. In 2003, he supervised "Art Development in Taiwan: A Retrospective Exhibition in Four Parts" and successively staged the research exhibitions of Taiwanese art history from the 1950s to the 1990s phased by decades. He devised the strategy of planned curating and targeted collection for the TFAM. The exhibitions organized under this strategy include "From the Ground up: Art in Taiwan 1950-1959," "The Experimental Sixties: Avant-Garde Art in Taiwan," "Reflections of the Seventies: Taiwan Explores Its Own Reality," "The Transitional Eighties: Taiwan's Art Breaks New Ground," and "Contemporary Art in Taiwan in the Nineties." In 2004, he

facilitated the exhibition "Contemporary Taiwanese Art in the Era of Contention" at the Herbert F. Johnson Museum of Art, Cornell University. In 2006, he pioneered in staging cross-strait museum exchange exhibitions "The Development of Art in Taiwan, 1950-2000" at the National Art Museum of China and "The Blossoming Realism: Oil Painting of China since 1978" at the TFAM. In 2007, he returned to the CCA as the chief of the First and the Third Sections, establishing the special exhibition "The MIT: Made in Taiwan, Taiwan Young Artists' Connection with the World" at Art Taipei since 2008.

Huang served as the director of the NTMoFA from 2009 onwards. He proactively enhanced the international visibility of contemporary Taiwanese art through exhibitions such as "Sensory Topology: Bodily Perception of Taiwan Contemporary Art," "At the Crossroad: Contemporary Artworks from Collection of GDMoA," "Ventriloquized Voices: Contemporary Art from Taiwan" (Gwangju Museum of Art, South Korea), "Landscape to Mindscape of Floating World: Contemporary Art from Taiwan" (Mitsuo Aida Museum, Japan), "Taiwan Calling" (Palace of Art and Ludwig Museum of Contemporary Art, Budapest, Hungary), "Flourishing and Flowing: A Contemporary Art Exhibition across the Strait 2011," "Inter-vision: A Contemporary Art Exhibition across the Strait 2013," "Rolling! Visual Art in Taiwan" (Seoul Museum of Art), "Gazing into Freedom: Taiwan Contemporary Art Exhibition" (Museum of Contemporary Art of Vojvodina, Serbia), and "Jie (Boundaries): Contemporary Art from Taiwan" (Herbert F. Johnson Museum of Art, Cornell University). In addition to promoting and staging large-scale international techno-art exhibitions from 2012 onwards, he engaged in the preparation for the Art Bank Taiwan under the directive of the Ministry of Culture, which has provided circulation services for young artists' works. Beginning from 2013, he launched the research exhibitions "The Pioneers of Taiwanese Artists" featuring five generations of Taiwanese artists born between 1931 and 1980 defined by decade as a generation.

The above-mentioned exhibitions led by Huang, whether at

home or abroad, can be collectively deemed a large-scale, comprehensive blueprint for cultural engineering. Huang believes that there is no such thing as a perfect system, and, if any, there is no guarantee that it will definitely produce talented artists and peerless masterpieces. On top of that, the reason why many art masters are able to create great works is exactly because they seclude themselves from the conservative, suffocating system. Serving as an official of the CCA and the director of major public museums, Huang would rather confront the core problems and solve them one by one than spend energy countering criticism or even passing the buck. Constraints on the artistic and cultural environment notwithstanding, he worked hard and persisted in promoting many relevant policies with good intentions. At first glance, his comments on the official documents and his paintings created in his spare time seemingly have nothing to do with the social trends. However, from the above-mentioned contributions he made, we may find the traces of his unwavering dedication against the ruthless wheel of time. I can't help but think of the folk song sung by Wang Meng-Ling during 1978 and 1989: "Shake your head when the gale blows. Straighten your back when it stops. Bend down and let the heavy rain fall on you when it comes. Raise your head and stand up straight when it ceases. Being unafraid of gale and rain, and determined to thrive, the grass is not weak at all." In this period, Huang was in all likelihood a passionate young man ready to devote himself to the arts according to the blueprint that he already drew up in his mind!

Several principles underpin Huang's blueprint, including holding senior Taiwanese artists in reverence, confirming the place and legacy of middle-aged artists in art history, supporting young artists, encouraging new media art exploration, accentuating the importance of historiography, as well as extensively publishing and circulating monologues of Taiwanese artists and academic journals. Together with Huang's flexible curatorial strategy in which localization and internationalization proceed side by side with public accessibility, these principles gently yet resolutely echo the spirit of reeds in his paintings. Huang's brush, whose

presence can be detected only in official documents, is artist-oriented. It serves artists from their perspective and highlights the nimbus of artists. It creates another invisible spectrum, an intangible blueprint for Taiwanese art. It is beyond the ability of banal cultural technocrats, and it cannot be fulfilled simply by words, funds, and art spaces. Thus, the significance of this invisible yet meticulously planned blueprint rivals that of the aforementioned six aspects of Huang's paintings. I believe that the profundity and breadth of this blueprint will be fairly judged by generations to come.

Of course, for those who joined the art world with genuine enthusiasm, it would be a pity if they only look at Huang's rich experience in arts administration and ignore his identity as an artist of remarkable self-discipline. Concealing his artistic talents for five decades to help others pursue their dreams has been an extraordinary achievement of Huang. He also paints in silence with simple paraphernalia at odd moments, which is nothing if not dashing and relaxed. The artistic value of Huang's paintings is not compromised even though their sizes are relatively small owing to the constraints of the external environment. The subjects of his paintings are ordinary objects in our quotidian existence. He nevertheless portrays them in an inimitable style as pleasant as peaceful. His selflessness in supporting his peers and the younger generation is even more admirable. It's worth noticing that only few of the numerous power-holders have a sense of propriety. Those who keep their nose to the grindstone are much fewer than those who talk in flowery language. In the art circle, there is no lack of silver-tongued people who are slick in establishing social relations and currying favor with those in power. Being talented yet self-effacing and farsighted with self-discipline, Huang had scrupulously abided by his duty to arts administration for five decades. After his retirement from public service, Huang returns to his original passion with contended charisma, and creates masterpieces with radiance in profusion, which reflects his true nature as a man of character.

作品圖版
Plates

子題一　從彩繪漸入素淡
From Colorful Painting to Noncolor

一九七〇年代就讀中國文化大學美術系初試油畫創作，即有野獸派的影響因子，係得自啟蒙之師郭柏川的薰陶。畢業後不久，因喜愛用炭精筆作畫，顏色趨於素淡，淡到僅剩黑白的禪畫境界。

When studying at the Department of Fine Arts of the Chinese Culture University in the 1970s, Huang started painting oil for the first time. His oil painting during this period shows an influence of Fauvism, which is due to the teaching of his mentor Kuo Po-Chuan. Not long after graduation, Huang gradually shifted to charcoal pencil drawing due to his personal preference, and the color of his works grew increasingly quiet until he only created black-and-white drawings and paintings informed by a sense of Zen.

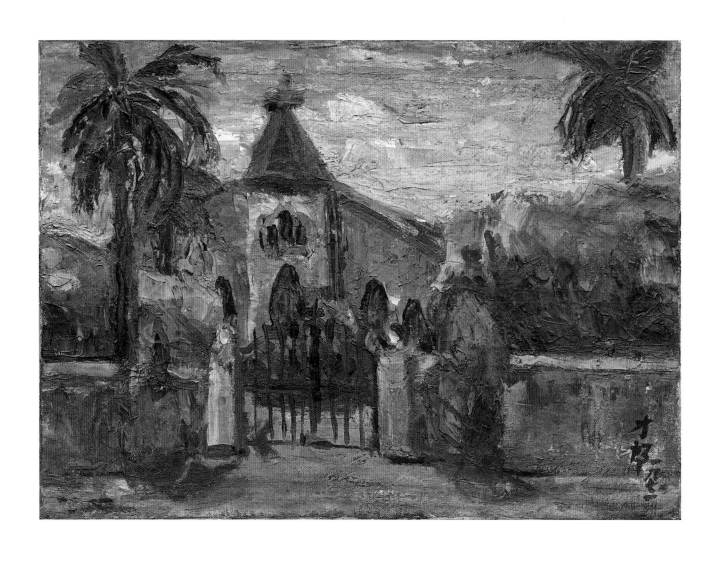

佳里教堂　1971　油彩、畫布　38.8×53.5公分　藝術家提供
The Jiali Church　1971　Oil on canvas　38.8 x 53.5 cm　Courtesy of the artist

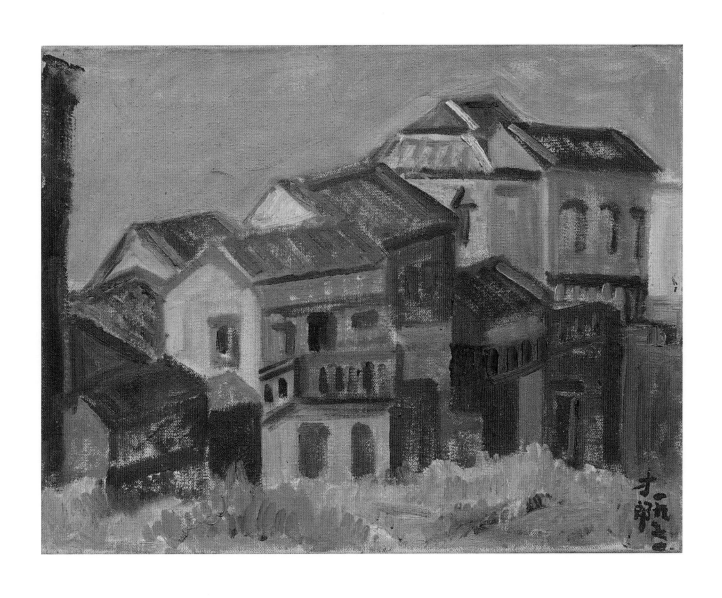

三峽　1971　油彩、畫布　31.5×41公分　藝術家提供
Sanxia　1971　Oil on canvas　31.5 x 41 cm　Courtesy of the artist

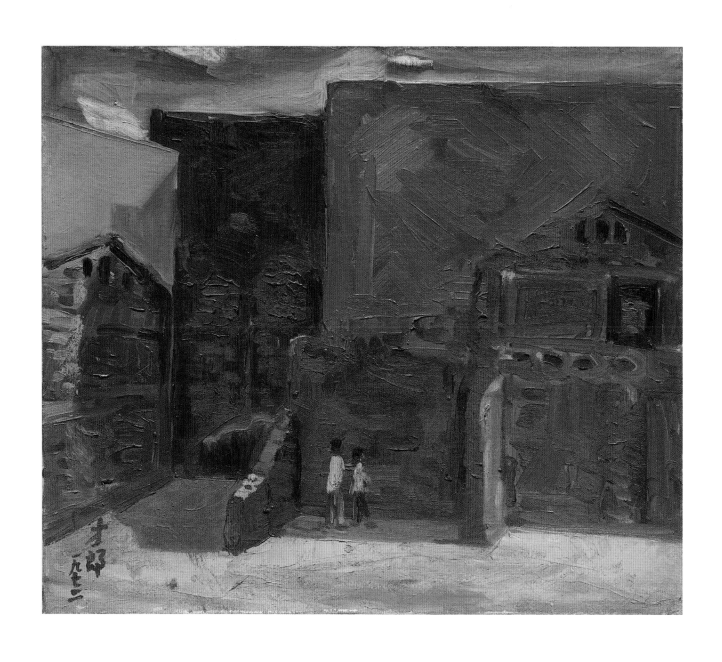

迪化街老牆　1972　油彩、畫布　45×52.7公分　藝術家提供
A Time-honored Wall on Dihua Street　1972　Oil on canvas　45 x 52.7 cm　Courtesy of the artist

臺南孔廟大成殿　1971　水彩、畫紙　35×50公分　藝術家提供
Ta-Cheng Hall of Tainan Confucius Temple　1971　Watercolor on paper　35 x 50 cm　Courtesy of the artist

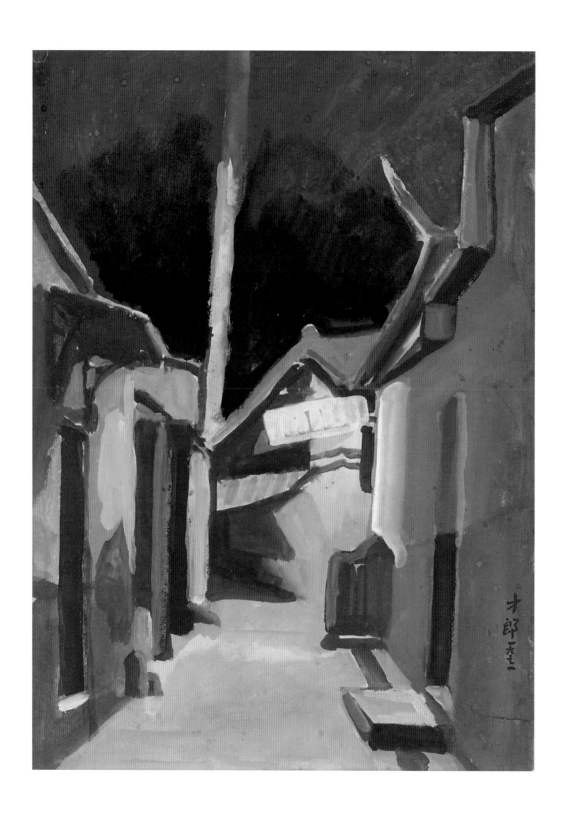

臺南天后宮小巷夜景　1971　水彩、畫紙　50×35公分　藝術家提供
An Alleyway at Night near Tainan Tianhou Temple　1971　Watercolor on paper　50 x 35 cm　Courtesy of the artist

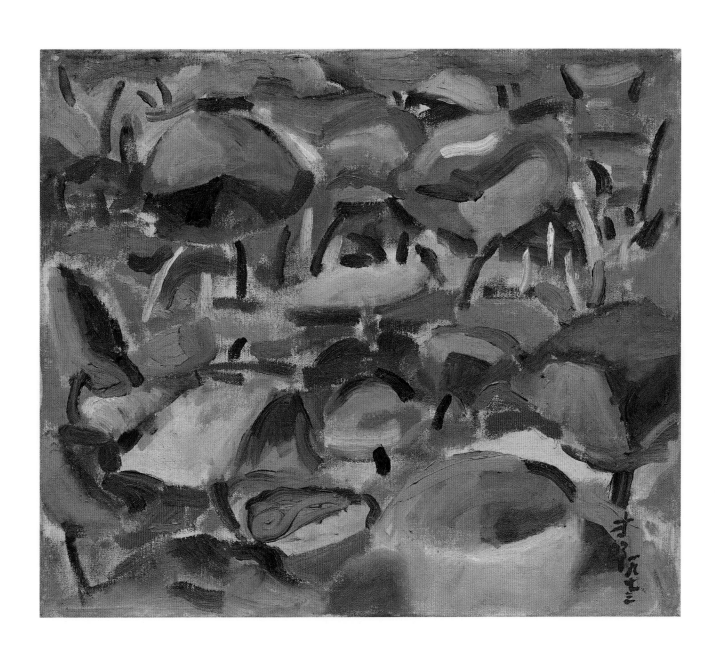

荷花池　1973　油彩、畫布　45.5×53公分　藝術家提供
Lotus Pond　1973　Oil on canvas　45.5 x 53 cm　Courtesy of the artist

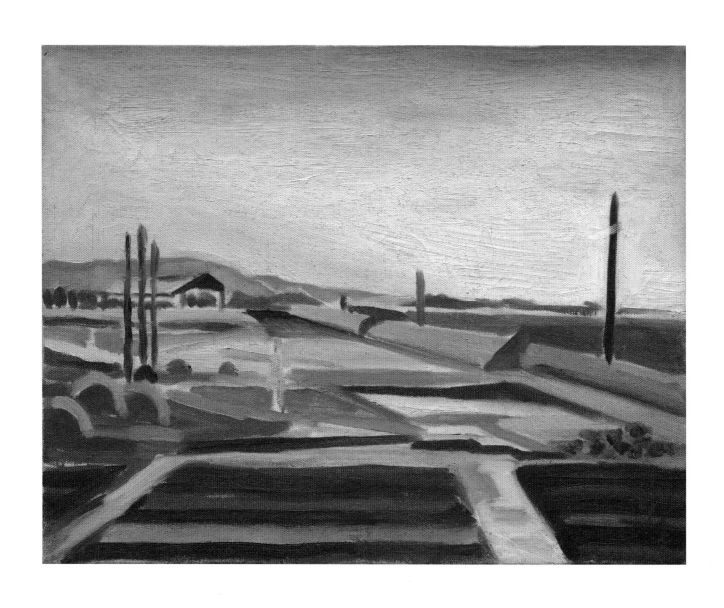

成功嶺靶場　1973　油彩、畫布　31.8×41公分　藝術家提供
Shooting Range at Chenggong Hill　1973　Oil on canvas　31.8 x 41 cm　Courtesy of the artist

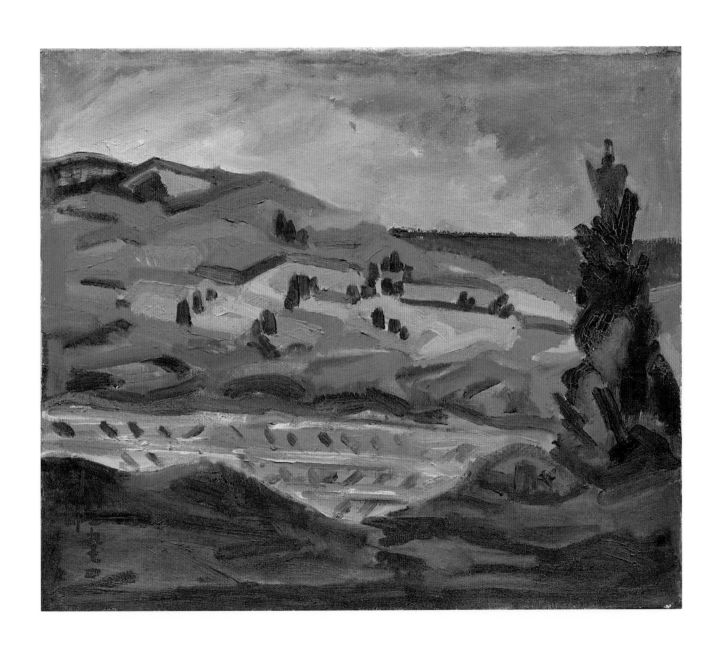

成功嶺　1974　油彩、畫布　45×53公分　藝術家提供
Chenggong Hill　1974　Oil on canvas　45 x 53 cm　Courtesy of the artist

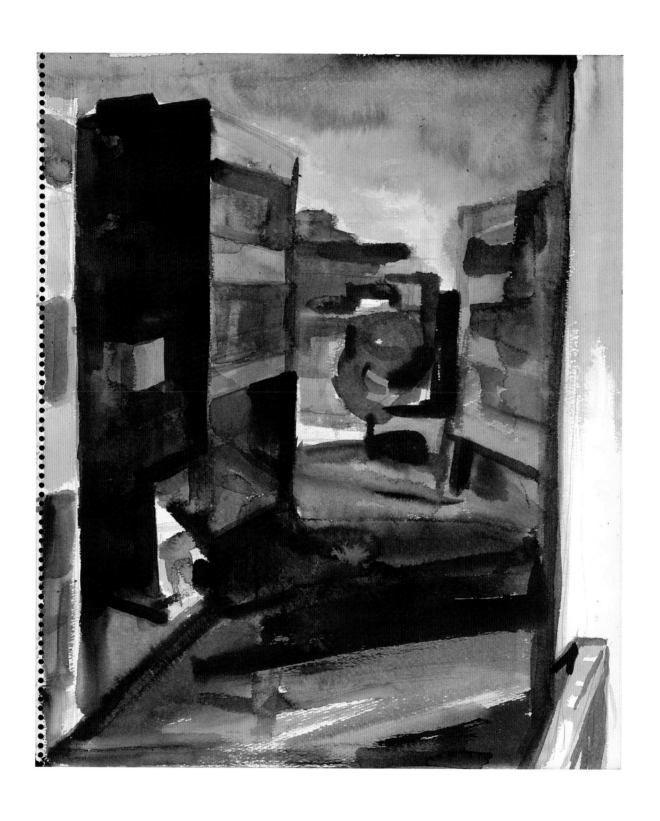

深夜的吳興街巷口　1974　水彩、畫紙　46×38公分　藝術家提供
Late Night in an Alley on Wuxing Street　1974　Watercolor on paper　46 x 38 cm　Courtesy of the artist

火車上的茶杯　1974　鉛筆、畫紙
37×26公分　藝術家提供
Tea Glass on the Train　1974　Pencil on paper
37 x 26 cm　Courtesy of the artist

夜宿宮廟前庭　1974　鉛筆、畫紙
26×19公分　藝術家提供
Stay the Night at the Front Yard of a Temple　1974
Pencil on paper　26 x 19 cm　Courtesy of the artist

延平中學校園老樹　1976　炭精筆、畫紙　38.3×25.8公分　藝術家提供
Old Tree on the Campus of Yanping High School　1976　Compressed charcoal pencil on paper　38.3 x 25.8 cm　Courtesy of the artist

秋日落葉　1980　油彩、畫布　72.5×91公分　藝術家提供
Fallen Leaves in Autumn　1980　Oil on canvas　72.5 x 91 cm　Courtesy of the artist

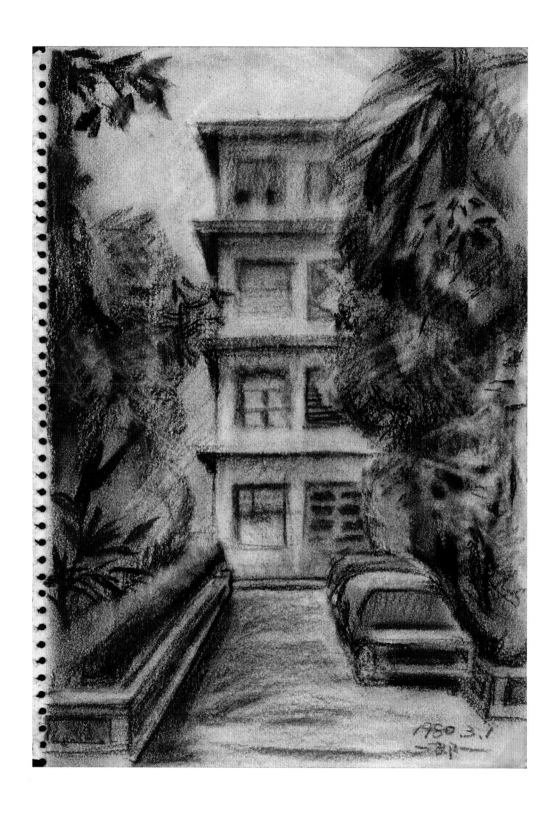

延平中學校園 1980 炭精、畫紙 53.5×38.8公分 藝術家提供
Campus of Yanping High School 1980 Compressed charcoal on paper 53.5 x 38.8 cm Courtesy of the artist

靜物　1972　水彩、畫紙　46×38公分　藝術家提供
Still life　1972　Watercolor on paper　46 x 38 cm　Courtesy of the artist

仙人掌　1972　油彩、畫布　41×53公分　藝術家提供
Cactus　1972　Oil on canvas　41 x 53 cm　Courtesy of the artist

畫室　1973　油彩、畫布　162×130公分　藝術家提供
Art Studio　1973　Oil on canvas　162 x 130 cm　Courtesy of the artist

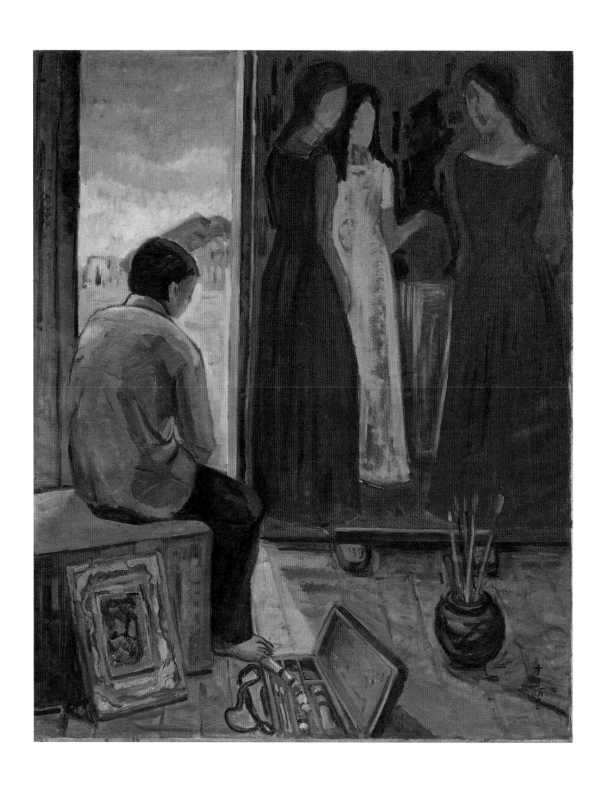

畫室　1972　油彩、畫布　162×130.5公分　藝術家提供
Art Studio　1972　Oil on canvas　162 x 130.5 cm　Courtesy of the artist

子題二　親情、人情與蘭嶼留影
Family, Friendship, and the Images of Lanyu

黃才郎從小就靠祖父母撫養長大，故以恭敬之
心、恩重之情描繪長輩肖像。結婚之後也趁夜闌
人靜，為襁褓中的兒女繪出他（她）們可愛的睡
姿。之後，更以油畫大作印記兒女成長的灑脫之
像，以及當兵時期的火車上速寫人物等等。
文化大學美術系尚未畢業，就曾嚮導洪瑞麟、張
萬傳、陳景容等知名畫家赴蘭嶼寫生，至今仍留
有當地寫生的粉彩和速寫。

Huang was raised by his grandparents. So, he painted
portraits of family elders with reverence and sincere
gratitude. After he got married, he also painted his
infant son and daughter in sleep at night. Later, he
even painted oils of his son and daughter growing up
as a record of their free spirit, and created sketching
drawings of figures observed on trains when he
did military service. Before graduating from the
Department of Fine Arts of the Chinese Culture
University, he had guided a group of renowned
painters, including Hung Jui-Lin (1912-1996), Chang
Wan-Chuan (1909-2003), Chen Ching-Jung (1934-)
and others, to conduct a painting trip to Lanyu. Until
today, he still keeps his Lanyu-themed pastel paintings
and sketch drawings created en plein air.

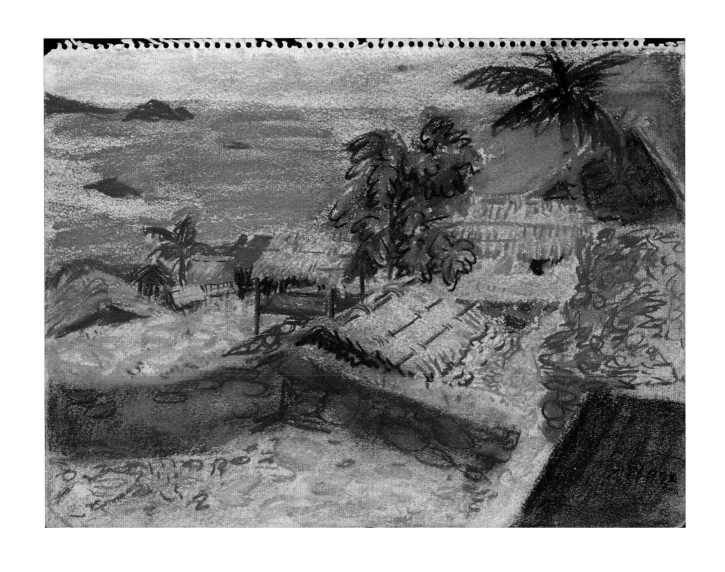

蘭嶼寫生　1972　粉彩、畫紙　26.5×36.5公分　藝術家提供
Lanyu En Plein Air　1972　Pastel on paper　26.5 x 36.5 cm　Courtesy of the artist

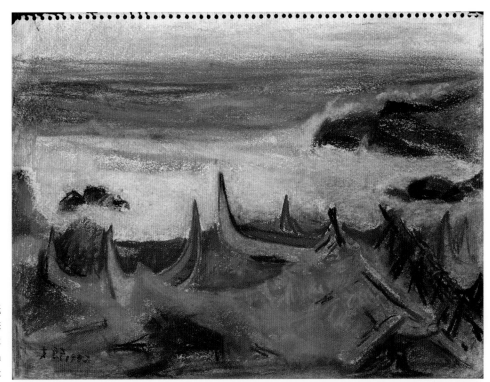

蘭嶼寫生　1972　粉彩、畫紙
26.5×36.5公分　藝術家提供
Lanyu En Plein Air　1972
Pastel on paper　26.5 x 36.5 cm
Courtesy of the artist

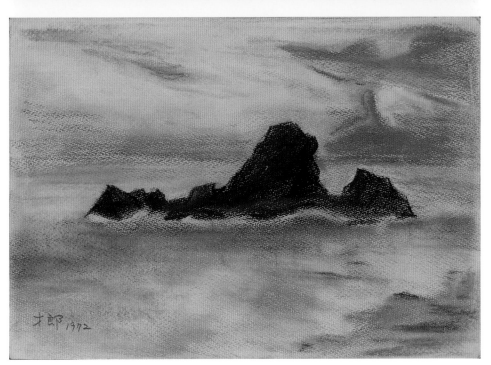

蘭嶼黃昏的軍艦島　1972
粉彩、畫紙　27×38.5公分
藝術家提供
Warship Rock in Lanyu at Sunset
1972　Pastel on paper　27 x 38.5 cm
Courtesy of the artist

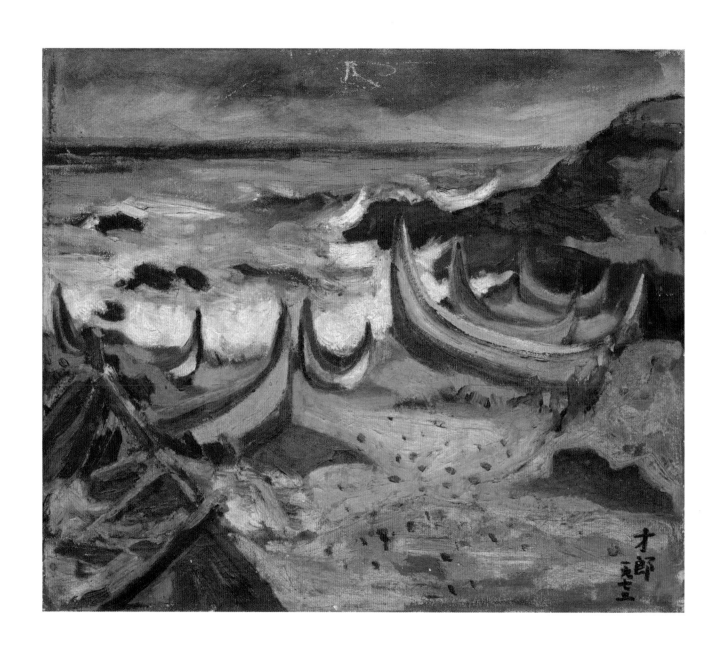

蘭嶼海灘　1972　油彩、畫布　45×53公分　藝術家提供
Beach in Lanyu　1972　Oil on canvas　45 x 53 cm　Courtesy of the artist

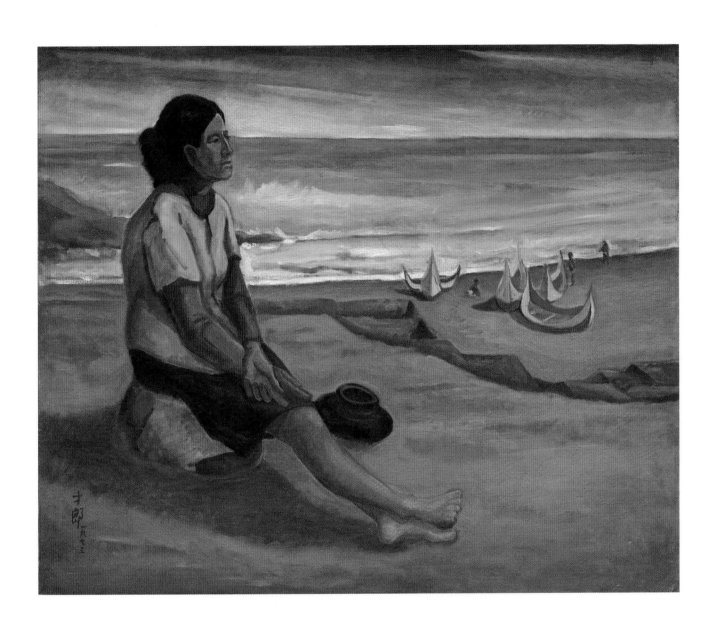

蘭嶼風光　1973　油彩、畫布　130×162公分　藝術家提供
Lanyu Scenery　1973　Oil on canvas　130 x 162 cm　Courtesy of the artist

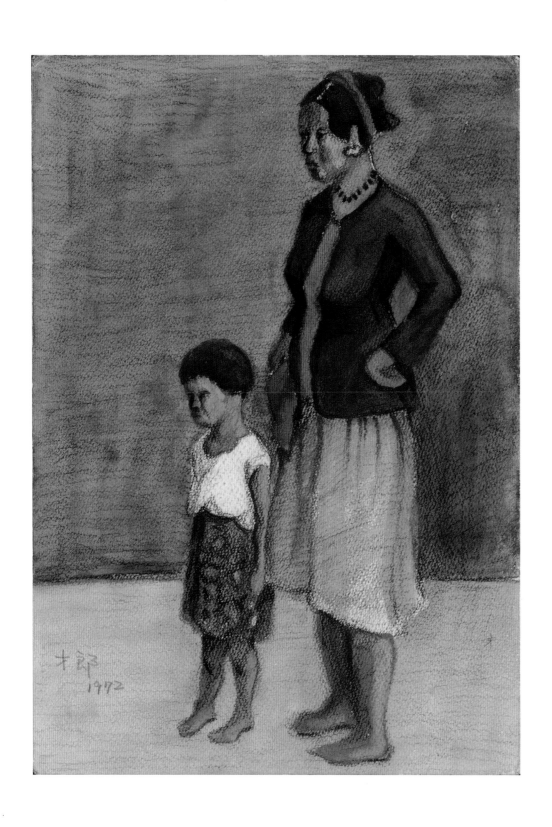

臺東母與女　1972　碳精、水彩、畫紙　38.5×27公分　藝術家提供
Mother and Daughter in Taitung　1972　Compressed charcoal and watercolor on paper　38.5 x 27 cm　Courtesy of the artist

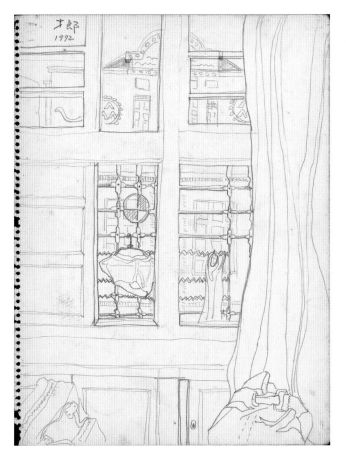

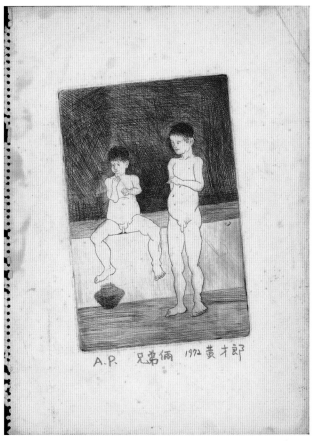

臺東旅社鐵花窗　1972　鉛筆、畫紙
36.5×21公分　藝術家提供
Hotel Window Grilles in Taitung　1972
Pencil on paper　36.5 x 21 cm　Courtesy of the artist

臺東兄弟倆　1972　壓克力版、畫紙
22×15公分　藝術家提供
Two Brothers in Taitung　1972
Acrylic plate, paper　22 x 15 cm　Courtesy of the artist

部落老人　1972　鉛筆、畫紙
36×26公分　藝術家提供
A Tribal Elder　1972　Pencil on paper
36 x 26 cm　Courtesy of the artist

臺東女子　1972　鉛筆、畫紙
36×26公分　藝術家提供
A Woman in Taitung　1972　Pencil on paper
36 x 26 cm　Courtesy of the artist

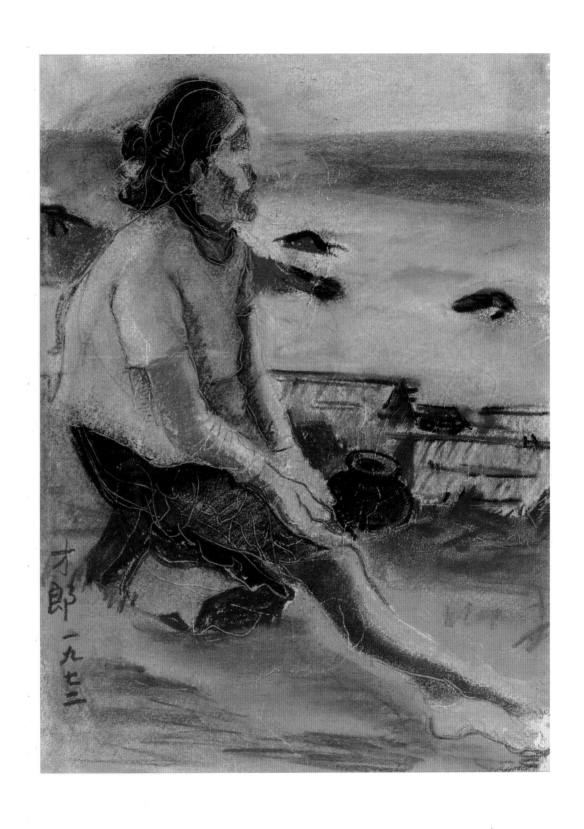

蘭嶼老婦　1972　粉彩、畫紙　35.5×26公分　藝術家提供
An Elderly Woman in Lanyu　1972　Pastel on paper　35.5 x 26 cm　Courtesy of the artist

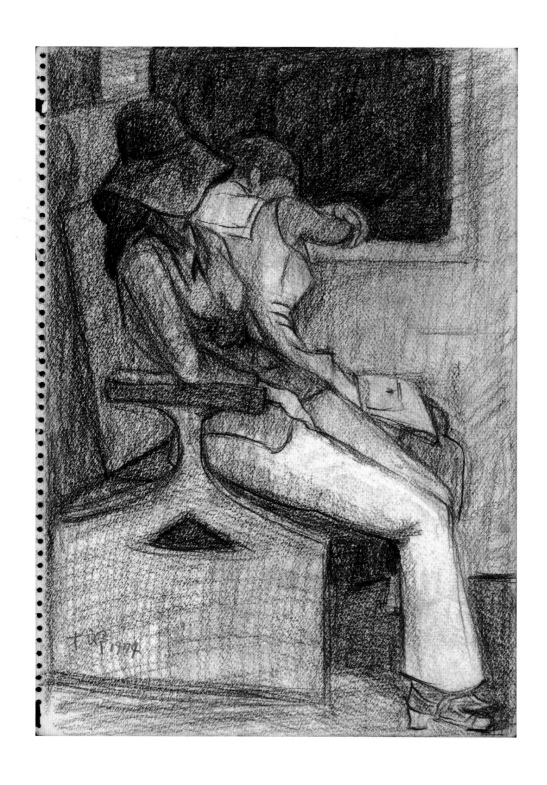

火車上　1974　鉛筆、畫紙　36×25公分　藝術家提供
On the Train　1974　Pencil on paper　36 x 25 cm　Courtesy of the artist

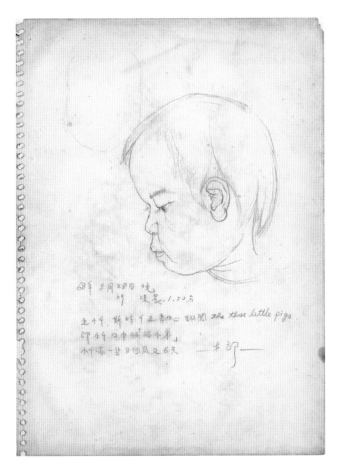

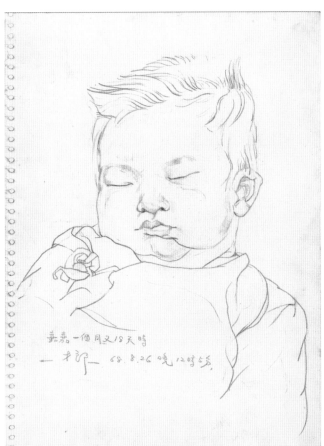

小千畫像　1979　鉛筆、畫紙
38×26公分　藝術家提供
Portrait of Xiao-Chien　1979　Pencil on paper
38 x 26 cm　Courtesy of the artist

茂嘉畫像　1979　鉛筆、畫紙
38×26公分　藝術家提供
Portrait of Mao-Chia　1979　Pencil on paper
38 x 26 cm　Courtesy of the artist

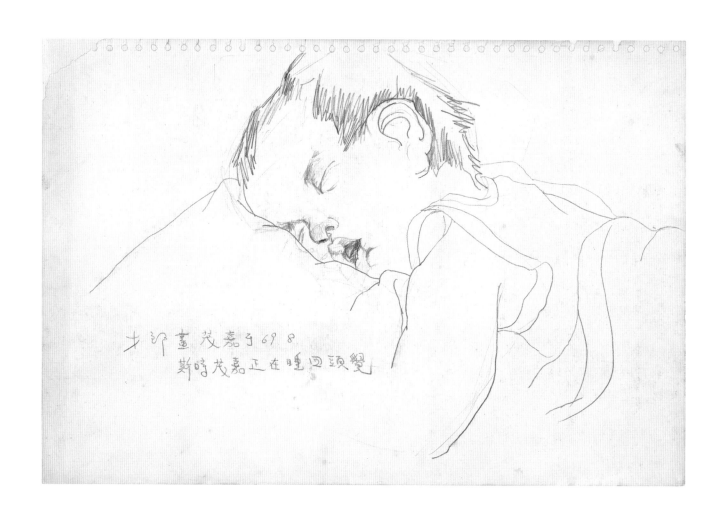

茂嘉畫像　1980　鉛筆、畫紙　26×38公分　藝術家提供
Portrait of Mao-Chia　1980　Pencil on paper　26 x 38 cm　Courtesy of the artist

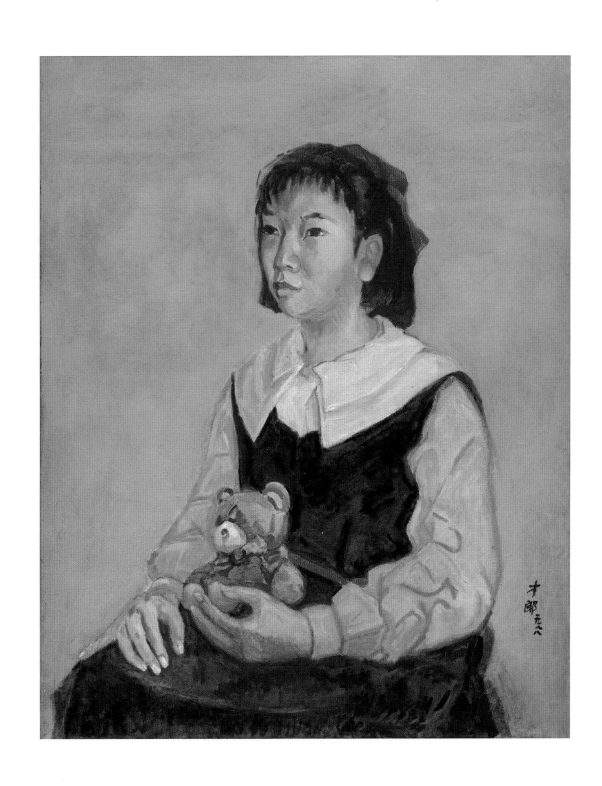

小千畫像　1988　油彩、畫布　72.5×60.5公分　藝術家提供
Portrait of Xiao-Chien　1988　Oil on canvas　72.5 x 60.5 cm　Courtesy of the artist

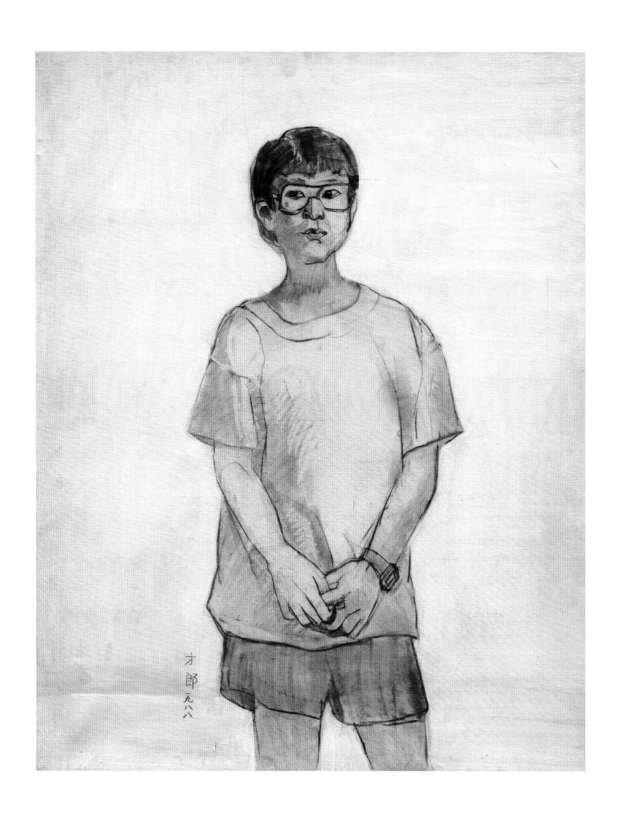

茂嘉畫像　1988　炭筆、畫布　91×72.5公分　藝術家提供
Portrait of Mao-Chia　1988　Charcoal pencil on canvas　91 x 72.5 cm　Courtesy of the artist

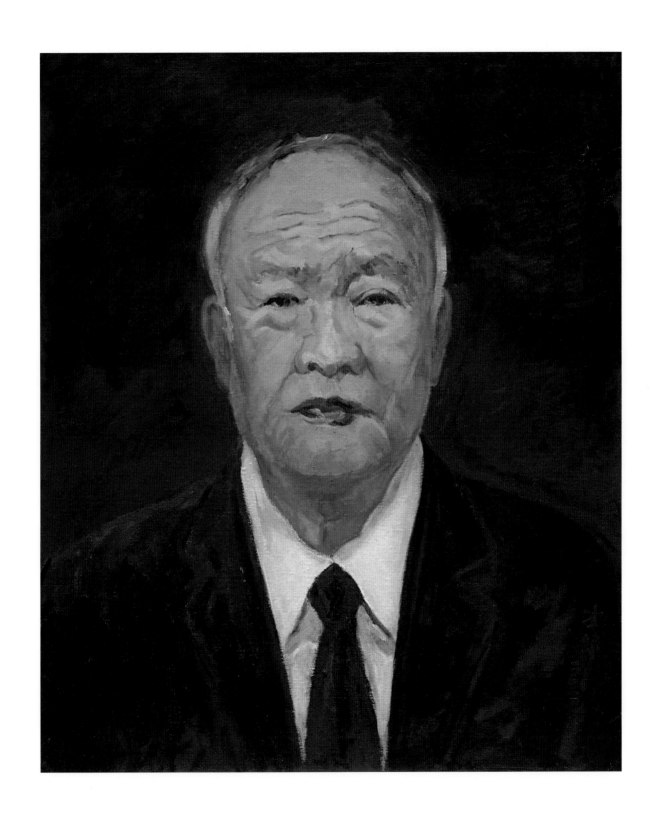

祖父的畫像　2022　油彩、畫布　72.5×60.5公分　藝術家提供
Portrait of Grandfather　2022　Oil on canvas　72.5 x 60.5 cm　Courtesy of the artist

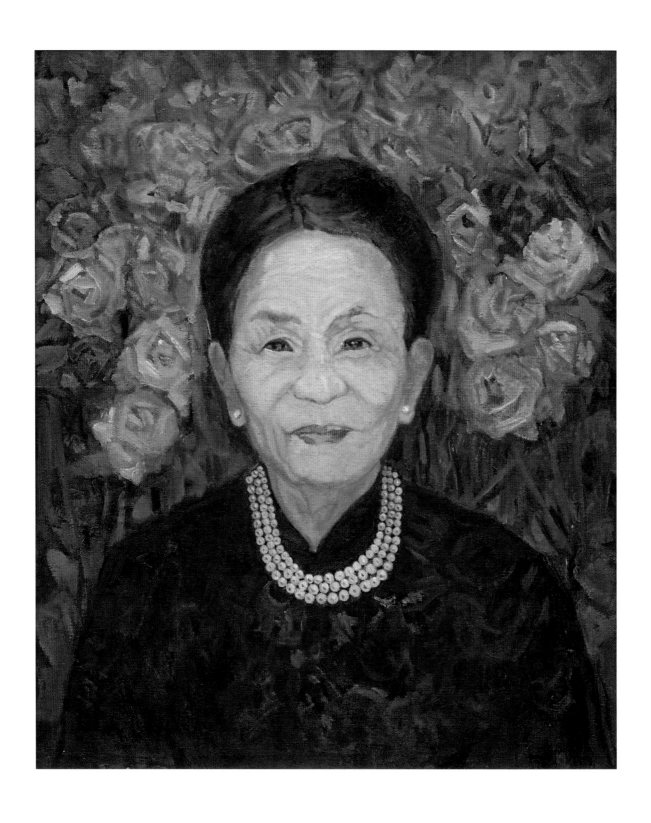

祖母的畫像　2022　油彩、畫布　72.5×60.5公分　藝術家提供
Portrait of Grandmother　2022　Oil on canvas　72.5 x 60.5 cm　Courtesy of the artist

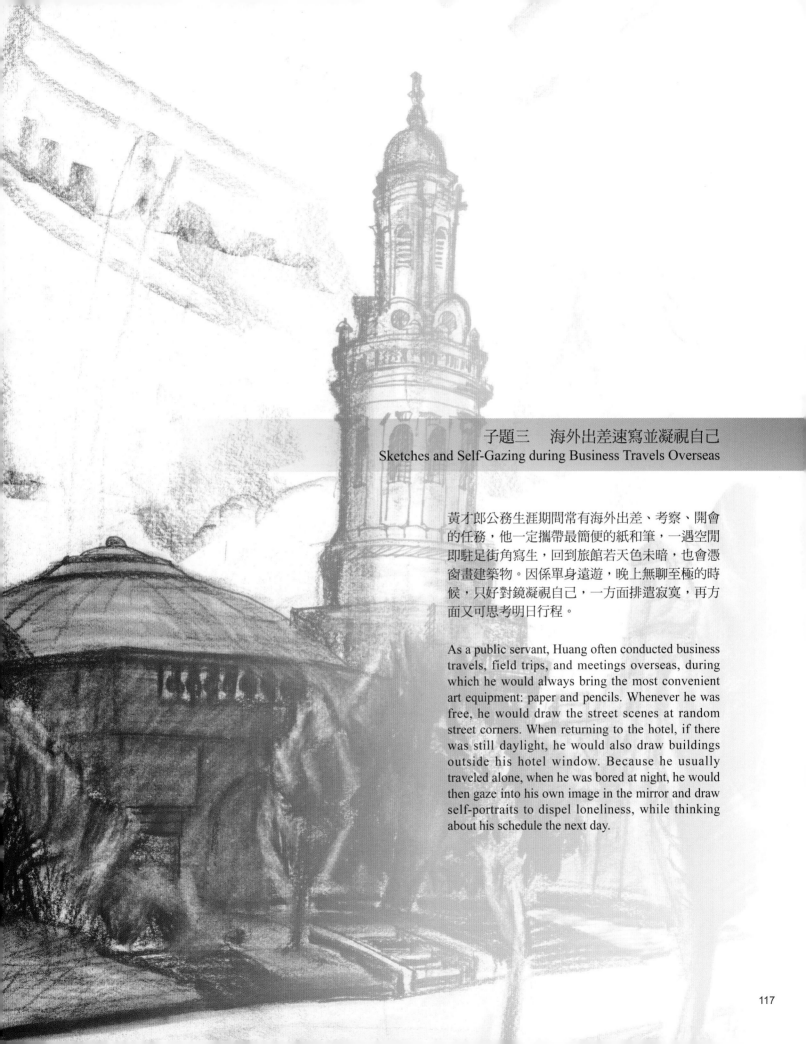

子題三　海外出差速寫並凝視自己
Sketches and Self-Gazing during Business Travels Overseas

黃才郎公務生涯期間常有海外出差、考察、開會
的任務，他一定攜帶最簡便的紙和筆，一遇空閒
即駐足街角寫生，回到旅館若天色未暗，也會憑
窗畫建築物。因係單身遠遊，晚上無聊至極的時
候，只好對鏡凝視自己，一方面排遣寂寞，再方
面又可思考明日行程。

As a public servant, Huang often conducted business
travels, field trips, and meetings overseas, during
which he would always bring the most convenient
art equipment: paper and pencils. Whenever he was
free, he would draw the street scenes at random
street corners. When returning to the hotel, if there
was still daylight, he would also draw buildings
outside his hotel window. Because he usually
traveled alone, when he was bored at night, he would
then gaze into his own image in the mirror and draw
self-portraits to dispel loneliness, while thinking
about his schedule the next day.

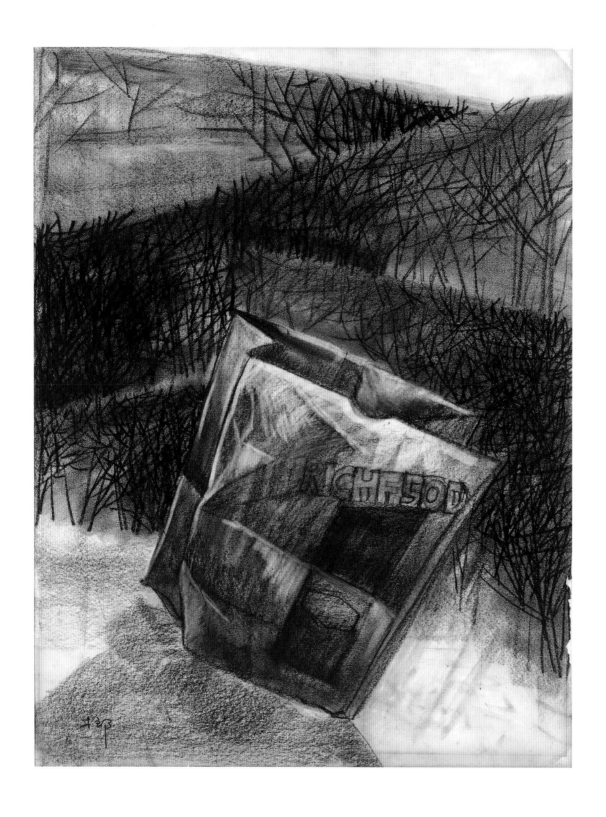

購物袋　1988　炭精筆、畫紙　59×46公分　藝術家提供
Shopping Bag　1988　Compressed charcoal pencil on paper　59 x 46 cm　Courtesy of the artist

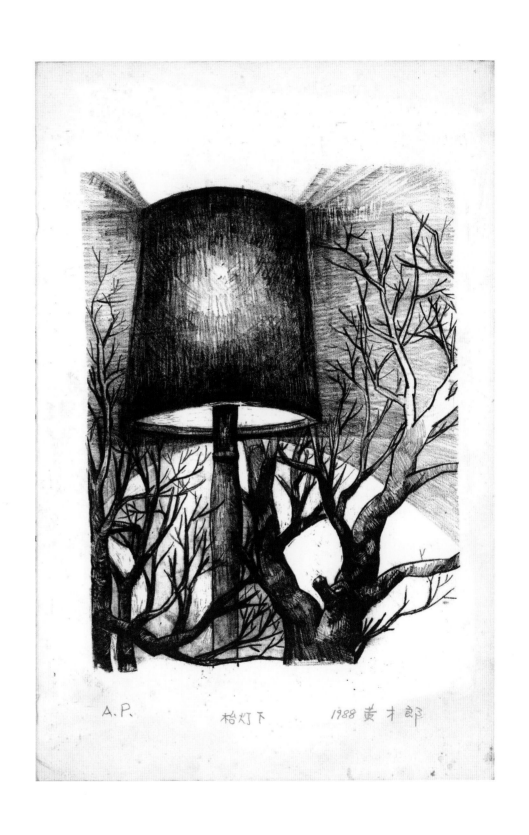

A. P.　　　　　枱灯下　　　　1988 黃才郎

寂　1988　版畫、紙　50×33公分　藝術家提供
Silence　1988　Print on paper　50 x 33 cm　Courtesy of the artist

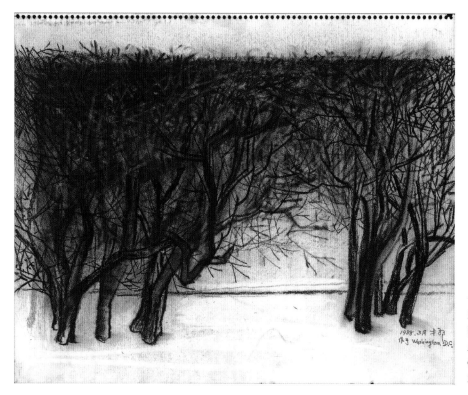

七里香樹籬　1988
炭精筆、畫紙　31.5×41公分
藝術家提供
Fences of Common Jasmine Orange　1988
Compressed charcoal pencil on paper
31.5 x 41 cm　Courtesy of the artist

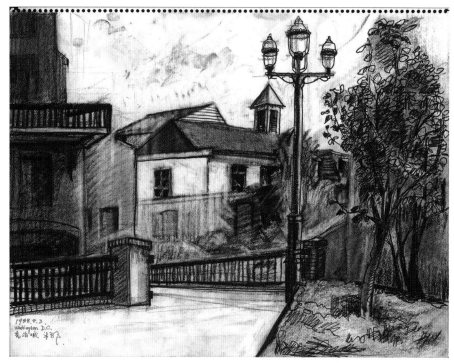

美國華盛頓喬治城　1988
炭精筆、畫紙　31.5×41公分
藝術家提供
Georgetown, Washington, D.C.　1988
Compressed charcoal pencil on paper
31.5 x 41 cm　Courtesy of the artist

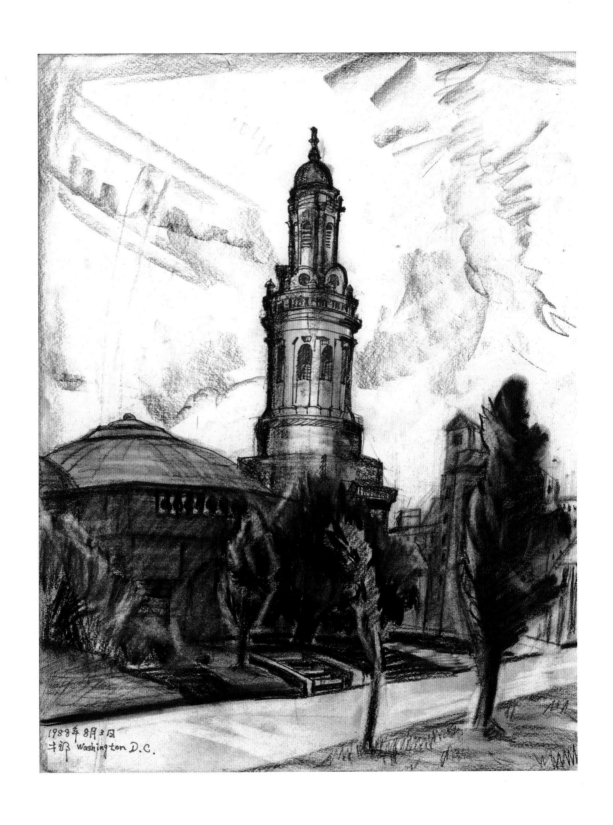

華盛頓特區　1988　炭精筆、畫紙　41×31.5公分　藝術家提供
Washington, D.C.　1988　Compressed charcoal pencil on paper　41 x 31.5 cm　Courtesy of the artist

巴黎速寫（一） 2001 簽字筆、紙
13×19公分 藝術家提供
Paris Sketch (I) 2001 Pen on paper
13 x 19 cm Courtesy of the artist

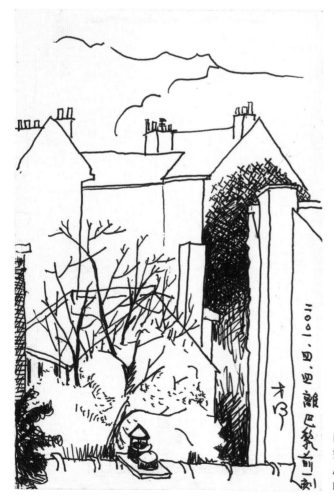

巴黎速寫（二） 2001
簽字筆、紙 19×13公分 藝術家提供
Paris Sketch (II) 2001
Pen on paper 19 x 13 cm Courtesy of the artist

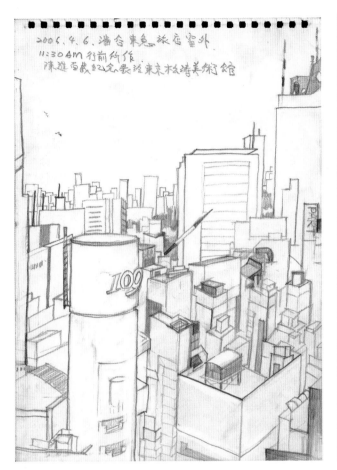

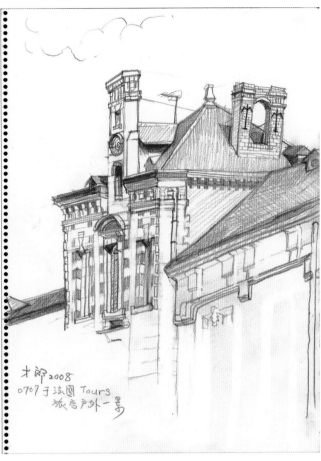

旅店（窗外） 2006 鉛筆、畫紙
29×21公分 藝術家提供
Lodging (Window View) 2006 Pencil on paper
29 x 21 cm Courtesy of the artist

Tours 旅店 2008 鉛筆、畫紙
33×23.5公分 藝術家提供
Hotel in Tours 2008 Pencil on paper
33 x 23.5 cm Courtesy of the artist

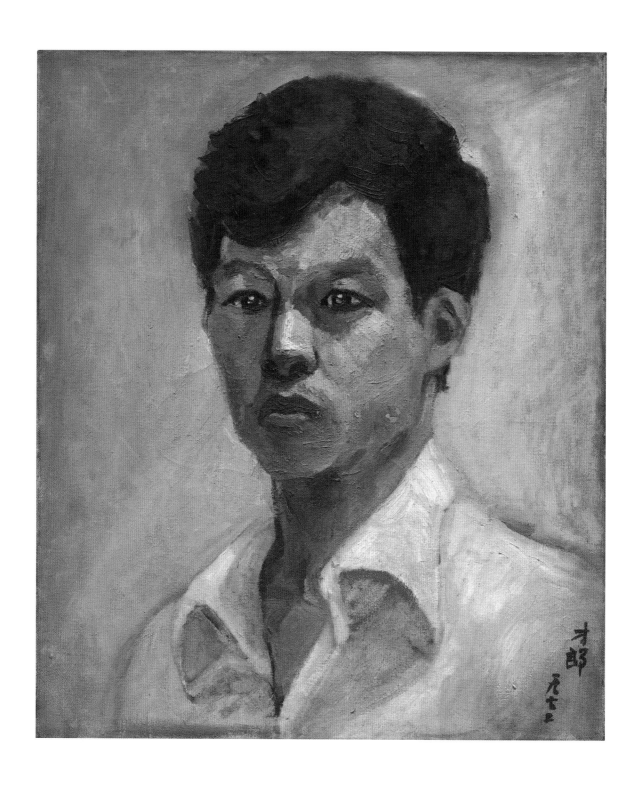

自畫像 1972 油彩、畫布 53.1×45.3公分 藝術家提供
Self-Portrait 1972 Oil on canvas 53.1 x 45.3 cm Courtesy of the artist

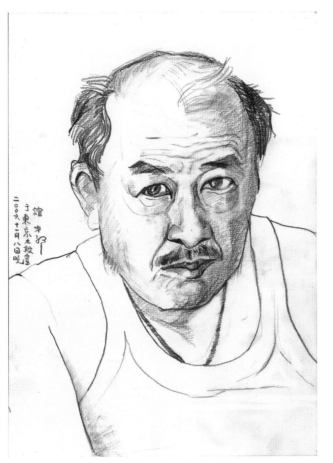

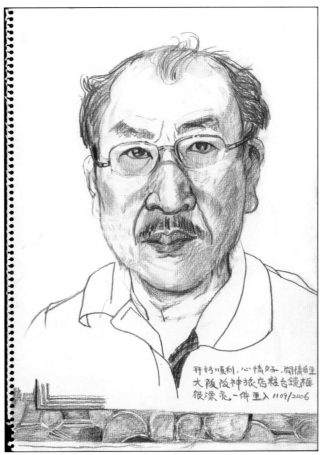

自畫像　2006　鉛筆、畫紙
33×23.5公分　藝術家提供
Self-Portrait　2006　Pencil on paper
33 x 23.5 cm　Courtesy of the artist

自畫像　2006　鉛筆、畫紙
33×23.5公分　藝術家提供
Self-Portrait　2006　Pencil on paper
33 x 23.5 cm　Courtesy of the artist

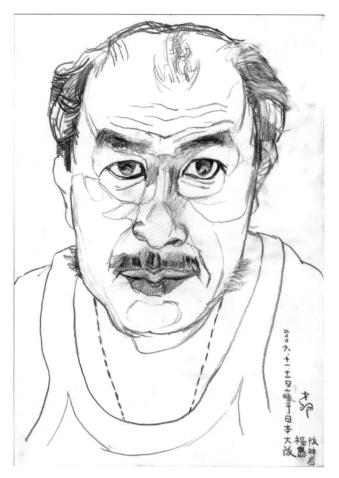

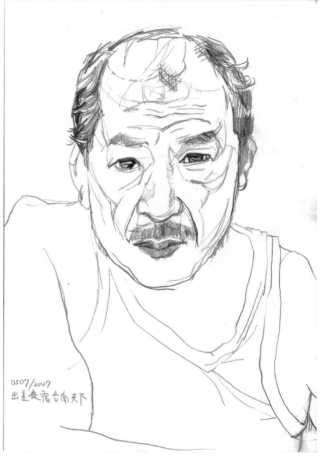

自畫像　2006　鉛筆、畫紙
33×23.5公分　藝術家提供
Self-Portrait　2006　Pencil on paper
33 x 23.5 cm　Courtesy of the artist

自畫像　2007　鉛筆、畫紙
33×23.5公分　藝術家提供
Self-Portrait　2007　Pencil on paper
33 x 23.5 cm　Courtesy of the artist

自畫像 2008 鉛筆、畫紙
33×23.5公分 藝術家提供
Self-Portrait 2008 Pencil on paper
33 x 23.5 cm Courtesy of the artist

自畫像 2009 鉛筆、畫紙
33×23.5公分 藝術家提供
Self-Portrait 2009 Pencil on paper
33 x 23.5 cm Courtesy of the artist

東京都千代田区九段南 1-6-5

但卷有感受，晚間欲後作此速寫、
頗有收獲，更見展出日本近代繪重，隨行程匆匆
下午覃見日本國立美術館法人理事長及營運部長等，
上午拜訪國立西洋美術館正展出此利時皇家收藏
二〇〇六年十一月六日公差出國汸日本研究美術館送此匯辭57生

1107/2006 於東京九段倉館新館

自畫像 2006 鉛筆、畫紙 33×23.5公分 藝術家提供
Self-Portrait 2006 Pencil on paper 33 x 23.5 cm Courtesy of the artist

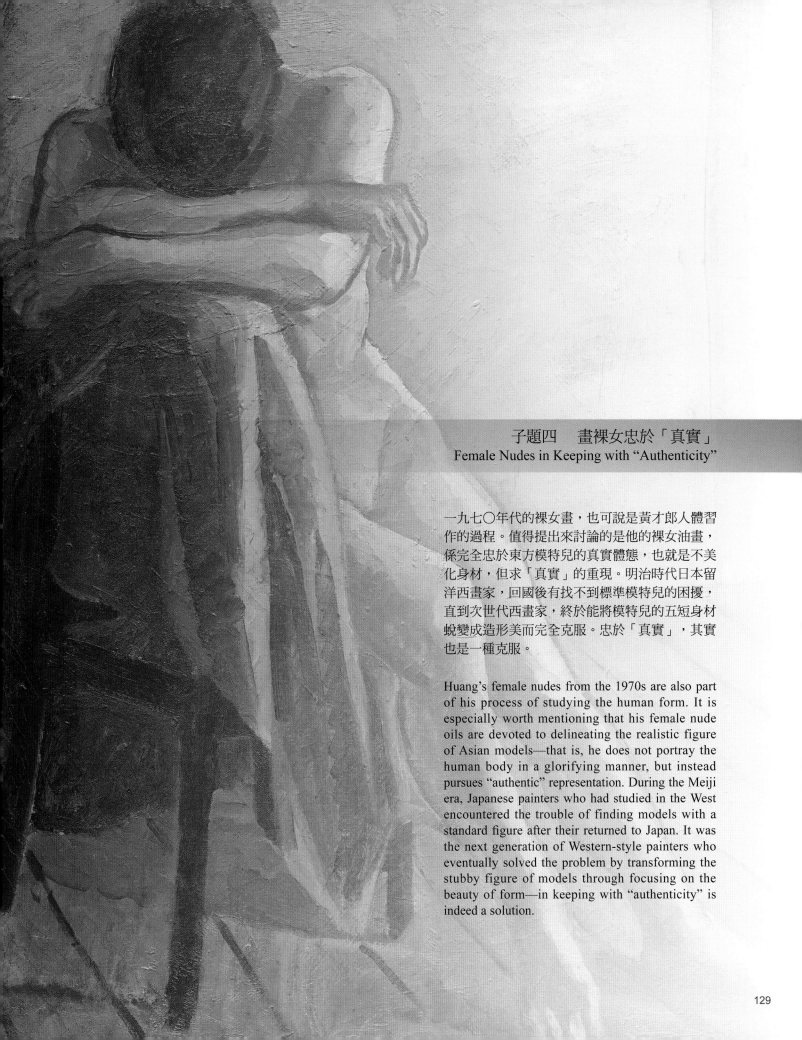

子題四　畫裸女忠於「真實」
Female Nudes in Keeping with "Authenticity"

一九七〇年代的裸女畫，也可說是黃才郎人體習作的過程。值得提出來討論的是他的裸女油畫，係完全忠於東方模特兒的真實體態，也就是不美化身材，但求「真實」的重現。明治時代日本留洋西畫家，回國後有找不到標準模特兒的困擾，直到次世代西畫家，終於能將模特兒的五短身材蛻變成造形美而完全克服。忠於「真實」，其實也是一種克服。

Huang's female nudes from the 1970s are also part of his process of studying the human form. It is especially worth mentioning that his female nude oils are devoted to delineating the realistic figure of Asian models—that is, he does not portray the human body in a glorifying manner, but instead pursues "authentic" representation. During the Meiji era, Japanese painters who had studied in the West encountered the trouble of finding models with a standard figure after their returned to Japan. It was the next generation of Western-style painters who eventually solved the problem by transforming the stubby figure of models through focusing on the beauty of form—in keeping with "authenticity" is indeed a solution.

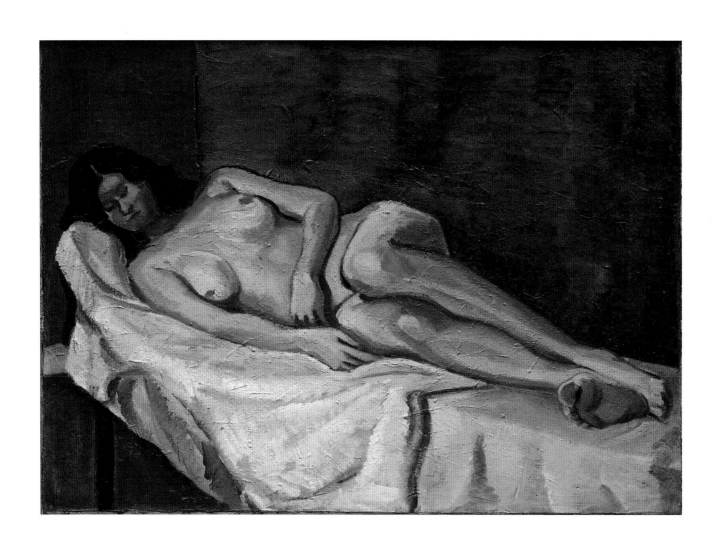

裸女 1972 油彩、畫布 65×90.7公分 藝術家提供
Female Nude 1972 Oil on canvas 65 x 90.7 cm Courtesy of the artist

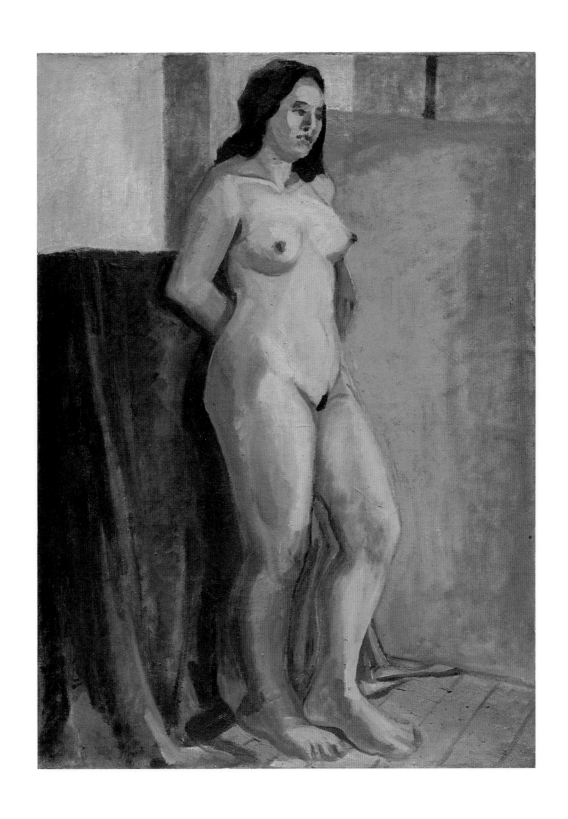

裸女　1972　油彩、畫布　90.5×65公分　藝術家提供
Female Nude　1972　Oil on canvas　90.5 x 65 cm　Courtesy of the artist

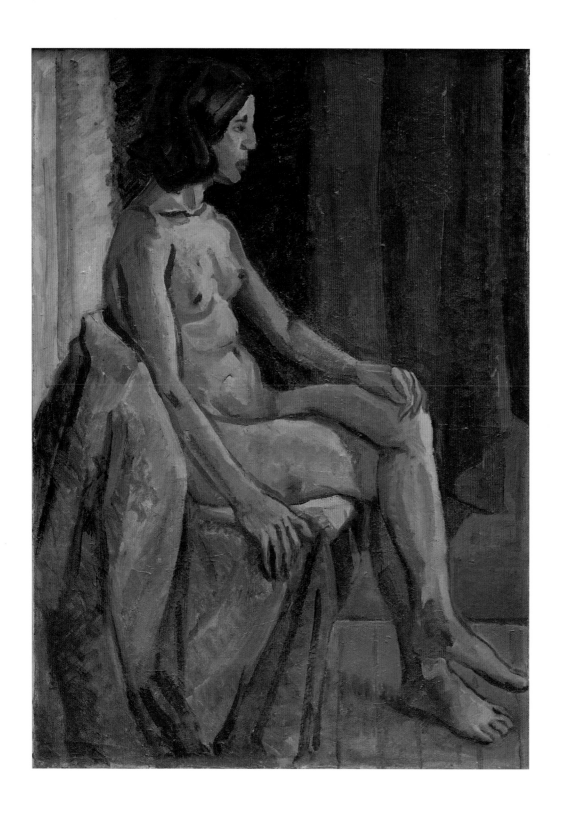

裸女　1972　油彩、畫布　90.5×60.5公分　藝術家提供
Female Nude　1972　Oil on canvas　90.5 x 60.5 cm　Courtesy of the artist

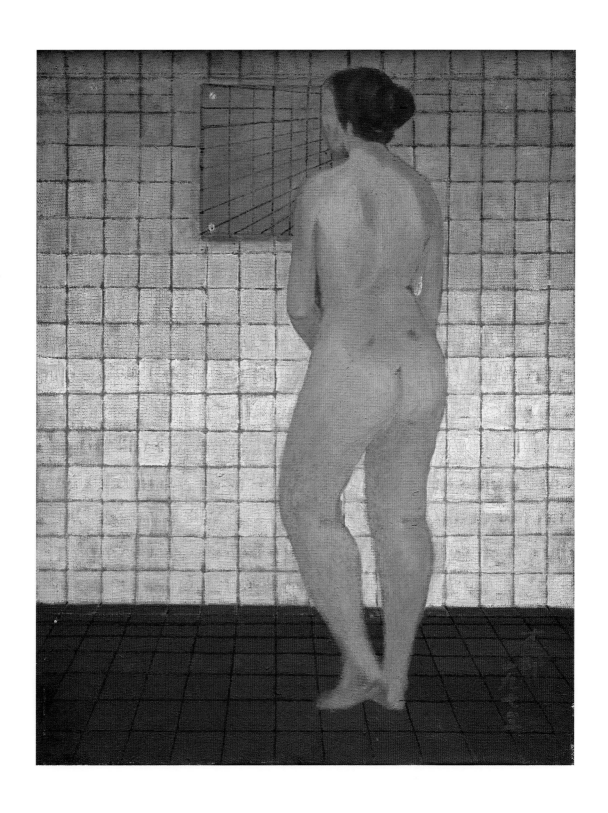

裸女　1973　油彩、畫布　40.8×31.7公分　藝術家提供
Female Nude　1973　Oil on canvas　40.8 x 31.7 cm　Courtesy of the artist

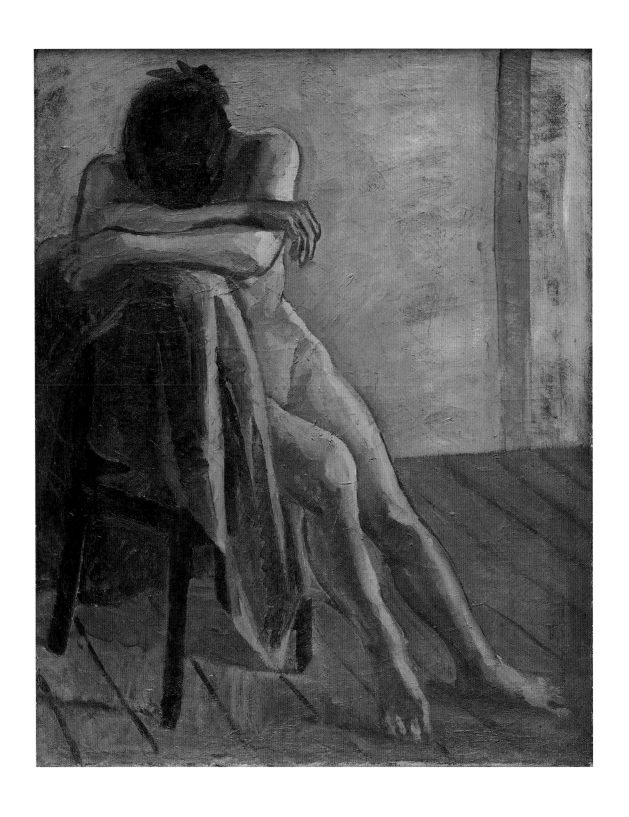

裸女　1973　油彩、畫布　90.8×72.8公分　藝術家提供
Female Nude　1973　Oil on canvas　90.8 x 72.8 cm　Courtesy of the artist

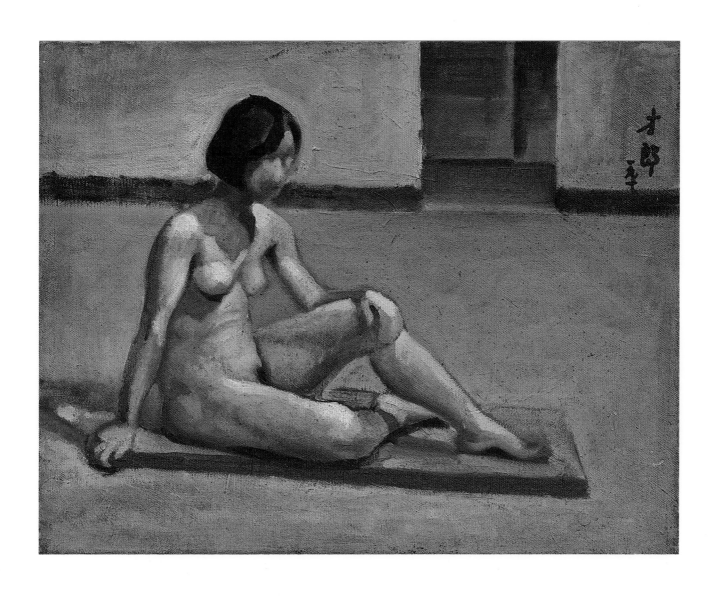

裸女 1973 油彩、畫布 31.7×40.8公分 藝術家提供
Female Nude 1973 Oil on canvas 31.7 x 40.8 cm Courtesy of the artist

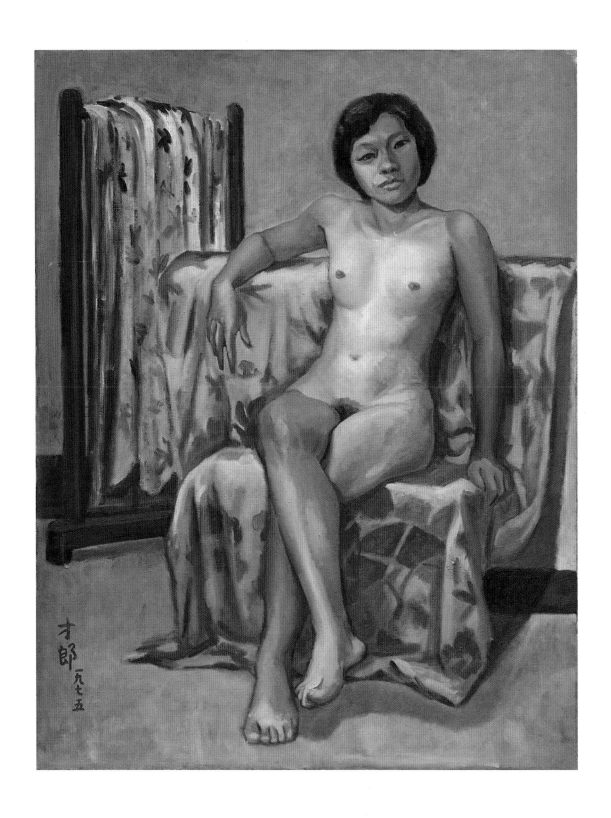

裸女　1975　油彩、畫布　117×91公分　藝術家提供
Female Nude　1975　Oil on canvas　117 x 91 cm　Courtesy of the artist

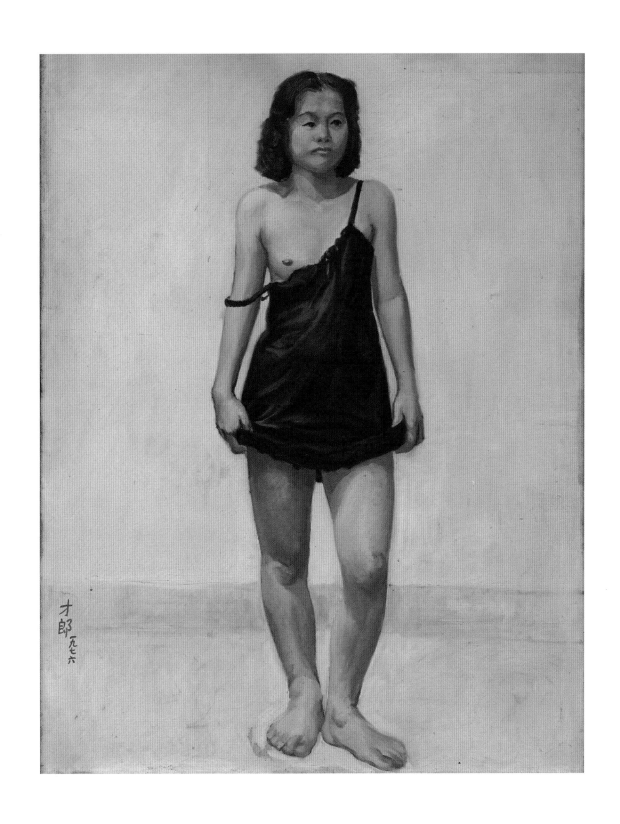

黑衣少女 1976 油彩、畫布 116.5×91公分 藝術家提供
The Young Girl in Black 1976 Oil on canvas 116.5 x 91 cm Courtesy of the artist

麗達與天鵝　1976　油彩、畫布　72×90公分　藝術家提供
Leda and the Swan　1976　Oil on canvas　72 x 90 cm　Courtesy of the artist

裸女　1979　油彩、畫布　90.8×116公分　藝術家提供
Female Nude　1979　Oil on canvas　90.8 x 116 cm　Courtesy of the artist

裸女 1979 炭精筆、畫紙 49.5×64.5公分 藝術家提供
Female Nude 1979 Compressed charcoal pencil on paper 49.5 x 64.5 cm Courtesy of the artist

 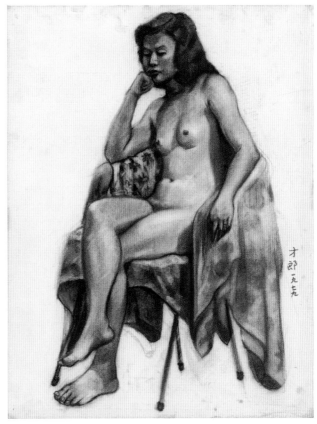

裸女　1973　炭精筆、畫紙
64.5×49.5公分　藝術家提供
Female Nude　1973　Compressed charcoal pencil on paper
64.5 x 49.5 cm　Courtesy of the artist

裸女　1979　炭精筆、畫紙
64.5×49.5公分　藝術家提供
Female Nude　1979　Compressed charcoal pencil on paper
64.5 x 49.5 cm　Courtesy of the artist

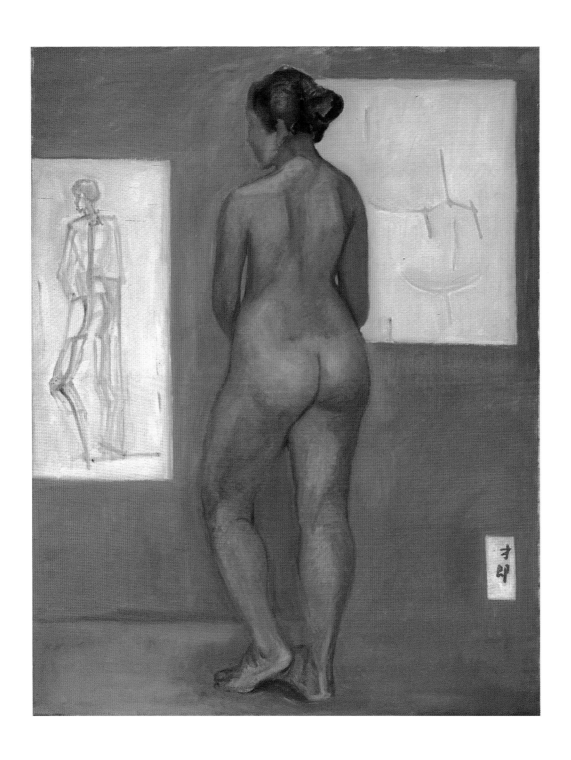

裸女　2021　油彩、畫布　116×91公分　藝術家提供
Female Nude　2021　Oil on canvas　116 x 91 cm　Courtesy of the artist

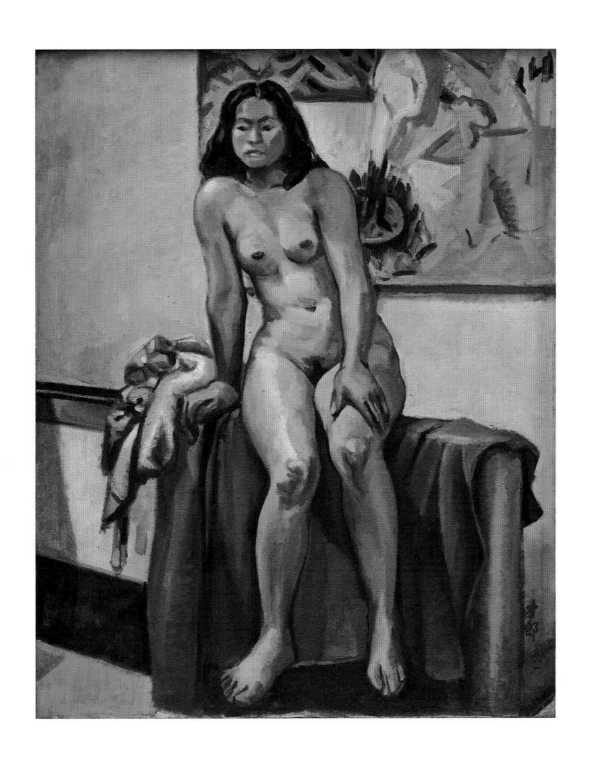

裸女　1981　油彩、畫布　91×73公分　藝術家提供
Female Nude　1981　Oil on canvas　91 x 73 cm　Courtesy of the artist

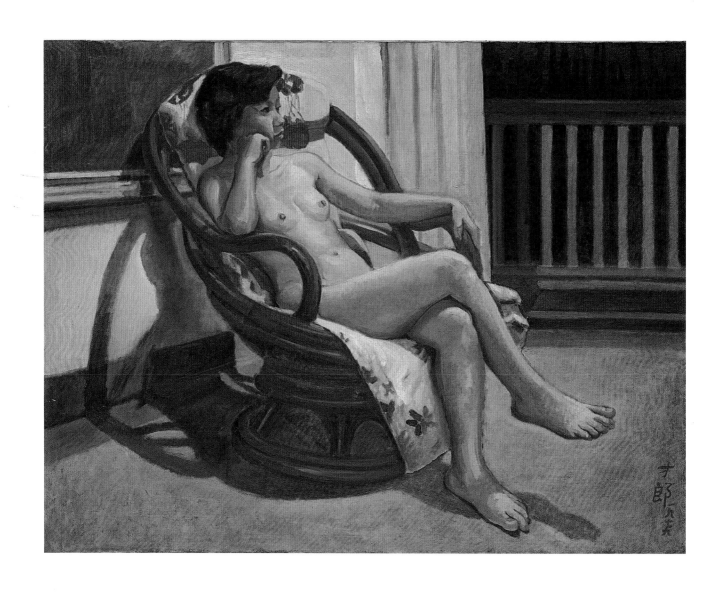

裸女 1979 油彩、畫布 90.8×117.2公分 藝術家提供
Female Nude 1979 Oil on canvas 90.8 x 117.2 cm Courtesy of the artist

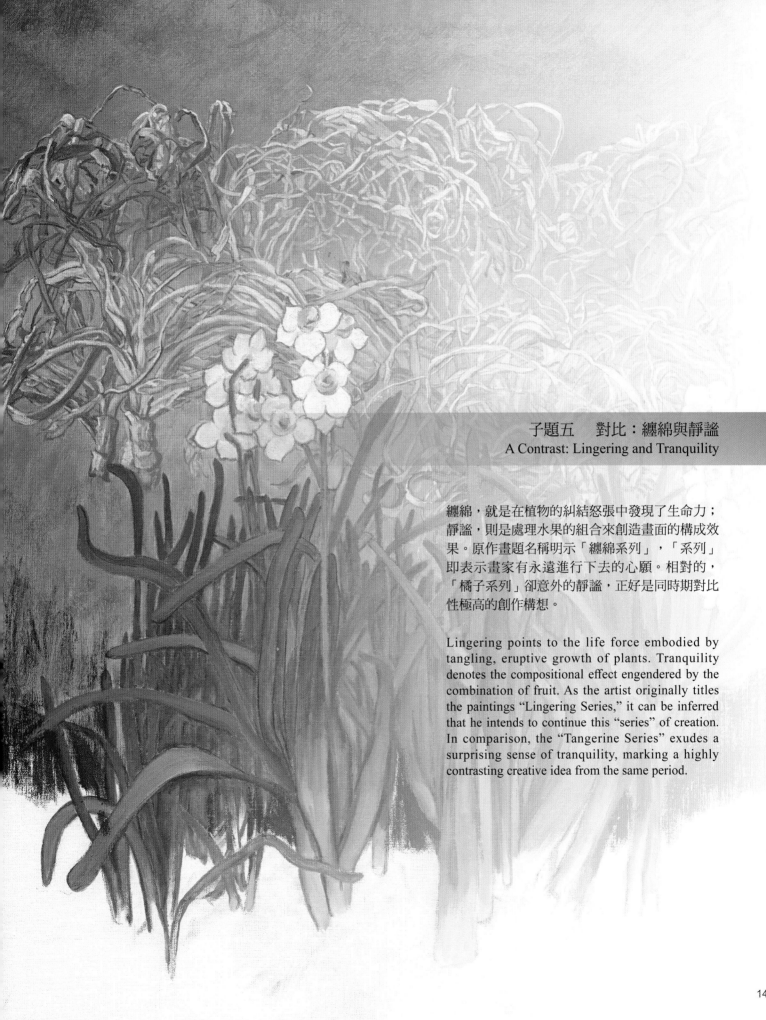

子題五　對比：纏綿與靜謐
A Contrast: Lingering and Tranquility

纏綿，就是在植物的糾結怒張中發現了生命力；靜謐，則是處理水果的組合來創造畫面的構成效果。原作畫題名稱明示「纏綿系列」，「系列」即表示畫家有永遠進行下去的心願。相對的，「橘子系列」卻意外的靜謐，正好是同時期對比性極高的創作構想。

Lingering points to the life force embodied by tangling, eruptive growth of plants. Tranquility denotes the compositional effect engendered by the combination of fruit. As the artist originally titles the paintings "Lingering Series," it can be inferred that he intends to continue this "series" of creation. In comparison, the "Tangerine Series" exudes a surprising sense of tranquility, marking a highly contrasting creative idea from the same period.

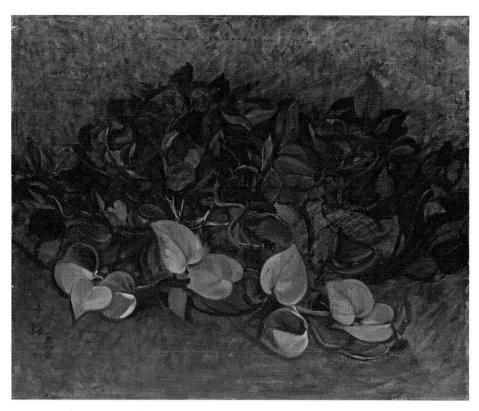

纏綿系列—黃金葛一　1980
油彩、炭精、畫布　52.8×65公分
藝術家提供
Lingering Series - Devil's Ivy I　1980
Oil and compressed charcoal on canvas
52.8 x 65 cm　Courtesy of the artist

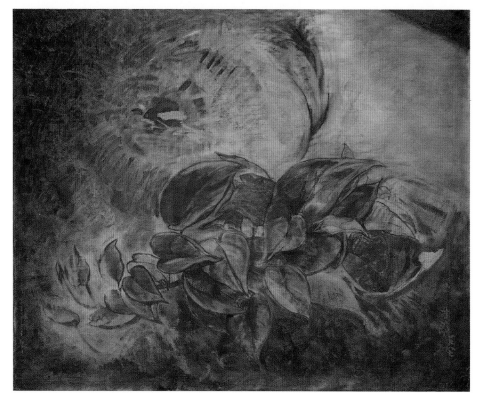

纏綿系列—黃金葛二　1987
油彩、炭精、畫布　72.7×90.8公分
藝術家提供
Lingering Series - Devil's Ivy II　1987
Oil and compressed charcoal on canvas
72.7 x 90.8 cm　Courtesy of the artist

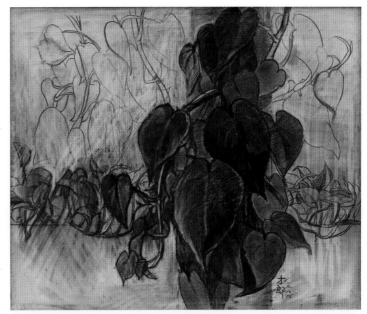

纏綿系列－黃金葛三
1988　炭精、畫布
52.8×65公分　藝術家提供
Lingering Series - Devil's Ivy III
1988　Compressed charcoal on canvas
52.8 x 65 cm　Courtesy of the artist

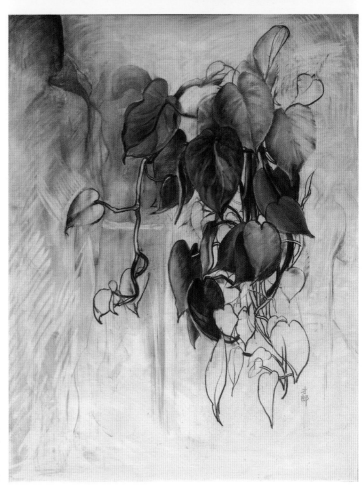

纏綿系列－黃金葛四
1989　油彩、炭精、木炭筆、畫布
116.5×91公分　藝術家提供
Lingering Series - Devil's Ivy IV
1989　Oil, compressed charcoal, and charcoal pencil on canvas
116.5 x 91 cm　Courtesy of the artist

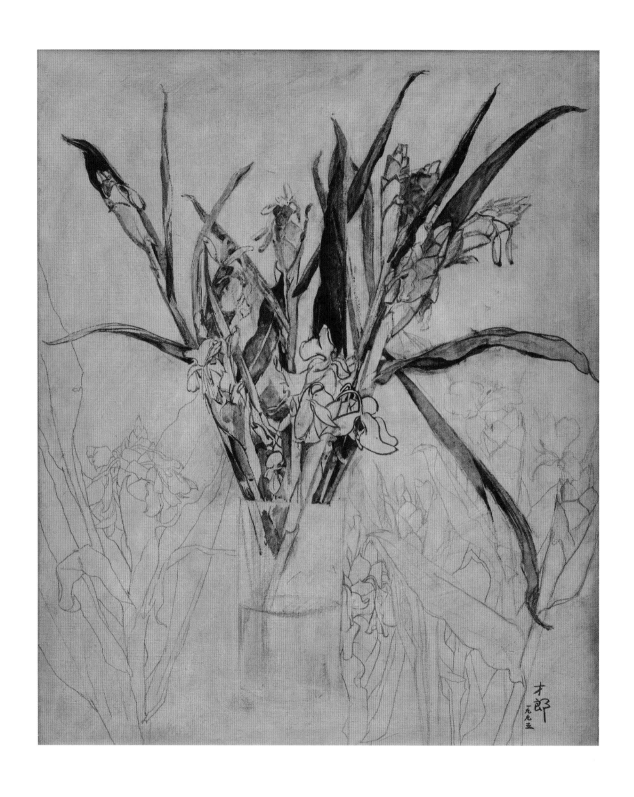

野薑花 1995 鉛筆、壓克力彩、畫布 90.8×72.7公分 藝術家提供
Ginger Lilies 1995 Pencil and acrylic on canvas 90.8 x 72.7 cm Courtesy of the artist

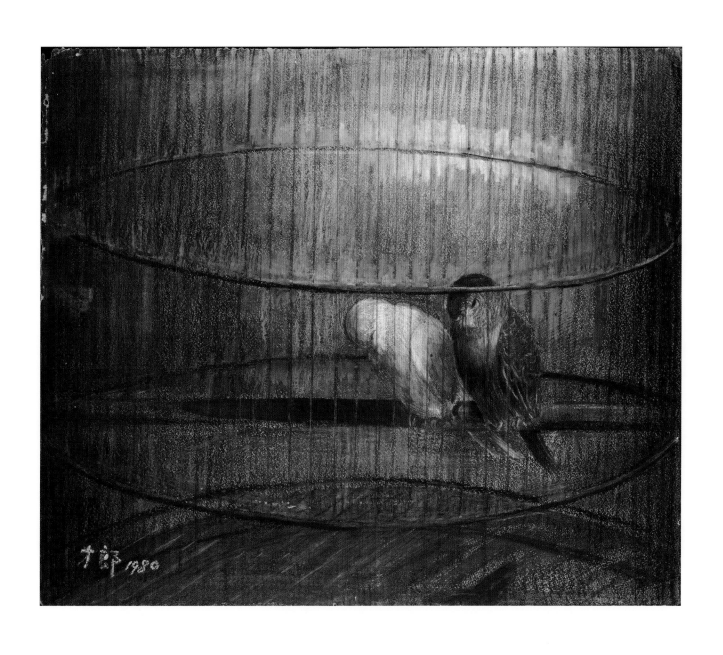

籠中鳥　1980　炭精筆、蠟筆、畫布　38×45公分　藝術家提供
Birds in a Cage　1980　Compressed charcoal pencil and crayon on canvas　38 x 45 cm　Courtesy of the artist

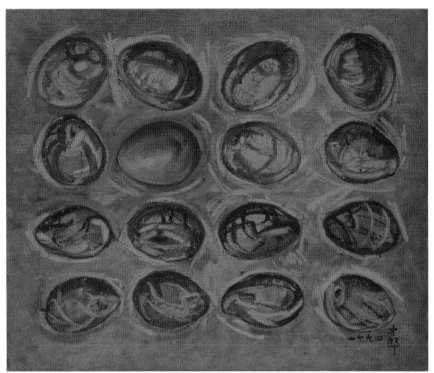

芒果　1994　油彩、畫布
60.5×73公分　藝術家提供
Mangoes　1994　Oil on canvas
60.5 x 73 cm　Courtesy of the artist

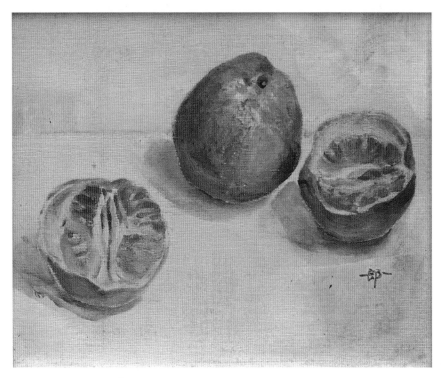

橘子系列　1983　油彩、畫布
22×27公分　藝術家提供
Tangerine Series　1983　Oil on canvas
22 x 27 cm　Courtesy of the artist

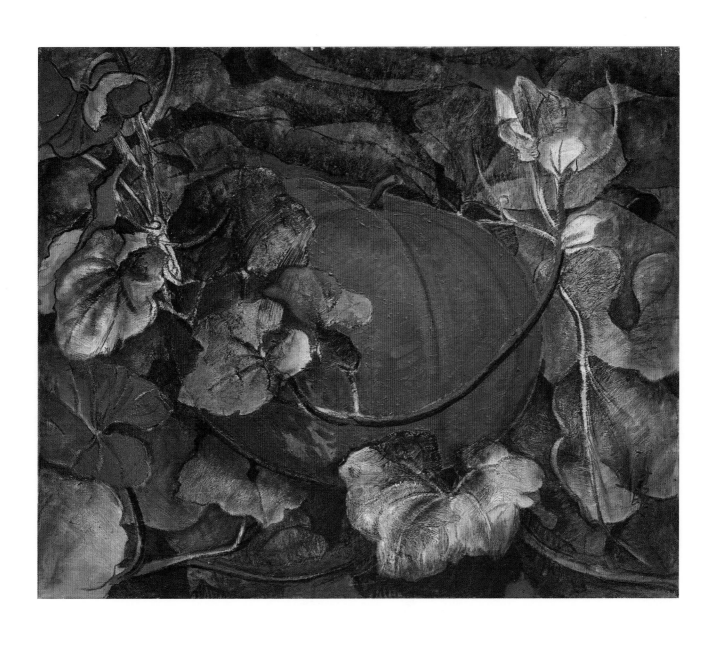

南瓜　1995　油彩、畫布　60×72公分　藝術家提供
Pumpkin　1995　Oil on canvas　60 x 72 cm　Courtesy of the artist

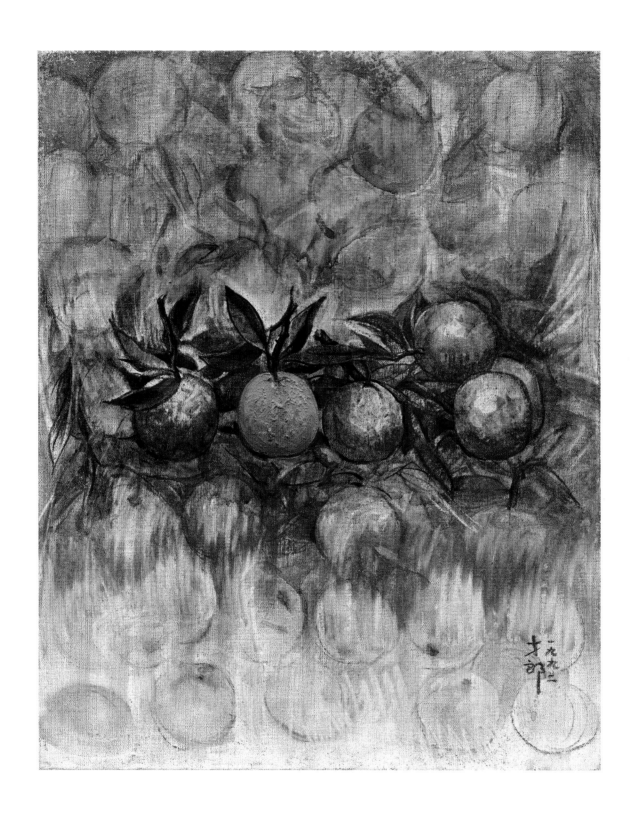

橘子系列－百吉　1992　油彩、炭精、畫布　65.5×53公分　藝術家提供
Tangerine Series - A Hundred Auspiciousness　1992　Oil and compressed charcoal on canvas　65.5 x 53 cm　Courtesy of the artist

蓮霧　2009　油彩、畫布　61×73公分　藝術家提供
Wax Apples　2009　Oil on canvas　61 x 73 cm　Courtesy of the artist

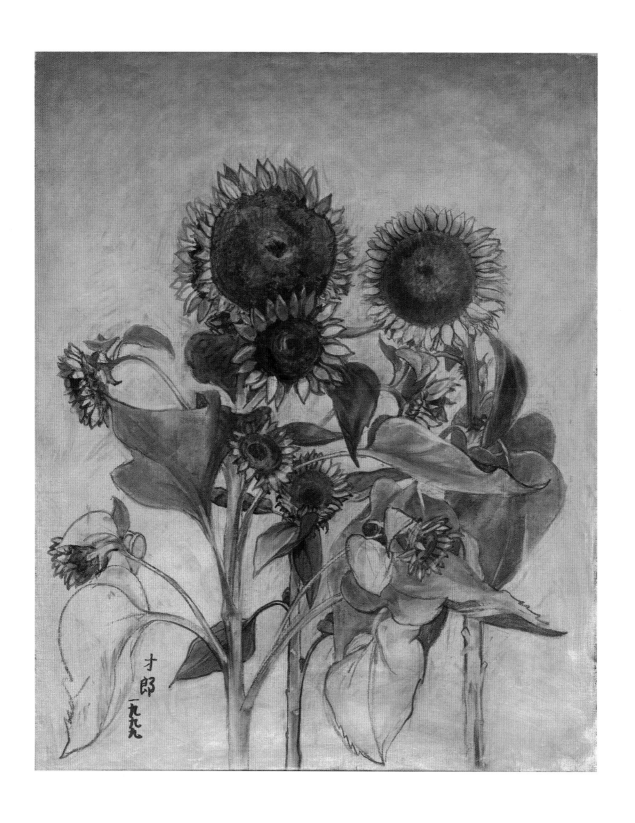

向陽　1999　油彩、炭精、畫布　90.8×72.7公分　藝術家提供
Facing the Sun　1999　Oil and compressed charcoal on canvas　90.8 x 72.7 cm　Courtesy of the artist

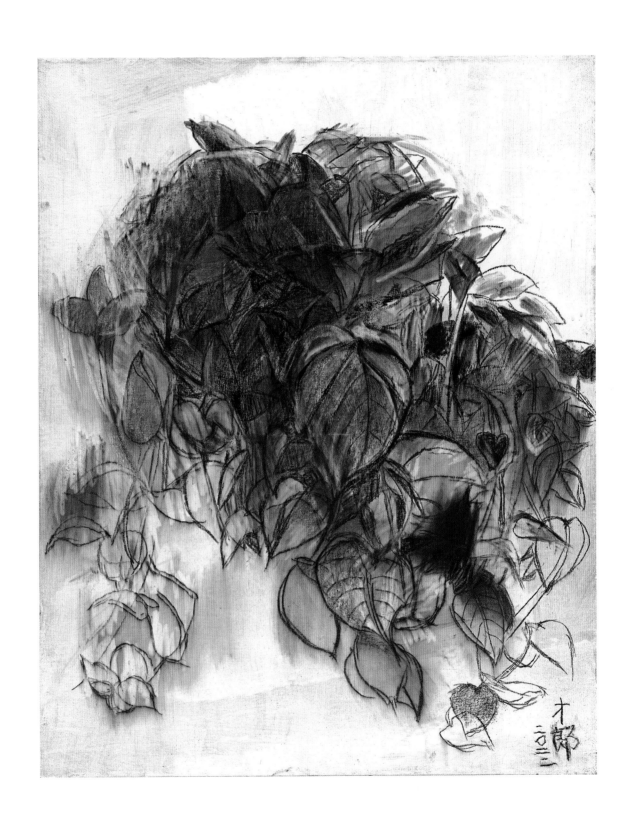

黃金葛　2022　炭精、畫布　90×72公分　藝術家提供
Devil's Ivy　2022　Compressed charcoal on canvas　90 x 72 cm　Courtesy of the artist

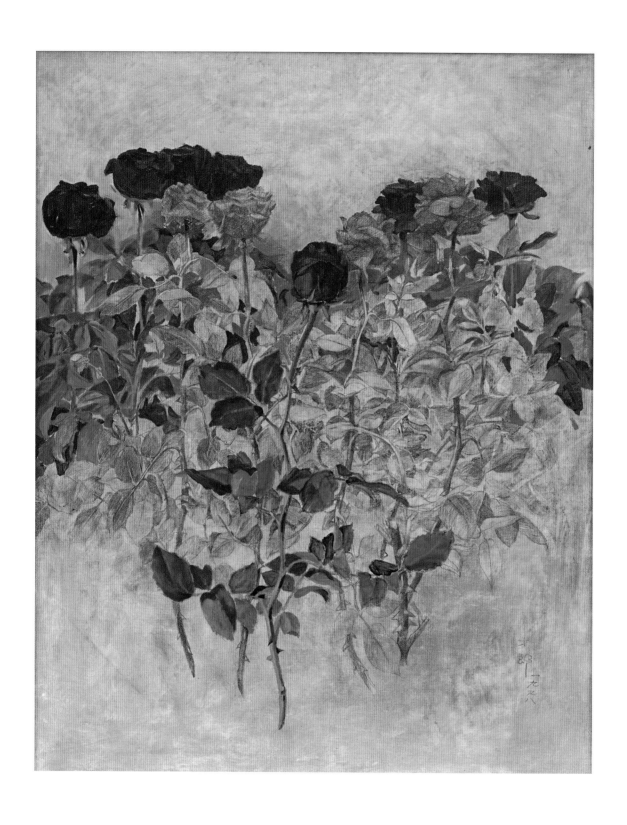

纏綿系列—玫瑰　1998　鉛筆、油彩、畫布　90.8×72.7公分　藝術家提供
Lingering Series - Roses　1998　Pencil and oil on canvas　90.8 x 72.7 cm　Courtesy of the artist

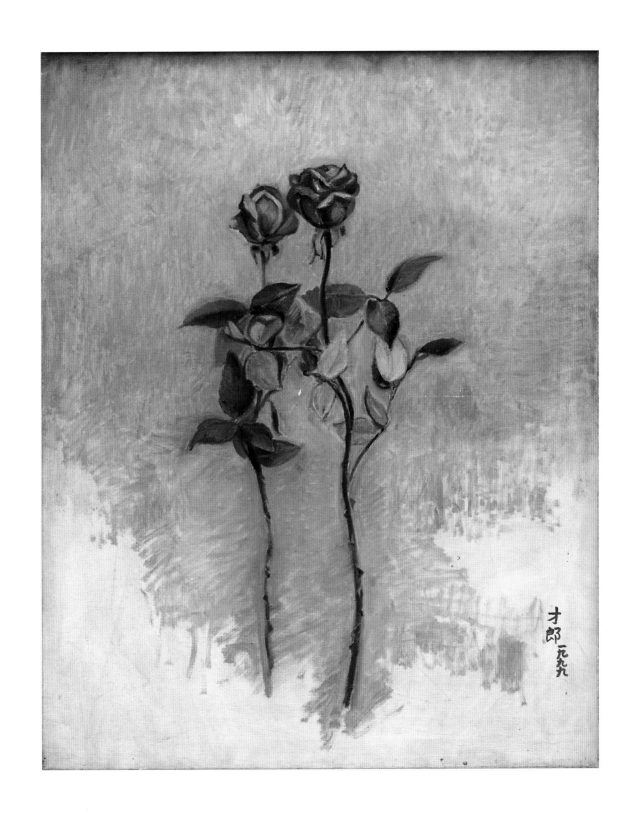

纏綿系列—玫瑰 1999 炭精筆、油彩、畫布 90.8×72.7公分 藝術家提供
Lingering Series - Roses 1999 Compressed charcoal pencil and oil on canvas 90.8 x 72.7 cm Courtesy of the artist

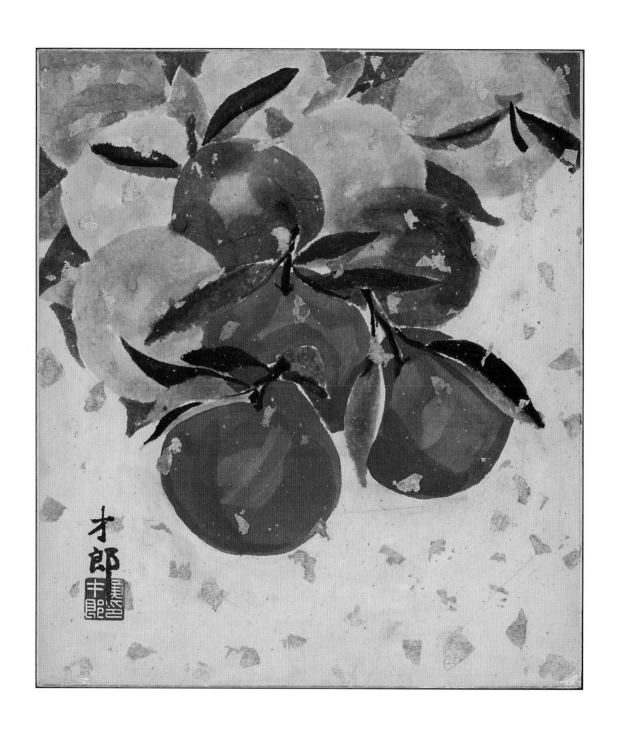

橘子系列　2002　朱標、墨、金箔、畫仙板　27×24公分　藝術家提供
Tangerine Series　2002　Cinnabar, ink, and gold foil on Xuan paper board　27 x 24 cm　Courtesy of the artist

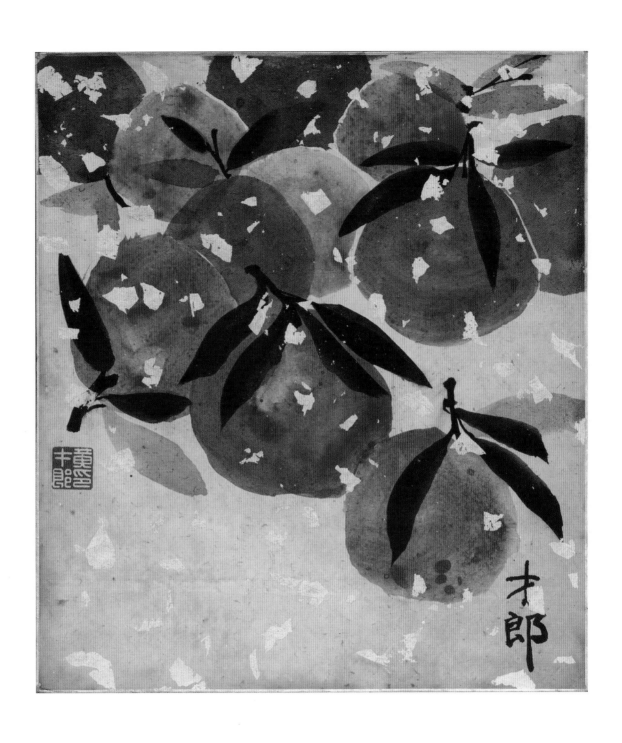

橘子系列　2002　朱標、墨、金箔、畫仙板　27×24公分　藝術家提供
Tangerine Series　2002　Cinnabar, ink, and gold foil on Xuan paper board　27 x 24 cm　Courtesy of the artist

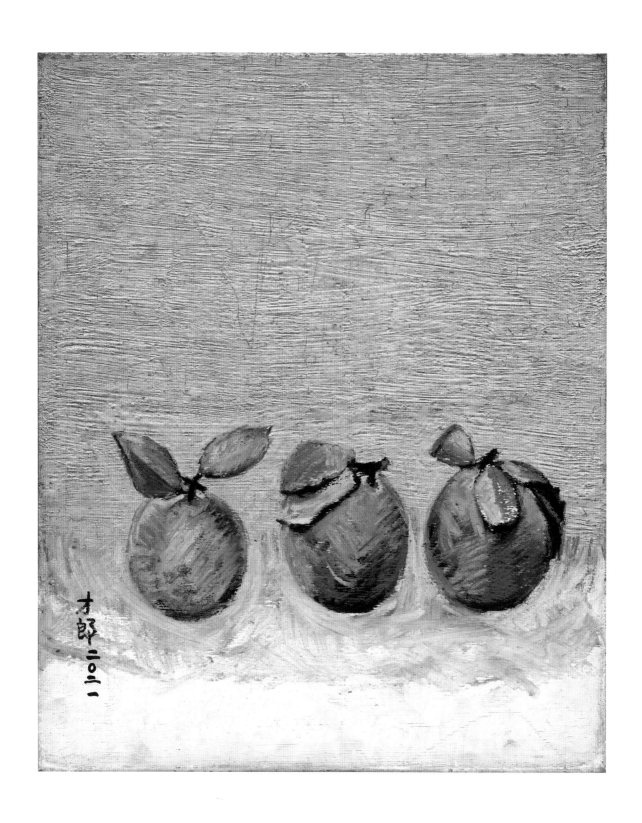

橘子系列　2021　油彩、金箔、畫布　90.8×72.7公分　藝術家提供
Tangerine Series　2021　Oil and gold foil on canvas　90.8 x 72.7 cm　Courtesy of the artist

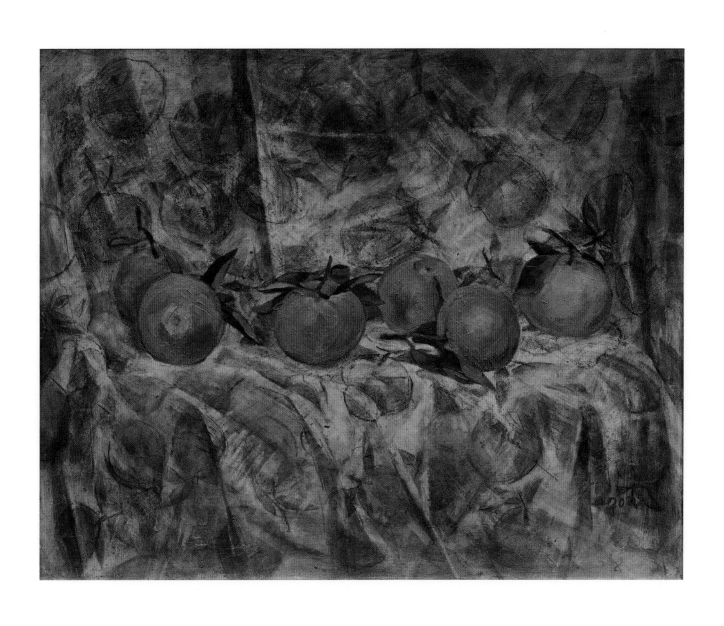

橘子系列 2002 炭精筆、油彩、畫布 52×65公分 藝術家提供
Tangerine Series 2002 Compressed charcoal pencil and oil on canvas 52 x 65 cm Courtesy of the artist

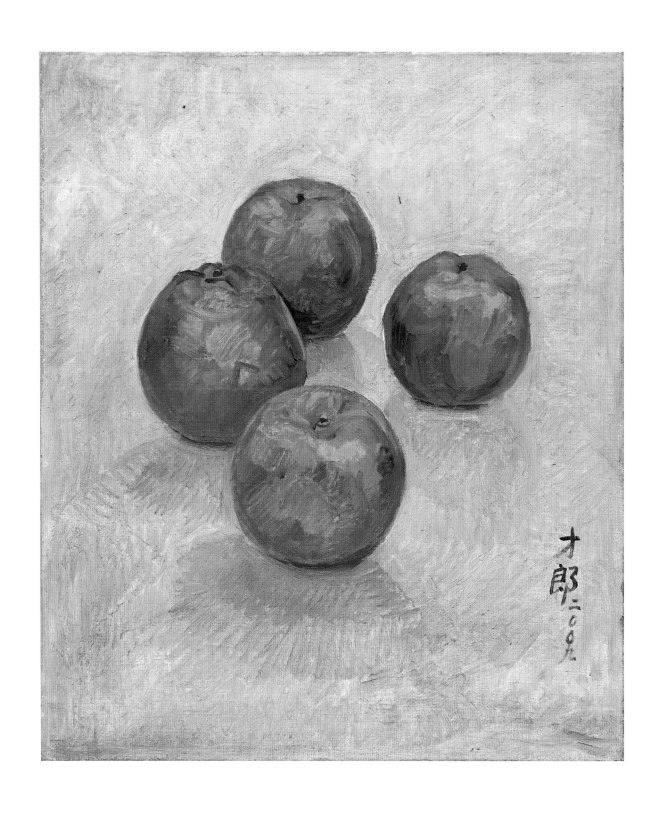

綠色的橘子　2009　油彩、畫布　53×45公分　藝術家提供
Green Tangerines　2009　Oil on canvas　53 x 45 cm　Courtesy of the artist

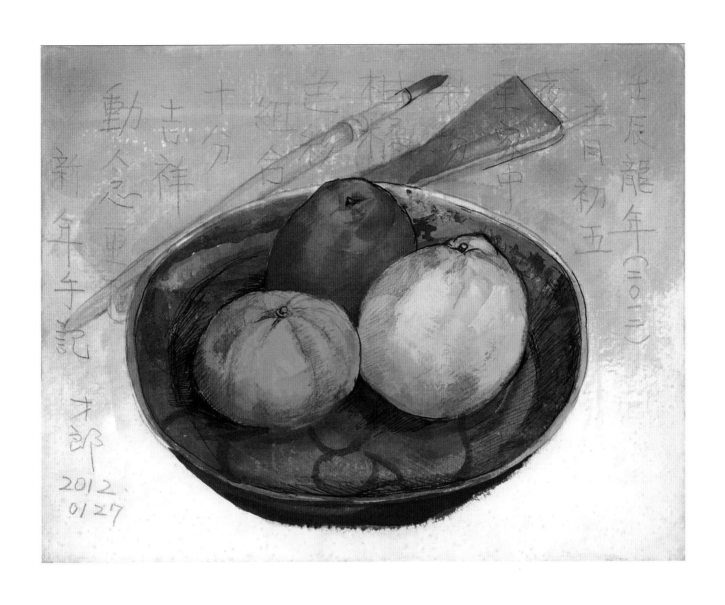

水果　2012　水彩、畫紙　28×36公分　藝術家提供
Fruits　2012　Watercolor on paper　28 x 36 cm　Courtesy of the artist

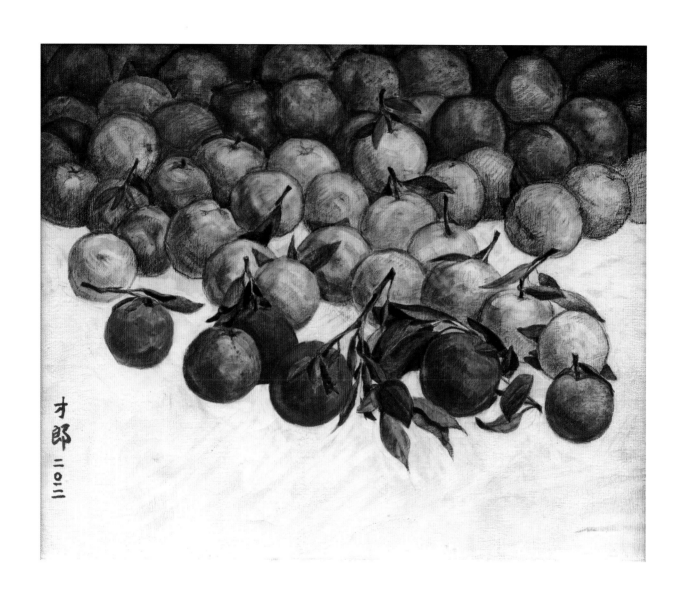

橘子系列　2012　炭精、朱標、油彩、畫布　60.5×72.5公分　藝術家提供
Tangerine Series　2012　Compressed charcoal, cinnabar, and oil on canvas　60.5 x 72.5 cm　Courtesy of the artist

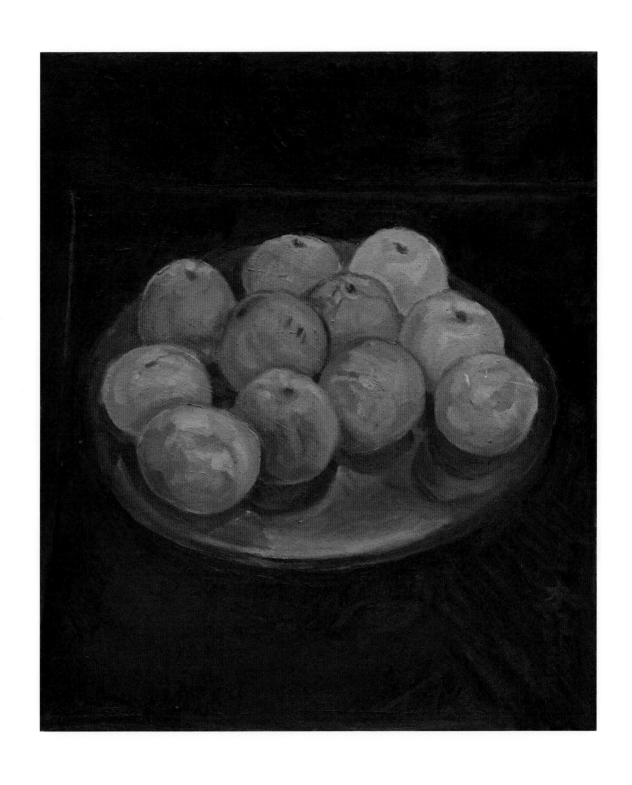

紅漆盤上的橘子　2018　油彩、畫布　45.5×38.5公分　藝術家提供
Tangerines on a Red Lacquer Plate　2018　Oil on canvas　45.5 x 38.5 cm　Courtesy of the artist

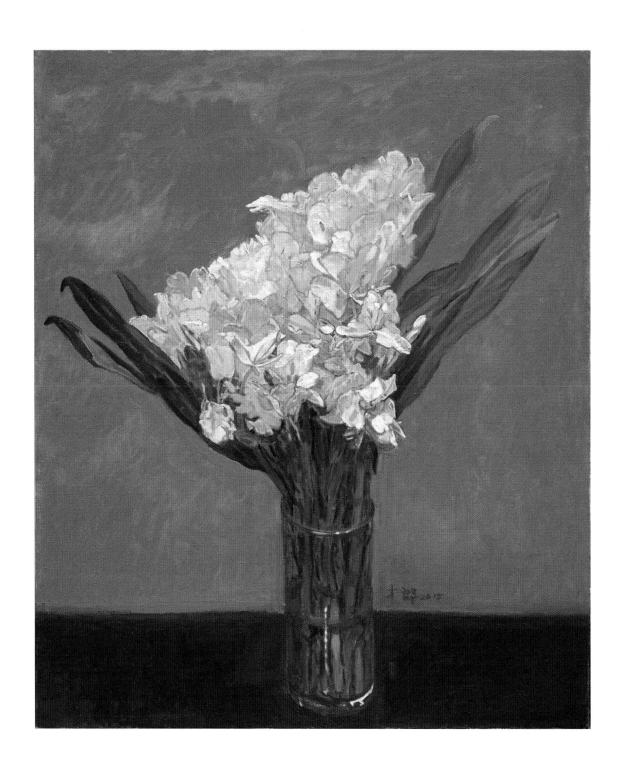

野薑花 2015 油彩、畫布 72×61公分 藝術家提供
Ginger Lilies 2015 Oil on canvas 72 x 61 cm Courtesy of the artist

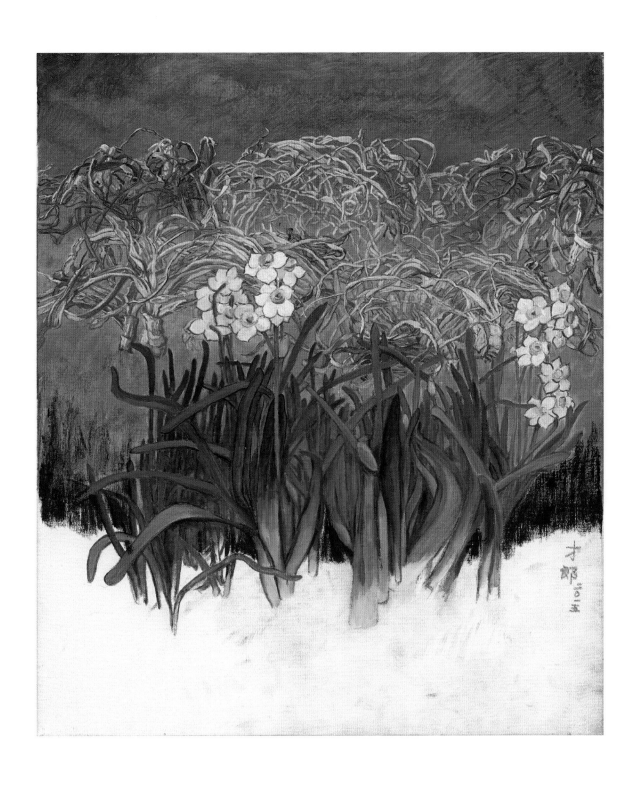

水仙系列　2015　油彩、畫布　72×53公分　藝術家提供
Narcissus Series　2015　Oil on canvas　72 x 53 cm　Courtesy of the artist

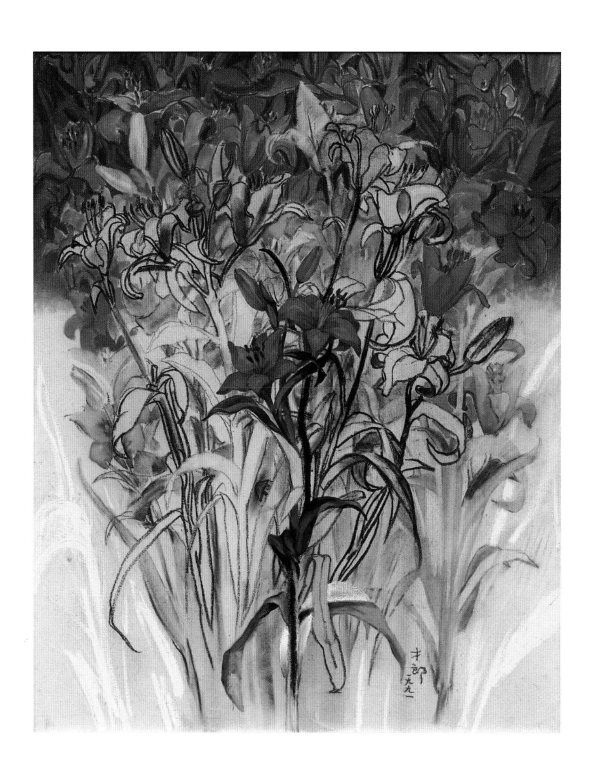

姬百合 1991 炭精筆、油彩、油畫棒、畫布 90.8×72.7公分 藝術家提供
Morning Star Lilies 1991 Compressed charcoal pencil, oil, and oil stick on canvas 90.8 x 72.7 cm Courtesy of the artist

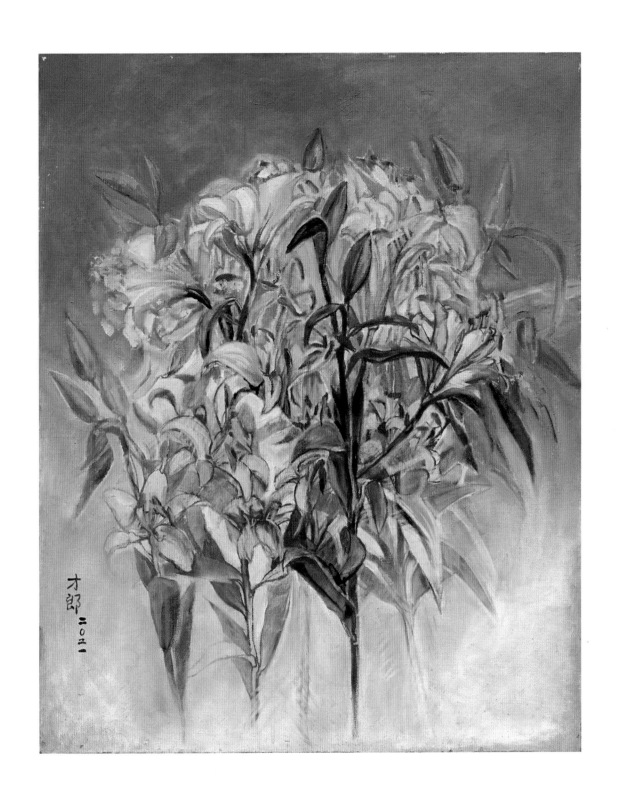

香水百合 2021 炭精筆、油彩、油畫棒、畫布 90.8×72.7公分 藝術家提供
Oriental Lilies 2021 Compressed charcoal pencil, oil, and oil stick on canvas 90.8 x 72.7 cm Courtesy of the artist

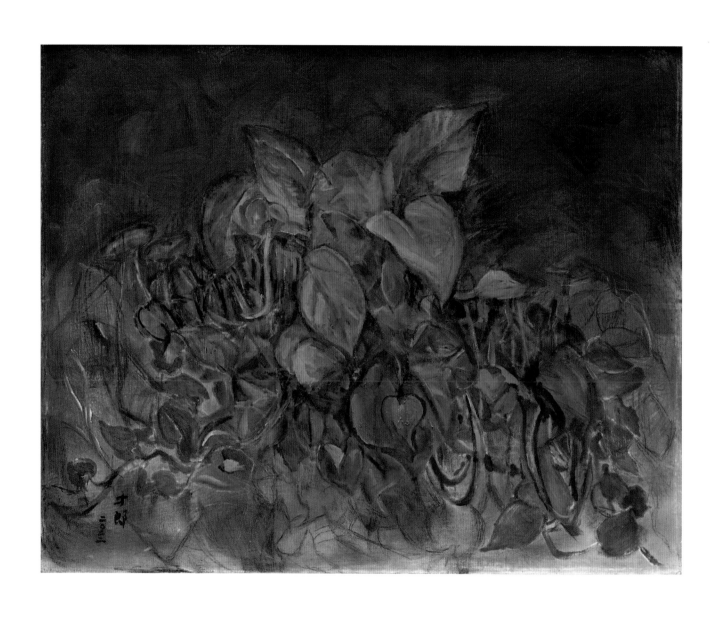

黃金葛 2022 油彩、畫布 72.5×91公分 藝術家提供
Devil's Ivy 2022 Oil on canvas 72.5 x 91 cm Courtesy of the artist

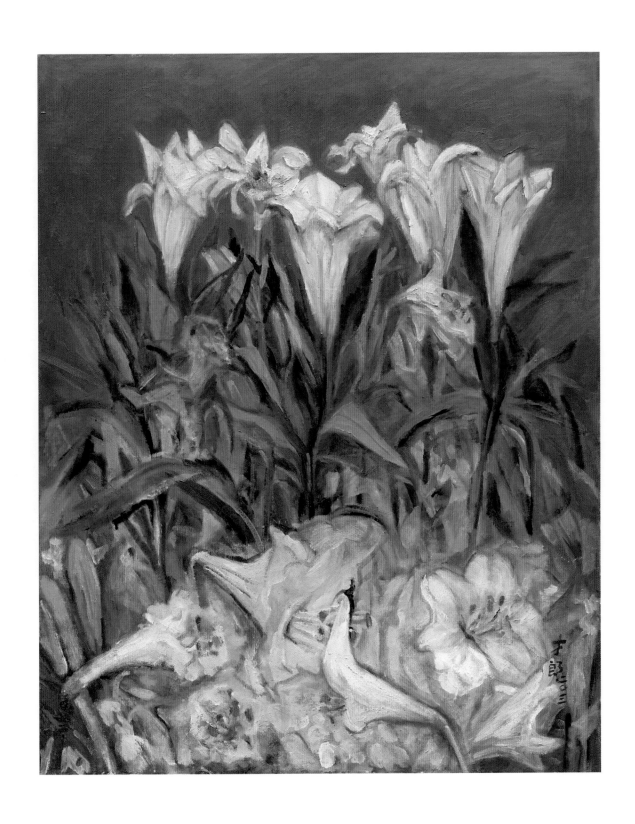

百合　2023　油彩、畫布　90×72.5公分　藝術家提供
Lilies　2023　Oil on canvas　90 x 72.5 cm　Courtesy of the artist

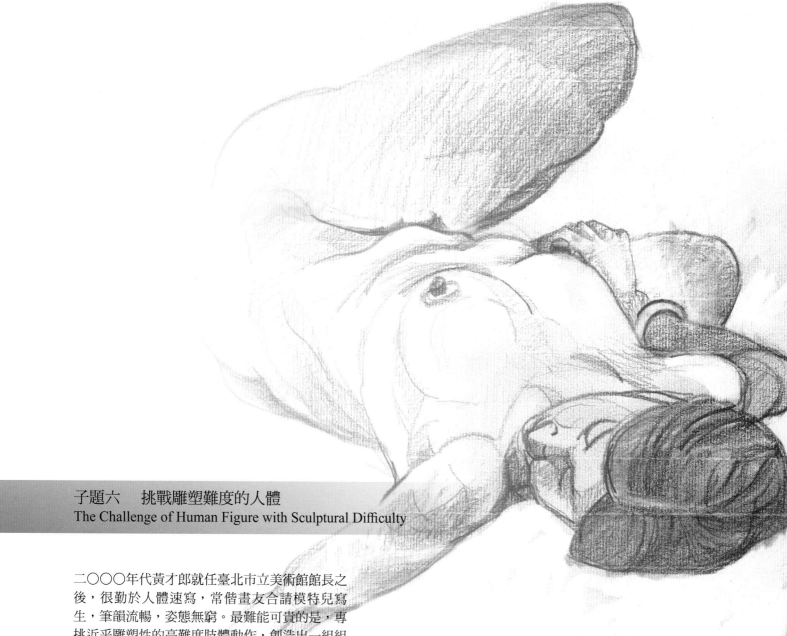

子題六　挑戰雕塑難度的人體
The Challenge of Human Figure with Sculptural Difficulty

二〇〇〇年代黃才郎就任臺北市立美術館館長之後，很勤於人體速寫，常偕畫友合請模特兒寫生，筆韻流暢，姿態無窮。最難能可貴的是，專挑近乎雕塑性的高難度肢體動作，創造出一組組挑戰性甚高的速寫佳作。

After Huang assumed the directorship of the Taipei Fine Arts Museum in the 2000s, he became diligent in making sketch drawings featuring the human form, and would often co-hire models with his artist friends. His works from this period show free-flowing brushwork, and depict ample postures. The most valuable thing is that he often picked and delineated highly difficult and sculptural postures, and thereby produced an excellent body of extremely challenging sketch drawings.

人體 2006 鉛筆、畫紙
38.8×53.5公分 藝術家提供
Human Figure 2006 Pencil on paper
38.8 x 53.5 cm Courtesy of the artist

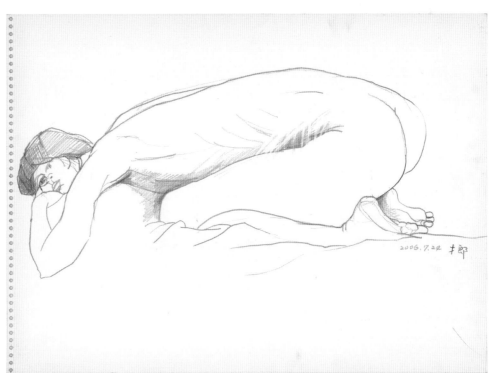

人體 2006 鉛筆、畫紙
38.8×53.5公分 藝術家提供
Human Figure 2006 Pencil on paper
38.8 x 53.5 cm Courtesy of the artist

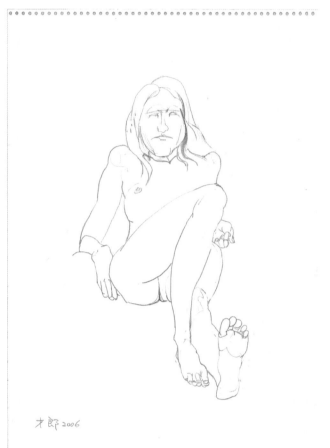

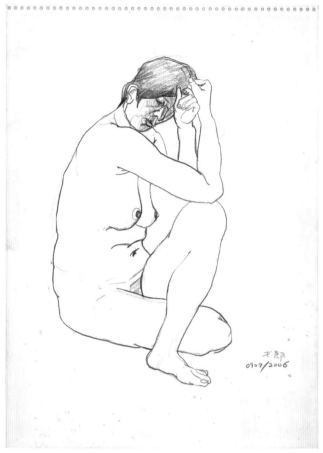

人體 2006 鉛筆、畫紙
53.5×38.8公分 藝術家提供
Human Figure 2006 Pencil on paper
53.5 x 38.8 cm Courtesy of the artist

人體 2006 鉛筆、畫紙
53.5×38.8公分 藝術家提供
Human Figure 2006 Pencil on paper
53.5 x 38.8 cm Courtesy of the artist

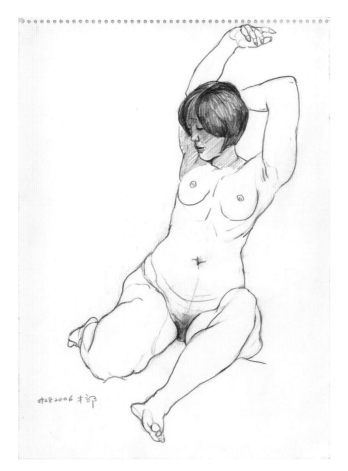

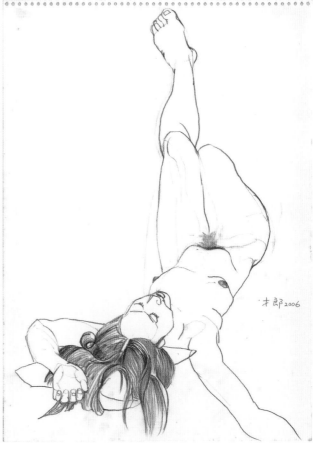

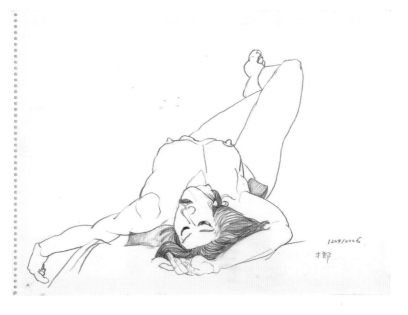

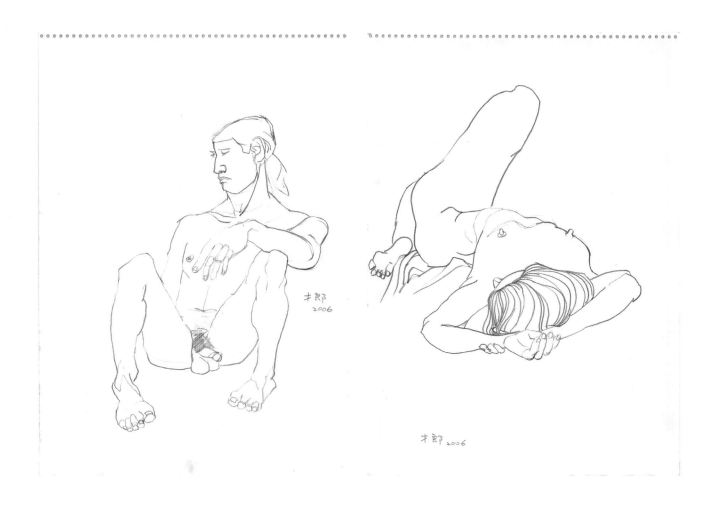

人體 2006 鉛筆、畫紙
53.5×38.8公分 藝術家提供
Human Figure 2006 Pencil on paper
53.5 x 38.8 cm Courtesy of the artist

人體 2006 鉛筆、畫紙
53.5×38.8公分 藝術家提供
Human Figure 2006 Pencil on paper
53.5 x 38.8 cm Courtesy of the artist

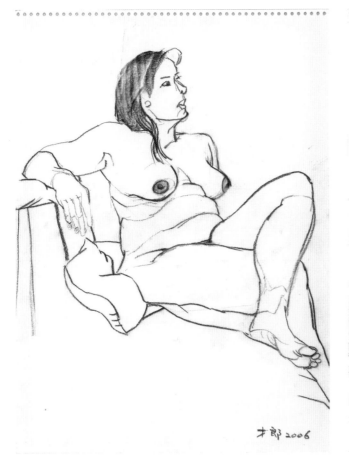

左上 | 人體　2006　炭筆、畫紙
Upper Left | 53.5×38.8公分　藝術家提供
Human Figure　2006
Charcoal pencil on paper
53.5 x 38.8 cm　Courtesy of the artist

右上 | 人體　2006　鉛筆、畫紙
Upper Right | 53.5×38.8公分　藝術家提供
Human Figure　2006
Pencil on paper
53.5 x 38.8 cm　Courtesy of the artist

右下 | 人體　2006　鉛筆、畫紙
Lower Right | 38.8×53.5公分　藝術家提供
Human Figure　2006
Pencil on paper
38.8 x 53.5 cm　Courtesy of the artist

人體　2006　鉛筆、畫紙
53.5×38.8公分　藝術家提供
Human Figure　2006　Pencil on paper
53.5 x 38.8 cm　Courtesy of the artist

人體　2007　鉛筆、畫紙
53.5×38.8公分　藝術家提供
Human Figure　2007　Pencil on paper
53.5 x 38.8 cm　Courtesy of the artist

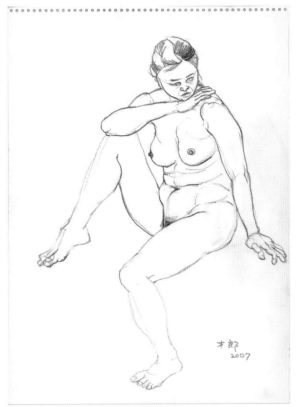

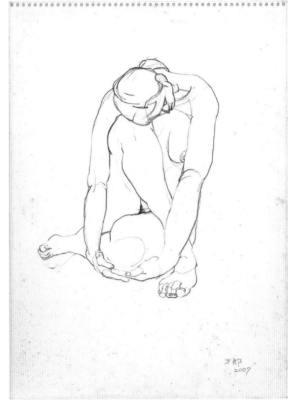

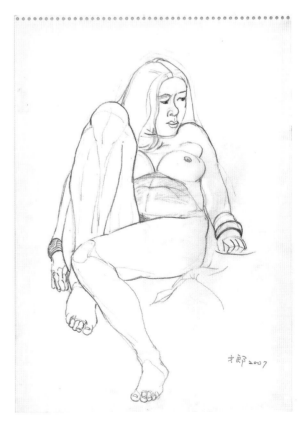

左上	人體　2007　鉛筆、畫紙
Upper Left	53.5×38.8公分　藝術家提供
	Human Figure　2007　Pencil on paper
	53.5 x 38.8 cm　Courtesy of the artist

右上	人體　2007　鉛筆、畫紙
Upper Right	53.5×38.8公分　藝術家提供
	Human Figure　2007　Pencil on paper
	53.5 x 38.8 cm　Courtesy of the artist

右下	人體　2007　鉛筆、畫紙
Lower Right	53.5×38.8公分　藝術家提供
	Human Figure　2007　Pencil on paper
	53.5 x 38.8 cm　Courtesy of the artist

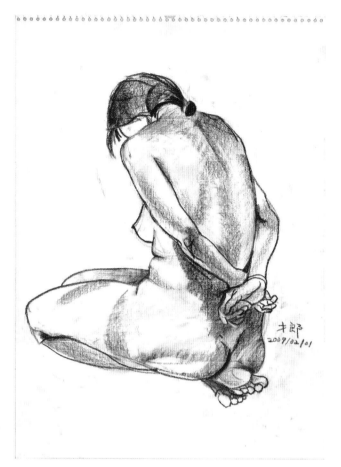

人體　2007　炭筆、畫紙
53.5×38.8公分　藝術家提供
Human Figure　2007　Charcoal pencil on paper
53.5.x 38.8 cm　Courtesy of the artist

人體　2007　炭筆、畫紙
53.5×38.8公分　藝術家提供
Human Figure　2007　Charcoal pencil on paper
53.5 x 38.8 cm　Courtesy of the artist

左上　　　人體　2007　鉛筆、畫紙
Upper Left　53.5×38.8公分　藝術家提供
Human Figure　2007　Pencil on paper
53.5 x 38.8 cm　Courtesy of the artist

右上　　　人體　2008　鉛筆、畫紙
Upper Right　53.5×38.8公分　藝術家提供
Human Figure　2008　Pencil on paper
53.5 x 38.8 cm　Courtesy of the artist

右下　　　人體　2007　鉛筆、畫紙
Lower Right　53.5×38.8公分　藝術家提供
Human Figure　2007　Pencil on paper
53.5 x 38.8 cm　Courtesy of the artist

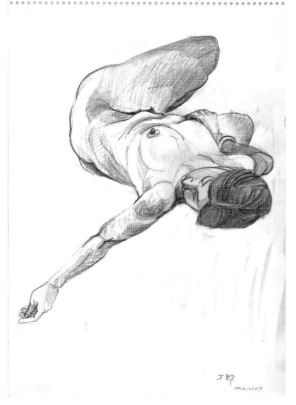

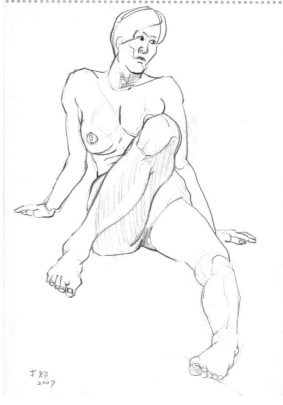

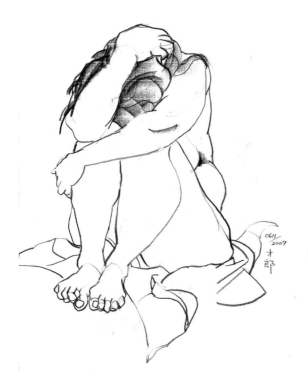

左上 Upper Left	人體　2007　鉛筆、畫紙 53.5×38.8公分　藝術家提供 *Human Figure*　2007　Pencil on paper 53.5 x 38.8 cm　Courtesy of the artist
右上 Upper Right	人體　2007　鉛筆、畫紙 53.5×38.8公分　藝術家提供 *Human Figure*　2007　Pencil on paper 53.5 x 38.8 cm　Courtesy of the artist
左下 Lower Left	人體　2007　炭筆、畫紙 53.5×38.8公分　藝術家提供 *Human Figure*　2007　Charcoal pencil on paper 53.5 x 38.8 cm　Courtesy of the artist

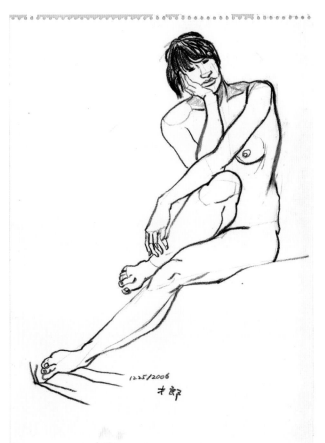

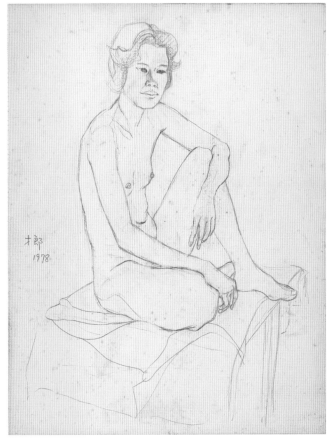

人體　2006　炭筆、畫紙
53.5×38.8公分　藝術家提供
Human Figure　2006　Charcoal pencil on paper
53.5 x 38.8 cm　Courtesy of the artist

人體　1978　鉛筆、畫紙
46×38.5公分　藝術家提供
Human Figure　1978　Pencil on paper
46 x 38.5 cm　Courtesy of the artist

子題七 開發新畫材、追求新創意
Developing New Painting Material, Seeking Fresh Creativity

畫貼金箔，是黃才郎得自江戶時代日本琳派屏風的啟發。金箔的材料費很貴，而且貼法程序繁複，必須一直實驗到金箔有凹凸、明暗與折射等效果；黃才郎將金箔與油畫顏料隔開，不同於琳派是在金箔之上塗膠彩。說到新創意，人體素描也有不同筆觸的嘗試，這即是黃才郎有試探現代風格的覺醒，試圖走出傳統，與時代接軌。

Huang drew the inspiration of laying gold leaf on his paintings from screens of the Japanese Rinpa school emerged in the Edo period. Gold leaf is an expensive material, and the process of laying gold leaf is complicated. One must keep experimenting so as to achieve the effects of texturizing, shading, and refraction. Unlike artists of the Rinpa school who applied gouache paint on gold leaf, Huang separates gold leaf and oil paint instead. Furthermore, he also demonstrates fresh creativity in experimenting with different brushstrokes in his sketch drawing—this marks Huang's awakening to exploring the contemporary style as he departed from the traditional practice to keep up with the times.

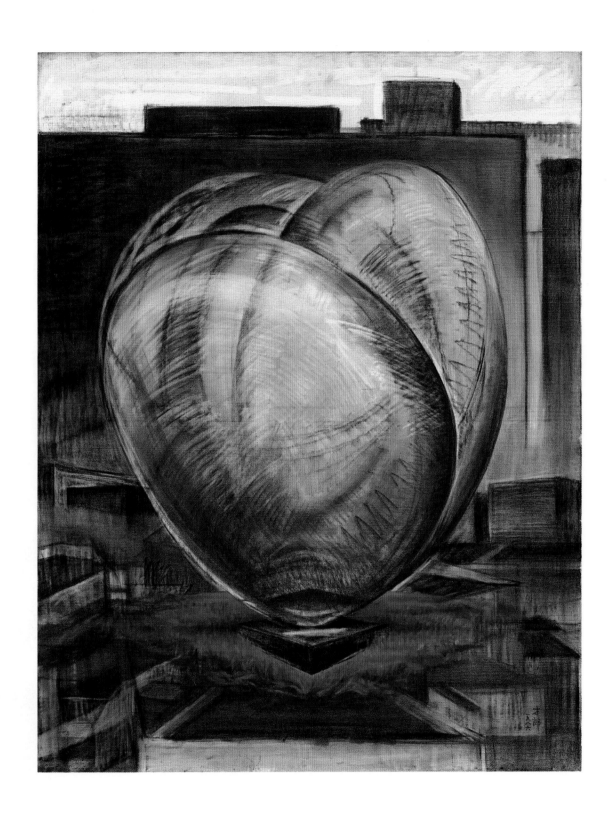

心想事成—公共藝術構想　1986　炭精筆、油彩、畫布　116.5×91公分　藝術家提供
A Wish Comes True - An Idea of Public Art　1986　Compressed charcoal pencil and oil on canvas　116.5 x 91 cm　Courtesy of the artist

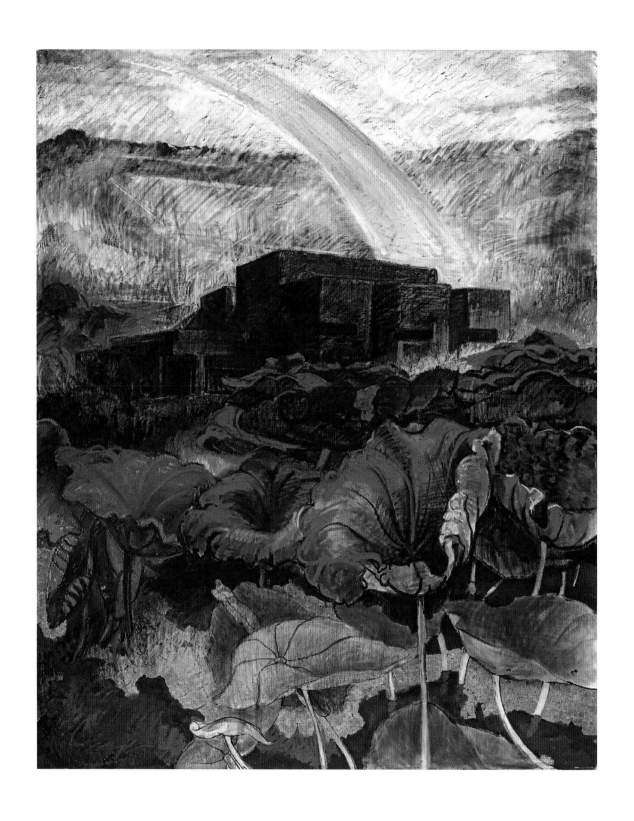

彩虹－雨後高美館　1995　油彩、炭精筆、金箔、畫布　162×130.5公分　藝術家提供
Rainbow - KMFA After the Rain　1995　Oil, compressed charcoal pencil, and gold foil on canvas　162 x 130.5 cm　Courtesy of the artist

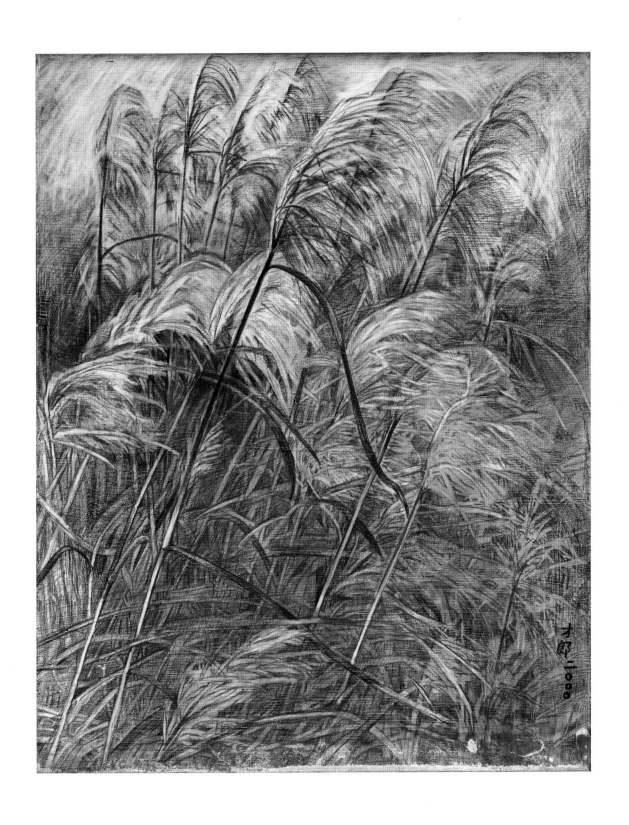

蘆葦　2000　炭精筆、畫布　72.5×60.5公分　藝術家提供
Reeds　2000　Compressed charcoal pencil on canvas　72.5 x 60.5 cm　Courtesy of the artist

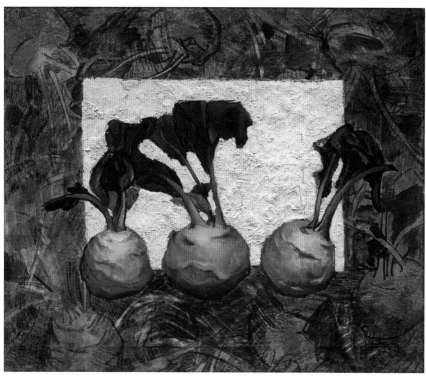

大頭菜　1996　油彩、金箔、畫布
60×72公分　藝術家提供
Kohlrabis　1996　Oil and gold foil on canvas
60 x 72 cm　Courtesy of the artist

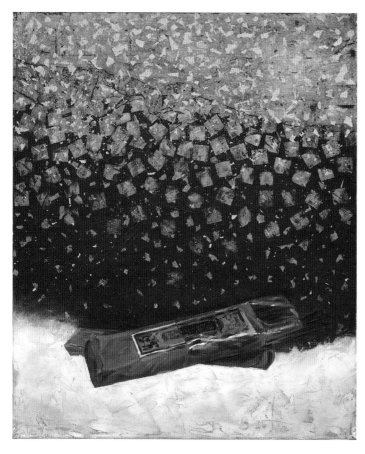

敬香　2001　油彩、金箔、畫布
73×61公分　藝術家提供
Incense Offering　2001　Oil and gold foil on canvas
73 x 61 cm　Courtesy of the artist

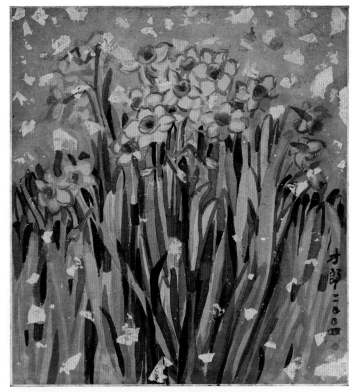

水仙 2004
朱標、墨、金箔、畫仙板
27×24公分 藝術家提供
Narcissuses 2004
Cinnabar, ink, and gold foil on Xuan paper board
27 x 24 cm Courtesy of the artist

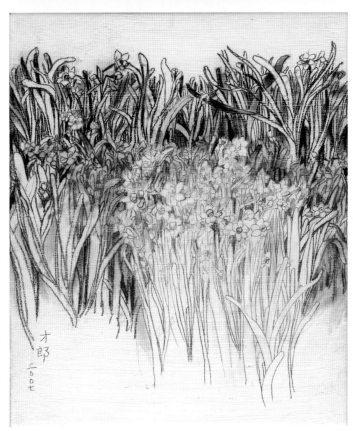

水仙系列 2007 油彩、炭精、畫布
65×53公分 藝術家提供
Narcissus Series 2007 Oil and compressed charcoal on canvas
65 x 53 cm Courtesy of the artist

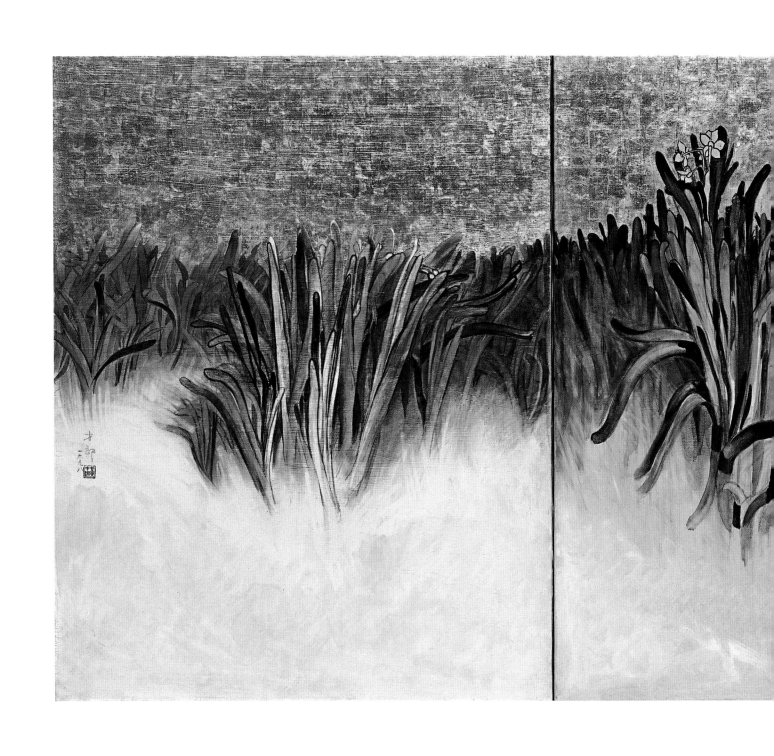

水仙三聯屏　1998　油畫、壓克力彩、金箔、混合媒材　90.5×218.5公分　臺北市立美術館典藏
Narcissuses　1998　Oil, acrylic and gold foil on canvas　90.5 x 218.5 cm　Collection of Taipei Fine Arts Museum

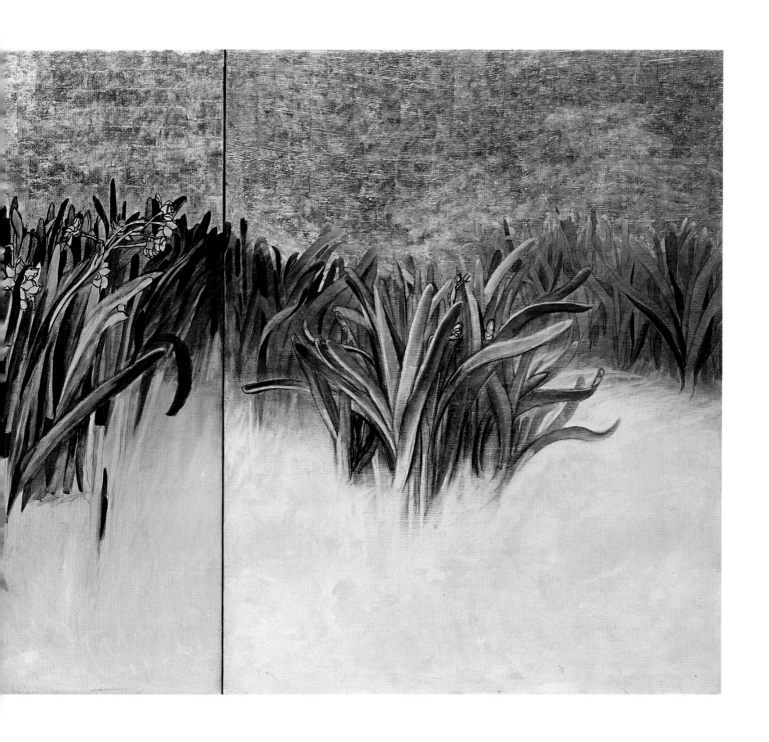

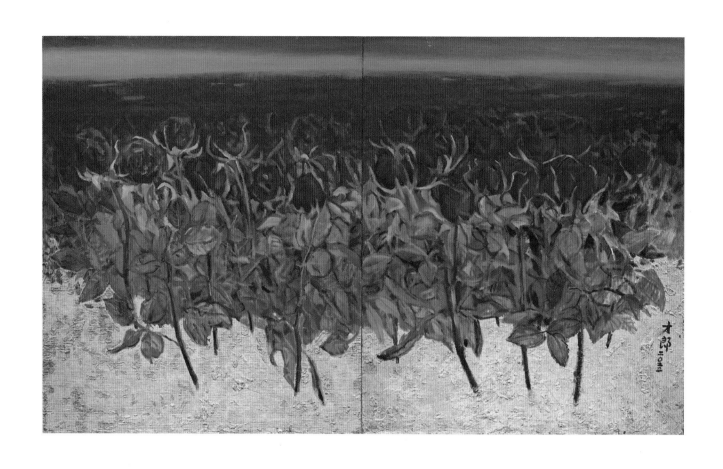

玫瑰花園　2022　油彩、金箔、畫布　72×120公分　藝術家提供
Rose Garden　2022　Oil and gold foil on canvas　72 x 120 cm　Courtesy of the artist

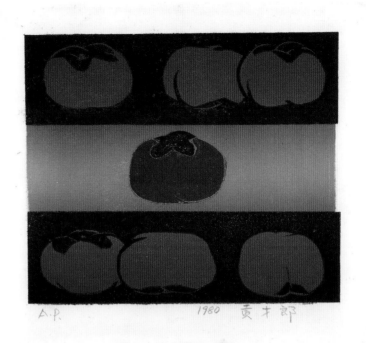

柿子　1980　版印、畫紙
25×32公分　藝術家提供
Persimmons　1980　Print on paper
25 x 32 cm　Courtesy of the artist

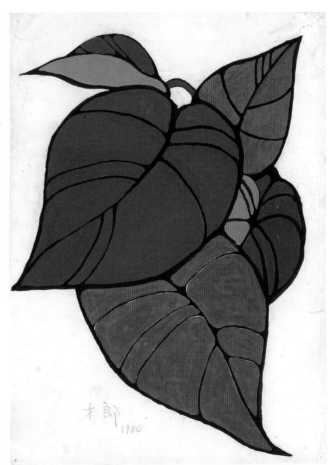

黃金葛　1980　廣告顏料、畫紙
34×25公分　藝術家提供
Devil's Ivy　1980　Poster color on paper
34 x 25 cm　Courtesy of the artist

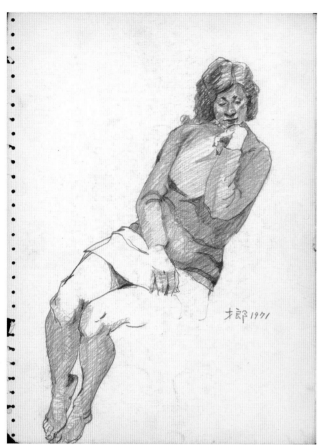

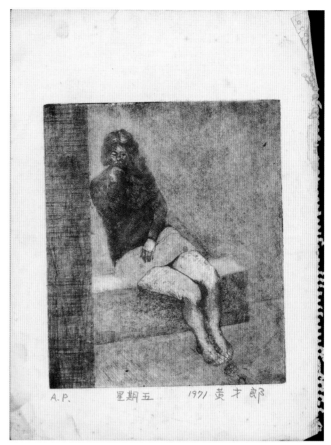

星期五下午　1971　鉛筆、畫紙
36.5×26.7公分　藝術家提供
Friday Afternoon　1971　Pencil on paper
36.5 x 26.7 cm　Courtesy of the artist

星期五下午　1971　銅版、畫紙
36×26公分　藝術家提供
Friday Afternoon　1971　Copper plate, drawing paper
36 x 26 cm　Courtesy of the artist

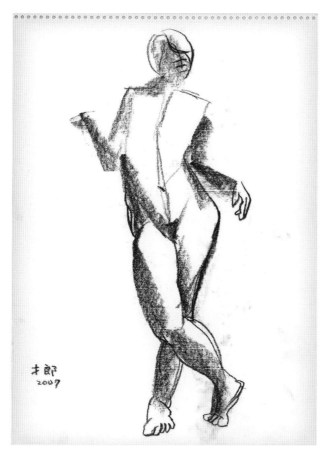 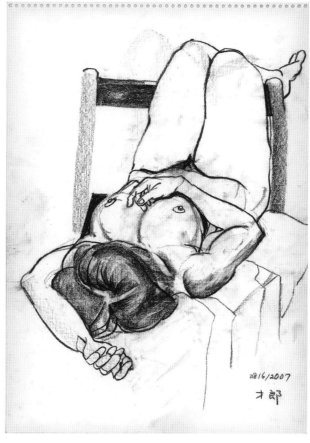

人體　2007　炭筆、畫紙
53.5×38.8公分　藝術家提供
Human Figure　2007　Charcoal pencil on paper
53.5 x 38.8 cm　Courtesy of the artist

人體　2007　炭精筆、畫紙
53.5×38.8公分　藝術家提供
Human Figure　2007　Compressed charcoal pencil on paper
53.5 x 38.8 cm　Courtesy of the artist

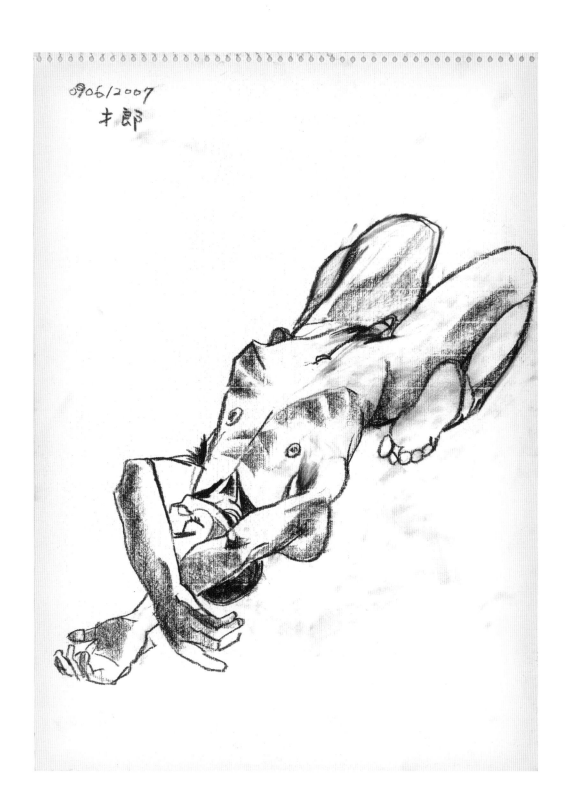

人體 2007 炭精筆、畫紙 53.5×38.8公分 藝術家提供
Human Figure 2007 Compressed charcoal pencil on paper 53.5 x 38.8 cm Courtesy of the artist

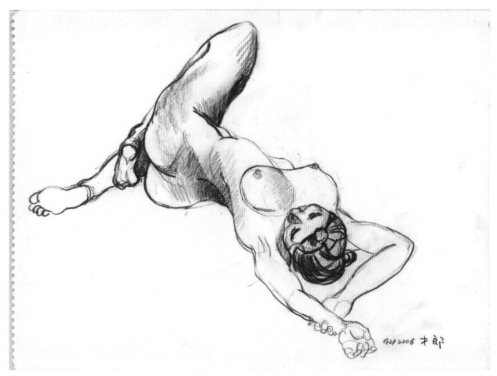

人體　2006　炭精筆、畫紙
38.8×53.5公分　藝術家提供
Human Figure　2006
Compressed charcoal pencil on paper
38.8 x 53.5 cm
Courtesy of the artist

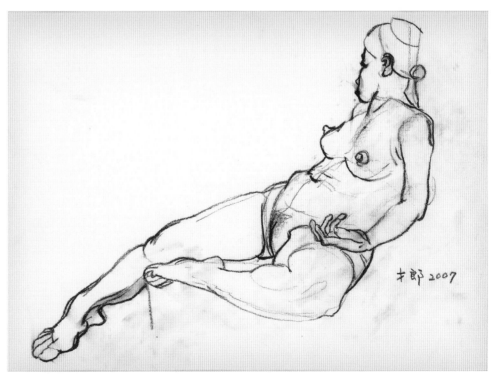

人體　2007　炭筆、畫紙
38.8×53.5公分　藝術家提供
Human Figure　2007
Charcoal pencil on paper
38.8 x 53.5 cm
Courtesy of the artist

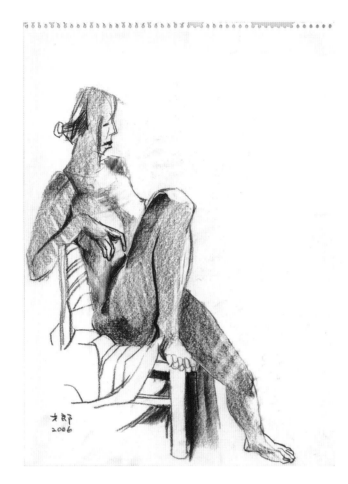

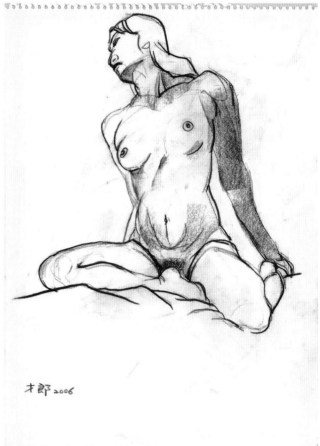

人體　2006　炭精筆、畫紙
53.5×38.8公分　藝術家提供
Human Figure　2006　Compressed charcoal pencil on paper
53.5 x 38.8 cm　Courtesy of the artist

人體　2006　炭精筆、畫紙
53.5×38.8公分　藝術家提供
Human Figure　2006　Compressed charcoal pencil on paper
53.5 x 38.8 cm　Courtesy of the artist

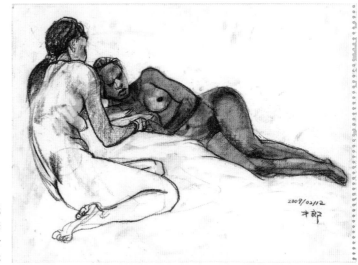

人體　2007　炭精筆、畫紙
38.8×53.5公分　藝術家提供
Human Figure　2007　Compressed charcoal pencil on paper
38.8 x 53.5 cm　Courtesy of the artist

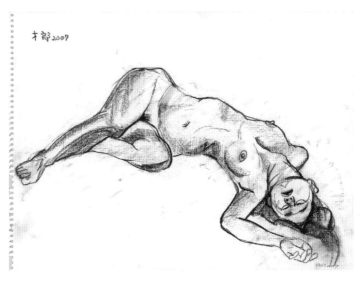

人體　2007　炭精筆、畫紙
38.8×53.5公分　藝術家提供
Human Figure　2007　Compressed charcoal pencil on paper
38.8 x 53.5 cm　Courtesy of the artist

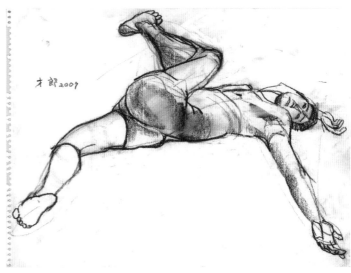

人體　2007　炭精筆、畫紙
38.8×53.5公分　藝術家提供
Human Figure　2007　Compressed charcoal pencil on paper
38.8 x 53.5 cm　Courtesy of the artist

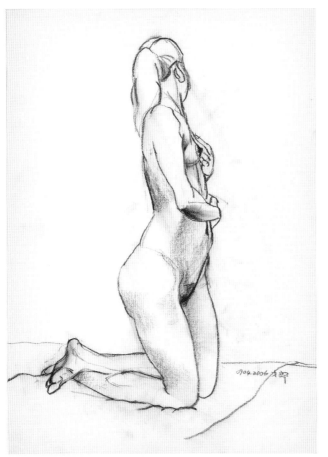

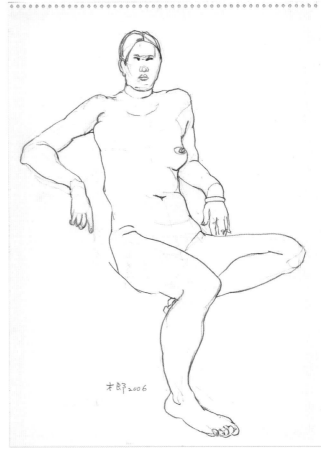

人體 2006 炭筆、畫紙
53.5×38.8公分 藝術家提供
Human Figure 2006 Charcoal pencil on paper
53.5 x 38.8 cm Courtesy of the artist

人體 2006 鉛筆、畫紙
53.5×38.8公分 藝術家提供
Human Figure 2006 Pencil on paper
53.5 x 38.8 cm Courtesy of the artist

左上 | 人體 2007 炭精筆、畫紙
Upper Left | 53.5×38.8公分 藝術家提供
Human Figure 2007 Compressed charcoal pencil on paper
53.5 x 38.8 cm Courtesy of the artist

右上 | 人體 2008 鉛筆、畫紙
Upper Right | 53.5×38.8公分 藝術家提供
Human Figure 2008 Pencil on paper
53.5 x 38.8 cm Courtesy of the artist

右下 | 人體 2008 炭精筆、畫紙
Lower Right | 53.5×38.8公分 藝術家提供
Human Figure 2008 Compressed charcoal pencil on paper
53.5 x 38.8 cm Courtesy of the artist

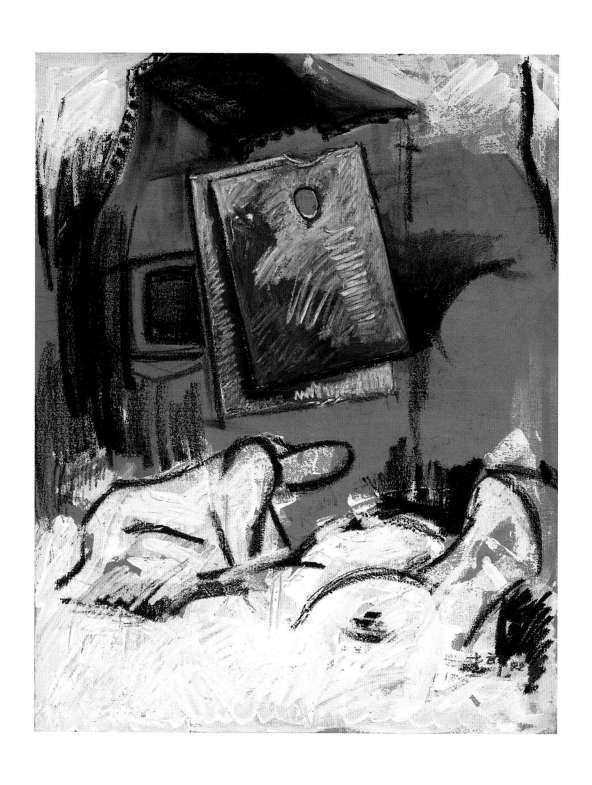

生活語錄　1992　油彩、畫布　91×72.5公分　藝術家提供
Everyday Recount　1992　Oil on canvas　91 x 72.5 cm　Courtesy of the artist

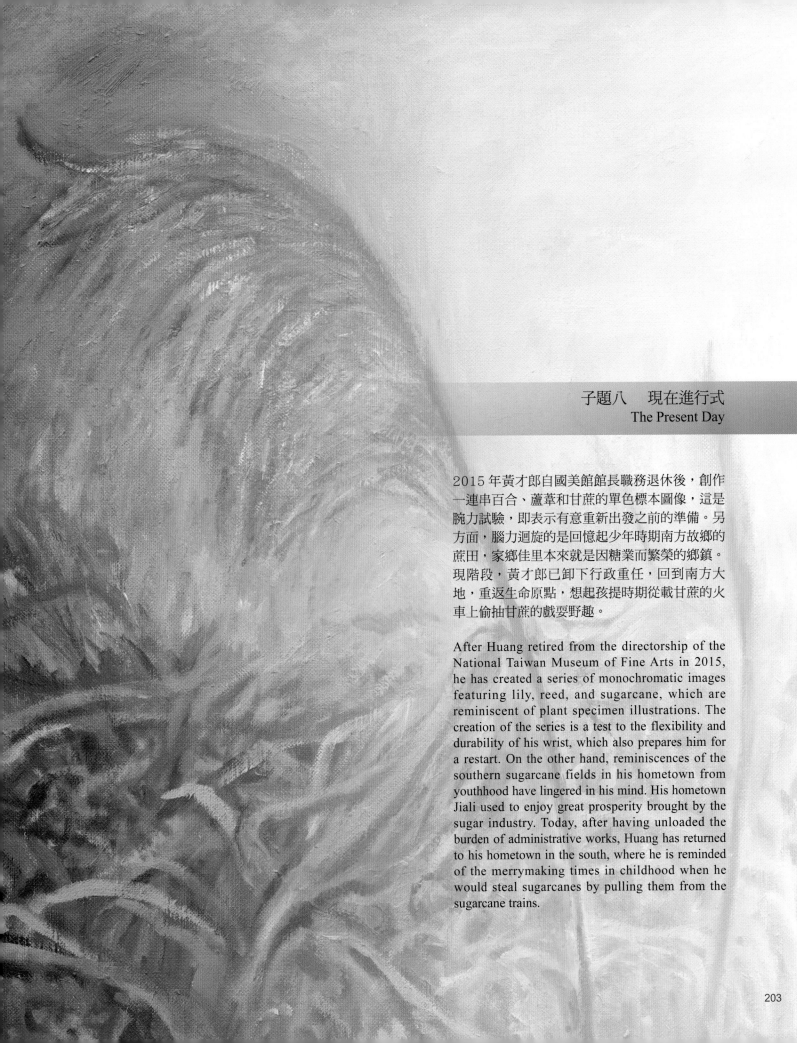

子題八　現在進行式
The Present Day

2015 年黃才郎自國美館館長職務退休後，創作一連串百合、蘆葦和甘蔗的單色標本圖像，這是腕力試驗，即表示有意重新出發之前的準備。另一方面，腦力迴旋的是回憶起少年時期南方故鄉的蔗田，家鄉佳里本來就是因糖業而繁榮的鄉鎮。現階段，黃才郎已卸下行政重任，回到南方大地，重返生命原點，想起孩提時期從載甘蔗的火車上偷抽甘蔗的戲耍野趣。

After Huang retired from the directorship of the National Taiwan Museum of Fine Arts in 2015, he has created a series of monochromatic images featuring lily, reed, and sugarcane, which are reminiscent of plant specimen illustrations. The creation of the series is a test to the flexibility and durability of his wrist, which also prepares him for a restart. On the other hand, reminiscences of the southern sugarcane fields in his hometown from youthhood have lingered in his mind. His hometown Jiali used to enjoy great prosperity brought by the sugar industry. Today, after having unloaded the burden of administrative works, Huang has returned to his hometown in the south, where he is reminded of the merrymaking times in childhood when he would steal sugarcanes by pulling them from the sugarcane trains.

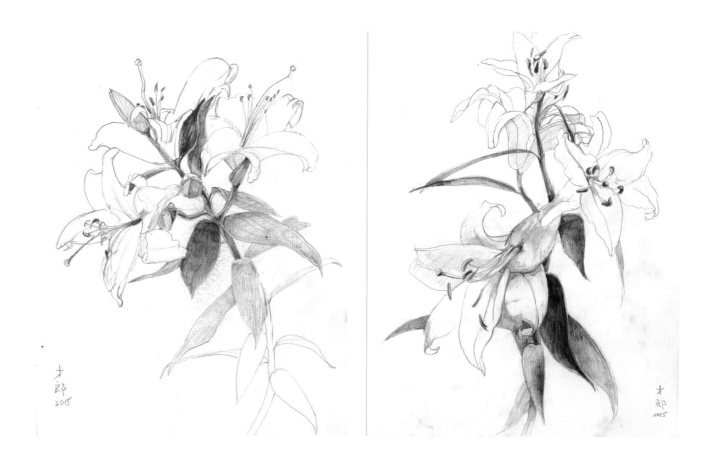

百合　2015　鉛筆、畫紙
40×31.5公分　藝術家提供
Lilies　2015　Pencil on paper
40 x 31.5 cm　Courtesy of the artist

百合　2015　鉛筆、畫紙
40×31.5公分　藝術家提供
Lilies　2015　Pencil on paper
40 x 31.5 cm　Courtesy of the artist

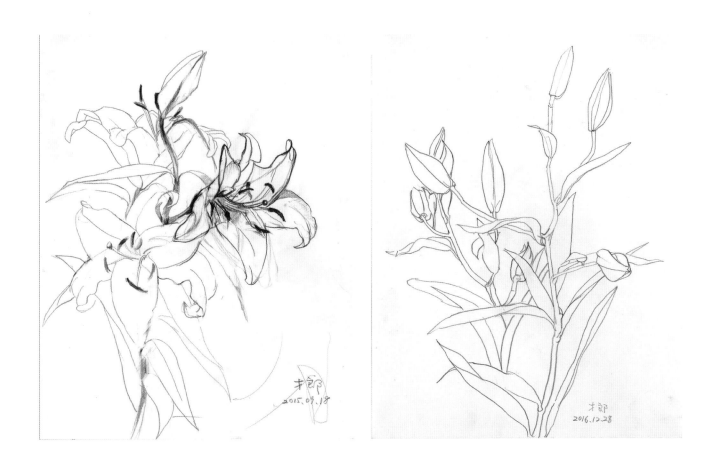

百合　2015　鉛筆、畫紙
40×31.5公分　藝術家提供
Lilies　2015　Pencil on paper
40 x 31.5 cm　Courtesy of the artist

百合　2016　鉛筆、畫紙
40×31.5公分　藝術家提供
Lilies　2016　Pencil on paper
40 x 31.5 cm　Courtesy of the artist

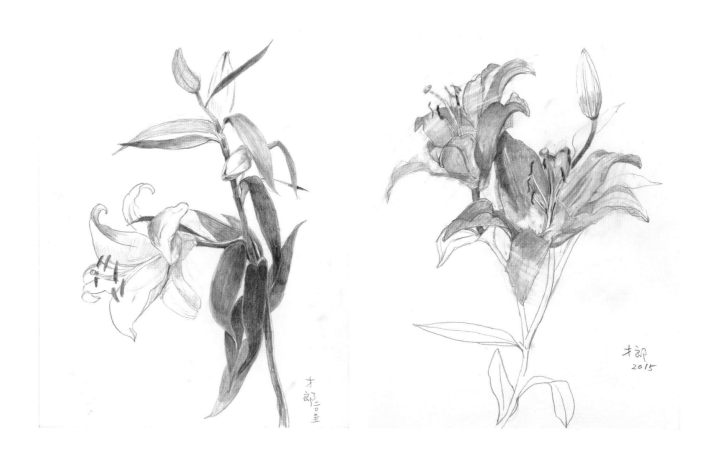

百合　2015　鉛筆、畫紙
40×31.5公分　藝術家提供
Lilies　2015　Pencil on paper
40 x 31.5 cm　Courtesy of the artist

百合　2015　鉛筆、畫紙
40×31.5公分　藝術家提供
Lilies　2015　Pencil on paper
40 x 31.5 cm　Courtesy of the artist

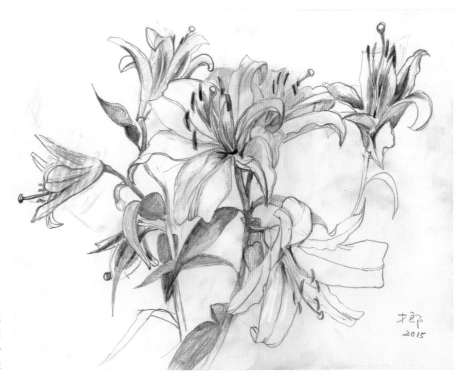

百合　2015　鉛筆、畫紙
31.5×40公分　藝術家提供
Lilies　2015　Pencil on paper
31.5 x 40 cm　Courtesy of the artist

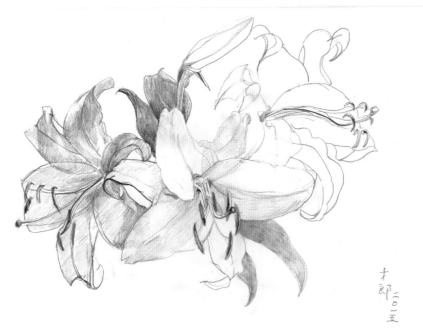

百合　2015　鉛筆、畫紙
31.5×40公分　藝術家提供
Lilies　2015　Pencil on paper
31.5 x 40 cm　Courtesy of the artist

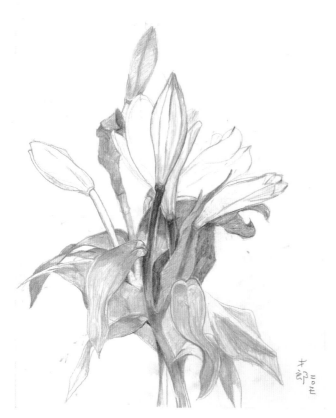

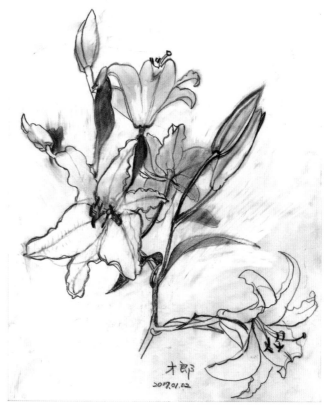

百合　2017　鉛筆、畫紙
40×31.5公分　藝術家提供
Lilies　2017　Pencil on paper
40 x 31.5 cm　Courtesy of the artist

百合　2017　鉛筆、畫紙
40×31.5公分　藝術家提供
Lilies　2017　Pencil on paper
40 x 31.5 cm　Courtesy of the artist

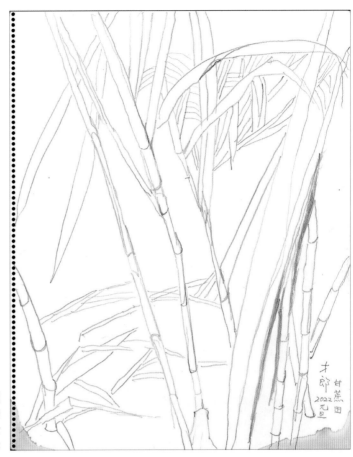

甘蔗田　2022　鉛筆、畫紙
53.5×38.8公分　藝術家提供
Sugar Cane Field　2022　Pencil on paper
53.5 x 38.8 cm　Courtesy of the artist

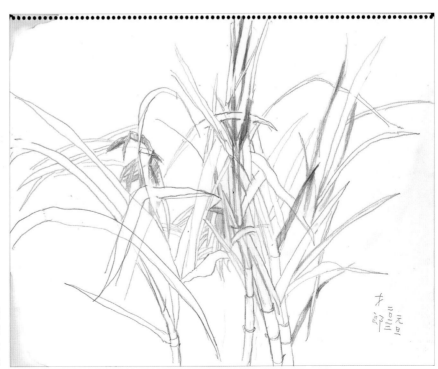

甘蔗園　2022　鉛筆、畫紙
38.8×53.5公分　藝術家提供
Sugar Cane Farm　2022　Pencil on paper
38.8 x 53.5 cm　Courtesy of the artist

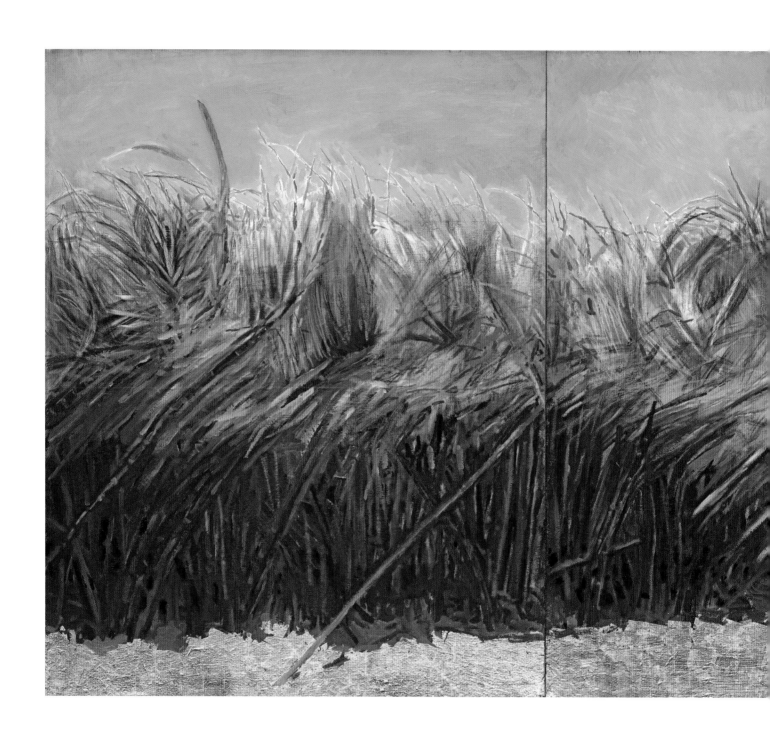

紅甘蔗園　2022　油彩、金箔、畫布　90×216公分　藝術家提供
Red Sugar Cane Farm　2022　Oil and gold foil on canvas　90 x 216 cm　Courtesy of the artist

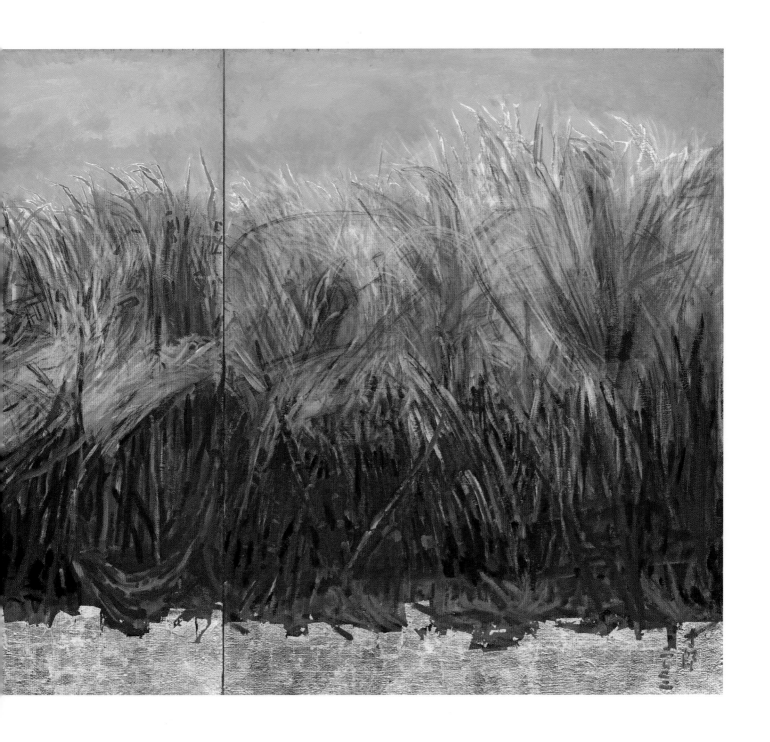

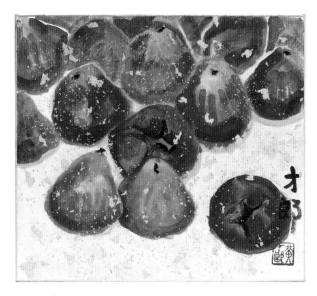

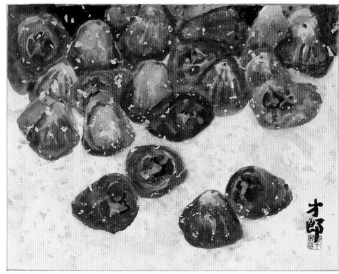

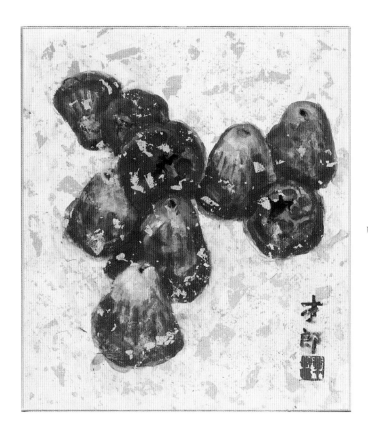

左上 | 蓮霧群像 2023
Upper Left | 朱標、墨、金箔、畫仙板
32×41公分 藝術家提供
Wax Apple Bunch 2023
Cinnabar, ink, and gold foil on Xuan paper board
32 x 41 cm Courtesy of the artist

右上 | 蓮霧群像 2023
Upper Right | 朱標、墨、金箔、畫仙板
32×41公分 藝術家提供
Wax Apple Bunch 2023
Cinnabar, ink, and gold foil on Xuan paper board
32 x 41 cm Courtesy of the artist

左下 | 蓮霧 2023
Lower Left | 朱標、墨、金箔、畫仙板
27×24公分 藝術家提供
Wax Apples 2023
Cinnabar, ink, and gold foil on Xuan paper board
27 x 24 cm Courtesy of the artist

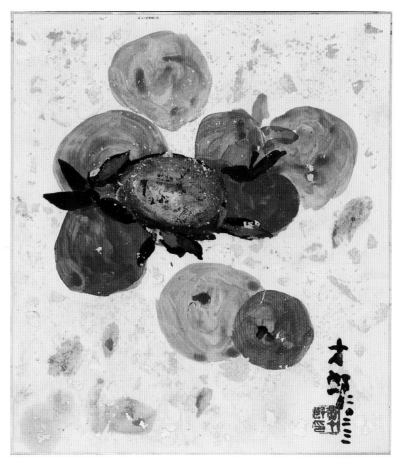

小橘子 2023
朱標、墨、金箔、畫仙板
27×24公分　藝術家提供
Small Tangerines 2023
Cinnabar, ink, and gold foil on Xuan paper board
27 x 24 cm　Courtesy of the artist

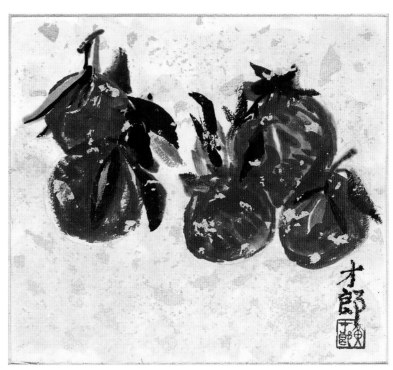

橘子 2023 朱標、墨、金箔、畫仙板
24×27公分　藝術家提供
Tangerines 2023
Cinnabar, ink, and gold foil on Xuan paper board
24 x 27 cm　Courtesy of the artist

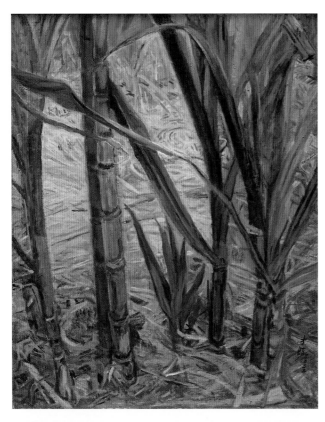

甘蔗田　2022　油彩、畫布
90.8×72.7公分　藝術家提供
Sugar Cane Field　2022　Oil on canvas
90.8 x 72.7 cm　Courtesy of the artist

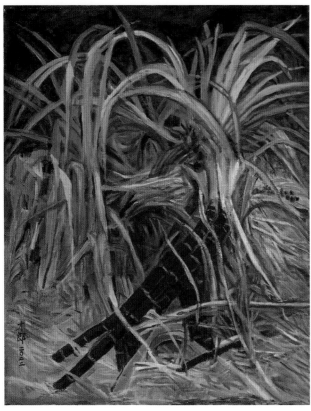

甘蔗　2022　油彩、畫布
90×72公分　藝術家提供
Sugar Cane　2022　Oil on canvas
90 x 72 cm　Courtesy of the artist

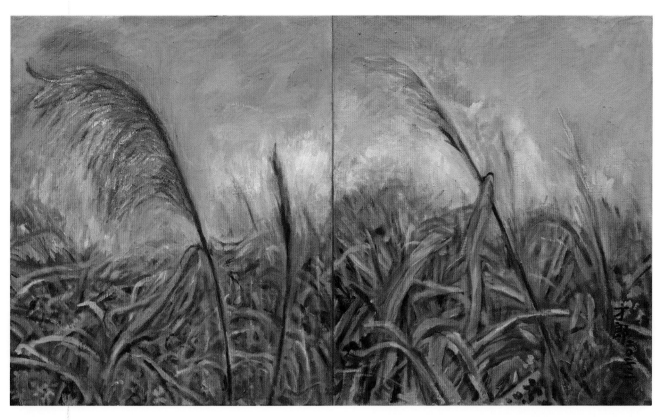

冷水坑
2023　油彩、畫布
53×90公分　藝術家提供
Lengshuikeng
2023　Oil on canvas
53 x 90 cm　Courtesy of the artist

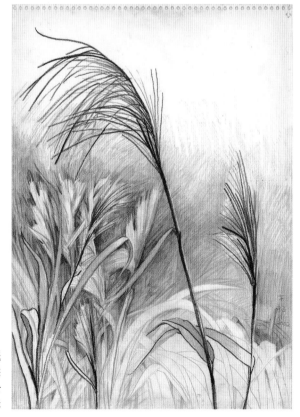

迎風　2002　炭筆、畫紙
53.5×38.5公分　藝術家提供
Facing the Wind　2002　Charcoal pencil on paper
53.5 x 38.5 cm　Courtesy of the artist

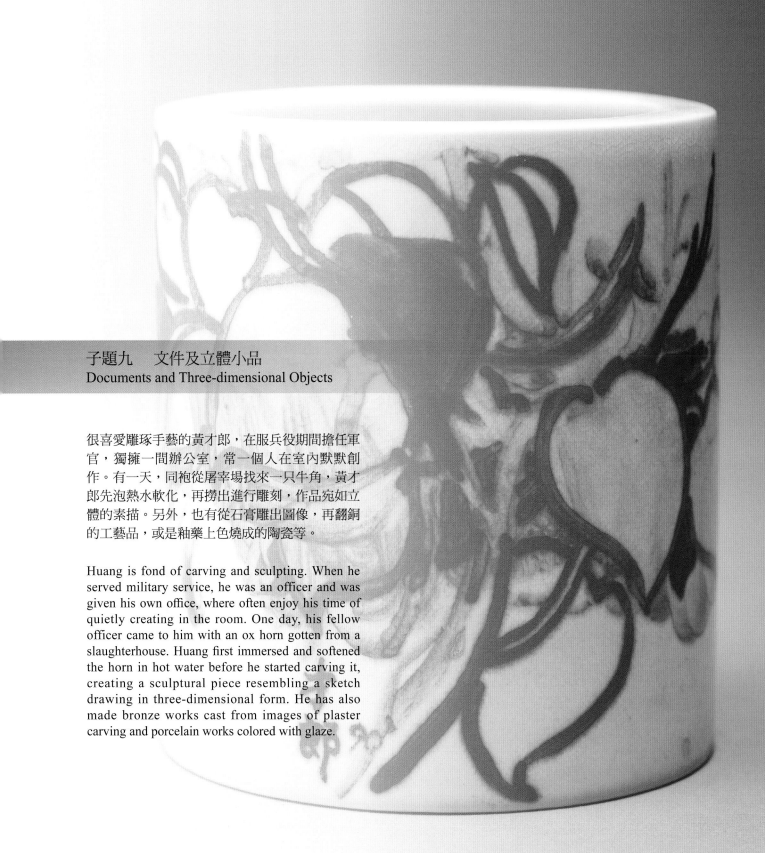

子題九　文件及立體小品
Documents and Three-dimensional Objects

很喜愛雕琢手藝的黃才郎，在服兵役期間擔任軍官，獨擁一間辦公室，常一個人在室內默默創作。有一天，同袍從屠宰場找來一只牛角，黃才郎先泡熱水軟化，再撈出進行雕刻，作品宛如立體的素描。另外，也有從石膏雕出圖像，再翻銅的工藝品，或是釉藥上色燒成的陶瓷等。

Huang is fond of carving and sculpting. When he served military service, he was an officer and was given his own office, where often enjoy his time of quietly creating in the room. One day, his fellow officer came to him with an ox horn gotten from a slaughterhouse. Huang first immersed and softened the horn in hot water before he started carving it, creating a sculptural piece resembling a sketch drawing in three-dimensional form. He has also made bronze works cast from images of plaster carving and porcelain works colored with glaze.

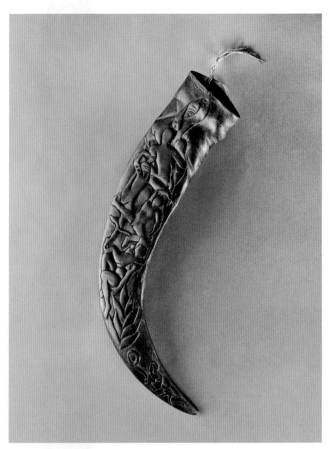 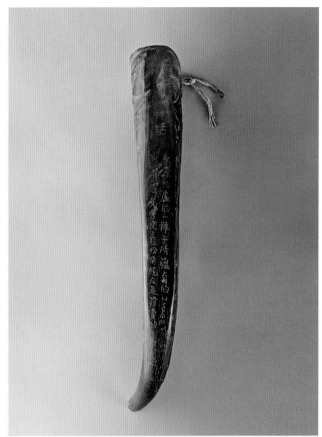

神話　1975　牛角　40×10×6.5公分　藝術家提供
Myth　1975　Cowhorn　40 x 10 x 6.5 cm　Courtesy of the artist

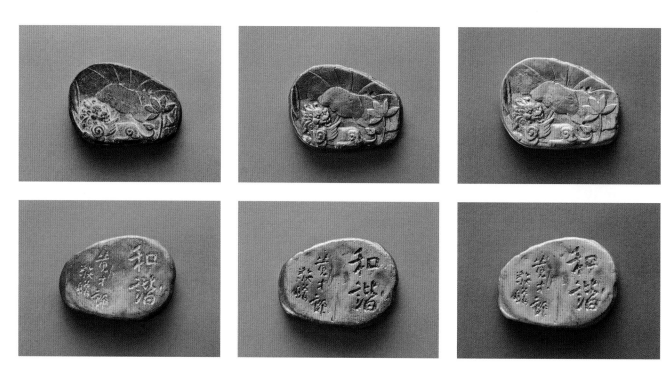

和諧紙鎮　2012　青銅　5×6.5×1公分×3件　藝術家提供
Harmony Paperweights　2012　Bronze　5 x 6.5 x 1 cm x 3 pieces　Courtesy of the artist

和諧紙鎮草圖　2012　鉛筆/原子筆、畫紙　41×63公分　藝術家提供
Sketches of the Harmony Paperweights　2012　Pencil and ballpoint pen on paper　41 x 63 cm　Courtesy of the artist

公文　1986　鉛筆、畫紙
42×30公分　藝術家提供
Official Document　1986　Pencil on paper
42 x 30 cm　Courtesy of the artist

黃金葛筆筒　1990　陶瓷
直徑10.9×高10公分　藝術家提供
Devil's Ivy Penholder　1990　Ceramics
Ø10.9 x H10 cm　Courtesy of the artist

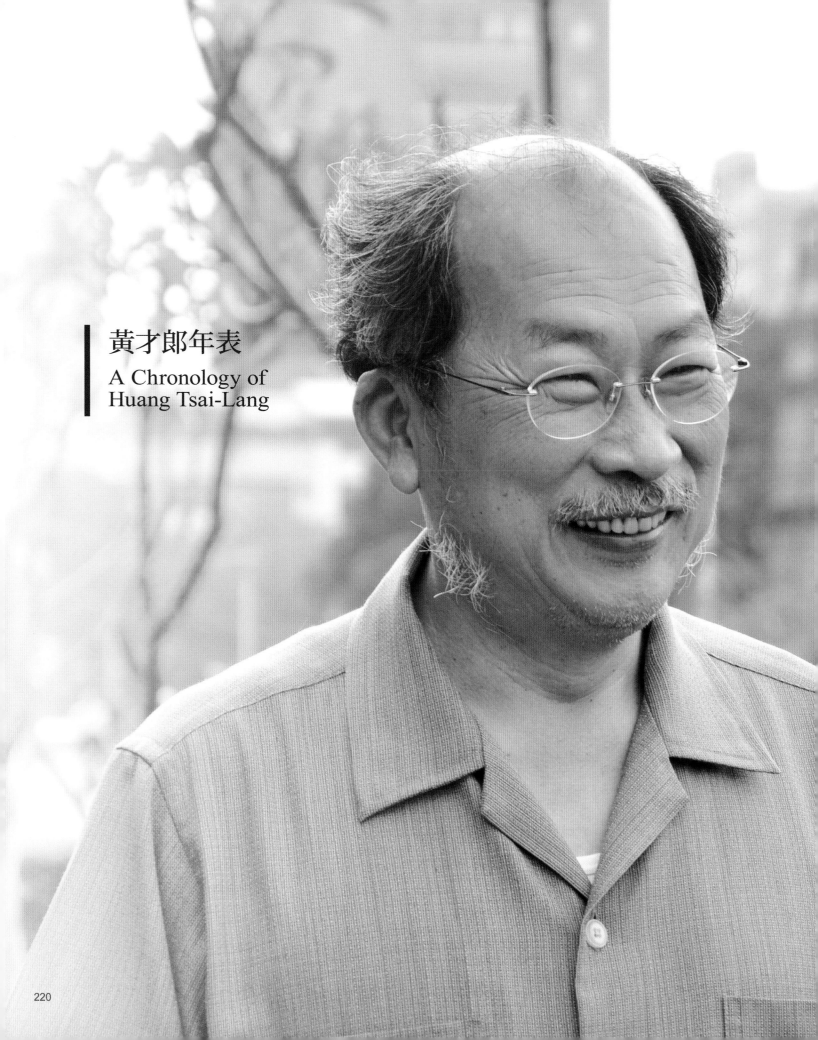

黃才郎年表
A Chronology of Huang Tsai-Lang

•1950

- 10月21日生於臺灣臺南縣佳里鎮
- 出生六個月即喪父,由祖父母撫養。
- Born on October 21st in Jiali Township, Tainan County of Taiwan.
- Father passed away when he was 6 months old, and he was raised by his grandparents.

•1955

- 進入臺南縣佳里國小寄讀
- Began to board and study at the Jiali Elementary School in Tainan County.

•1957

- 進入臺南縣佳里國小正式就讀,受教於美術教師陳基隆。
- Began to officially study at the Jiali Elementary School in Tainan County and was taught by art teacher, Chen Kee-Lung.

•1963

- 臺南縣佳里國小畢業
- 考入臺南市立中學
- Graduated from the Jiali Elementary School in Tainan County.
- Admitted to the Tainan Municipal Jr. High School.

•1966

- 臺南市立中學初中部畢業
- 考入臺南市私立長榮中學就讀高一
- Graduated from the Tainan Municipal Jr. High School.
- Admitted to the private Chang Jung Senior High School in Tainan and started his freshman year.

•1967

- 高二轉入臺南縣省立北門中學,進入郭柏川畫室學習。
- 高中期間多次代表北門中學參加校外繪畫比賽(1967~1969)
- Transferred in his sophomore year to the provincial Beimen Senior High School in Tainan County and was trained at the painting studio of Kuo Po-Chuan.
- As a high school student, he represented the Beimen Senior High School in several off-campus art competitions (1967-1969).

•1969

- 臺南縣省立北門中學畢業
- 考入中國文化大學美術系就讀,獲張光遠、沈國仁指導。
- Graduated from the Provincial Beimen Senior High School in Tainan County.
- Admitted to the Department of Fine Arts at the Chinese Culture University, where he was mentored by Chang Kuang-Yuan and Shen Guo-Ren.

•1970

- 獲陳銀輝、陳景容、周月坡、施翠峰、楊乾鐘、沈以正、莊尚嚴指導。
- 擔任美術系學會會長
- 創辦中國文化大學美術系學刊
- Mentored by Chen Yin-Huei, Chen Ching-Jung, Chou Yue-Po, Shih Tsui-Feng, Shen Yi-Cheng, and Chuang Shang-Yen.
- Served as President of the Student Association of the Department of Fine Arts.
- Founded a journal for the Department of Fine Arts at the Chinese Culture University.

•1971

- 經系主任施翠峰推薦,進入英文中國郵報《美術雜誌》擔任美術文稿編輯、策劃,並撰寫西洋美術專欄,介紹世界名作(自1971年10月至1973年7月,共主筆22期)。
- 創作了生平第一張油畫〈佳里教堂〉
- Referred by then Head of the Department, Prof. Shih Tsui-Feng, to work as an editor for *Meishu zazhi* (Fine Arts Magazine) under *The China Post* and wrote a column on Western art, which introduced famous artworks from around the world. (He was the chief editorial writer for 22 issues of the magazine from October 1971 to July 1973.)
- Created first oil painting, *The Jjiali Churce*.

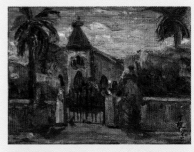

〈佳里教堂〉,1971
The Jiali Church, 1971

1971年,22歲的黃才郎創作了生平第一張油畫〈佳里教堂〉,他自言這是「揣摩康丁斯基抽象繪畫進入野獸派表現主義的開始」。
The Jjiali Church created in 1971 was the first oil painting by Huang Tsai-Lang, and according to the artist, "It was an interpretation of Kandinsky's abstract art that was marked by Fauvist style, which launched the beginning of Expressionism."

•1972

- 於此段時間(1972-1973)受教於廖繼春、李梅樹、楊三郎、林克恭、吳承硯、黃朝謨、郭柏川,獲得指導。
- 國際婦女協會舉辦美術比賽,獲大專組版畫首獎,作品並由主辦單位義賣後被收藏。
- 中國文化大學美術系西畫組畢業
- 7月與洪瑞麟、張萬傳、陳景容、汪壽寧、周月坡、黃昌惠共7位藝術家至蘭嶼寫生,創作十餘幅臺東、蘭嶼寫生繪畫作品;同時拍製8釐米電影,且撰文〈畫家筆下的蘭嶼風光〉,刊載於1972年9月號《美術雜誌》。
- Often sought out advice from and was mentored by Liao Chi-Chun, Li Mei-Shu, Yang San-Lang, Lin Ko-Kung, Wu Cheng-Yen, Hwang Chao-Mo, and Kuo Po-Chuan.
- Participated in an art competition organized by the International Council of Women and won first place in the University Division's Printmaking Category. The artwork was sold and collected in a charity auction held by the organizer.
- Graduated from the Western Painting Division under the Department of Fine Arts at the Chinese Culture University.
- Traveled to Lanyu (Orchid Island) in July to paint outdoors with Hung Jui-Lin, Chang Wan-Chuan, Chen Ching-Jung, Wang Shou-Ling, Chou Yue-Po, and Huang Chang-Huei, and created a dozen of paintings depicting the landscapes in Taitung and Lanyu. An 8mm film was also produced at the same time, and he penned the piece, "Orchid Island Landscapes Painted by Artists," which was published in the September 1972 issue of *Meishu zazhi* (Fine Arts Magazine).

〈蘭嶼〉,1972,銅版、粉彩、畫紙,23.6 x 19.2 cm,藝術家自藏
Lanyu, 1972. Copperplate, pastel on paper. 23.6 x 19.2 cm. Courtesy of the artist.

•1973

- 作品參加「臺陽美展」獲葛達利獎
- 擔任英文中國郵報《美術雜誌》專職編輯
- 擔任救國團自強活動美術研習會水彩組駐會指導
- 中國文化大學院美術系畢業
- 入伍服役於臺南，結識潘元石，借用其版畫工作室創作。
- Won the *Tai-yang Art Exhibition*'s Gallery Prize.
- Started working as a full-time editor at *The China Post*'s *Meishu zazhi* (Art Magazine).
- Mentored at the Watercolor Division of China Youth Corps' Art Workshop.
- Graduated from the Department of Fine Arts at the Chinese Culture University.
- Started serving military duties in Tainan; met Pan Yuan-Shih and created art in his printmaking studio.

•1974

- 服務於英文中國郵報期間，與作家劉延湘小姐合譯《西洋美術辭典》，草成A、B兩大字母段落。
- While working at *The China Post*, he co-translated the *Western Art Dictionary* with Liu Yan-Xiang and preliminarily completed the "A" and "B" sections of the dictionary.

•1975

- 擔任世界紅卍字會臺灣省分會附設慈幼幼稚園美術教師，爲期四年。
- Worked for 4 years as an art teacher at the kindergarten under the Taiwan Provincial Branch of the Red Swastika Society.

•1977

- 與王蕙芳女士結婚
- 長女黃之千出生
- Married Wang Hui-Fang.
- Birth of daughter, Huang Chih-Chien.

•1978

- 與夫人王蕙芳女士共同創辦「一代兒童美術教室」，致力於兒童美術教育之推廣。
- 擔任私立延平中學、私立長青幼稚園、雄獅兒童畫班美術教師
- Co-founded the One Generation Children's Art Class with his wife Wang Hui-Fang, with the mission of advocating children's art education.
- Worked as an art teacher at the private Yanping High School, Evergreen Kindergarten, and Hsiung Shih Art Children's Painting Class.

•1979

- 長子黃茂嘉出生
- Birth of son, Huang Mao-Chia.

〈星期五下午〉，1971，銅版、畫紙
本件〈星期五下午〉，爲黃才郎借用潘元石版畫工作室期間所印製完成的作品。
Friday Afternoon, 1971. Copperplate, paper.
Friday Afternoon by Huang Tsai-Lang was printed in Pan Yuan-Shih's printmaking studio.

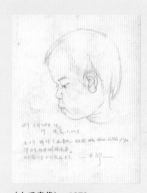

〈小千畫像〉，1979
本作繪於女兒1歲8個月又6天
Portrait of Xiao-Chien, 1979
Drawn when his daughter was 1 year, 8 months, and 6 days old.

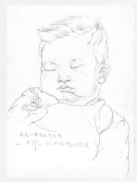

〈茂嘉畫像〉，1979
本作繪於兒子1個月又18天
Portrait of Mao-Chia, 1979
Drawn when his son was 1 month and 18 days old.

•1980

- 擔任雄獅美術叢書部主編，協同編輯何傳馨、李梅齡、沈德傳、李伊文、王效祖等人費時兩年餘，編纂完成《西洋美術辭典》。
- Worked as Editor-in-chief of Hsiung Shih Art Books and co-edited and spent over two years completing the *Western Art Dictionary* with Ho Chuan-Hsing, Lee Mei-Ling, Shen Te-Chuan, Lee Yi-Wen, and Wang Hsiao-Tsu.

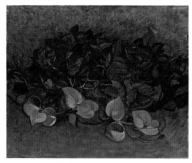

〈纏綿系列－黃金葛一〉，1980
Lingering Series - Devil's Ivy I, 1980

1980年，黃才郎在工作之餘投注相當多時間於創作，完成了包含油畫、素描、版畫等不同媒材的多件作品，其首件「纏綿系列」繪畫以黃金葛為題材，完成於本年。
In 1980, Huang Tsai-Lang spent a lot of his free time making art and completed many artworks with different media, which included oil paintings, drawings, and prints. The first piece in his *Lingering Series* depicted the evergreen pothos vines and was completed that year.

1980年於雄獅圖書工作時的黃才郎
Huang Tsai-Lang from his time working at Hsiung Shih Art Books in 1980.

文建會時期 (1) Council for Cultural Affairs Period (I)

•1981

- 行政院文化建設委員會初創（後於2012年升格為文化部），應時任第三處處長申學庸之邀，擔任美術科首位科長（1982~1989）。
- 提出「文化海報」構想，推動海報媒體之提升，使增加設計性及文化深度。
- 「一代兒童美術教室」搬遷至敦化南路，由夫人王蕙芳女士主持經營。
- When the Council for Cultural Affairs under the Executive Yuan was founded (which was upgraded in 2012 to the Ministry of Culture), the then Director of its 3rd Department, Shen Hsueh-Yung, invited Huang to serve as the inaugural Section Chief of the council's Division of Arts (1982-1989).
- Proposed the idea of "Cultural Posters" with the aim of elevating the medium of posters with enhanced design and cultural depth.
- One Generation Children's Art Class moved to Dunhua South Road and was managed by his wife, Wang Hui-Fang.

•1982

- 主導籌劃辦理「年代美展」
- 主導推動辦理「地方美展」
- 主編之中文版《西洋美術辭典》出版，並榮獲民國71年新聞局頒給圖書金鼎獎。
- Directed the organization of the *Exhibition of Periodic Works*.
- Directed and advocated the organization of "local art exhibitions."
- Editor-in-chief of *Western Art Dictionary* in Traditional Chinese, which was published and won a Golden Tripod Award in 1982 from the Government Information Office.

•1983

- 主導籌劃拍攝系列前輩美術家紀錄影片，導演爲柯冬靑，著手整理臺灣繪畫史蹟資料。
- 主導策劃辦理「中華民國國際版畫展」；第二屆「中華民國國際版畫展」（1985）改名爲「中華民國國際版畫雙年展」，每兩年舉辦一次，以大型展覽將臺灣能見度推向國際。
- 主導策劃辦理「明淸時代台灣書畫展」，著手彙整地方美術發展史料。
- 主導策劃辦理「中、日、韓、香港視覺研習會」，吸引國際藝術家與臺灣藝壇交流互動。
- 策劃執行鑄銅保存臺北市中山堂黃土水〈水牛群像〉石膏浮雕，分贈臺北市立美術館及中南部公立美術館，分享全臺灣各地美術愛好者。
- Directed the organization of a documentary series on veteran artists, with Ko Tung-Ching as the director and materials on the history of painting in Taiwan organized.
- Directed the organization of the *International Print Exhibit, R.O.C.,* which was renamed in its second iteration held in 1985 to the *International Biennial Print Exhibit, R.O.C.* as a large-scale exhibition held twice a year to enhance Taiwan's international visibility.
- Directed the organization of the exhibition, *Painting and Calligraphic Works in Taiwan during the Ming-Ch'ing Period*, with historical materials on the development of local art organized.
- Directed the organization of the "Taiwan, Japan, Korea, Hong Kong Visual Seminar" and invited international artists to engage in exchanges with the arts community in Taiwan.
- Organized for Huang Tu-Shui's plaster relief sculpture, *Taiwan Buffalo*, at the Taipei Zhongshan Hall to be cast in bronze, with the casts produced donated to the Taipei Fine Arts Museum and other public art museums in central and southern Taiwan, in order for the artwork to be appreciated by more people around Taiwan.

•1984

- 主導籌劃辦理「臺灣地區美術發展回顧展」
- 策劃辦理爲唐代書法家顏眞卿逝世一千二百年紀念之「中國書法國際學術研討會」。同時，國立故宮博物院配合主辦「歷代書法展」、國立歷史博物館配合主辦「中國書法國際交流展」，首開國內公辦大型美展以深化且學術化方式之系列活動同時進行。
- 中華民國公務人員高等考試藝術行政人員美術組考試及格
- Directed the organization of Art *Development in Taiwan - A Retrospective Exhibition in Four Parts*.
- Directed the organization of the *International Seminar on Chinese Calligraphy*, to commemorate the 1200th posthumous anniversary of Tang dynasty calligrapher, Yen Chen-Ching. Co-organized with the National Palace Museum the exhibition, *Selections from the History of Chinese* and *the International Exchange Exhibition of Chinese Calligraphy* with the National Museum of History, which were the first series of large-scale public art exhibitions in Taiwan organized through an in-depth academic-driven approach.
- Passed the Art Administrator Division of the Republic of China (Taiwan) Civil Service Senior Examination.

在時任文建會主委陳奇祿的支持下，黃才郎戮力推動辦理具歷史脈絡、學術觀點的大型公辦美展，開啓公部門主導籌劃辦理「臺灣美術」研究性展覽的先河。本照攝於1987。
With support from the Council for Cultural Affairs' inaugural minister, Chen Chi-Lu, Huang began advocating the organization of large-scale exhibitions focusing on historical contexts and academic perspectives, which launched the public sector's focus on planning and presenting research-oriented exhibitions on the art of Taiwan. This photo was taken in 1987.

1987年第三屆「中華民國國際版畫雙年展」徵件作品初審會議，右起：廖修平、黃才郎、方向、潘元石、王哲雄。
Preliminary evaluation meeting for the entries received for the 3rd *International Biennial Print Exhibit, R.O.C.* in 1987. From the right: Liao Shiou-Ping, Huang Tsai-Lang, Fang Hsiang, Pan Yuan-Shih, and Wang Che-Hsiong.

1983年黃土水〈水牛群像〉石膏浮雕翻銅時的現場，右下角三人爲陳奇祿、申學庸、黃才郎
On location at the bronze casting of Huang Tu-Shui's plaster relief sculpture, *Taiwan Buffalo*, in 1983. On the lower right corner: Chen Chi-Lu, Shen Hsueh-Yung, and Huang Tsai-Lang.

•1985

- 主導策劃辦理「明清時代臺灣書畫」赴比利時、法國、義大利、德國、菲律賓等地展出
- 應「美國在臺協會」邀請，前往美國考察訪問美國藝術行政一個月。
- Directed the organization for the exhibition, *Painting and Calligraphic Works in Taiwan during the Ming-Ch'ing Period*, to tour to Belgium, France, Italy, Germany, and the Philippines.
- At the invitation of the American Institute in Taiwan, conducted a month-long art administration visit in the U.S.

•1986

- 主導策劃辦理「中華民國傳統版畫特展」赴韓國華克山莊美術館展出
- 主導策劃辦理「中華民國工藝展」前往中南美洲八國巡迴展出
- 赴日本接洽「臺灣地區美術發展回顧展」展出事宜
- 創作〈澎湖印象〉戶外壁畫於馬公市街口
- Directed the organization for the exhibition, *Traditional Chinese Woodcut Prints*, to show at the Walker Hill Art Museum in Korea.
- Directed the organization for the exhibition, *Arts and Crafts from the Republic of China*, to tour in eight countries in Central and South America.
- Traveled to Japan to discuss the exhibition, *Retrospective Exhibition of the Painting Development in Taiwan 1739~1980*.
- Created the outdoor mural, *Penghu Impression*, located in Magong City of Penghu County, Taiwan.

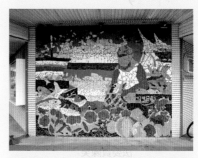

黃才郎1986年於澎湖馬公市創作的〈澎湖印象〉壁畫
Penghu Impression, a mural created by Huang Tsai-Lang in 1986 at Magong City, Penghu.

•1987

- 主導策劃辦理「中華民國現代十大美術家」赴日本展出
- 榮獲中華民國青年商業總會頒發十大傑出青年獎章
- Directed the organization for the exhibition, *Top Ten Modern Artists of the Republic of China*, to show in Japan.
- Recognized as one of the "Ten Outstanding Young Persons of Taiwan" by the Junior Chamber International Taiwan.

黃才郎1987年獲十大傑出青年獎章，返鄉與祖母及親友合影。
A commemorative photograph taken back home with Huang Tsai-Lang's grandmother and relatives after he was named one of the "Ten Outstanding Young Persons of Taiwan" in 1987.

•1988

- 開始擔任「奇美藝術獎評審委員」
- 應美國傅爾布萊特學者訪問計畫邀請赴美國，爲期7個半月，研究文化行政及公共藝術。
- Started serving as a jury member of the Chimei Art Awards.
- At the invitation of the United States' Fulbright Program, traveled to the U.S. as a visiting scholar to conduct research on cultural policies and public art for seven and a half months.

黃才郎1988年擔任美國傅爾布萊特學者訪問期間，致贈美國相關單位其所主編的中文版《西洋美術辭典》。
While visiting the U.S. as a Fulbright scholar in 1988, Huang Tsai-Lang presented the *Western Art Dictionary* in Traditional Chinese, which was published under his leadership, to people working in various departments in the U.S.

•1989

- 榮獲日本交流協會邀請，擔任副團長，率臺灣優秀青年邀訪團赴日本參訪。
- 獲法國文化傳播部頒贈文藝一等特殊貢獻勳章。
- Invited by the Japan-Taiwan Exchange Association to lead a delegation of outstanding young people from Taiwan to visit Japan and to serve as the deputy head of the delegation.
- Decorated by the Ministry of Culture, France with a First Class Medal for his special contribution to arts and culture.

•1990

- 辭卸文建會職務
- 接受立法委員陳癸淼之聘擔任文化立法助理（1990-1991），推動「文化藝術獎助條例」公共藝術「1% For Art」法案。
- Resigned from his position at the Council for Cultural Affairs.
- Accepted Legislator Chen Kuei-Miao's offer to serve as a cultural legislative assistant (1990-1991) and pushed for the enactment of the "1% for Art" bill for public art under the "Culture and Arts Reward Act."

•1991

- 撰寫〈爲締造良好創作環境而努力〉，刊載於《文訊》雜誌9月號。
- Penned the article, "Strive to Create a Favorable Creative Environment," published in the September issue of *Wenshun* magazine.

〈心想事成－公共藝術構想〉，1986
A Wish Comes True - An Idea of Public Art, 1986

黃才郎1990-1991擔任立法委員陳癸淼之文化立法助理期間，是起草「文化藝術獎助條例」的關鍵人物。他在本條例「1% for art」（即公共建設以百分之一經費設置公共藝術）1992年通過立法院審議時，爲本作加筆並更名爲〈心想事成－公共藝術構想〉，誌記個人心情。

Served as Legislator Chen Kuei-Miao's cultural legislative assistant from 1990 to 1991 and was a key figure behind the drafting of the "Culture and Arts Reward Act." When the public art "1% for Art" bill (which stipulated that 1% of the total cost of a public construction project shall be used toward the installment of public art) was passed by the Legislative Yuan in 1992, Huang embellished this artwork and renamed it, *A Wish Comes True - An Idea of Public Art*, to commemorate this important event.

高雄市立美術館時期 Kaohsiung Museum of Fine Arts Period

•1992

- 1月30日，就任高雄市立美術館籌備處主任。
- 中國文化大學藝術研究所碩士畢業，碩士論文《文化政策影響下的藝術贊助——台灣1950年代文化政策、文化贊助與畫壇的互動》。
- 撰寫《臺灣美術全集10——郭柏川》，藝術家出版社出版。
- 受邀擔任「奇美美術館藝術人才培育獎助美術類召集人」，至今32年。
- 參加發起「文化環保」，與林懷民、吳靜吉、許博允、邱坤良、楊英風、楚戈等發起人，主張推動公共建築應設置藝術品美化空間。

- Appointed on January 30th as Director of the Kaohsiung Museum of Fine Arts Preparatory Department.
- Graduated from the Graduate School of Fine Arts at the Chinese Culture University; the topic of his Master's thesis was: *Art Sponsorship Under the Impact of Cultural Policy: Interaction Between Cultural Policy, Art Sponsorship, and the Art World in Taiwan in the 1950s.*
- Penned *Taiwan Fine Arts Series 10 - Kuo Po-Chuan*, published by the Artist Publishing Co.
- Served for the last 32 years and is still serving as the convenor of Chimei Museum's Fine Arts Scholarship.
- Co-initiated the movement of "Cultural Environmental Protection" with Lin Hwai-Min, Wu Jing-Ji, Hsu Po-Yun, Chiu Kun-Liang, Yang Yuyu, and Chu Ko, advocating for artworks to be installed in public buildings to enhance their aesthetics.

•1994

- 6月高雄市立美術館落成開館，10月起擔任高雄市立美術館首任館長（1994~1999）。
- 主導策劃辦理「高雄建築300年」特展
- 主導策劃辦理「時代的形象－台灣地區繪畫發展回顧展」
- 主導策劃辦理「比利時表現主義」
- 主導策劃辦理美國藝術家超寫實「查‧克羅斯版畫特展」
- 主導策劃辦理「布爾代勒雕塑展」
- 主導策劃辦理比利時眼鏡蛇畫派「卡‧阿貝爾回顧展」
- 李登輝總統蒞臨高美館，工作簡報後提出故宮藏品南下建言，促成「國之重寶－國立故宮博物院文物珍藏特展」40年來首次南下展出。
- 撰寫《公共藝術與社會的互動》，藝術家出版社出版。
- Kaohsiung Museum of Fine Arts was inaugurated in June, and Huang began serving as its first director in October (1994-1999).
- Directed the organization of the exhibition, *The Architectural Beauty of Kaohsiung 1683~2000.*
- Directed the organization of the *Retrospective Exhibition of Painting Development in Taiwan 1739~1980.*
- Directed the organization of the exhibition, *Belgian Expressionism.*
- Directed the organization of *Chuck Close Print Exhibition*, featuring the American hyper-realism artist.
- Directed the organization of the *Exhibition of the Sculptures of Bourdelle.*
- Directed the organization *A Retrospective of Karel Appel*, featuring the Belgium artist who was a part of the Cobra Art movement.
- President Lee Teng-Hui visited the Kaohsiung Museum of Fine Arts, and in a work briefing presented, Huang proposed for an exhibition featuring the collection of the National Palace Museum to be held in southern Taiwan, which led to the realization of *Great National Treasures of China: A Special Exhibition on Loan from the National Palace Museum*, marking the first time in 40 years for the museum's collection to be shown in southern Taiwan.
- Penned *Interaction Between Public Art and Society*, published by the Artist Publishing Co.

•1995

- 主導推動辦理「朱銘：箱根雕塑森林大展」於日本雕刻之森美術館展出
- 主導策劃辦理「台灣近代雕塑發展」展，並長期陳列於高美館
- 主導策劃辦理「黃土水百年誕辰紀念特展」，親自拜訪臺日兩地公私收藏家，借得黃土水遺作37件。
- 主導策劃辦理「台灣傳統版畫特展」
- 主導策劃辦理「培梅克回顧展」
- 召開「公共藝術國際學術研討會」
- Directed the organization of *Ju Ming: Sculpture Exhibition* at the Hakone Open-Air Museum, Japan.
- Directed the organization of *Modern Sculpture Development in Taiwan: Exhibition of Museum Collection*, which is a permanent exhibition at the Kaohsiung Museum of Fine Arts.
- Directed the organization of *The Centenary of Huang Tu-Shui* and personally visited private collectors in Taiwan and Japan to secure 37 posthumous artworks by Huang Tu-Shui on loan for the exhibition.
- Directed the organization of the exhibition, *Traditional Woodblock Prints of Taiwan.*
- Directed the organization of *A Retrospective of Constant Permeke.*
- Convened the "International Public Art Symposium."

李登輝總統出席1994年訪視高美館並參觀「布爾代勒雕塑展」，黃才郎提出故宮藏品至高美館展出建言，促成「國之重寶－國立故宮博物院文物珍藏特展」40年來首次南下展出。
President Lee Teng-Hui visited *Exhibition of the Sculptures of Bourdelle* in 1994, and Huang proposed for an exhibition featuring the collection of the National Palace Museum to be held in the Kaohsiung Museum of Fine Arts, which led to the realization of *Great National Treasures of China: A Special Exhibition on Loan from the National Palace Museum*, marking the first time in 40 years for the museum's collection to be shown in southern Taiwan.

〈大頭菜〉，1996
Kohlrabis, 1996
黃才郎自1995起開始運用金箔入畫，他特別注重在油畫上貼金箔所留下的「手勢」與「手感」，使金箔在畫面上的肌理能形成明暗與折射的效果。
Huang Tsai-Lang started applying gold foils to his paintings in 1995 and paid particular attention to the gestural qualities and textures created by pasting gold foils on oil paintings, creating contrasting light and shadow effects and reflections on the textures of the paintings.

•1996

- 主導策劃辦理「趙無極回顧展」
- 主導策劃辦理「邁約雕塑展」
- 主導策劃辦理法國藝術家「畢費回顧展」
- 主導策劃辦理「義大利當代版畫展」
- 應邀在國際公共藝術Junction '96 發表論文〈公共藝術的挑戰〉，里斯本Metropolitano de Lisboa出版
- Directed the organization of *A Retrospective of Zao Wou-ki*.
- Directed the organization of the sculpture exhibition, *Aristide Maillo*.
- Directed the organization of *A Retrospective of Bernard Buffet*, featuring the French artist.
- Directed the organization of the exhibition, *Italian Contemporary Prints*.
- Presented the paper, *The Challenge of Public Art* at "Junction '96: Lisbon Worldwide Conference on Art and Public Transport," which was published by Metropolitano de Lisboa.

黃才郎與趙無極合影於高美館1996年「趙無極回顧展」現場
Huang Tsai-Lang and Zhao Wou-Ki photographed at *A Retrospective of Zao Wou-ki* presented at the Kaohsiung Museum of Fine Arts.

黃才郎主持「邁約雕塑展」記者會，1996。
Huang Tsai-Lang hosting the press conference for the sculpture exhibition, *Aristide Maillo*, 1996.

畢費於展覽記者會現場簽送專輯，1996。
Bernard Buffet autographing monographs at the exhibition press conference, 1996.

黃才郎與法國藝術家畢費合影於高美館1996年「畢費回顧展」現場
Huang Tsai-Lang and French artist Bernard Buffet photographed at *A Retrospective of Bernard Buffet* presented at the Kaohsiung Museum of Fine Arts.

•1997

- 主導策劃辦理「黑色的精靈－巴斯奇亞畫展」
- Directed the organization of the exhibition, *Jean-Michel Basquiat*.

•1998

- 榮獲香港文學藝術家協會頒贈中華文學藝術家金龍獎
- Presented with a Golden Dragon Award of Chinese Literature by the Hong Kong Literators & Artists Association.

1997年高美館辦理「黑色的精靈－巴斯奇亞畫展」（左起：黃才郎、王效蘭、吳敦義、羅文基）
The exhibition, *Jean-Michel Basquiat*, presented in 1997 at the Kaohsiung Museum of Fine Arts. (From the left: Huang Tsai-Lang, Wang Shaw-Lan, Wu Den-Yih, and Lo Wen-Chi.)

臺北市政府文化局時期
Department of Cultural Affairs, Taipei City Government Period

•1999

- 10月,擔任臺北市政府文化局副局長
- Appointed in October as Deputy Director of the Department of Cultural Affairs, Taipei City Government

臺北市立美術館時期 Taipei Fine Arts Museum Period

•2000

- 9月,擔任臺北市立美術館第四任館長(2000~2007)
- 邀請學者專家,與館員開始進行北美館典藏品點檢作業。
- Appointed in September as the 4th Director of the Taipei Fine Arts Museum (2000-2007).
- Invited scholars and experts to conduct an inventory inspection of the Taipei Fine Arts Museum's collection with the museum's staff members.

•2001

- 連續四年,主導推動辦理北美館的美術教育展覽:
 「藏在石頭裡的鳥:關於布朗庫西作品的遊戲空間」,2001展出
 「11張床:一樣/不一樣」,2002展出
 「城市中的旅行」,2003展出
 「發現馬諦斯與畢卡索教育展」,2004展出
- 自本年起,領導北美館引進時尚、設計、建築類展覽,包括:
 「少與多:法國國立當代藝術基金會設計收藏展」,2001展出
 「科比意—介於知性與感性之間」,2002展出
 「領域:當代以色列設計展」,2003展出
 「義大利設計展—米蘭三年中心經典藏品」,2004展出
 「普立茲克建築獎作品展 1979-2000」,2005展出
 「薇薇安·魏斯伍德的時尚生涯」,2005展出
 「義大利燈飾設計展」,2006展出
- Directed the organization of art education exhibitions for four consecutive years at the Taipei Fine Arts Museum, including:
 L'oiseau Cache dans la Pierre – Un espace-jeu autour de l'oeuvre de Brancusi (The Bird Hidden in the Stone – A play space based on the works of Brancusi), 2001; 11 Beds – Alike/Unalike, 2002; Travel Around a City, 2003; and Matisse/Picasso Discovery Workshop, 2004.
- Starting this year, the Taipei Fine Arts Museum began to introduce and present exhibitions featuring fashion, design, and architecture, including
 Moins et Plus: Collection design du Fonds national d'art contemporain Ministère de la Culture, Paris, France, 2001; Le Corbusier: Morceaux Choisis, 1912-1965, 2002; Domains – Contemporary Israeli Design, 2003; Il design in Italia – la Collezione del Design Italiano della Triennale di Milano, 2004; The Art of Architecture: Works by Laureates of the Pritzker Architecture Prize, 2005; Vivienne Westwood, 2005; and Italian Light: 70 Designer Lamps from 1950 to 1980, 2006.

2000-2006照片來源:臺北市立美術館
Photos from 2000 to 2006: Courtesy of the Taipei Fine Arts Museum

黃才郎2000年就任北美館館長,新任館長佈達典禮由臺北市文化局時任局長龍應台主持。
Then Taipei Cultural Bureau Chief, Lung Ying-Tai, hosting the ceremony for Huang Tsai-Lang's inauguration as Director of the Taipei Fine Arts Museum in 2000.

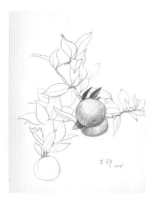

〈橘子〉，2001，鉛筆、畫紙，42.2 x 32 cm，
藝術家自藏
Tangerines, 2001. Pencil on paper. 42.2 x 32 cm. Courtesy
of the artist.

黃才郎（左1）領導北美館引進法國龐畢度中
心兒童工作室策辦的「城市中的旅行」教育
展，2003。
Led by Huang Tsai-Lang (first on the left), the Taipei Fine
Arts Museum presented the education exhibition, *Travel
Around a City*, curated by the Centre Pompidou Kids
Workshop, 2003.

黃才郎於2004年「義大利設計展─米蘭三年中
心經典藏品」展覽現場
Huang Tsai-Lang at the exhibition, *Il design in Italia – la
Collezione del Design Italiano della Triennale di Milano*,
2004.

黃才郎於「藏在石頭裡的鳥：關於布朗庫西
作品的遊戲空間」展場中與參觀民眾互動，
2001。
Huang Tsai-Lang interacting with the audience at the
exhibition, *The Bird Hidden in the Stone - A Play Space
Based on the Works of Brancusi*, 2001.

黃才郎於2004年「發現馬諦斯與畢卡索教育
展」現場
Huang Tsai-Lang at the *Matisse/Picasso Discovery
Workshop*, 2004.

2005年「薇薇安・魏斯伍德的時尚生涯」展覽
開幕式
Opening ceremony of the exhibition, *Vivienne Westwood*,
2005.

•2002

• 結合中華郵政公司，發行臺灣近代畫作郵票三組共12枚。
• 美術節邀請市民參加
• Collaborated with the Chunghwa Post Co., Ltd. and released three collections with 12 stamps featuring modern
Taiwanese paintings.
• Invited the city's citizens to participate in art festivals.

2002年黃才郎促成北美館與中華郵政公司共同
發行臺灣近代畫作郵票
Huang Tsai-Lang facilitated the collaboration between the
Taipei Fine Arts Museum and Chunghwa Post Co., Ltd. on
the release of stamps featuring modern Taiwanese paintings
in 2002.

•2003

- 主導策劃「臺灣地區美術發展回顧展」系列，以十年爲一單位，陸續推出50-90年代臺灣美術史研究展，開創北美館計畫性策展、目標性典藏之方略，爲館內典藏許多美術史上重要作品。計有：
 「長流－五〇年代臺灣美術發展」，2003展出
 「前衛－六〇年代臺灣美術發展」，2003展出
 「反思－七〇年代臺灣美術發展」，2004展出
 「開新－八〇年代臺灣美術發展」，2004展出
 「立異－九〇年代臺灣美術發展」，2004展出
- 適逢北美館建館20週年，主導策劃編印《20週年典藏圖錄總覽》。
- 撰文〈細水長流──1950年代台灣美術發展中的民間畫會〉，收錄於《長流－五〇年代臺灣美術發展》，臺北市立美術館出版。
- 撰文〈遊玩藝術的空間──北美館的資源教室〉，發表於《遊於藝：美術館教育國際研討會2003》，臺北市立美術館出版。
- Started planning the exhibition series, *Art Development in Taiwan - A Retrospective Exhibition in Five Parts*, with a research-oriented exhibition series launched for each decade between the 1950s and 1990s. This launched the Taipei Fine Arts Museum's approach to strategically curate exhibitions and its objective-oriented collection, leading to the museum's acquisition of many significant and historic artworks. The exhibitions included:
 From the Ground Up –Art in Taiwan 1950-1959, 2003; *The Experimental Sixties: Avant-Garde Art in Taiwan*, 2003; *Reflections of the Seventies: Taiwan Explores Its Own Reality*, 2004; *The Transitional Eighties - Taiwan's Art Breaks New Ground*, 2004; and *The Multiform Nineties: Taiwan's Art Branches Out*, 2004.
- Directed the planning and publishing of *Taipei Fine Arts Museum Collection Catalogue 1983-2002* to commemorate the museum's 20th anniversary.
- Penned the essay, "From the Ground Up Artist Associations in 1950s" included in the exhibition catalog, *From the Ground Up –Art in Taiwan 1950-1959*, published by the Taipei Fine Arts Museum.
- Penned and presented the paper, "Art Experience Corner at the Taipei Fine Arts Museum," at the *Play with Art: 2003 International Symposium on Art Museum Education*, published by the Taipei Fine Arts Museum.

2003年「長流－五〇年代臺灣美術發展」開幕式
Opening ceremony of *From the Ground Up –Art in Taiwan 1950-1959*, presented in 2003.

2004年「開新－八〇年代臺灣美術發展」開幕式
Opening ceremony of *The Transitional Eighties: Taiwan's Art Breaks New Ground*, 2004.

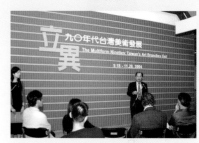

2004年「立異－九〇年代臺灣美術發展」開幕式
Opening ceremony of *The Multiform Nineties: Taiwan's Art Branches Out*, 2004.

•2004

- 主導編印《典藏百選：臺北市立美術館館藏精品》，增加中、英、日文版，提供國際策展方向開拓。
- 撰文〈爲兒童而藝術──美術館爲兒童所做的特別規劃〉，收錄於《2004兒童美術教育學術研討會論文集》，高雄市立美術館出版。
- 推動「正言世代：臺灣當代視覺文化」展赴美國康乃爾大學強生美術館展出。
- Directed the publishing of *100 Highlights from the Permanent Collection of Taipei Fine Arts Museum*, which included Chinese, English, and Japanese versions to open up for more international curatorial exhibition possibilities.
- Penned the essay, "Art for Children – Art Museum's Special Planning Dedicated to Children," included in the *2004 Children's Art Education Symposium Essay Collection*, published by the Kaohsiung Museum of Fine Arts.
- Pushed for the presentation of the exhibition, *Contemporary Taiwanese Art in the Era of Contention*, at the Herbert F. Johnson Museum of Art, Cornell University, U.S.A.

2004年「正言世代：臺灣當代視覺文化」於美國康乃爾大學強生美術館開幕式場景
Opening Ceremony of *Contemporary Taiwanese Art in the Era of Contention* at the Herbert F. Johnson Museum of Art, Cornell University, 2004.

•2005

- 撰文〈爲藝術而教育；爲教育而藝術〉，發表於「跨入藝術：2005美術館教育國際學術研討會」。
- 推出「樂透可見與不可見教育展」、藝術體驗空間的「水墨桃花源教育展」等富於教育意義的展覽，成立「資源教室」。
- 繪畫作品〈纏〉，受邀參加關渡美術館「2005關渡英雄志—臺灣現代美術大展」。
- Penned and presented the essay, "Education for Art, and Art for Education" at the "Stride into Art: 2005 International Symposium on Art Museum Education."
- Launched *Lots o'LOTTO: Visible and Invisible* and *Ink Painting Dreamland*, education-oriented exhibitions that provided a space for experiencing art; established the "Resource Classroom."
- Invited by the Kuandu Museum of Fine Arts to show the painting, *Intertwined*, in the *2005 Kuandu Extravaganza - Exhibition of Modern Art in Taiwan*.

黃才郎（左2）引介時任文建會主委陳奇南（右1）體驗「樂透可見與不可見教育展」，2005。
Huang Tsai-Lang (second on the left) with the then Minister of the Council for Cultural Affairs, Chen Chi-Nan (first from the right), at the exhibition, *Lots o'LOTTO: Visible and Invisible*, 2005.

黃才郎主持「水墨桃花源教育展」開幕式，2005。
Huang Tsai-Lang hosting the opening ceremony of *Ink Painting Dreamland*, 2005.

•2006

- 榮獲頒贈義大利總統「義大利騎士團結之星勳章」，由義大利駐華代表代安琦麗女士（Maria Assunta Accili Sabbatini）代表總統頒贈。
- 兼任台北當代藝術館館長
- 撰文〈老園新苗——北美館的青少年活動〉，發表於《「博物館與青少年」—2006年博物館館長論壇》，國立歷史博物館出版。
- 首開兩岸美術館互動交流，「台灣美術發展1950~2000」於中國美術館展出；「展開的現實主義—1978年以來中國大陸油畫」於臺北市立美術館展出。
- 協助日本松濤美術館辦理「陳進百歲紀念展」於東京、兵庫縣、福岡巡迴展出。
- Decorated with the Order of the Star of Italian Solidarity by the president of Italy, which was presented by Maria Assunta Accili Sabbatini, representative of Italy to Taiwan, on behalf of the president.
- Served concurrently as Director of the Museum of Contemporary Art, Taipei.
- Penned and presented the essay, "Old Garden with New Shoots – TFAM's Activities for Teenagers," at the *Museums and Teenagers: Forum of Museum Directors, 2006*, published by the National Museum of History.
- Initiated exchanges between art museums in China and Taiwan, with the exhibition, *The Odyssey of Art in Taiwan 1950-2000*, presented at the National Art Museum of China, and *The Blossoming of Realism: The Oil Painting of Mainland China Since 1978* presented at the Taipei Fine Arts Museum.
- Assisted the Shoto Museum of Art in Japan with the organization of the exhibition, *Centennial Celebration of Chen Chin*, in Tokyo, Hyogo, and Fukuoka.

2006年「台灣美術發展1950~2000」於北京的中國美術館開幕
Opening ceremony of *The Odyssey of Art in Taiwan 1950-2000* at the National Art Museum of China in Beijing, 2006.

黃才郎主持「陳進百歲紀念展—赴日巡迴前展」於北美館的開幕式，2006。
Huang Tsai-Lang hosting the opening ceremony of *Centennial Celebration of Chen Chin - A Preview of the Touring Exhibition in Japan* at the Taipei Fine Arts Museum, 2006.

文建會時期 (2) Council for Cultural Affairs Period (II)

•2007

- 3月，調職文化建設委員會，陸續擔任第一處、第三處處長。
- 規劃MIT（Made in Taiwan－新人推薦特區）計畫，自2008年開始於臺北國際畫廊博覽會展出。
- Transferred to the Council for Cultural Affairs in March and served as Director of the 1st Department and then the 3rd Department.
- Organized the project, "Made in Taiwan – Art Taipei Young Artists Discovery," which has been a part of the art fair, Art Taipei, since 2008.

•2008

- 撰文〈福爾摩莎國際藝術節的文化政策面向〉，發表於「文化政策與文化首都國際論壇」。
- Penned and presented the essay, "The Cultural Policy of Art Formosa," at the "International Forum for Cultural Policy and Capitals of Culture."

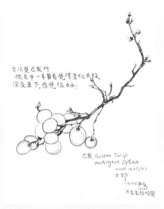

〈葡萄〉，2008，鉛筆、畫紙，
33.2 x 24.3 cm，藝術家自藏
Grapes, 2008. Pencil on paper. 33.2 x 24.3 cm.
Courtesy of the artist.

國立臺灣美術館時期 National Taiwan Museum of Fine Arts Period

•2009

- 9月，就任國立臺灣美術館館長（2009~2015）
- 撰文〈2009臺灣美術館行政與趨勢〉，收錄於《2009臺灣視覺藝術年鑑》，藝術家出版社出版。
- Appointed in September to serve as Director of the National Taiwan Museum of Fine Arts (2009-2015).
- Penned the essay, "2009 Administration and Trends of Art Museum in Taiwan," which was included in *The 2009 Yearbook of Visual Art of Taiwan*, published by the Artist Publishing Co.

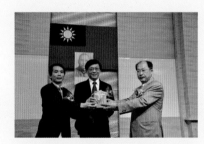

黃才郎（右）2009年9月4日就任國美館館長，由文建會時任副主委張譽騰（中）監交，左為國美館時任代理館長張仁吉。
Huang Tsai-Lang (right) appointed Director of the National Taiwan Museum of Fine Arts on September 4th, 2009. The directorship turnover ceremony was overseen by the then Deputy Minister of the Council for Cultural Affairs, Chang Yui-Tan (middle), with the museum's then Acting Director Chang Jen-Chi on the left.

•2010

- 應法國文化部邀請，特別專題訪問法國
- 推動辦理「凝望的時代－日治時期寫眞館的影像追尋」展
- 推動國美館「感官拓樸－台灣當代藝術體感測」展、廣東美術館「時空中的一個點－廣東美術館藏當代藝術作品展」之館際交流展出。
- 推動「複語·腹語－台灣當代藝術展」赴韓國光州市立美術館、「浮世山水－台灣藝術心貌」赴日本相田美術館、「台灣響起」赴匈牙利布達佩斯藝術館及路德維格現代美術館展出。
- Invited by the Ministry of Culture, France to visit France on a special feature program.
- Facilitated the organization of the exhibition, *In Sight: Tracing the Photography Studio Images of the Japanese Period in Taiwan.*
- Facilitated the exchange project between the National Taiwan Museum of Fine Art (NTMoFA) and the Guangdong Museum of Art (GDMoA), with the exhibitions, *Sensory Topology: Bodily Perception of Taiwan Contemporary Art* from NTMoFA and *At the Crossroad – Contemporary Artworks from Collection of GDMoA.*
- Facilitated the presentations of *Ventriloquized Voices: Contemporary Art from Taiwan* at the Gwangju Museum of Art in South Korea; *Landscape to Mindscape of Floating World: Contemporary Art from Taiwan* at the Mitsuo Aida Museum in Japan; and *Taiwan Calling* at Műcsarnok-Kunsthalle and the Ludwig Museum of Contemporary Art in Budapest, Hungary.

2010年「台灣響起」赴匈牙利達佩斯藝術館及路德維格現代美術館展出前，於文建會辦理行前記者會。
Press conference at the Council for Cultural Affairs before the exhibition, *Taiwan Calling*, departed for showing at the Műcsarnok-Kunsthalle and the Ludwig Museum of Contemporary Art in Budapest, Hungary, 2010.

•2011

- 主導策劃辦理「國美無雙－館藏精品常設展」
- 推動兩岸雙年性的館際合作策劃展於國美館、中國美術館巡迴展出：
 「複感·動觀－2011海峽兩岸當代藝術展」
 「交互視象－2013海峽兩岸當代藝術展」
- 推動辦理「畫家風景·國民風景－百年台灣行旅」、「現代潮－五〇、六〇年代台灣美術」等臺灣美術研究展。
- 自本年起開辦「數位藝術策展案」及「數位藝術創作案」競爭型徵件機制暨展覽，提供臺灣新媒體藝術優秀創意人才發表的資源及舞台。
- Directed the organization of the exhibition, *Unique Vision: Highlights from the National Taiwan Museum of Fine Arts Collection.*
- Initiated biennial inter-museum collaborations between the National Taiwan Museum of Fine Arts and the National Art Museum of China, which included:
 Flourishing and Flowing—A Contemporary Art Exhibition across the Strait 2011 and *Inter-vision: A Contemporary Art Exhibition Across the Strait 2013.*
- Facilitated the organization of research-oriented exhibitions on Taiwanese art, including *Scenery and Vistas of Taiwan through the Eyes of Artists: A Century of Taiwanese Landscape and Scenic Art* and *The Modernist Wave – Taiwan Art in the 1950s and 1960s.*
- Launched in this year the "Digital Art Curatorial Exhibition Program" and the "Digital Art Creation Project," which are competitions with open calls for entries and exhibitions that provide outstanding new media art creators with resources and platforms to present their works.

「複感·動觀－2011海峽兩岸當代藝術展」於中國美術館展出時貴賓參觀情形
Distinguished guests at the exhibition, *Flourishing and Flowing — A Contemporary Art Exhibition Across the Strait 2011*, at the National Art Museum of China.

2011年「現代潮－五〇、六〇年代台灣美術」，開展前於臺北辦理記者會
Pre-opening press conference in Taipei for *The Modernist Wave – Taiwan Art in the 1950s and 1960s*, presented in 2011.

「交互視象－2013海峽兩岸當代藝術展」於國美館的開幕式貴賓合影。
Group photograph of distinguished guests at the opening ceremony of *Inter-vision: A Contemporary Art Exhibition Across the Strait 2013*, at the National Taiwan Museum of Fine Arts.

•2012

- 撰寫郭柏川《鳳凰城－台南一景》，藝術家出版社出版。
- 奉文化部指示研擬籌備藝術銀行
- 主導策劃辦理「國美無雙II－館藏精品常設展」
- 為建構臺灣與國際數位藝術交流網絡，引介數位藝術的最新創作趨勢，自本年起連續3年，持續推動辦理大型國際科技藝術展，包括：
 「集體智慧－2012國際科技藝術展」
 「We are the Future－藝術超未來」日本跨領域團隊「teamLab團體實驗室」特展，2012展出
 「超級關係－2013國際科技藝術展」
 「奇幻視界－2014國際科技藝術展」
- Penned the book, *Kuo Po-Chuan: Phoenix City – A Scenery in Tainan*, published by the Artist Publishing Co.
- Instructed by the Ministry of Culture to begin the planning of Art Bank.
- Directed the organization of the exhibition, *Unique Vision II: Highlights from the National Taiwan Museum of Fine Arts Collection*.
- Began introducing the latest trends in digital art with the objective of building an exchange network between Taiwan and the international digital art community; starting this year, large-scale international techno art exhibitions were held for three consecutive years, including:
 Collective Wisdom - 2012 International Techno Art Exhibition; teamLab exhibition, *We are the Future, 2012*; *SUPER-CONNECT - 2013 International Techno Art Exhibition*; and *Wonder of Fantasy: 2014 International Techno Art Exhibition*.

「超級關係－2013國際科技藝術展」開幕，黃才郎接受媒體採訪。
Huang Tsai-Lang interview by the media at the opening of *SUPER-CONNECT – 2013 International Techno Art Exhibition*.

•2013

- 推動辦理國際級藝術大師Tony Cragg「東尼‧克雷格：雕塑與繪畫展」、Yaacov Agam「超越視界－亞科夫‧亞剛回顧展」、Robert Capa「在現場－卡帕百年回顧展」等，展現國美館推動國際接軌的成果。
- 推出一系列臺灣藝術家「刺客列傳」研究展，整體企劃以1931 (民國20年)～1980 (民國69年) 出生的藝術家為對象，每十年為一個世代，共五個世代藝術家的研究型策展：
 台灣美術家「刺客列傳」1931～1940－二年級生，2013展出
 台灣美術家「刺客列傳」1941～1950－三年級生，2013展出
 台灣美術家「刺客列傳」1951～1960－四年級生，2014展出
 台灣美術家「刺客列傳」1961～1970－五年級生，2014展出
 台灣美術家「刺客列傳」1971～1980－六年級生，2014～2015展出
- Facilitated the organization of exhibitions featuring internationally renowned artists, including *Tony Cragg: Sculptures and Drawing*; *Yaacov Agam: Beyond the Invisible*; and *On Site: A Centennial Retrospective of Robert Capa*, which showcased the result of the National Taiwan Museum of Fine Arts' effort to make international connections.
- Launched a series of research-oriented exhibitions under the overarching theme, *The Pioneers of Taiwanese Artists*, featuring Taiwanese artists born between 1931 and 1980. The series was divided into five decades with artists from each respective decade presented in the exhibitions:
 The Pioneers of Taiwanese Artist, 1931-1940, 2013; *The Pioneers of Taiwanese Artist, 1941-1950, 2013*; *The Pioneers of Taiwanese Artist, 1951-1960, 2014*; *The Pioneers of Taiwanese Artist, 1961-1970, 2014*; and *The Pioneers of Taiwanese Artist, 1971-1980, 2014-2015*,

2012年「國美無雙II－館藏精品常設展」開幕式貴賓合影
Group photograph of distinguished guests at the opening ceremony of *Unique Vision II: Highlights from the National Taiwan Museum of Fine Arts Collection*, 2012.

「國美無雙II－館藏精品常設展」，黃才郎與藝術家賴傳鑑一同參觀展覽，2012。
Huang Tsai-Lang and artist Lai Chuan-Jian at the exhibition, *Unique Vision II: Highlights from the National Taiwan Museum of Fine Arts Collection*, 2012.

2013年「超越視界－亞科夫‧亞剛回顧展」開幕式與會貴賓合影
Group photograph of distinguished guests at the opening ceremony of *Yaacov Agam: Beyond the Invisible*, 2013.

黃才郎主持「台灣美術家『刺客列傳』1931~1940－二年級生」展覽開幕式，2013。
Huang Tsai-Lang hosting the opening ceremony of *The Pioneers of Taiwanese Artists, 1931-1940*, presented in 2013.

•2013

- 推出「生命的禮拜天：張義雄百歲回顧展」
- 推動「轉動藝台灣」赴韓國首爾市立美術館、「凝視自由：台灣當代藝術展」赴塞爾維亞佛伊弗迪納當代美術館展出。
- Launched the exhibition, *The Sunday of Life: A Centennial Retrospective of Chang Yi-Hsiung*.
- Facilitated the presentations of the exhibitions, *Rolling! Visual Art in Taiwan*, at the Seoul Museum of Art and *Gazing into Freedom: Taiwan Contemporary Art Exhibition* at the Museum of Contemporary Art of Vojvodin in Serbia.

「台灣美術家『刺客列傳』1951～1960－四年級生」臺北記者會，左起李銘盛、賴純純、黃才郎、陸先銘及策展人蔡昭儀，2014。
Press conference in Taipei for *The Pioneers of Taiwanese Artists, 1951-1960*, from the left: Lee Ming-Sheng, Jun T. Lai, Huang Tsai-Lang, Lu Hsien-Ming, and curator Tsai Chao-Yi, 2014.

「台灣美術家『刺客列傳』1971～1980－六年級生」展覽開幕式，黃才郎與策展人黃舒屏、參展藝術家合影，2014。
Group photograph of Huang Tsai-Lang, curator Iris Shu-Ping Huang, and contributing artists at the opening ceremony of *The Pioneers of Taiwanese Artists, 1971-1980*, presented in 2014.

2013年「轉動藝台灣」於韓國首爾市立美術館展覽開幕式，左1為首爾市立美術館時任館長金弘姬博士、左2為黃才郎。
Opening ceremony of *Rolling! Visual Art in Taiwan* at the Seoul Museum of Art in 2013, with the then Director of the Seoul Museum of Art, Dr. Kim Hong-hee (first on the left) and Huang Tsai-Lang (second on the left).

•2014

- 推動「界－台灣當代藝術」展赴美國康乃爾大學強生美術館展出
- 推動辦理「台灣木刻版畫現在進行式」、「『看見的時代－影會時期的影像追尋』1940s～1970s」等臺灣美術主題研究展。
- Facilitated the presentation of the exhibition, *Jie (Boundaries): Contemporary Art from Taiwan*, at the Herbert F. Johnson Museum of Art, Cornell University.
- Facilitated the organization of research-oriented exhibitions on Taiwanese art, including *The Progress in Taiwan Modern Printmaking: Woodcut & Its Variations* and *The Era Seen: The Pursuit of Images During the Days of the Photo Club 1940s-1970s*.

•2015

- 7月，國立臺灣美術館館長退休。
- Retired in July as Director of the National Taiwan Museum of Fine Arts.

「界－台灣當代藝術」於美國康乃爾大學強生美術館展出之貴賓合影，2014。
Group photograph of distinguished guests at the opening ceremony of *Jie (Boundaries): Contemporary Art from Taiwan*, at the Herbert F. Johnson Museum of Art, Cornell University. 2014.

•2016

- 受邀參加「百年華人繪畫巡迴展」於長流美術館
- Invited to show his work in *A Century of the Chinese Paintings Tour Exhibition* at the Chan Liu Art Museum.

•2017

- 繪畫作品〈大頭菜〉（1996）、〈南瓜〉（1995）兩件參與臺北市「有璽藝術空間」舉辦之「我們一起做自己」創作聯展。
- Presented two drawings, *Kohlrabis* (1996) and *Pumpkin* (1995), at the group exhibition, *Let's Be Ourselves*, presented by the YX Art Space.

•2019

- 受邀擔任臺北市立文獻館文獻委員。
- Invited to serve as a committee member of the Taipei City Archives.

•2022

- 受邀擔任111年度奇美藝術獎評審委員
- 獲教育部頒發藝術教育貢獻獎終身成就獎
- Invited to serve as a jury member of the 2022 Chimei Art Awards.
- Presented with Life Time Achievement Award in Art Education Contribution by the Ministry of Education.

•2023

- 2月於國立國父紀念館博愛藝廊舉辦「纏綿—黃才郎作品展」，首次展出自1971年以來半世紀於公餘之暇的創作成果。
- 8月於國立臺灣美術館舉辦「藝術行路—黃才郎的繪畫探索」展覽，由臺灣美術史研究者李欽賢策劃，以回顧展形式，耙梳整理繪畫創作理路。
- *Lingering: Huang Tsai-Lang Solo Exhibition* presented in February at the Boai Gallery of the National Dr. Sun Yat-sen Memorial Hall, which presented for the first time Huang's oeuvre created in his spare time throughout the last 50 years since 1971.
- *A Journey of Art Exploration: Huang Tsai-Lang's Paintings and Drawings* presented in August at the National Taiwan Museum of Fine Arts. Curated by Lee Chin-Hsien, a historian of Taiwanese art, the exhibition is a retrospective that examines the artist's creative journey.

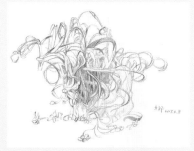

〈枯萎的水仙〉，2017，鉛筆、畫紙，
30.6 x 39.6 cm，藝術家自藏
Withered Daffodils, 2017. Pencil on paper. 30.6 x 39.6 cm.
Courtesy of the artist.

2022年獲教育部「藝術教育貢獻獎終身成就獎」，左為由頒獎人教育部政務次長蔡清華。
Presented in 2022 with Life Time Achievement Award in Art Education Contribution by the Ministry of Education. The award was presented by Tsai Ching-Hwa, Deputy Minister of the Ministry of Education (on the left).

「纏綿—黃才郎作品展」2023年2月25日於國立國父紀念館辦理開幕式（圖片由陳忠峰提供）
Distinguished guests at the opening ceremony of *Lingering: Huang Tsai-Lang Solo Exhibition*, at the Boai Gallery of the National Dr. Sun Yat-sen Memorial Hall on February 25th, 2023. (Photo by Chen Chung-Feng.)

感謝誌 Acknowledgments

我們對於以下個人、機構團體及未具名之收藏家表達誠摯的謝意，因為他們的慷慨支持及合作促使本展得以圓滿且順利舉辦。

We would like to express our sincere gratitude to the following organizations and individuals for their generous assistance to the realization of this exhibition. We also want to express our sincere gratitude to those anonymous private collectors who have kindly lent their art to this exhibition.

借展單位 Lenders to the Exhibition

臺北市立美術館 Taipei Fine Arts Museum
所有未具名收藏家 Anonymous private collectors

特別感謝 Special Thanks

臺北市立美術館 Taipei Fine Arts Museum
高雄市立美術館 Kaohsiung Museum of Fine Arts
陳淑鈴　Chen Shu-Ling
陳泳任　Chen Yung-Jen
曾芳玲　Tseng Fangling
盧妙芳　Lu Miao-Fang
應廣勤　Ying Kuang-Chin

國家圖書館出版品預行編目（CIP）資料

藝術行路：黃才郎的繪畫探索 = A Journey of art exploration :
Huang Tsai-Lang's paintings and drawings /
黃舒屏主編. -- 臺中市：國立臺灣美術館, 2023.08
240 面；27.5×23 公分
ISBN 978-986-532-857-3(平裝)
1.CST: 繪畫 2.CST: 畫冊

947.5 112011688

藝術行路
黃才郎 的繪畫探索

A Journey of Art Exploration: Huang Tsai-Lang's Paintings and Drawings

指導單位 / 文化部	Supervisor / Ministry of Culture
主辦單位 / 國立臺灣美術館	Organizer / National Taiwan Museum of Fine Arts
發行人 / 陳貺怡	Publisher / CHEN Kuang-Yi
編輯委員 / 汪佳政、亢寶琴、黃舒屏	Editorial Committee / WANG Chia-Cheng, KANG Pao-Ching, HUANG Shu-Ping,
蔡昭儀、林明賢、賴岳貞	TSAI Chao-Yi, LIN Ming-Shien, LAI Yueh-Chen,
駱正偉、尤文君、曾淑錢	LUO Zheng-Wei, YO Wen-Chun, TSENG Shu-Chien,
吳榮豐、粘惠娟	WU Rong-Feng, NIEN Hui-Chuan
策展人 / 李欽賢	Curator / LEE Chin-Hsien
主編 / 黃舒屏	Chief Editor / Iris Shu-Ping HUANG
專文撰稿 / 李欽賢、陳長華、蔡昭儀、姚瑞中	Essay Writers / LEE Chin-Hsien, CHEN Chang-Hwa, TSAI Chao-Yi, YAO Jui-Chung
執行編輯 / 張慧玲、黃薇、王愈方	Executive Editors / CHANG Hui-Ling, HUANG Wei, WANG Yu-Fang
展覽執行 / 張慧玲、黃薇、王愈方	Exhibition Coordinators / CHANG Hui-Ling, HUANG Wei, WANG Yu-Fang
主視覺設計 / 郭美魚	Graphic Designer / Emily GUO
美術編輯 / 郭美魚	Layout Designer / Emily GUO
翻譯 / 黃亮融、廖蕙芬、王聖智	Translators / HUANG Liang-Jung, Anne LIAO Hui-Fen, WANG Sheng-Chih
展覽日期 / 2023年8月12日至2023年10月29日	Exhibition Date / August 12, 2023 – October 29, 2023
出版單位 / 國立臺灣美術館	Publisher / National Taiwan Museum of Fine Arts
地址 / 臺中市403414西區五權西路一段2號	Address / No.2, Sec. 1, Wu-Chuan W. Road, 403414, Taichung, Taiwan, R.O.C.
電話 / 04-23723552	TEL / +886-4-23723552
傳真 / 04-23721195	FAX / +886-4-23721195
網址 / www.ntmofa.gov.tw	https://www.ntmofa.gov.tw
製版印刷 / 宏國群業股份有限公司	Printer / HK Printing Group Ltd.
出版日期 / 2023年8月	Publishing Date / August 2023
定價 / 新臺幣900元	Price / NT$900
ISBN / 978-986-532-857-3(平裝)	ISBN / 978-986-532-857-3
GPN / 1011200864	GPN / 1011200864